JOHN HEDGECOE'S NUDE PHOTOGRAPHY

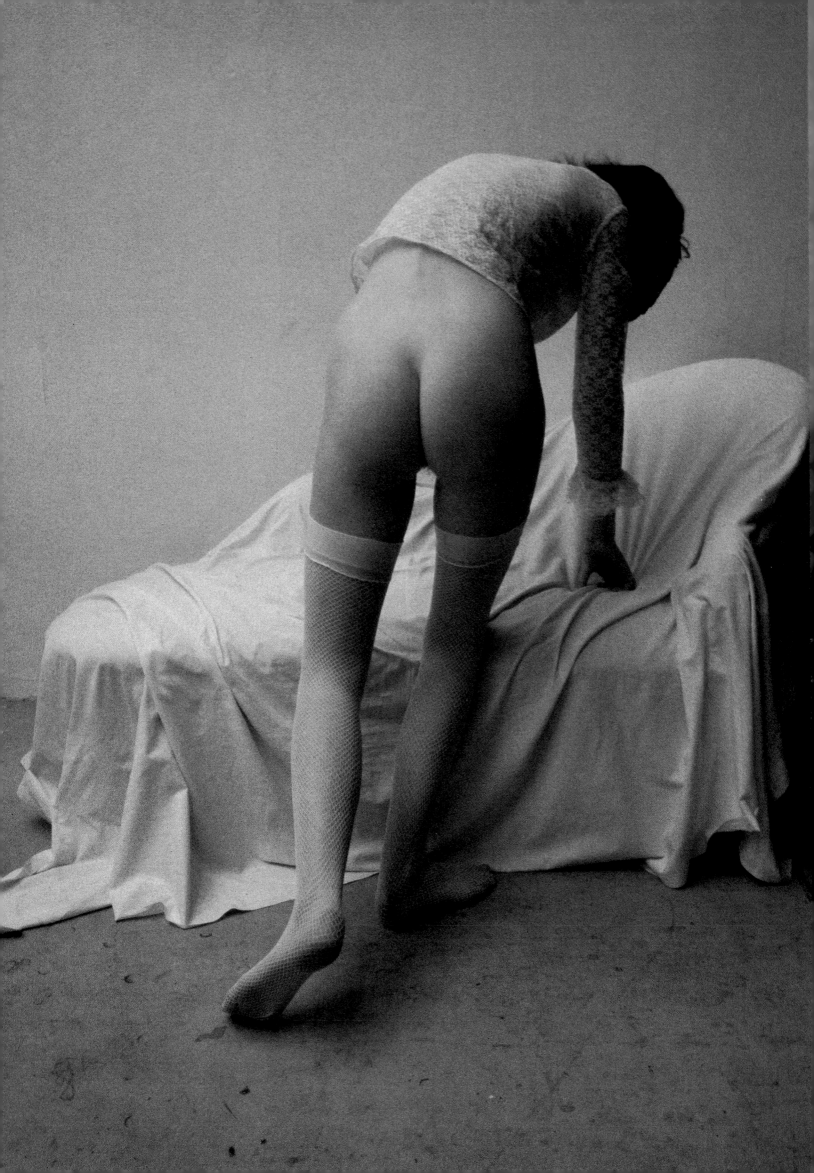

JOHN HEDGECOE'S NUDE PHOTOGRAPHY

BY JOHN HEDGECOE

Simon and Schuster New York

EDITOR Richard Dawes

ART EDITOR Jane Owen

MANAGING EDITOR Jackie Douglas

ART DIRECTOR Roger Bristow

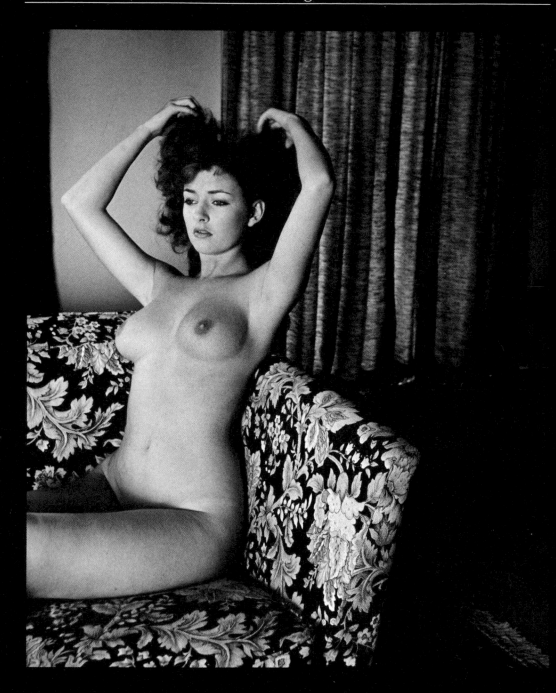

John Hedgecoe's Nude Photography was conceived, edited, and designed by
Dorling Kindersley Limited, 9 Henrietta Street, Covent Garden, London WC2
First published in Great Britain in 1984 by Ebury Press, National Magazine House,
72 Broadwick Street, London W1V 2BP
Copyright © 1984 by Dorling Kindersley Limited and John Hedgecoe
Photographs copyright © 1984 by John Hedgecoe
All rights reserved including the right of reproduction in whole or in part in any form
Published by Simon and Schuster, A Division of Simon & Schuster, Inc.
Simon & Schuster Building, Rockefeller Center, 1230 Avenue of the Americas
New York, New York 10020
SIMON AND SCHUSTER and colophon are registered trademarks of Simon & Schuster, Inc.
Library of Congress Cataloging in Publication Data
Hedgecoe, John.
John Hedgecoe's Nude photography.

1. Photography of the nude. I. Title. II. Title:
Nude photography.
TR675.H395 1984 778.9'21 84-10619
ISBN 0-671-52326-0

1 2 3 4 5 6 7 8 9 10

CONTENTS

6
INTRODUCTION

9
FORM AND EXPRESSION

61
MOOD AND ATMOSPHERE

105
PERCEPTION AND RESPONSE

141
FANTASY AND ILLUSION

193
EQUIPMENT AND TECHNIQUES

224
ACKNOWLEDGMENTS

INTRODUCTION

The nude has occupied the sensibilities of the artist for many centuries, inspiring some of the greatest works of painting and sculpture. At the time of the birth of photography, in 1839, the study of the nude was well established in fine-art training. Indeed, four centuries earlier Alberti had stated that the basis of the academic procedure is the study of human anatomy. "Begin with bone," he advised, "add muscle, then cover the body with flesh."

The history of the nude as an art form takes us back ultimately to classical Greece, for as Kenneth Clark writes in *The Nude*: "The Ephebe of Kritios (c. 480 BC) remains the first beautiful nude in art. Here for the first time we feel (the) passionate pleasure in the human body."

Photography embraced the nude as a subject as early as 1840, at the beginning of the most prudish period of the Victorian era. The photographs of nudes exhibited at that time imitated the idealized view of contemporary painting. The sexuality of the model was suppressed beneath a perfectly smooth and waxen surface in order to find acceptance with the prevailing code of respectability.

There were also countless photographs of mothers and children, with titles like Cherub and Seraph, Divine Love, Madonna and Child, and an inexhaustible stream of Nymphs and Venuses, posed in elaborate settings with hazy backgrounds and offering no insight into the human condition.

Another branch of photography provided reference pictures for painters of the human form. Among these were Courbet, Ingres, Monet, Renoir, Degas, Cézanne, and Gauguin. These photographs comprised sets of poses depicted naturalistically and, because of the speed of the camera, their observation was very accurate. This accuracy was despised at first because, in addition to the pleasing aspects of the human body, it reproduced the faults. However, in observing without embellishing this type of picture offered a new form of erotic stimulus. Sometimes sold as postcards to an eager public, these studies of the nude attracted strong censure, so that retouching techniques were introduced to "perfect" the models. Blemishes and pubic hair were removed or concealed and points of beauty were added or accentuated. These techniques were deemed necessary in popular photographic images until the 1950s.

Another method of concealing the unpalatable was the classical tradition of drapery. When used with skill, this technique in fact partly concealed and partly revealed those areas considered offensive to delicate taste, the rhythmic line of the drapery following and emphasizing the contours of the body. Woodland settings, a stream, a fallen tree, were all used to provide a naturalistic context that complemented the beauty of the form. In this way the long evolution of art was re-enacted in a few decades by photography.

The nude survived the onslaught of Victorian modesty precisely because the academic instruction of the day involved drawing from life in the classical tradition. But photography was soon indicted for the decline of standards of drawing—a criticism still current. Nevertheless the medium rapidly embraced all the subjects formerly claimed by painters, and many more. Almost any thing was regarded as a subject and soon the camera's voracious appetite seemed to have devoured all in its sight. This simple tool gave the photographer, apart from the ability to record with speed and accuracy, the addictive power to confer importance and pass judgment.

Like painters, photographers sometimes talk about a certain mystery in their pictures. This idea is often criticized by those who regard the photograph as a simple mirror of reality. Yet, like a mirror image, the subject of a photograph does not exist; it is an illusion. The mystery in a picture is not normally there for the sake of mystification or as a pretentious ploy. Art without mystery would be like religion without mystery—it could not survive. Visual images also demand faith—the faith that although all is not revealed at first sight, the imagination is nevertheless not being cheated but given the chance to extend itself. In short, the motive behind the picture is not the creation of a mystery, for the mystery is something perceived by the imagination of the viewer, not deliberately shown.

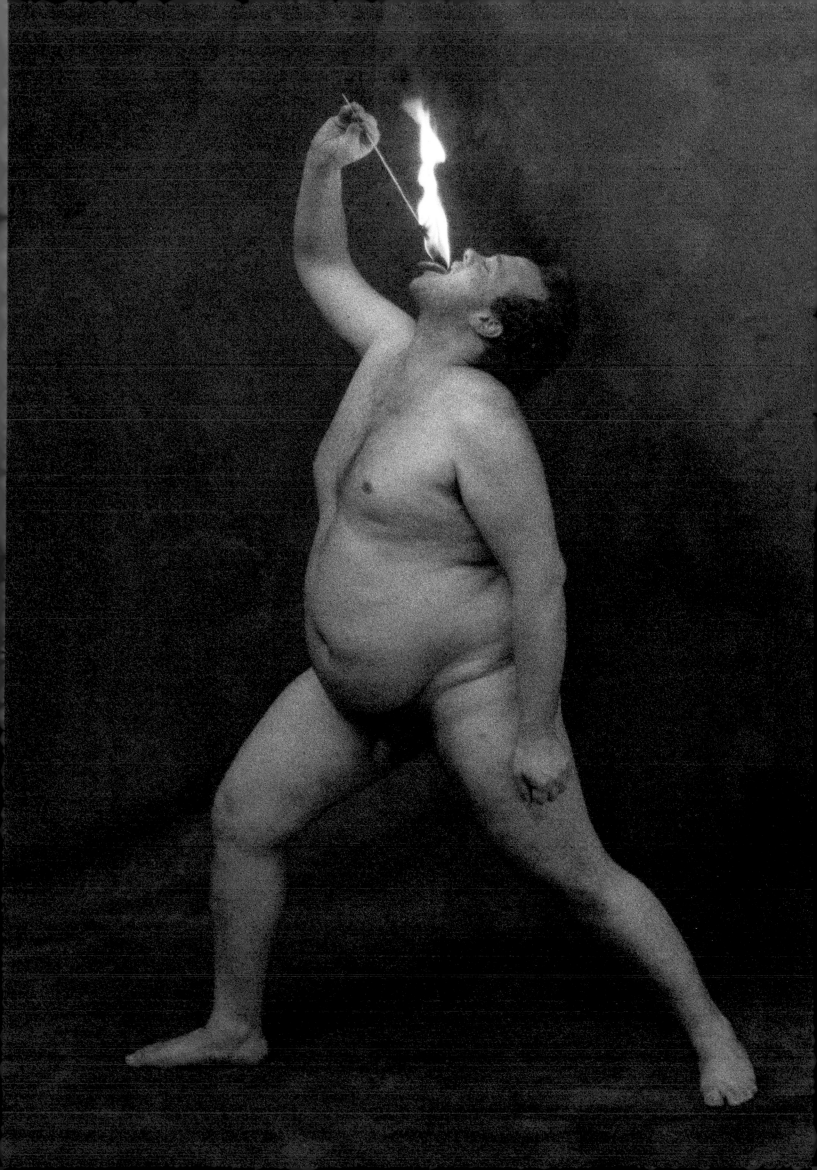

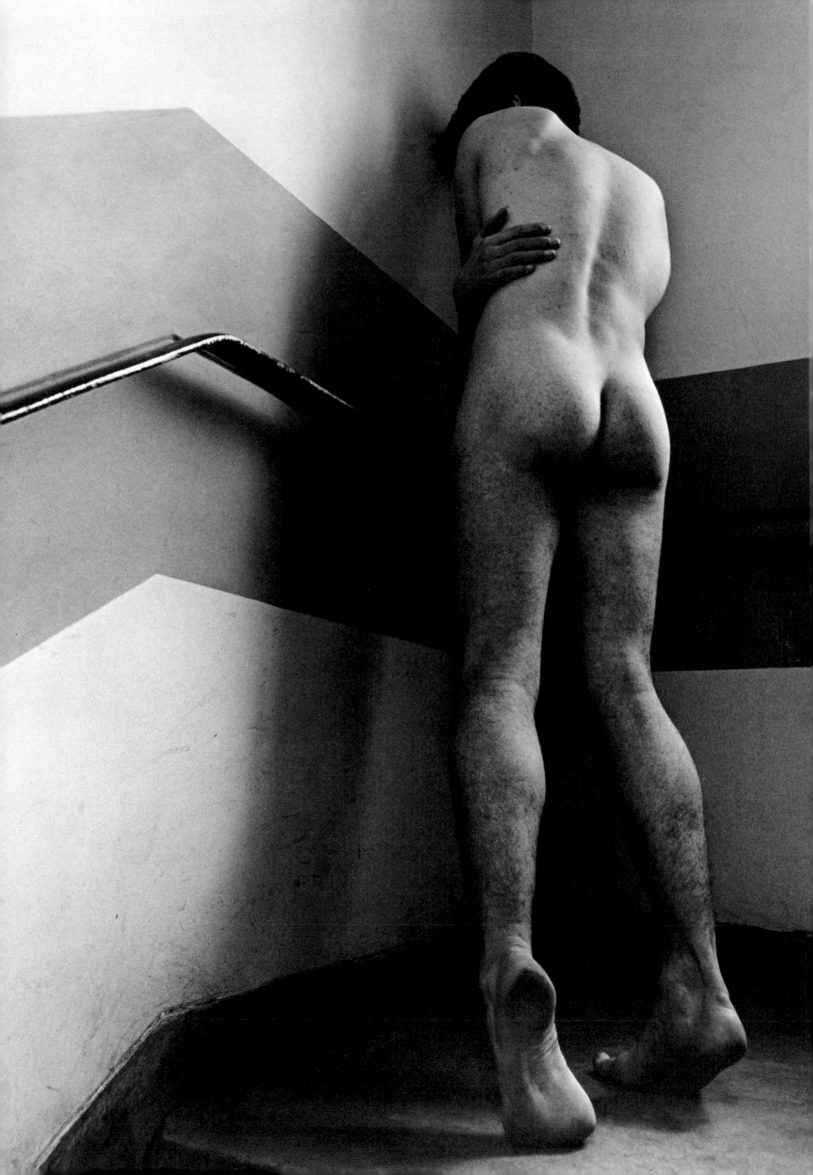

FORM
AND
EXPRESSION

The naked human form is often thought to possess an intrinsic beauty which makes it an unfailing delight to the eye. Yet it is its very nakedness, which Kenneth Clark in his study *The Nude* characterizes as compounded of apparent vulnerability and embarrassment, that we notice above all else. Clark ascribes completely different qualities to the nude, however. The nude is a product of art rather than of everyday experience and is, by contrast with the naked figure, "balanced, prosperous and confident: the body re-formed."

Since the time of man's earliest artifacts, the desire to represent the human form as symbolic of the ideal has dominated its portrayal. For, as Kenneth Clark adds, "We do not wish to imitate; we wish to perfect." The female figurines of palaeolithic times, with their grossly exaggerated proportions, represent the earliest-known impulse to idealize the human form. To the cave-dwellers of that period these large-breasted, huge-bellied, and ample-hipped figures symbolized fertility and the life force.

Many centuries later the early Greek sculptors were preoccupied with perfecting the depiction of a nude form that was usually male. Originally, their statuary represented in a severe but recognizably human shape the god Apollo. By the fifth century BC these figures had assumed an idealized human form that was intended to embody the notions of youth and energy. The classical Greek sculptors understood the structure of the body, prizing in particular the vital way in which skin ripples over muscle and bone to produce both rhythm and grace in movement. *(cont.)*

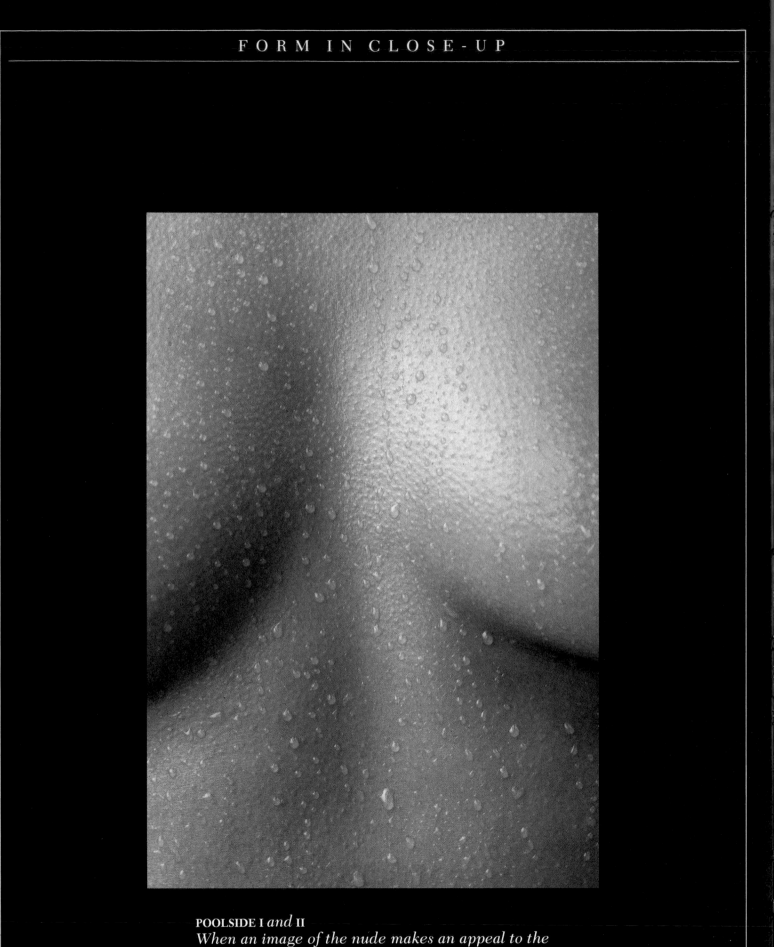

POOLSIDE I *and* **II**
When an image of the nude makes an appeal to the
primary sense of touch as well as that of sight, our
response is all the stronger. In these two pictures
portions of the body charged with both aesthetic
and emotional power are used to convey the
sensuous play of water on skin.

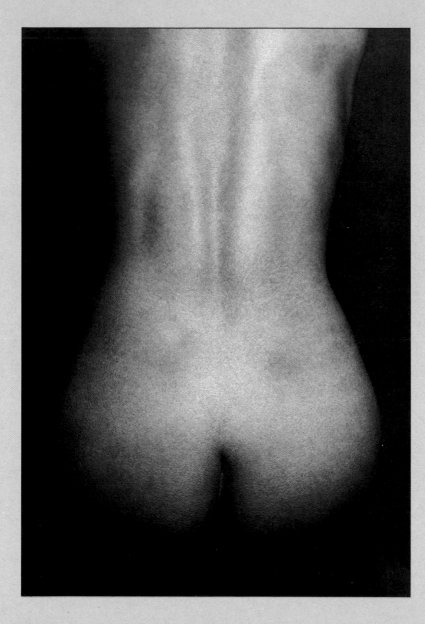

HOGLANDS 1966 (TORSO SERIES I)
The most expressive studies of the nude rely on suggestion rather than revelation, referring to ideas and feelings rather than simply reflecting the human form. In the example above, the intense, bone-like shape of the body and the clear evidence of the vertebrae and muscles beneath the skin combine to suggest a rich sensuality. As with the picture opposite, the isolation of an area of the body challenges the imagination to furnish a mental image of the unseen parts of the figure.

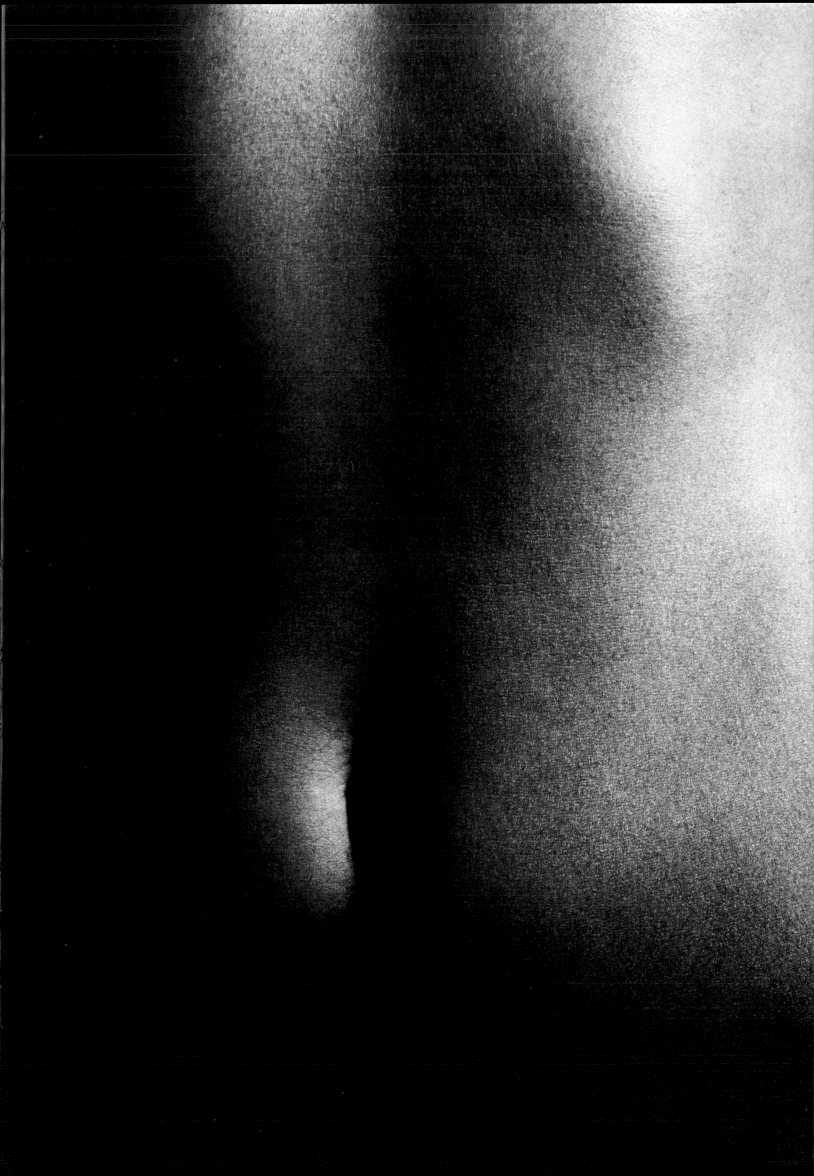

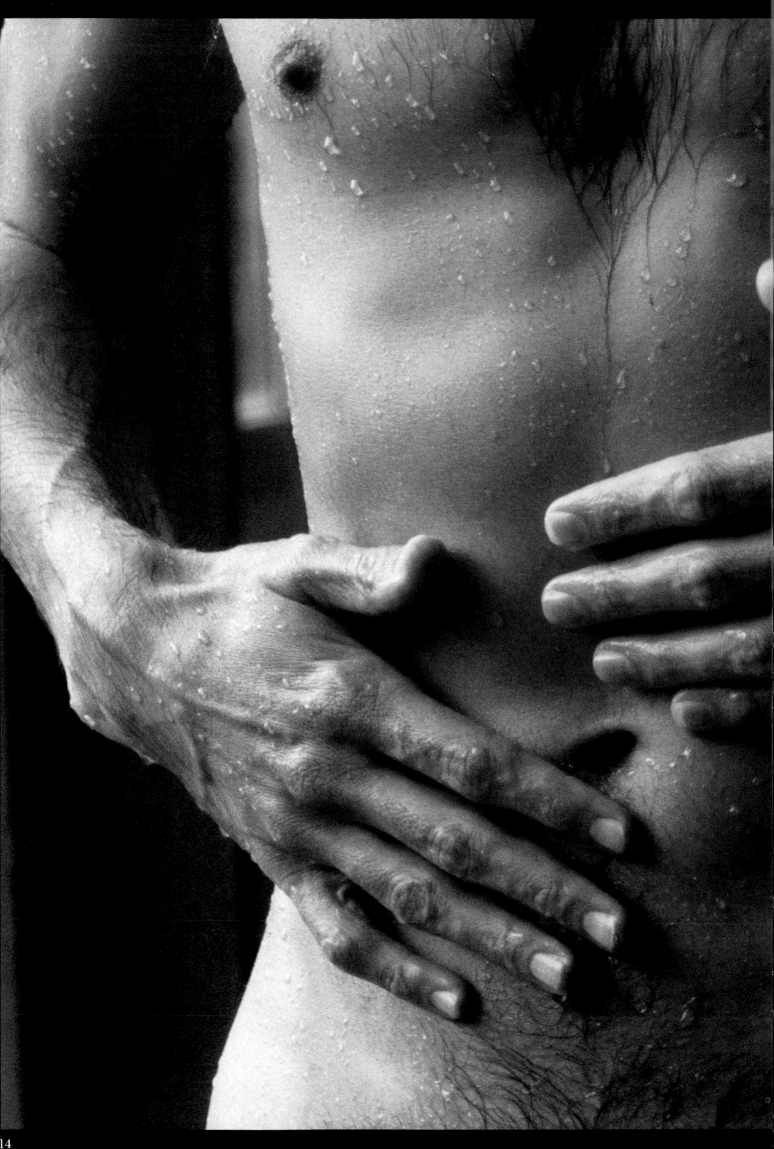

MALE & FEMALE

In the centuries between the time of classical Greek sculpture and the Renaissance, there grew up a countertradition of naturalistic depiction that has its roots in the Medieval Christian view of the world. The work of the artists of the later Middle Ages reflected forcefully the belief that Man's fallen state is revealed in his body, that guilt and despair are written on his feeble frame, and that he is truly naked before God.

While exaggeration of the faults of the human body was pursued with the aim of symbolizing Man's moral frailty, this style of depiction was nevertheless to lead to the more balanced and humane naturalism of the later Rembrandt. His male models were emaciated, while his women were fat and showed the signs of a lifetime of servitude and humiliation. And yet in such apparent ugliness he found truth and beauty, depicting the inward qualities of his subjects with as much compassion as any artist has shown for the living subject.

Rembrandt gave value to the female form, notwithstanding the lack of proportion of his models. In this he reversed the judgment of the early Renaissance that the proportions of the female did not lend themselves to representation. This belief had been expressed in 1400 by Cernini thus: "I will give the exact proportions of a man. Those of a woman I shall omit as they are not exact multiples of one another". Michelangelo also regarded the female body as greatly inferior to that of the male, sketching his studies of women from the male form, which he considered far more sensuous.

POOLSIDE III
My eye was caught by the way the model placed his hands after a brisk swim between shots, and I was led to try and capture the exhilarating tactile quality of the glistening skin and matted hair.

DUNMOW 1978 *(overleaf)*
Here, delicate curves contrast with straight, sure lines to symbolize the female form. The linear strength lies in the paradoxical framing: far from minimizing the impression of length, the truncation of the legs and the torso summons up the unseen portions of the elongated figure.

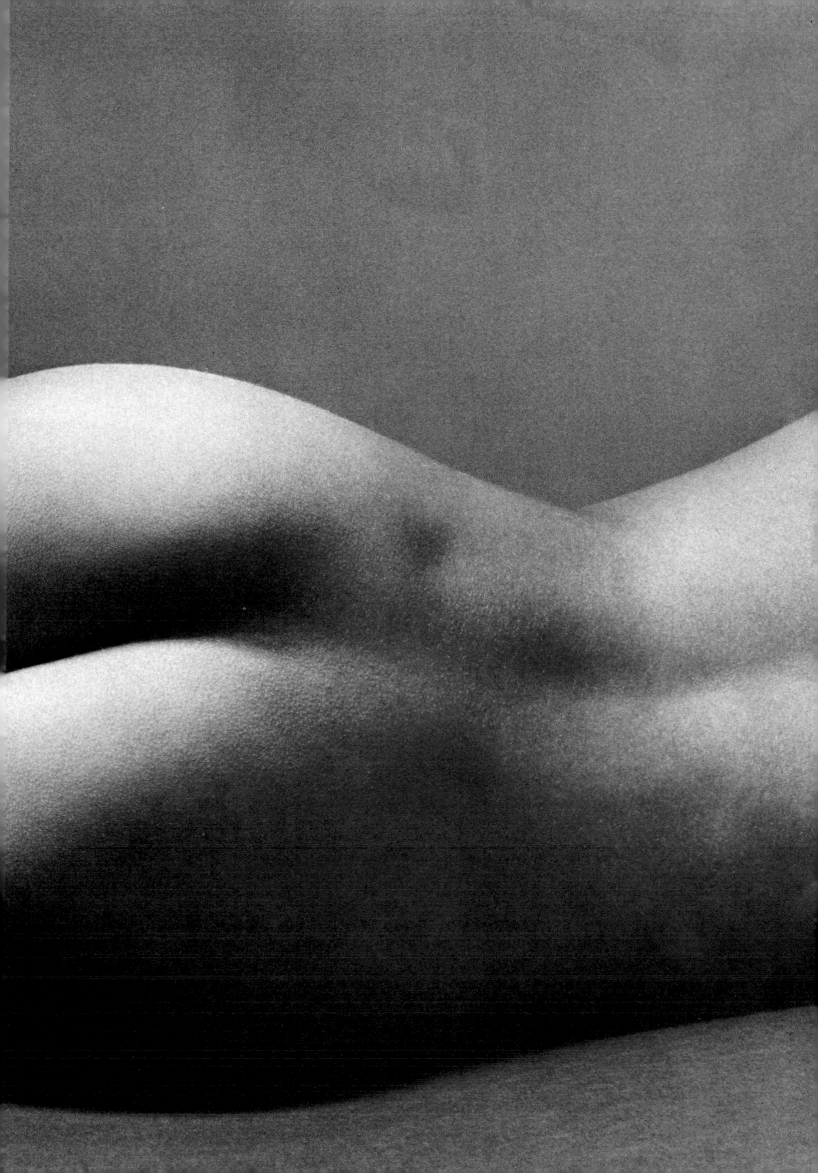

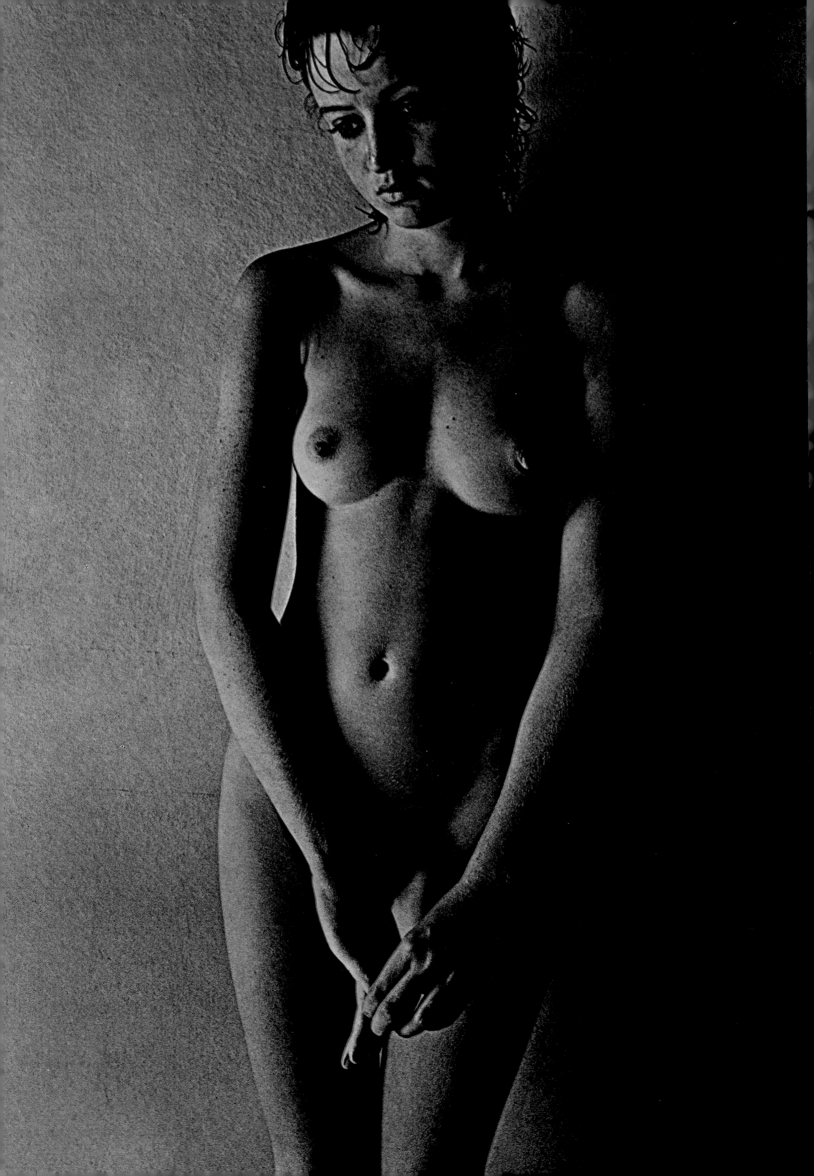

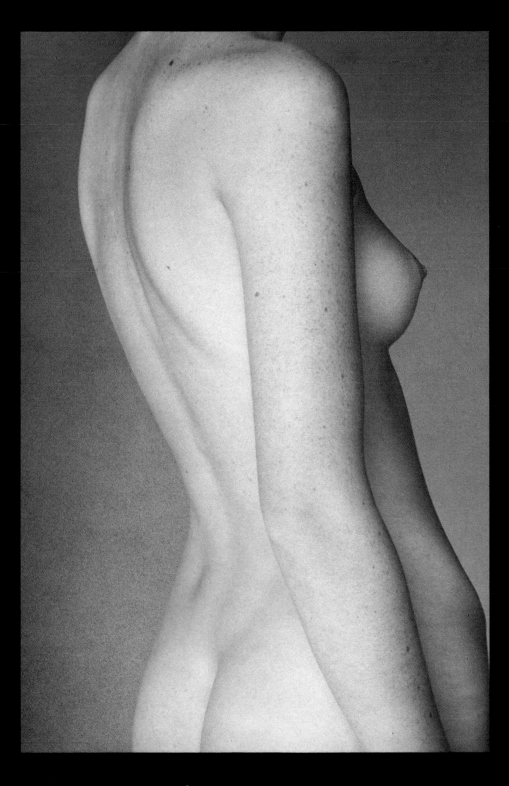

SOFT TONES I *and* **II**
*The wistful mood of the girl on the left and the
restraint of the classic pose above both create a
sense of distance. The images belong to a self-
contained world of feeling and might well come, for
lack of circumstantial detail, from another time.*

ELEMENT (*overleaf*)
*The light pressure of the swelling breast and the
gentle folding of the flesh can almost be felt.
Abstraction can convey the sensuous quality of the
body with even greater immediacy than the full-
figure study.*

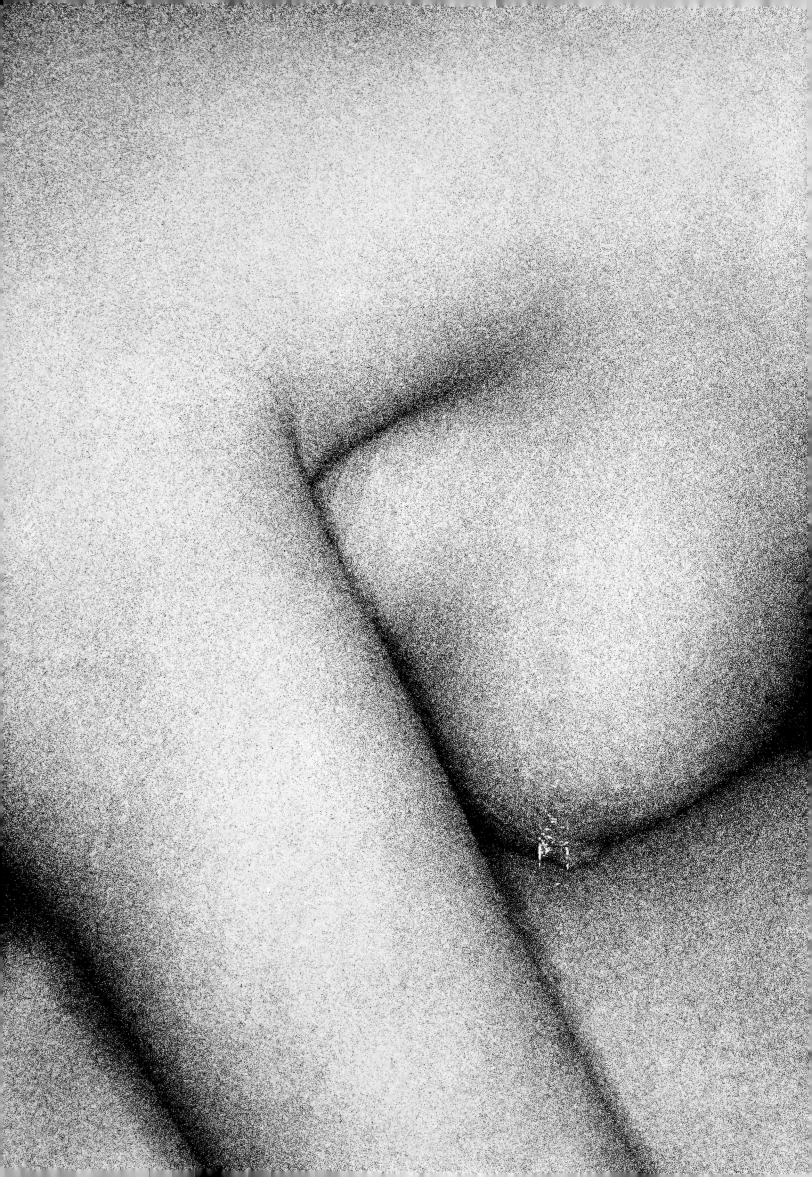

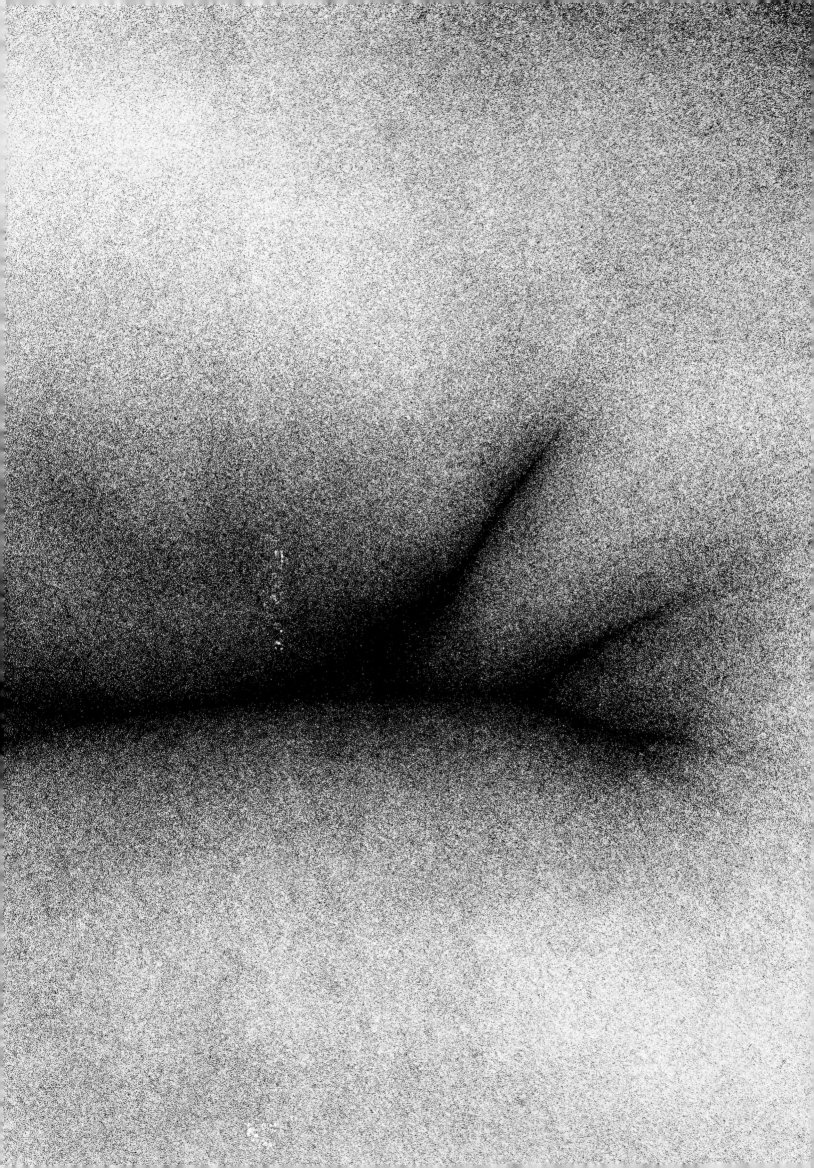

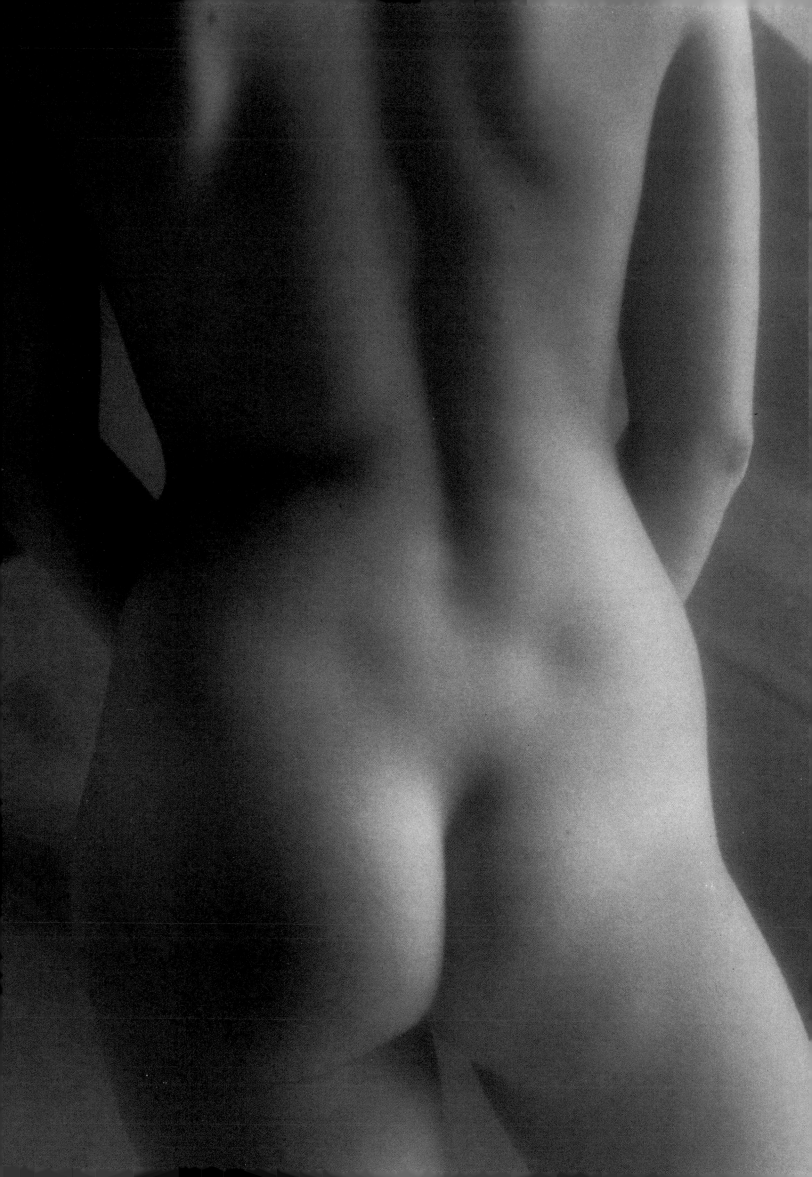

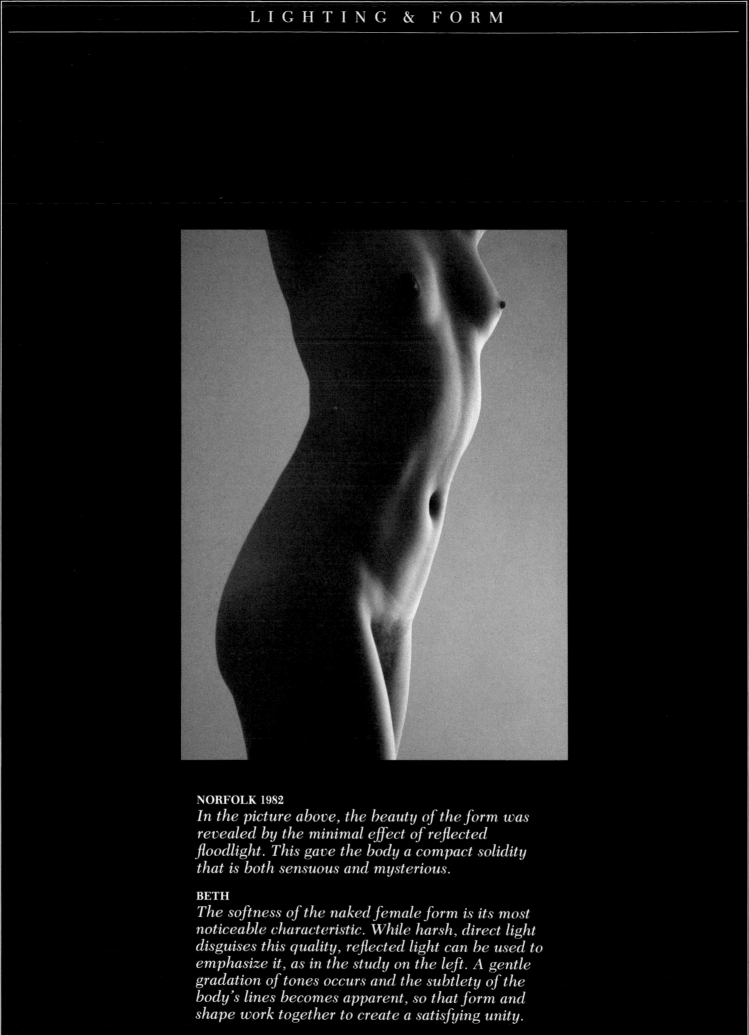

NORFOLK 1982
*In the picture above, the beauty of the form was
revealed by the minimal effect of reflected
floodlight. This gave the body a compact solidity
that is both sensuous and mysterious.*

BETH
*The softness of the naked female form is its most
noticeable characteristic. While harsh, direct light
disguises this quality, reflected light can be used to
emphasize it, as in the study on the left. A gentle
gradation of tones occurs and the subtlety of the
body's lines becomes apparent, so that form and
shape work together to create a satisfying unity.*

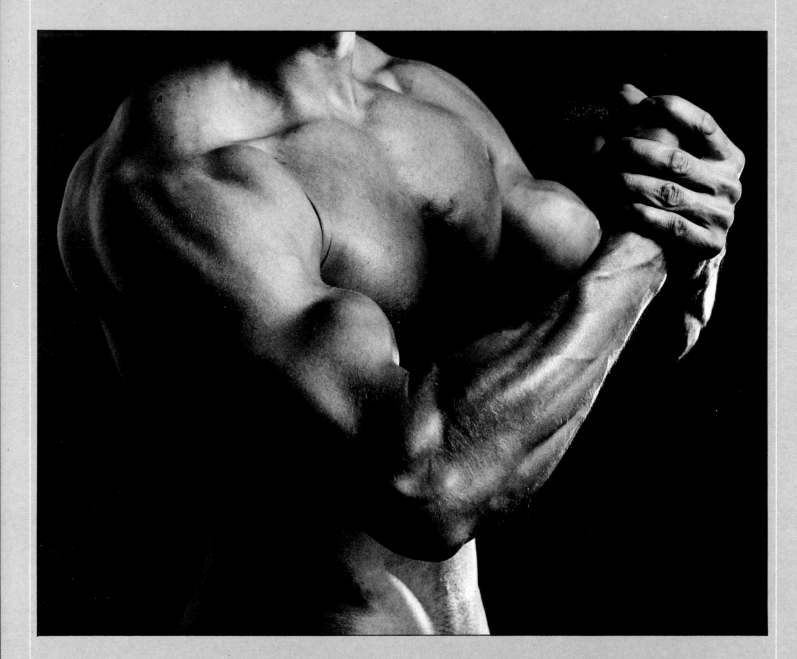

MUSCLES *and* **KENSINGTON 1984 II**
No art has cultivated the depiction of youthful athleticism more consistently than that of classical Greece. Bodybuilding that was not in the service of sporting prowess was unknown at that time, while the spare male figure not trained for athletic or gymnastic pursuits possessed no attraction for the sculptor. Nowadays, however, the types of physique seen in these pictures have both found acceptance in popular imagery.

DILLY, DUNMOW 1984 I *(overleaf, left)*
A simple pose in direct light reveals both the surface quality of the body and the sensuous array of muscles beneath the skin. Strength and solidity characterize the form, but there is no hint of its overdevelopment and the rhythm of the body is fluent and expressive.

DUNMOW 1982 *(overleaf, right)*
Where the human form is depersonalized by the framing, a sense of mystery persists and the imagination is triggered.

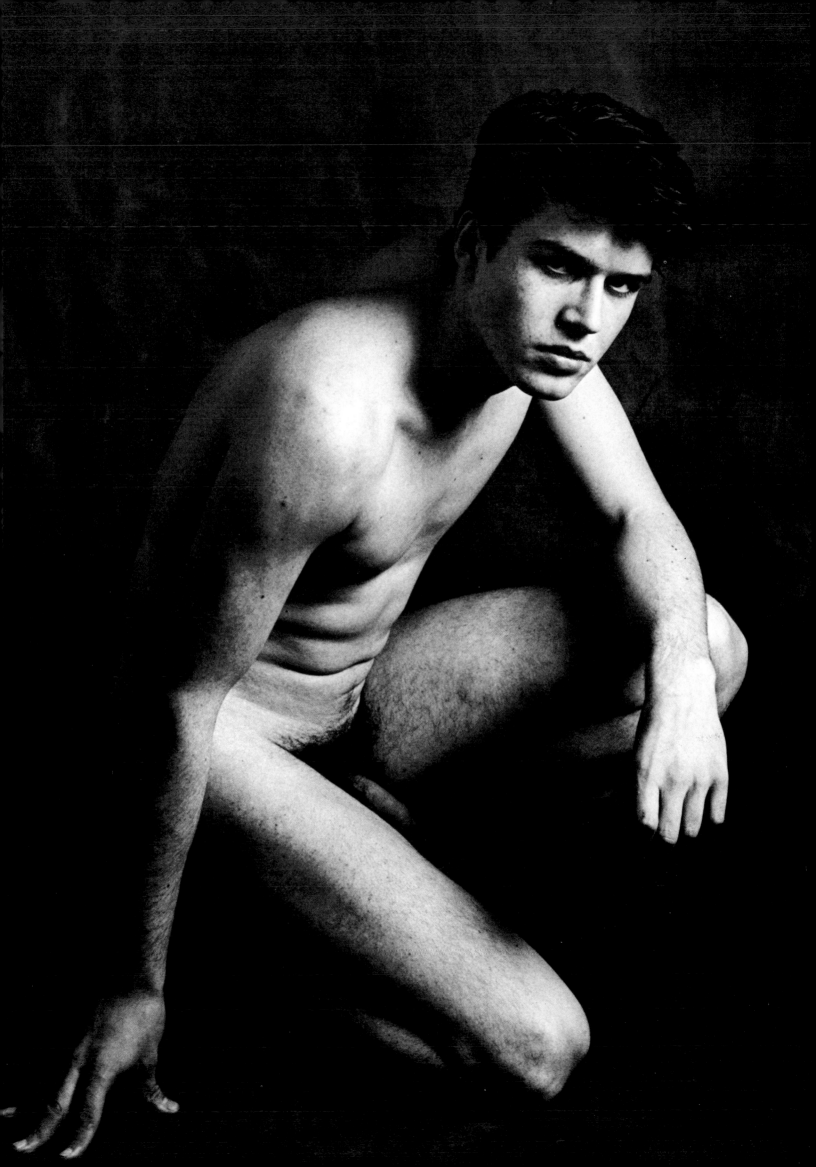

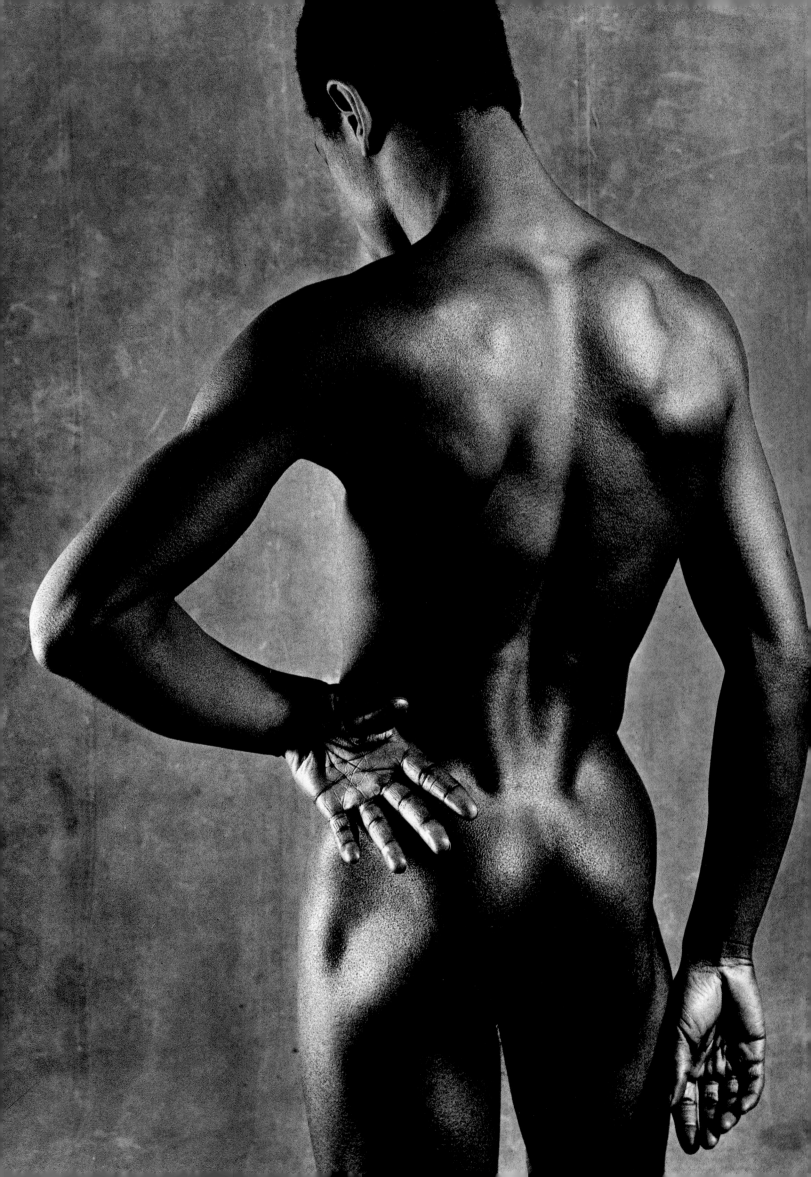

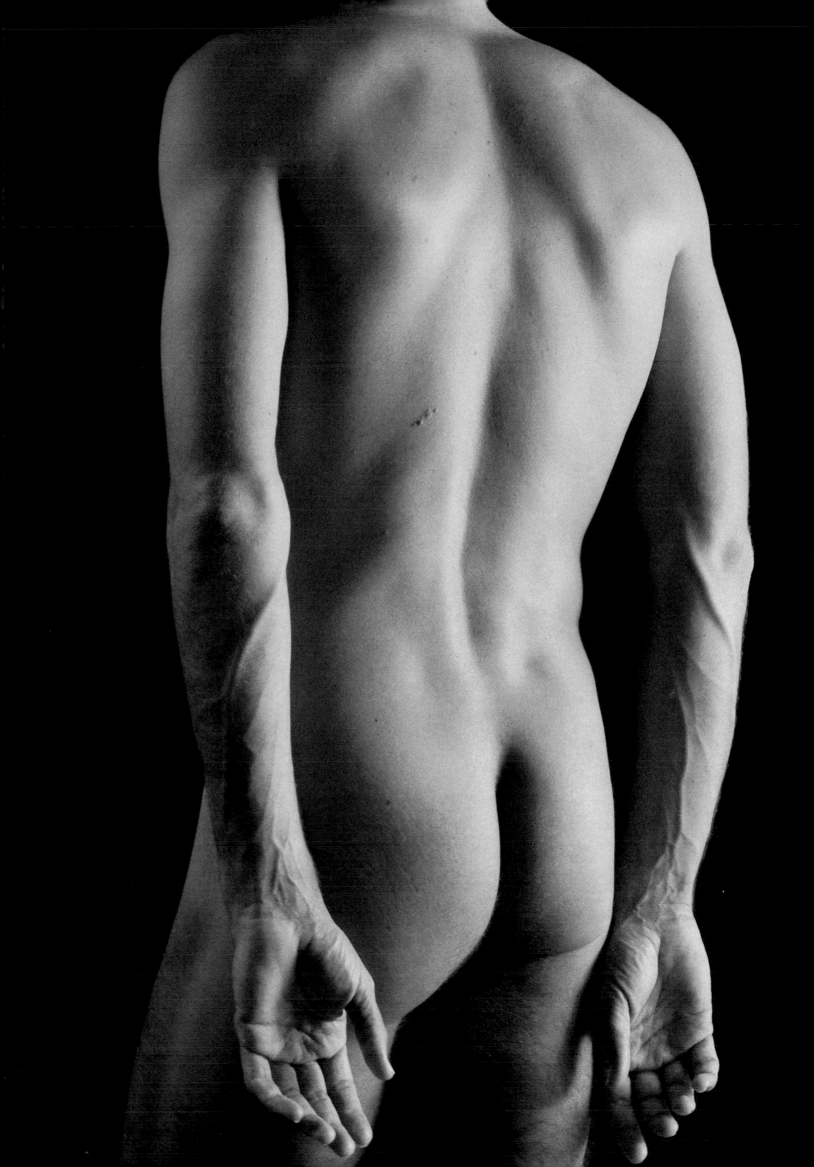

The early photographers of the nude were influenced above all by the post-Renaissance artists, from Titian to Ingres. The work of both represents a peak in the portrayal of the human form. Titian is regarded as the master of "generous areas of flesh", of soft, smooth, luminous skin and sensual bodies caught in the half light. Ingres produced some of the most outstanding nudes of any period, and his example was a dominant influence on the academic system of art schools. He often sent models to the photographer Nadar, who supplied him with pictures of preliminary poses as source material for his paintings.

Many other painters also seized upon the freedom afforded by photography to achieve a more honest portrayal, as opposed to the obsessive perfection of academic painting. They came to understand that photographs have their role to play, like painting and sculpture, in the visual interpretation of the world, and they appreciated the ability of the camera to capture the beauty of form and texture, prizing its depiction of the way in which light subtly defines the human body.

Photographs of the nude soon became a highly efficient way of investigating both form and the different characteristics of lighting, for a photograph allows an intense concentration and an intimacy that would offend the flesh-and-blood model. There is an inevitable distance between the photographer and the reference picture, and it is this distance that frees him from normal patterns of seeing and allows subjective meanings to emerge during prolonged study.

CROUCHING MAN
The primitive quality of the model's posture is complemented by strong natural light, which seems to hew out his form. A crude background furnishes an appropriately primeval setting.

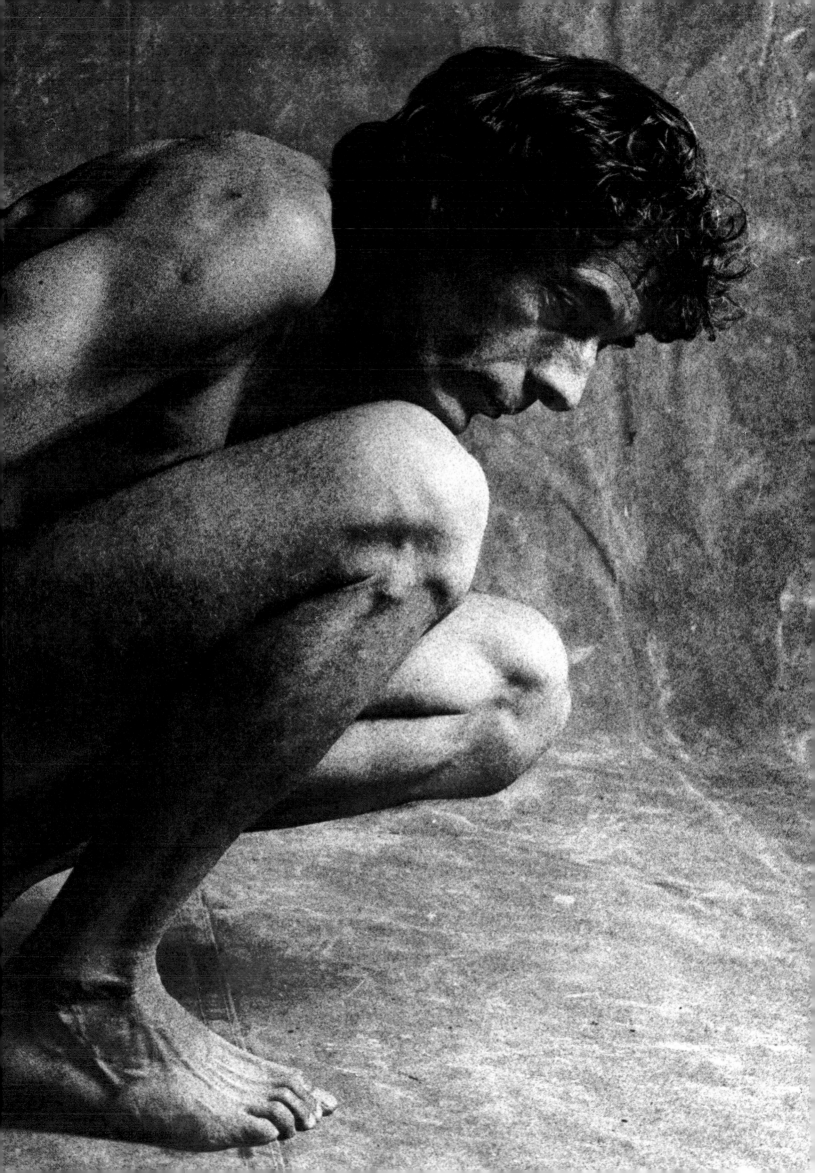

The idea that there is a perfect human form is fallacious, for everyone has his own ideal. Artists have long used the best features of several models, enlarging and diminishing areas or proportions to give greater emphasis. Photographers do this by their choice of lens and viewpoint, enlarging and elongating with a wide-angle lens, flattening and compressing with a telephoto.

The life model is more important to the photographer than to the painter or sculptor, simply because he or she has to be present at the time the pictures are taken. The artist's source material, by contrast, might come from memory, imagination, a sketchbook, other works, or in the form of *objets trouvés*. Henry Moore's statement, "The greatest influence in my life sculpture is the study of the human figure", does not mean that he worked from a model. Scouring the beaches for flint stones, he was not seeking a stone to inspire him: he was searching for a reclining figure, a seated torso, and other female forms that he already had in his mind. Nature had created interesting forms for him in asymmetrical growth or the deformities caused by environmental forces. But, in seeking a subject that had taken root in his mind, he could see nothing else.

Of this quest the sculptor has said: "Flint stones, pebbles, shells, and driftwood have all helped me to start off ideas, but far more important to me has been the human figure and its inner skeleton structure. You can feel that a bone has had some sort of use in its life; it has experienced tensions, supported weights, and has actually performed an organic function, which a pebble has not done at all."

BLUE PLASTIC
A few simple devices combine here to transform the model into a dreamlike vision. Transcending the convention of coyness-with-provocation that so often dominates images of beautiful women, the model's ageless pose emphasizes her formal perfection.

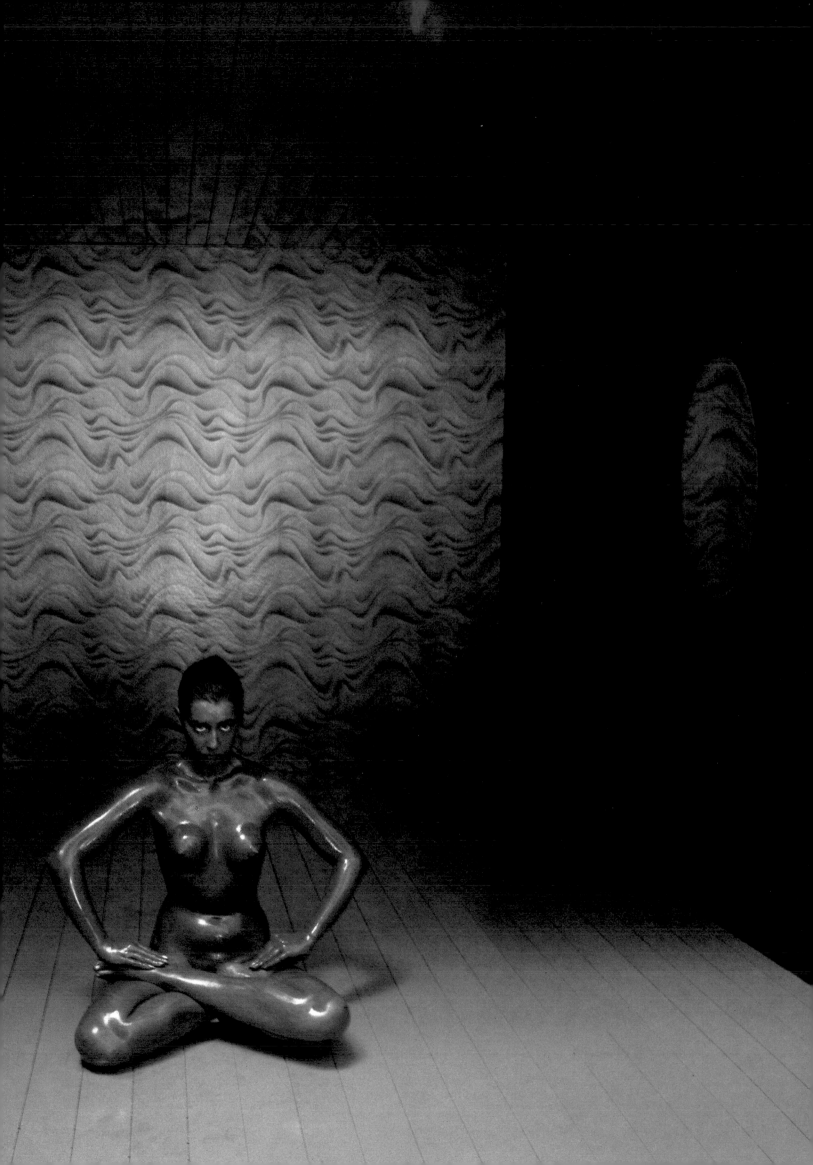

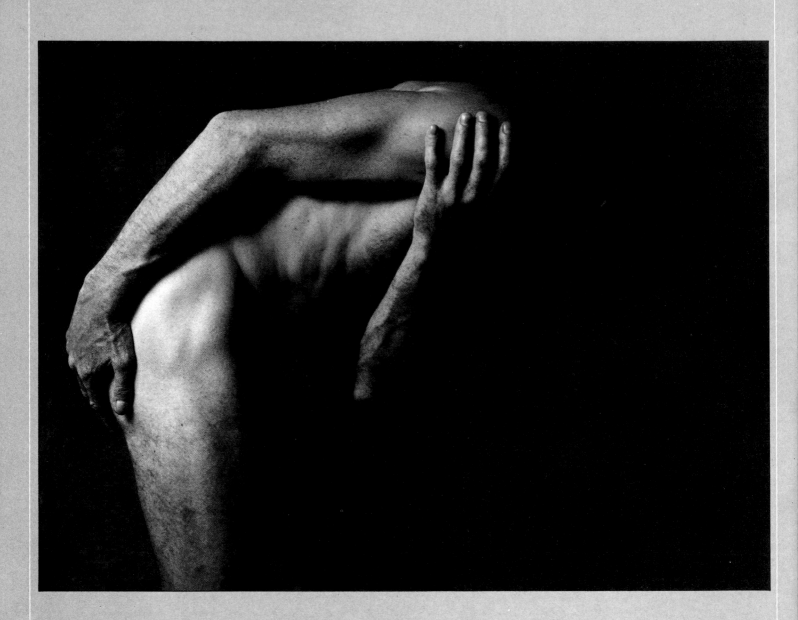

BENDING MAN
The nude in late Medieval art was far removed from the heroic image of Man cultivated by the Greek sculptors. The body had come to be seen as reflecting the terrible burden of guilt and despair that it is, in the Christian view, our lot to bear. The study above borrows from Christian imagery of that period in its dramatization of human suffering, the hands gripping the body in a paroxysm of anguish, while the head is swathed in darkness.

TACTILE FORM
The hands in the picture on the right set up a contradiction: the right invites an exploration of the flesh, while the left suggests the vulnerability so often conveyed unintentionally by the nude model. Such double meanings in body language are everyday sights, but words normally mask the discrepancy. The mute medium of photography prevents this deception.

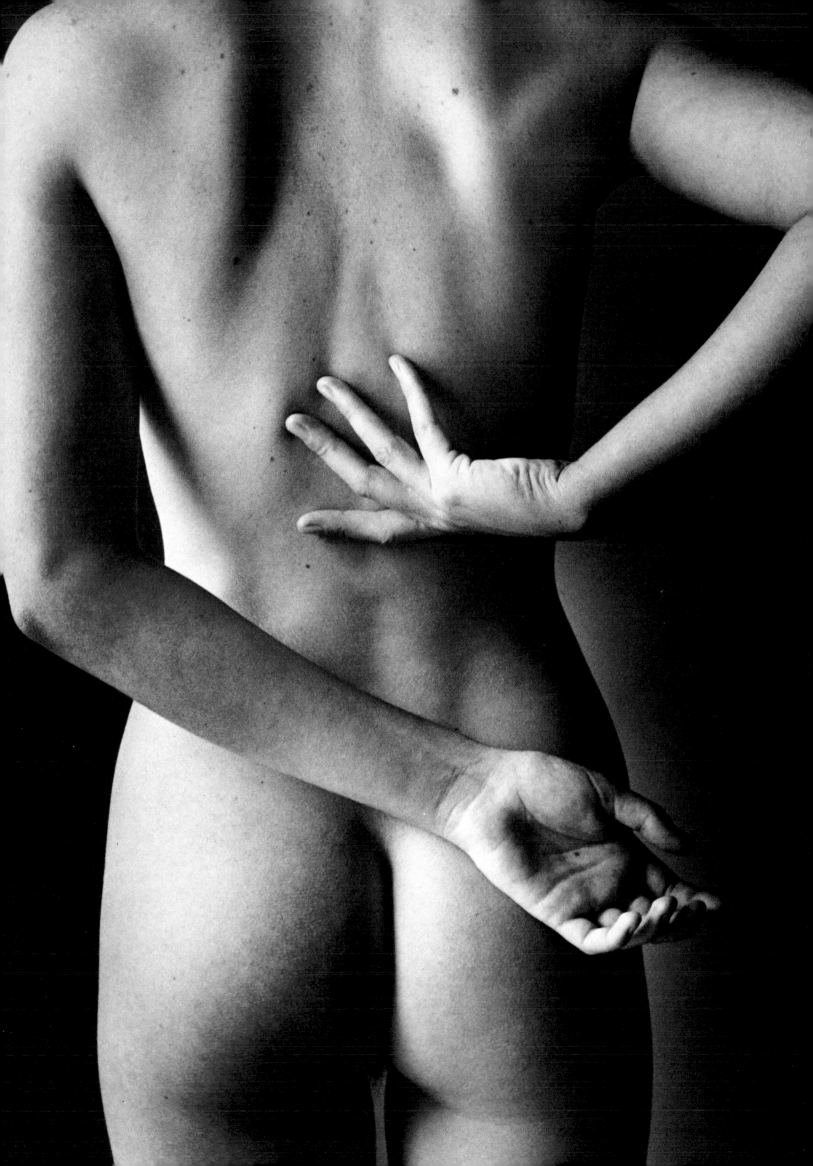

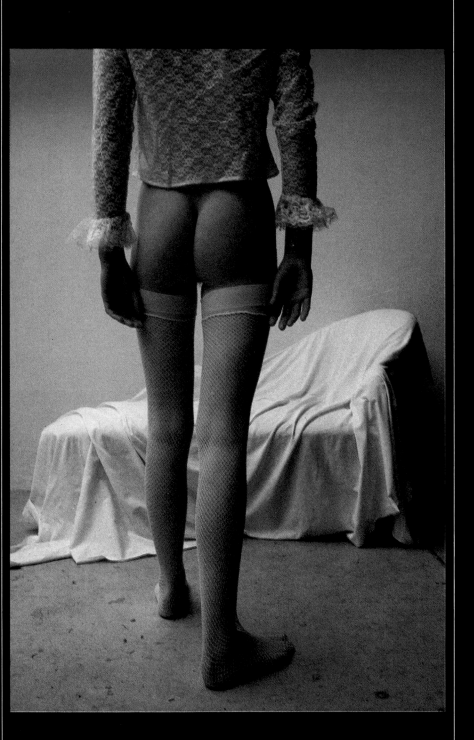

BRAMERTON 1984 II
Clothing often emphasizes the sensuousness of the rounded bottom in covering it. In the picture above, its presence both reveals and accentuates.

ANNABEL I
The passive pose of the model on the right suggests an equivocal attitude to the camera. It heightens the sense of voyeurism that can easily be felt when looking at images taken of others. She seems wary; perhaps she is reluctant to be transformed into an image for the gaze of the unknown viewer.

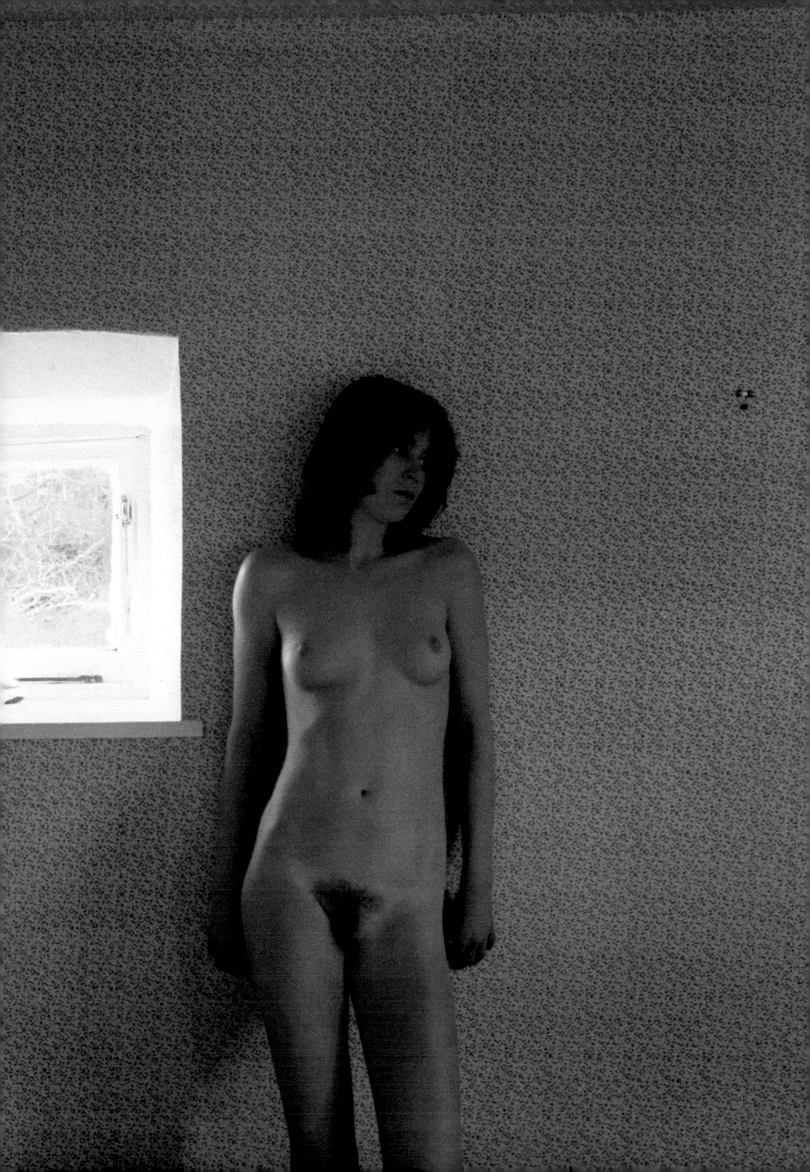

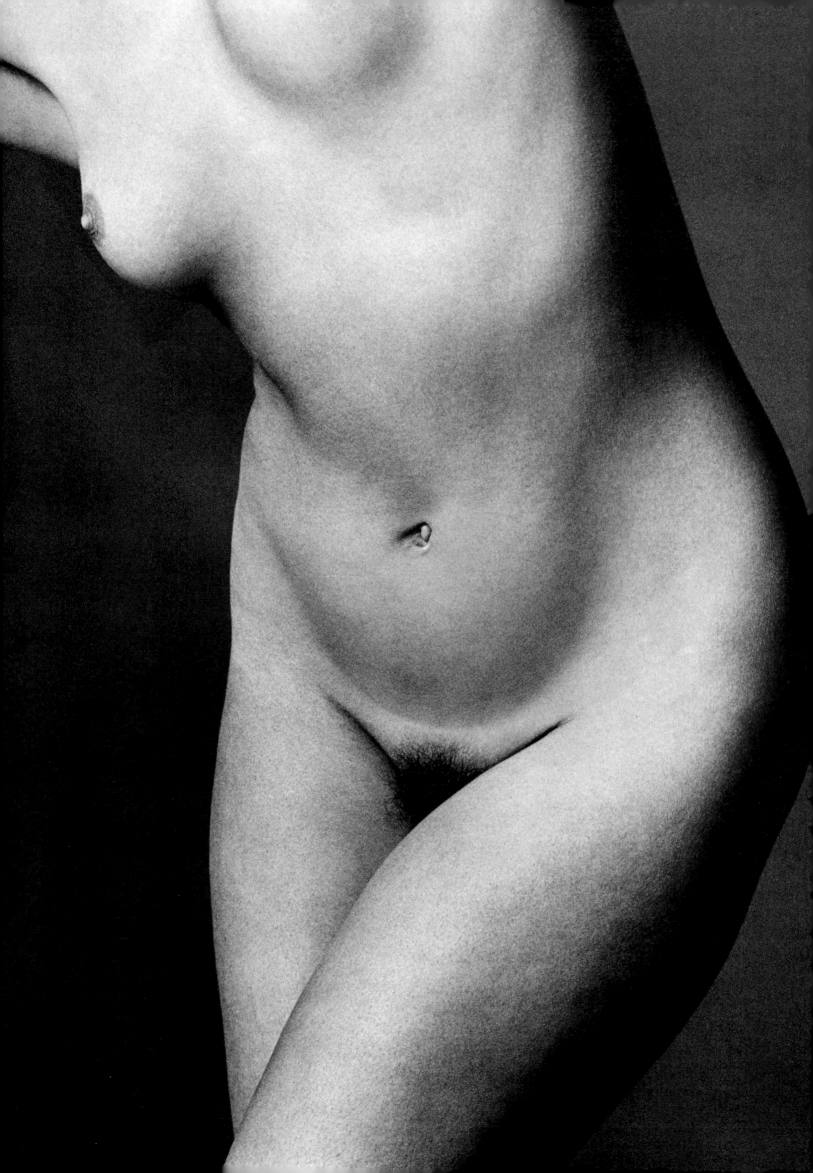

VIRGINIA (TORSO SERIES III) I *and* **II**
Photography's capacity for depicting a subject realistically gives great creative freedom. In comparison with the figurative artist working in unyielding materials, the photographer can arrive rapidly at a naturalistic portrayal of the human form. This ability frees him to pursue the expressive aspects of his subject and to combine idealization with realism. In the pictures on the left and above, left, the camera's intense observation of detail is complemented by arrangements of the body that best express its vitality and formal beauty.

KENSINGTON (TORSO SERIES II)
The equation of youth with energy transcends differences of gender, but historically the notion has most often been associated with the male alone. In the picture above, the taut body seemingly bursting from its denim casing creates a forceful female image of such youthful vitality.

ANNABEL II *(overleaf)*
The pose is submissive, but it has a warmth that hints at the kindling of communication. Yet the model's expression suggests that she is still unsure about being photographed. The decision as to whether to reveal or conceal one's identity faces everyone in the presence of the camera.

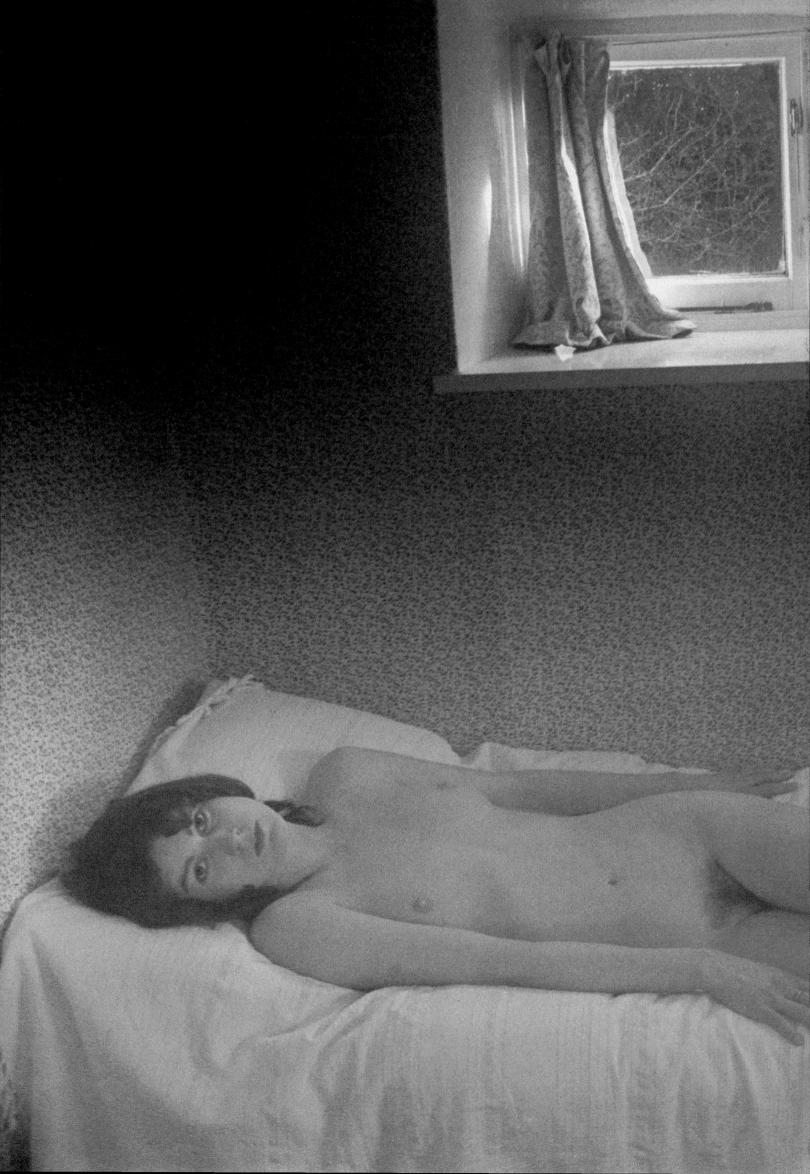

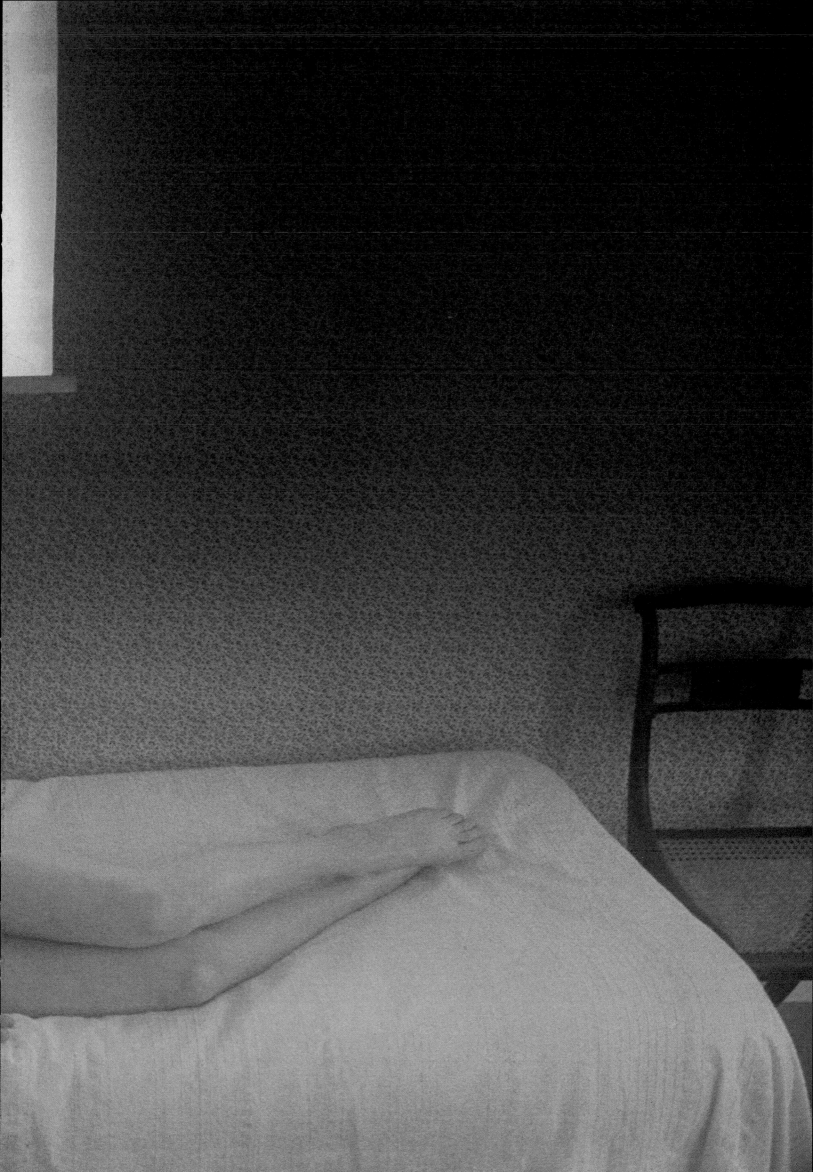

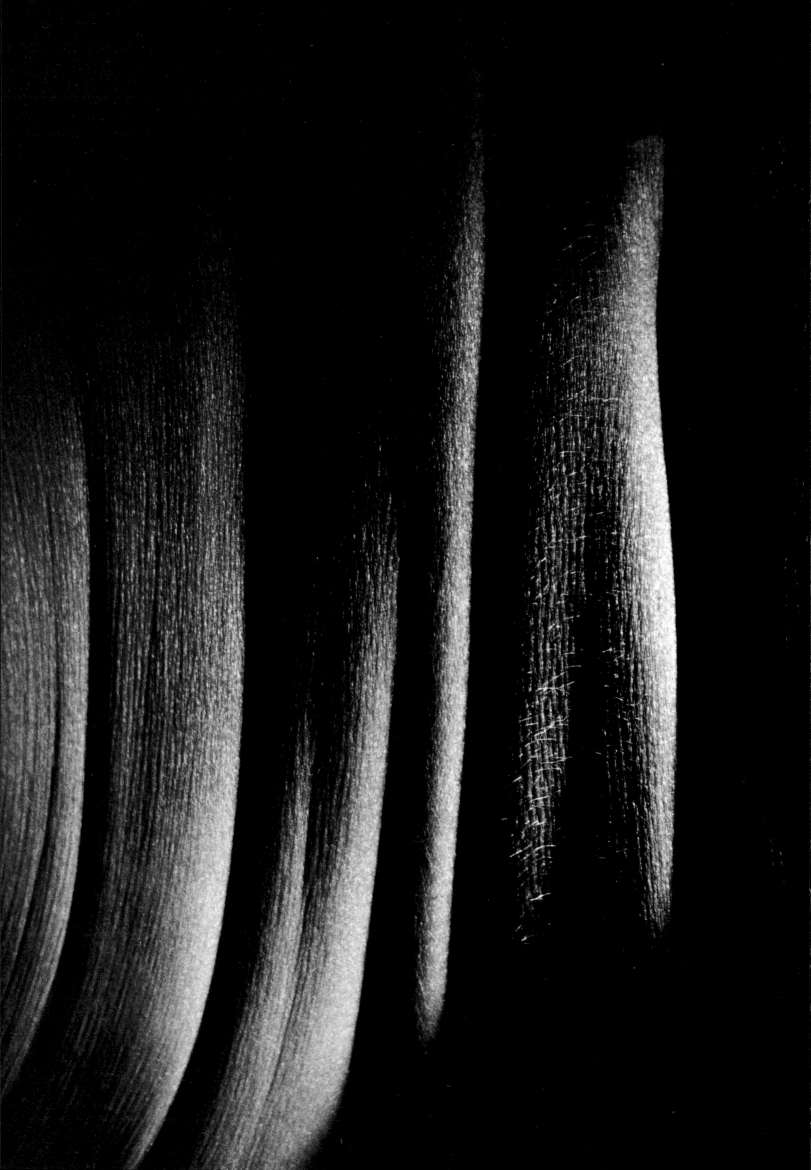

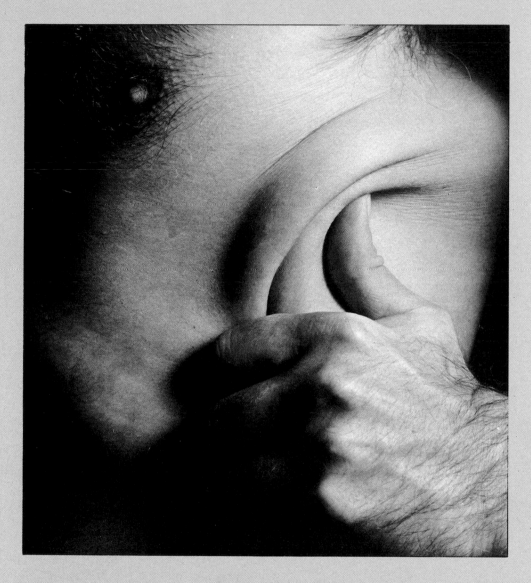

HOGLANDS 1966 (TORSO SERIES I)
Loose skin between the shoulder blades provides a good example of the contortions of which human flesh is capable, bringing to mind the qualities of a landscape.

KENSINGTON (TORSO SERIES II)
In the image above, the localized emphasis on the rippling flesh suggests the intense pleasure that spreads in waves over the whole of the body.

KAREN 1983 I *(overleaf)*
The blatant poses of glamor photography are often aggressive and superficial. But given a more delicate treatment, the playful, slightly erotic, spirit of this model is just as exciting and provocative.

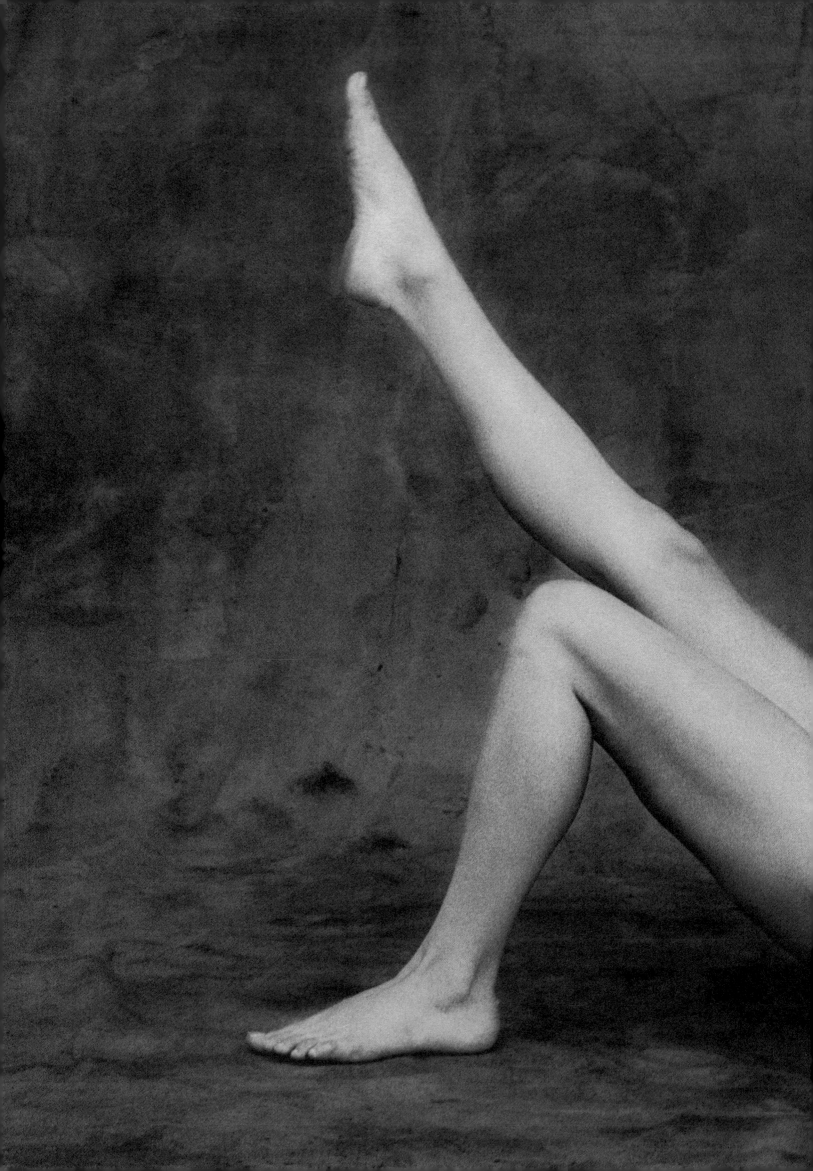

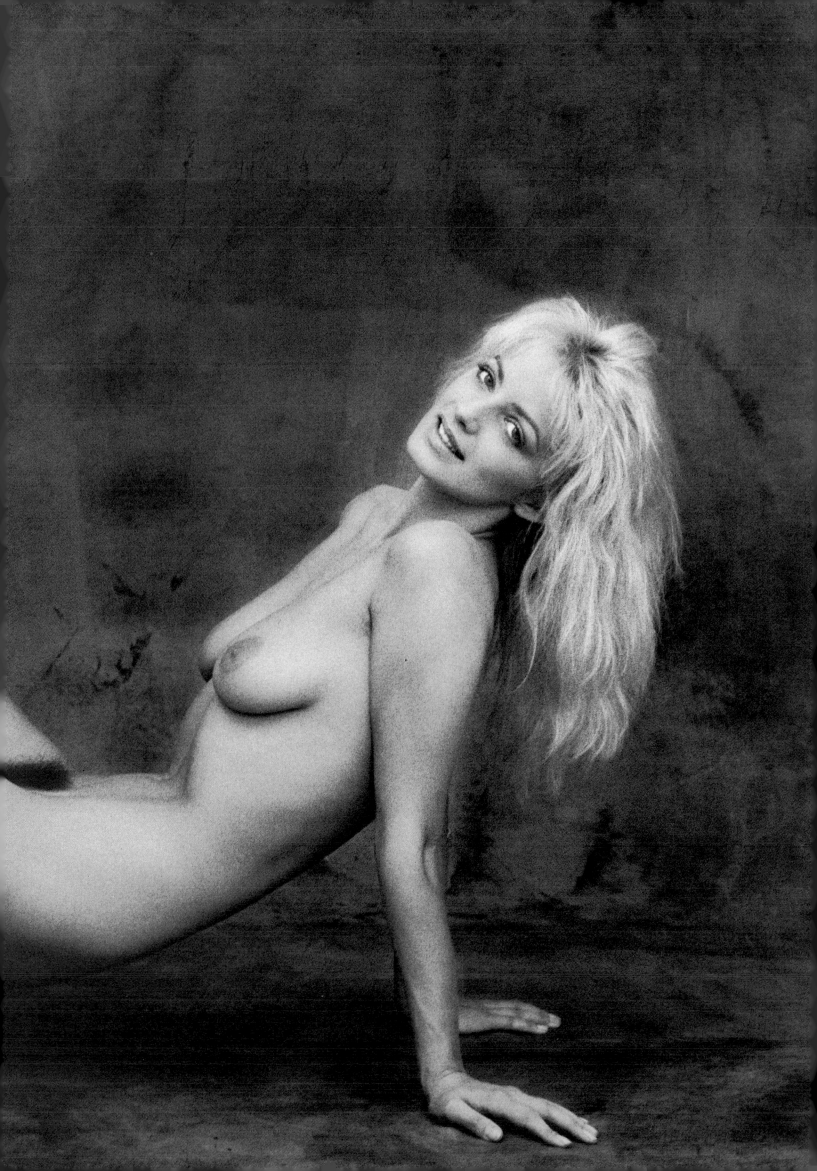

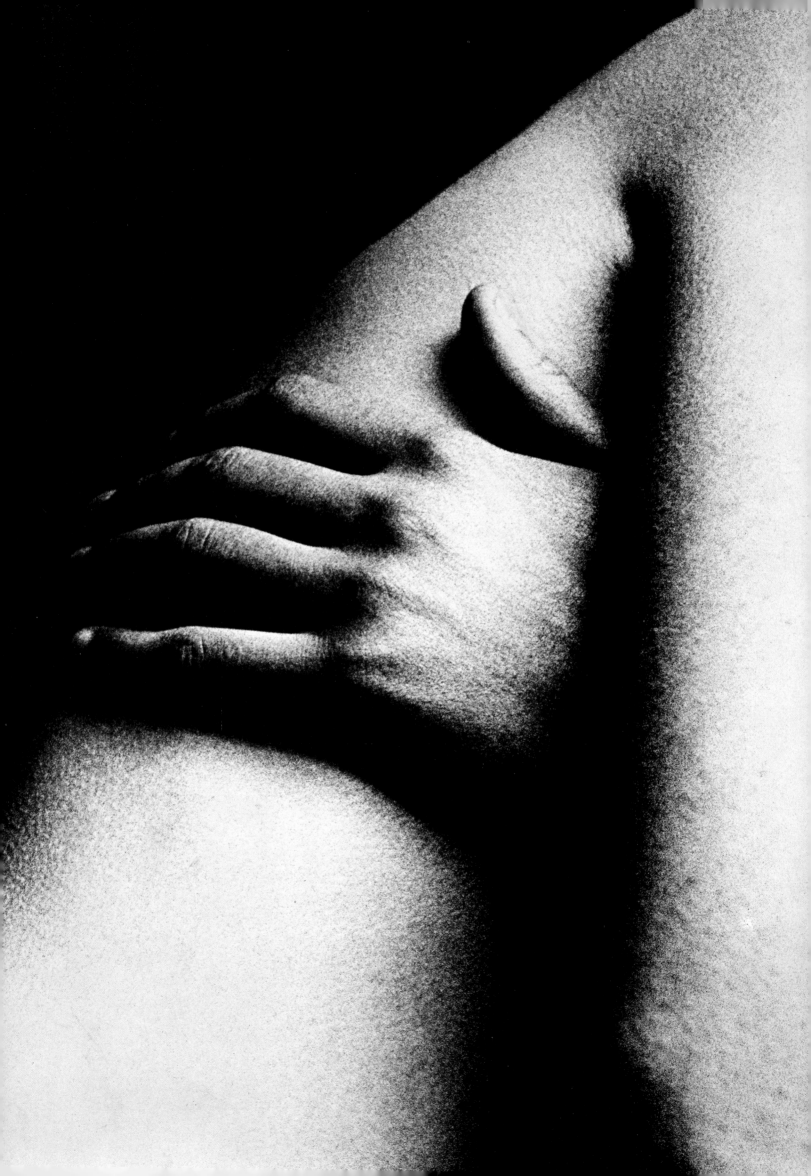

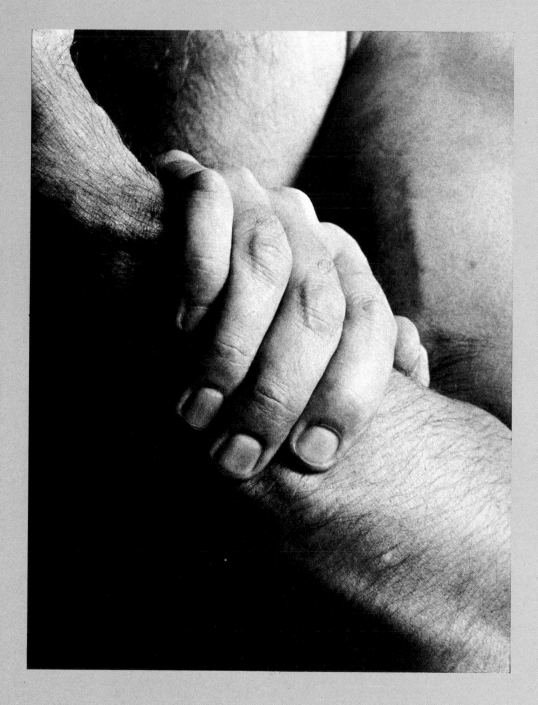

KENSINGTON (TORSO SERIES II)
The close framing of the subject above lends an intensity to the grip which makes it symbolic, as well as descriptive, of strength and tension.

HOGLANDS 1966 (TORSO SERIES I)
After the face, the hands are the most expressive feature of the human form. In the picture on the left the body is depersonalized but the hand has come to rest in a way that speaks of both tenderness and apprehension.

SUSIE-ANN *(overleaf, left)*
For a moment we can glimpse the fragility of the voyeur's situation. The model's stance creates uncertainty as to whether she is aware of being watched and so able to shatter the safety of a hitherto undetected scrutiny.

DOUBLE IMAGE *(overleaf, right)*
The reflections from the garden enhanced the wistful quality of a stock glamor pose, the statue echoing the past and the bushes suggesting a fur wrap gently framing the model's face.

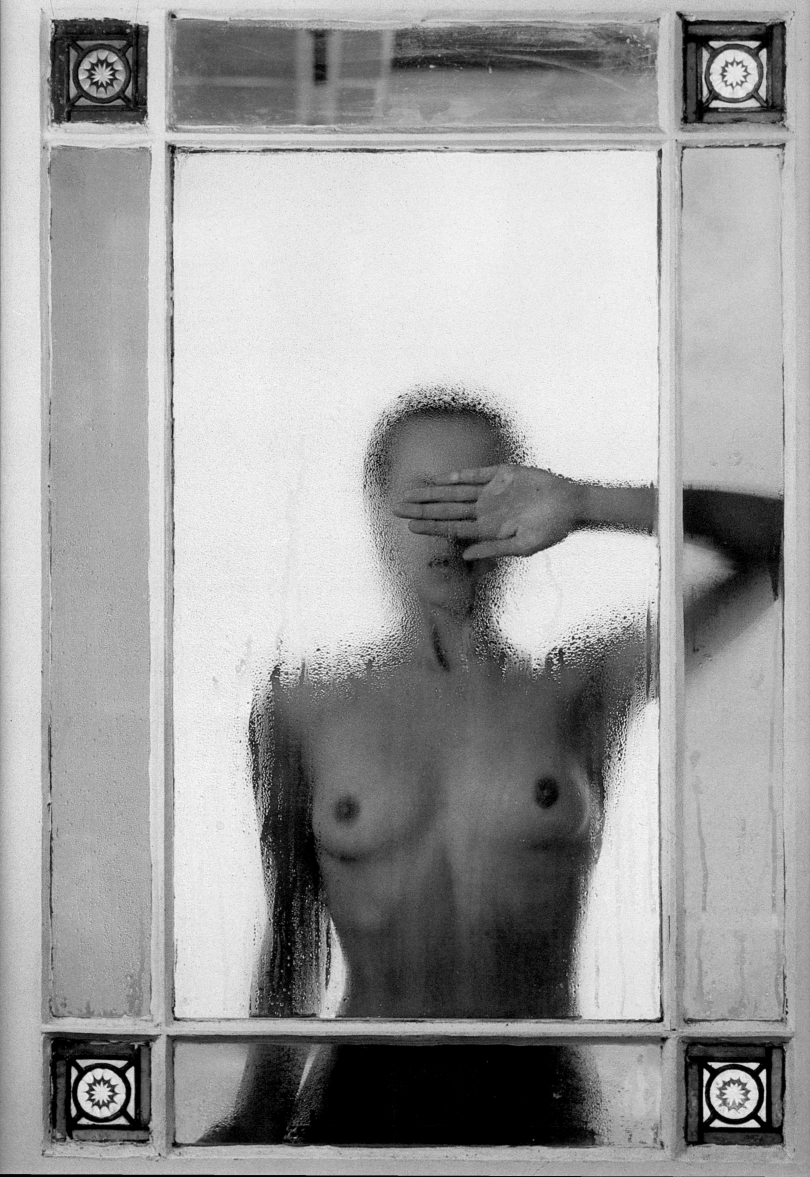

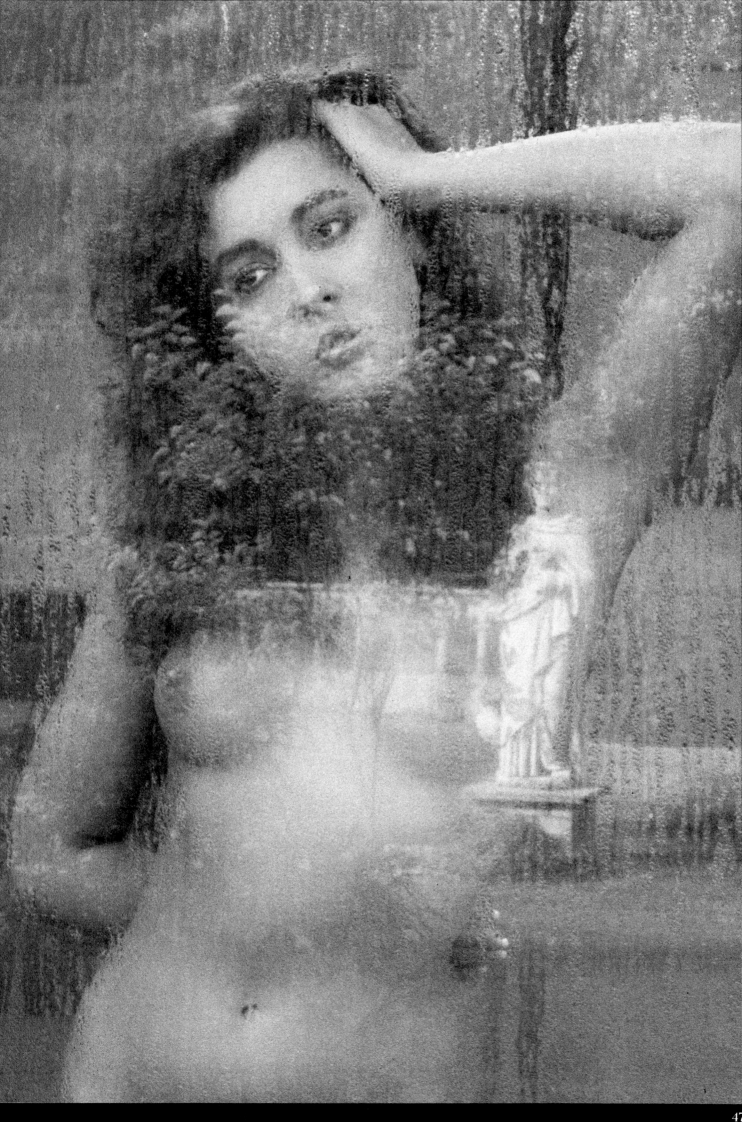

ABSTRACTION
The image on the right is at once arresting and coolly abstract. An almost total absence of texture concentrates the eye on the body's exaggerated proportions, which are conveyed in deceptive lines rather than form.

STOCKINGS
A photograph arrests a single moment. And yet it is the choice of a special configuration of elements—Roland Barthes refers to the photograph as "the absolute Particular"—which can make that moment express a whole mood. In this way I attempted in the picture below to encapsulate the sinuous rhythm of uninhibited movement.

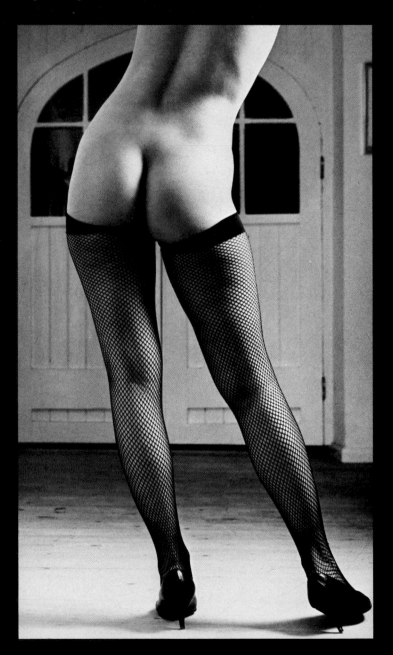

EXTENDED NUDE (*overleaf*)
Stormy weather produced a morbid light in the studio that was ideal for this uneasy study of desolation. The effect of the pose was intensified by relegating the model to the back of the image area, as if in rejection.

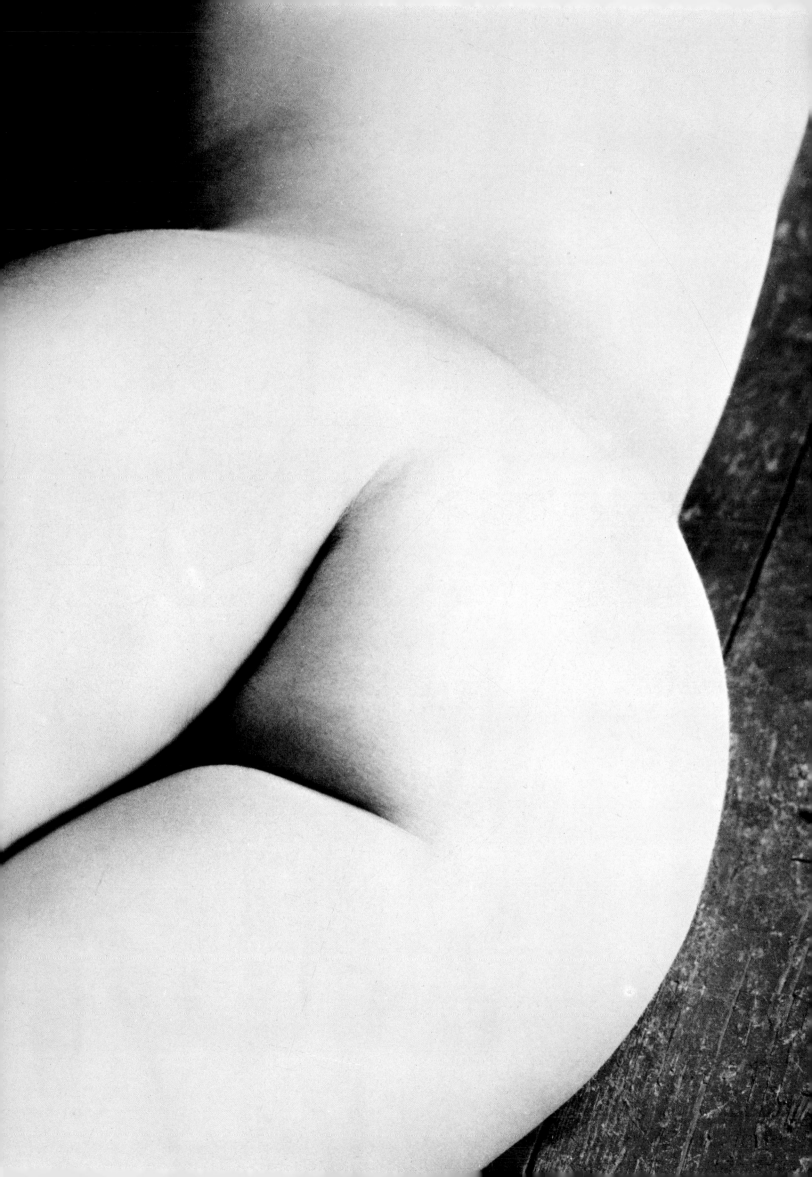

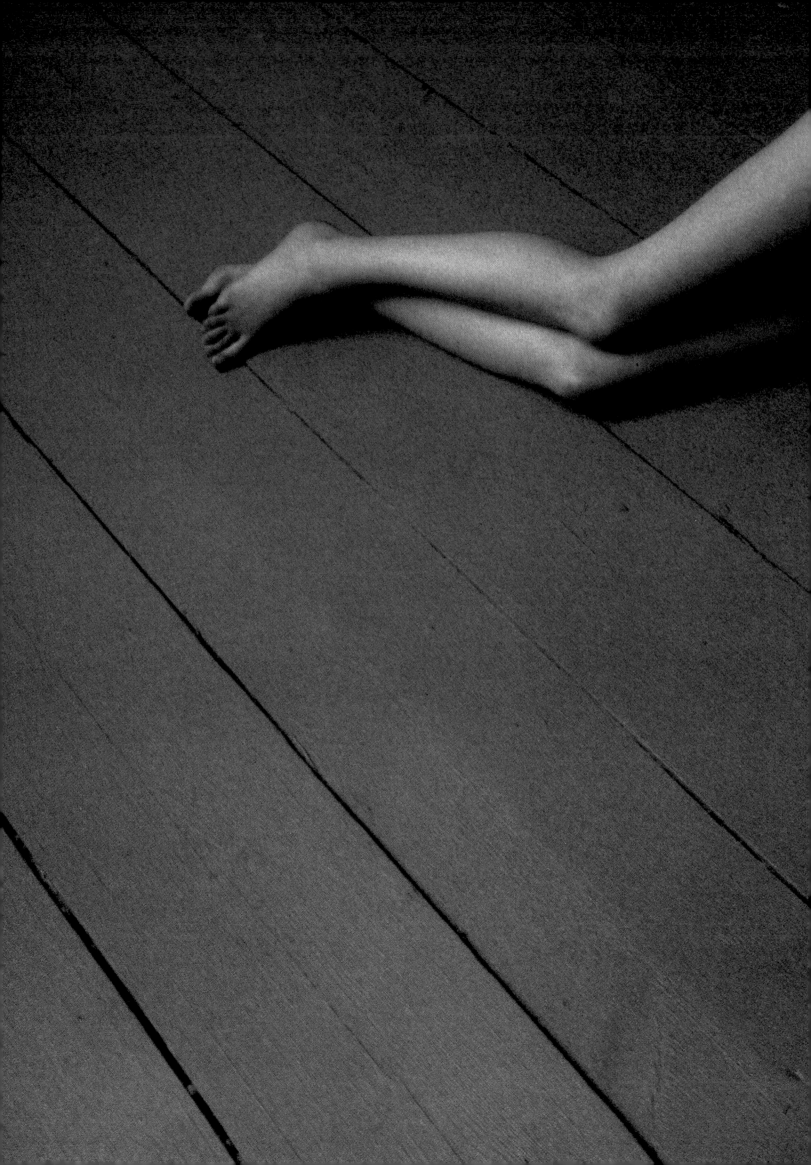

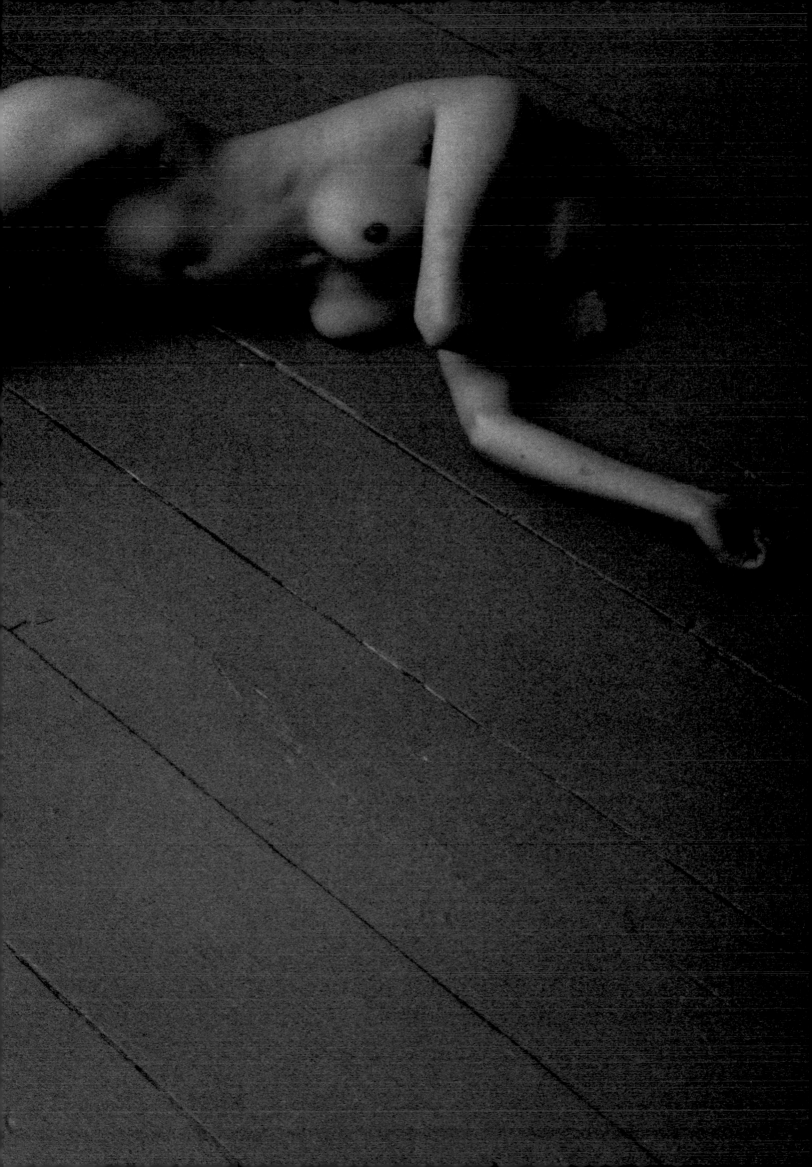

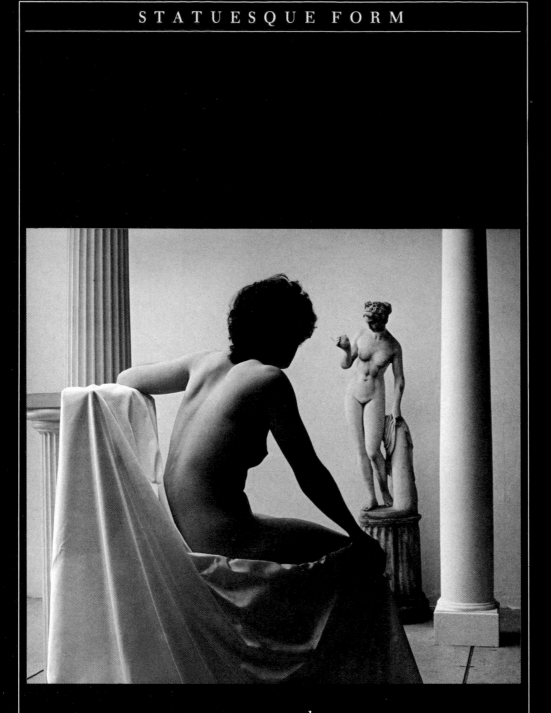

ANNE, MONTREUIL, FRANCE I *and* **II**
In the picture above, the coolness of the classical
ornamentation complements the formal pose of the
model, while in the picture opposite, her generous
shape suggests the monumental nature of modern
sculpture.

DILLY, DUNMOW 1984 II *(overleaf, left)*
A simple pose is usually more suggestive of
character than a contrived one. Although basically
conventional, this easy stance speaks of a strong
individuality in its forthright lines.

BRAMERTON 1984 III *(overleaf, right)*
The power of many images derives from their
ability to evoke mystery. Where information is
withheld—here it is the face—the imagination
seeks a resolution of the puzzle.

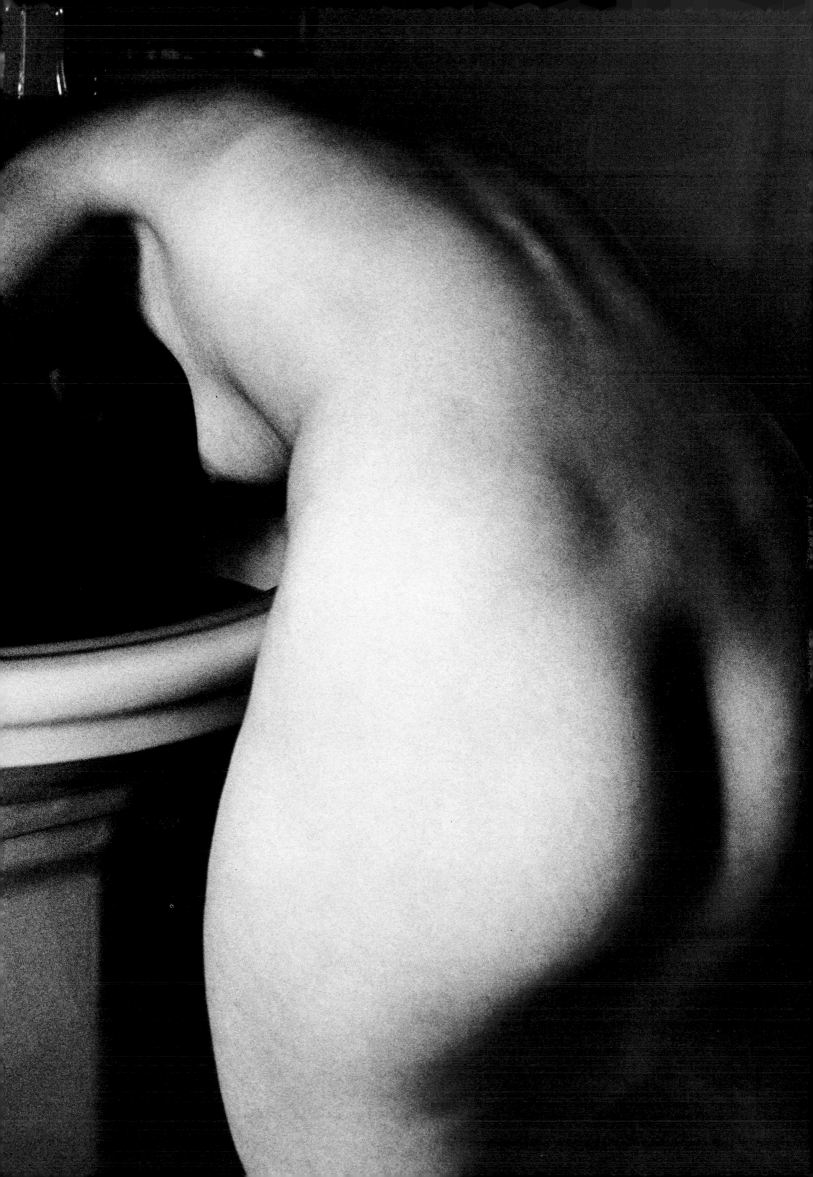

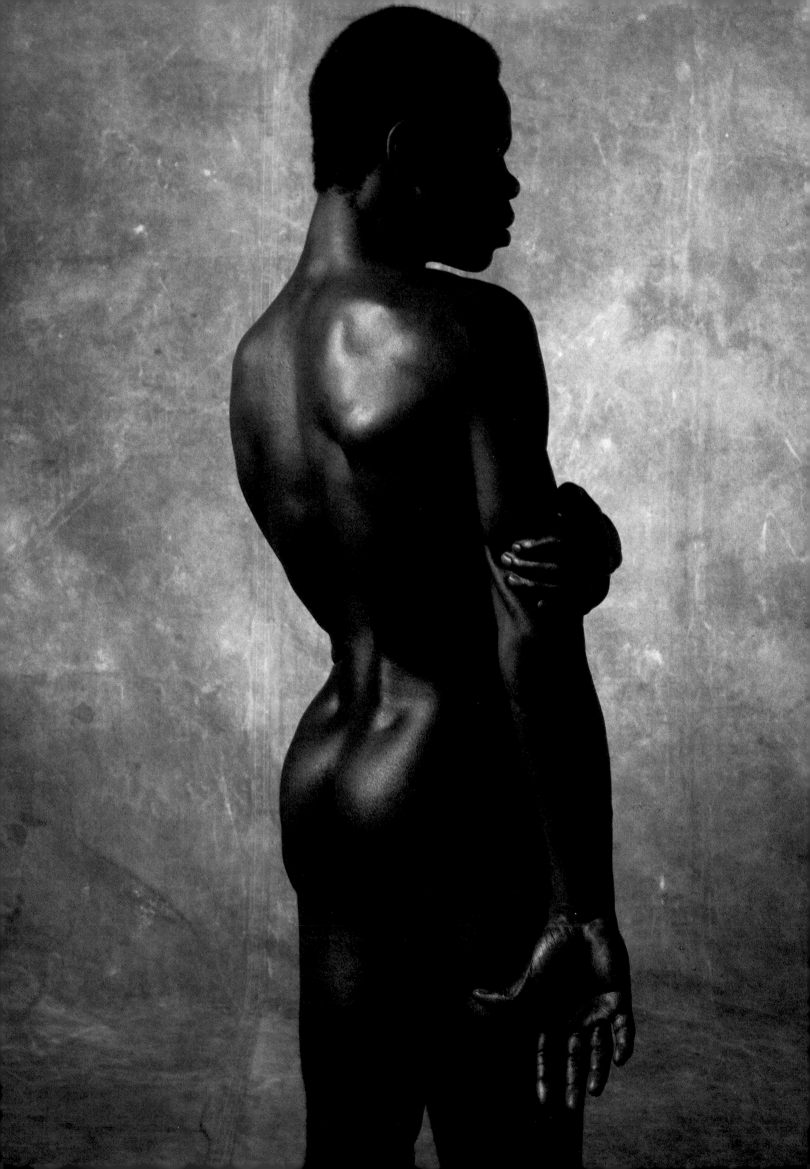

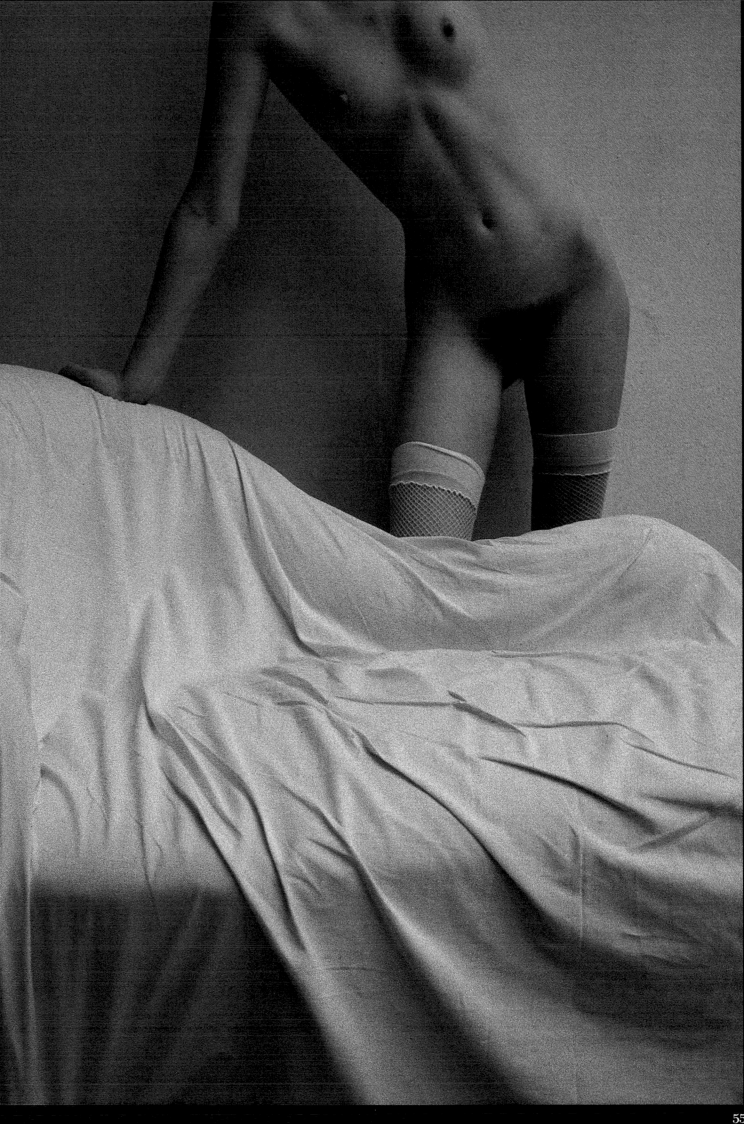

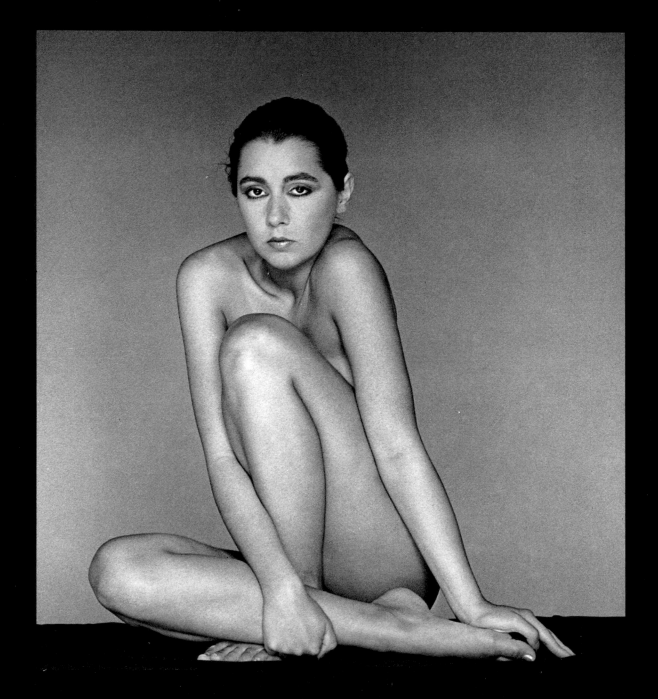

TRACY, DUNMOW 1983
In many pictures of the female nude where there is eye contact with the viewer, the model exaggerates her sexuality provocatively. For the study above I used a model who simply conveyed a reserved self-assurance, rather like that seen in fashion shots. The viewer's eye is thus freed to explore the form for its aesthetic as well as its erotic possibilities.

RACHEL 1983
Responding to an atmosphere he senses in the environment, the photographer works with a pose and expression that come naturally to the model to convey its mood.

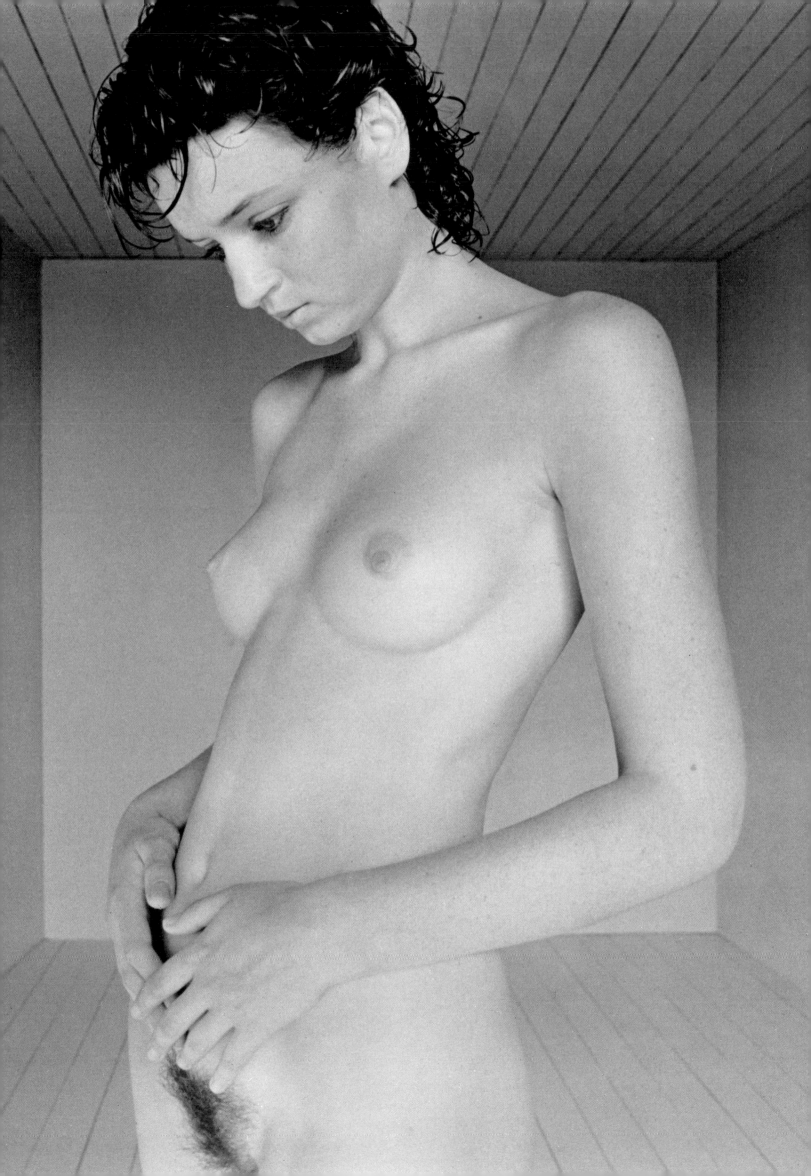

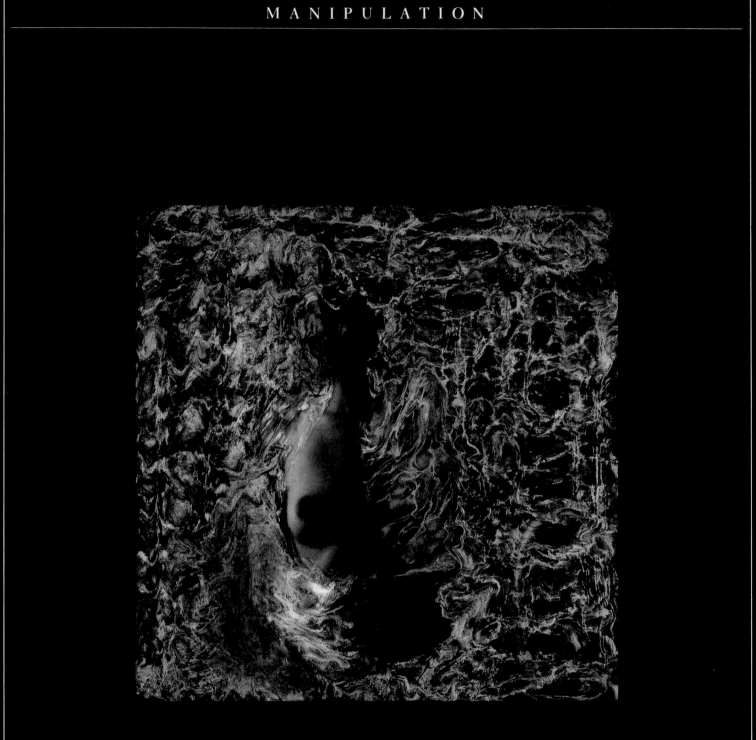

MANIPULATION I

For a few minutes after an instant print has emerged from the camera, the emulsion can be manipulated with unpredictable results. I used the rounded end of a pencil on the picture above to create a frame around the model which hints at, rather than describes, a pleasing form.

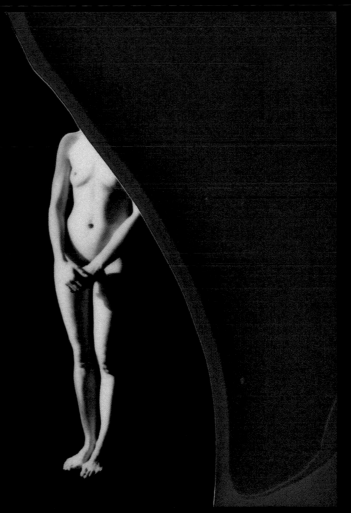

FRAGMENT
*In the instant print above, a development fault
yielded an incomplete but nevertheless expressive
picture. The truncation of the model's head,
coupled with the somber background, made a
dramatic image of what would otherwise have been
a straightforward square-on study.*

STOOPING MAN (*overleaf*)
*The nude form need not be beautiful to engage our
feelings, as the pioneering realism of Rembrandt
demonstrated. The ungainly stance of this figure
suggests a poignant vulnerability.*

MOOD
AND
ATMOSPHERE

Nowadays we are so accustomed to using the camera to record subjects of even the slightest importance to us that the world seems to be swamped with photographs. At times it appears that everything has been photographed and that there is nothing left for the camera to capture. There is some truth in this observation, but since taking pictures is a very personal matter, and no two individuals have an identical perception of the same subject, there are always new treatments of a theme, even if it has already been widely exploited.

The painter Francis Bacon has stated that "art is a method of opening areas of feeling rather than merely the illustration of an object". The ability to explore feeling does not depend on a preceding philosophical insight that directs the eye of the artist. On the contrary, most artists work in an intuitive way, the eye convincing the brain, the explanations coming later. Perception, in all its contradiction and irrationality, precedes the artist's analysis of his work.

However, the perception of the painter or sculptor develops slowly, so that he builds his creation by stages. By contrast, when the photographer shoots a picture, it is necessarily instantaneous and the image is complete (short of manipulation in the darkroom) the process of perception having occurred beforehand.

Photography is often seen as a dispassionate recorder of people, things, and events—the epitome of objectivity. But it is essentially a subjective medium, because, before all else, the photograph is a symbol in two dimensions of what is in reality three *(cont.)*

dimensional. Consequently, each picture requires of the viewer an instantaneous comparison of what it represents with his experience in the real world of the same or a similar subject, in order that he can imbue it with solidity. We have no difficulty in accepting, as with painting, photography's need for this simple deception.

However, the subjectivity of the medium involves a further, more profound, exercise of the imagination that is not based on a convention but derives from our differences as individuals. Just as the photographer imparts to the image his own personal vision, based on his previous experiences and present perceptions, so the viewer responds to his picture in terms of his own fund of ideas and feelings. If a picture is to convey significance to the viewer, his intellect and emotions must be fully engaged. The idea of the photographer Paul Strand that "the potential power of a photograph depends on the purity of its use . . . it must be distilled through one's head and heart" has relevance both to the photographer's perception and to the viewer's interpretation. The previous experiences of the communicator and the receiver are necessarily different, but this discrepancy enhances the value of communication rather than precludes it.

When we look at a photograph we are at first conscious of the mood created by the imagery, of what we might describe as our emotional response to the picture. Then we attempt, through thought, to understand its meaning. Some images reveal their meaning readily, others reveal it slowly, others again are like dreams in that they convey meaning in fragments, erratically. The successful image combines, and indeed denies the separateness of, emotion and thought, mood and meaning, forming a whole that extends the boundaries of our experience.

SARAH, DORSET 1983 I
Derelict buildings are commonly used in nude photographs to provide a counterpoint to the perfection of the model. Often, as in the picture on the right, the striking juxtaposition presents what seems to be a mysterious fragment of a narrative that we can reconstruct as we wish.

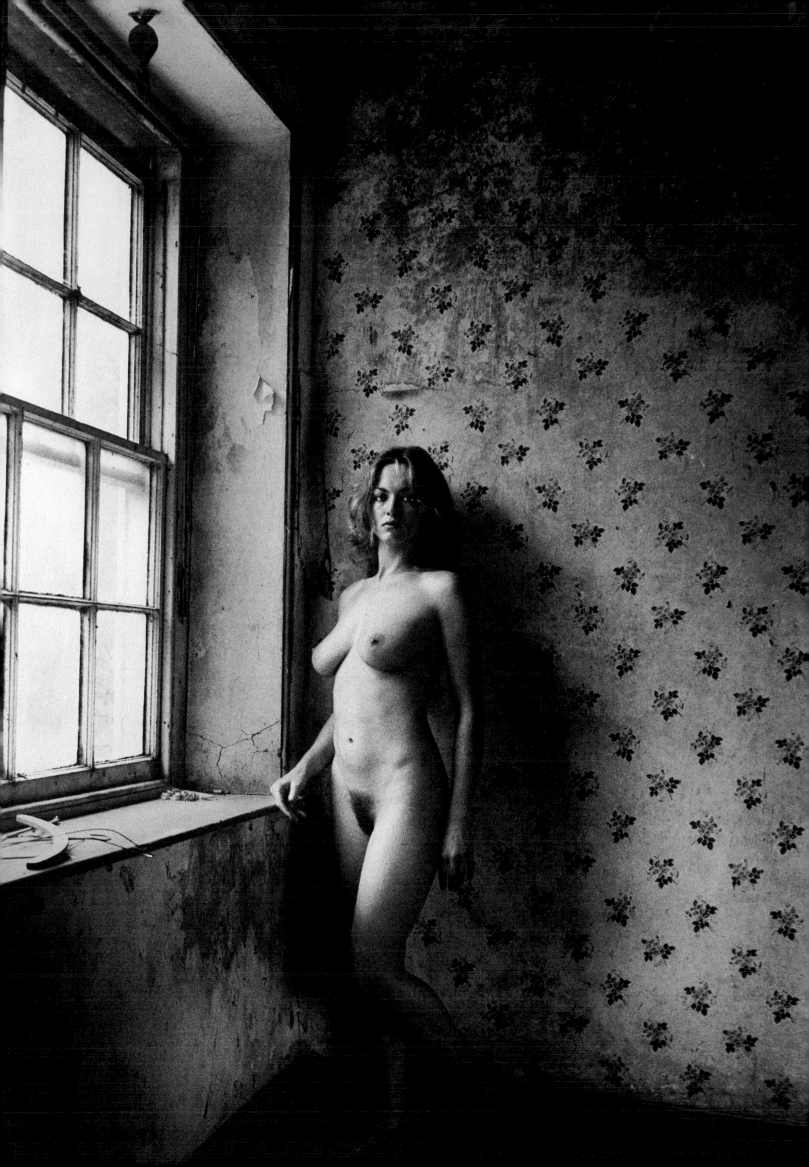

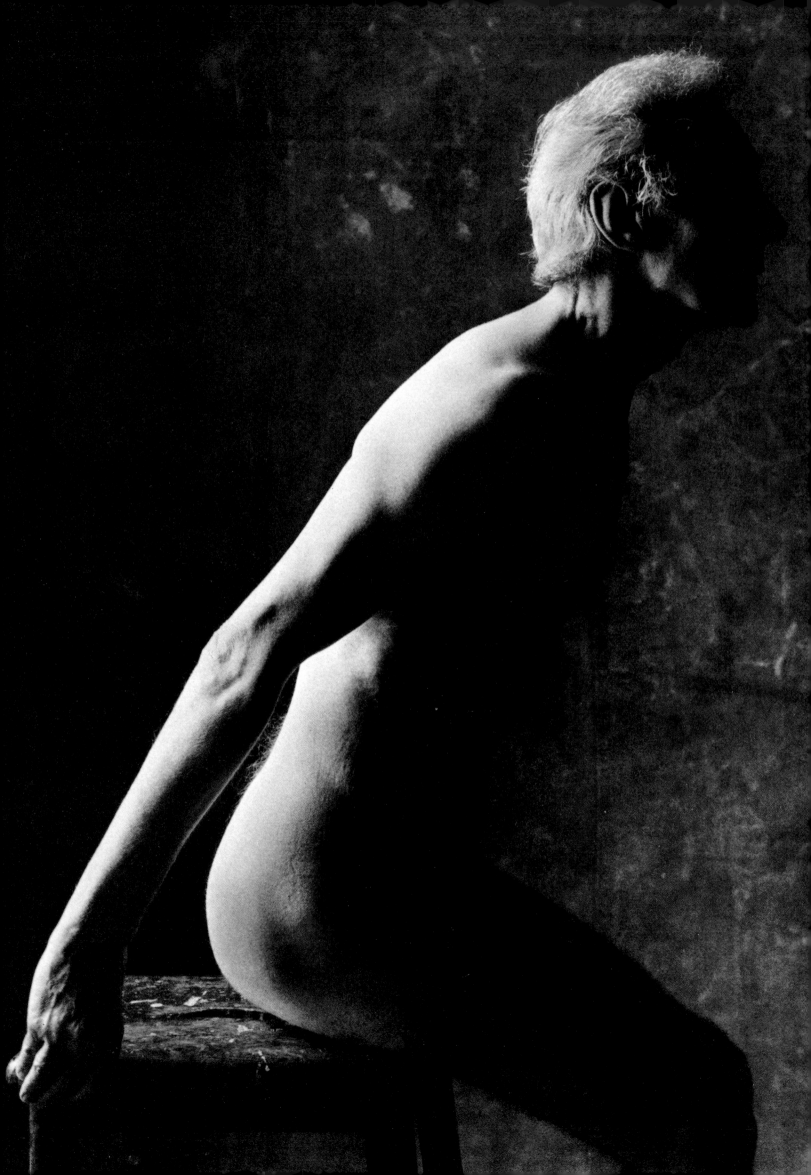

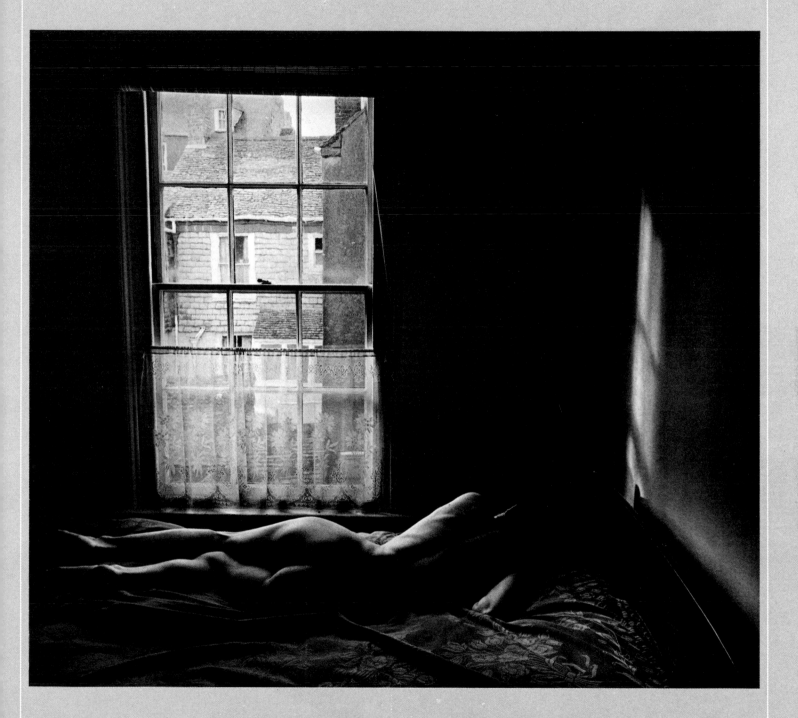

LIFE MODEL
Photographic studies of the nude concentrate largely on the combination of youth and beauty. Painters and sculptors, however, often seek older subjects, such as the life model on the left. For the photographer too there is a challenge in the fragility of the aging form.

ST IVES 1983
When the subject is seemingly unaware of the camera, as in the picture above, we experience by proxy the photographer's privileged glimpse. The imagination ranges over the setting, looking for signs of the lifestyle of another.

WOMAN IN WHITE *(overleaf, left)*
Clothing has long played an equivocal role in art. While at times it has served to conceal nakedness for reasons of propriety, it has also been used, often simultaneously, to emphasize the studied aspect of nakedness that we call nudity.

THE BLUE TOWEL *(overleaf, right)*
In most glamor photography the portrait presents a mild sexual confrontation and little else. But it is possible to capture an expression that transcends this stance without losing in erotic strength.

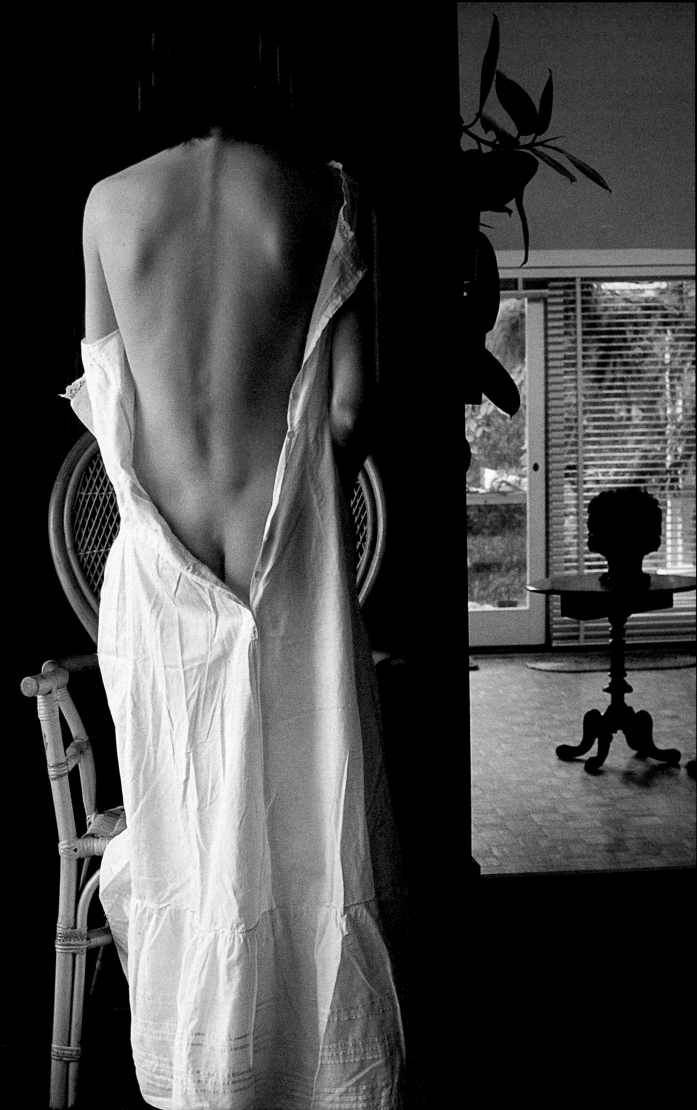

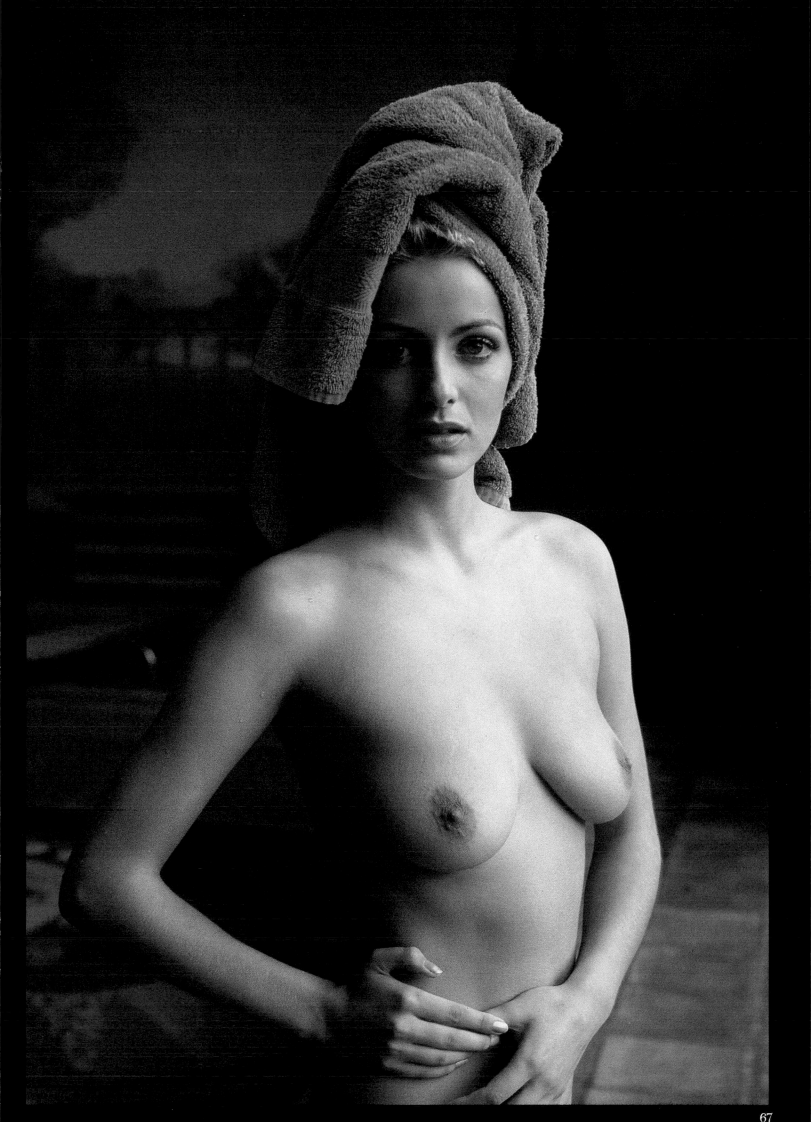

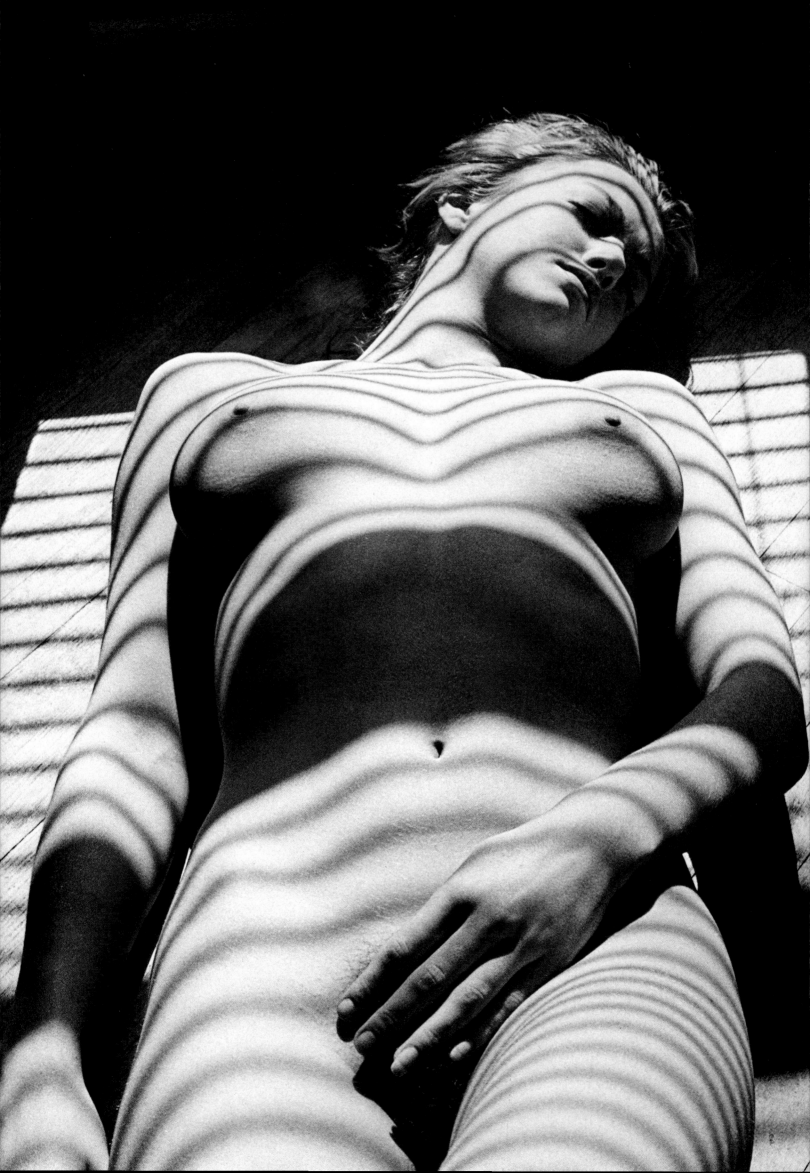

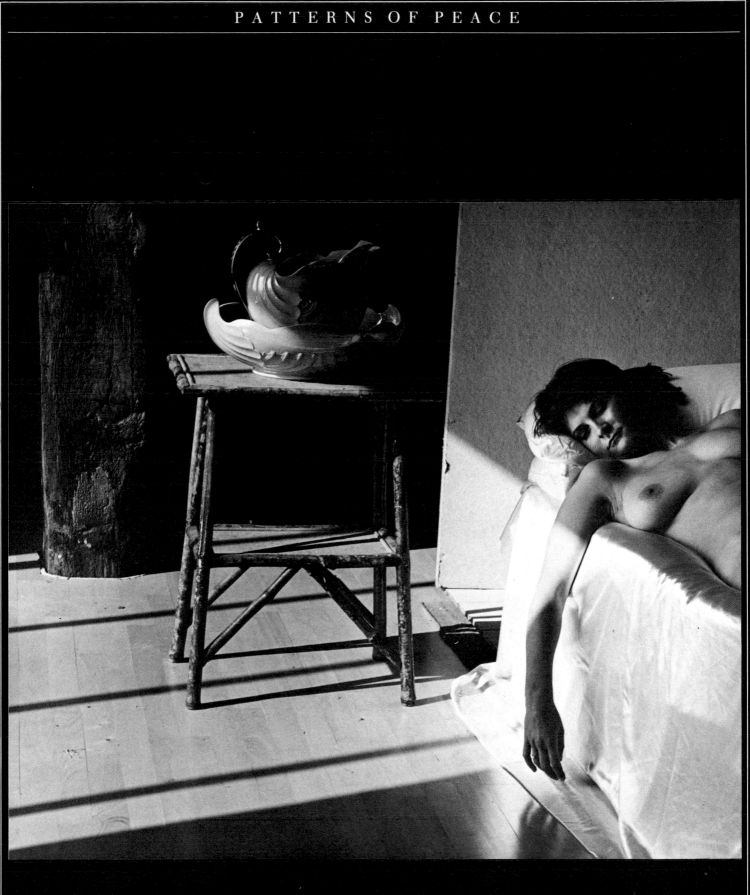

SARAH, DORSET 1983 II
*In the picture on the left the bars of shadow
projected by a Venetian blind are so integral a part
of the scene that they appear immovable, like those
of a cell. Similarly, time seems to be suspended and,
for a moment, it seems that it might be the girl's
fate to remain imprisoned for ever.*

REPOSE
*The strong pattern of light in the picture above
creates a mood of immobility. But in casting the
model into slight shadow it also stimulates the
curiosity, unsettling our sense of serenity.*

CAROLINE

It is in the nature of most photographs to present us with recognizable objects. But while the medium seems to be figurative, the photographer's choice of a subject is often determined by the associations it furnishes as much as by its visual qualities. Faced with an image such as that above, we take for granted what it depicts, but our feelings about it are more likely than our immediate visual response to echo the photographer's perception.

RACHEL 1984

Pattern often gives a two-dimensional appearance to a subject, but in the picture on the right the contours of the symmetrical projected image follow the lines of the body in such a way as to bring out the model's form. The brightness of the projector's light gives a strong presence to the model by evoking the spotlit radiance of the stage.

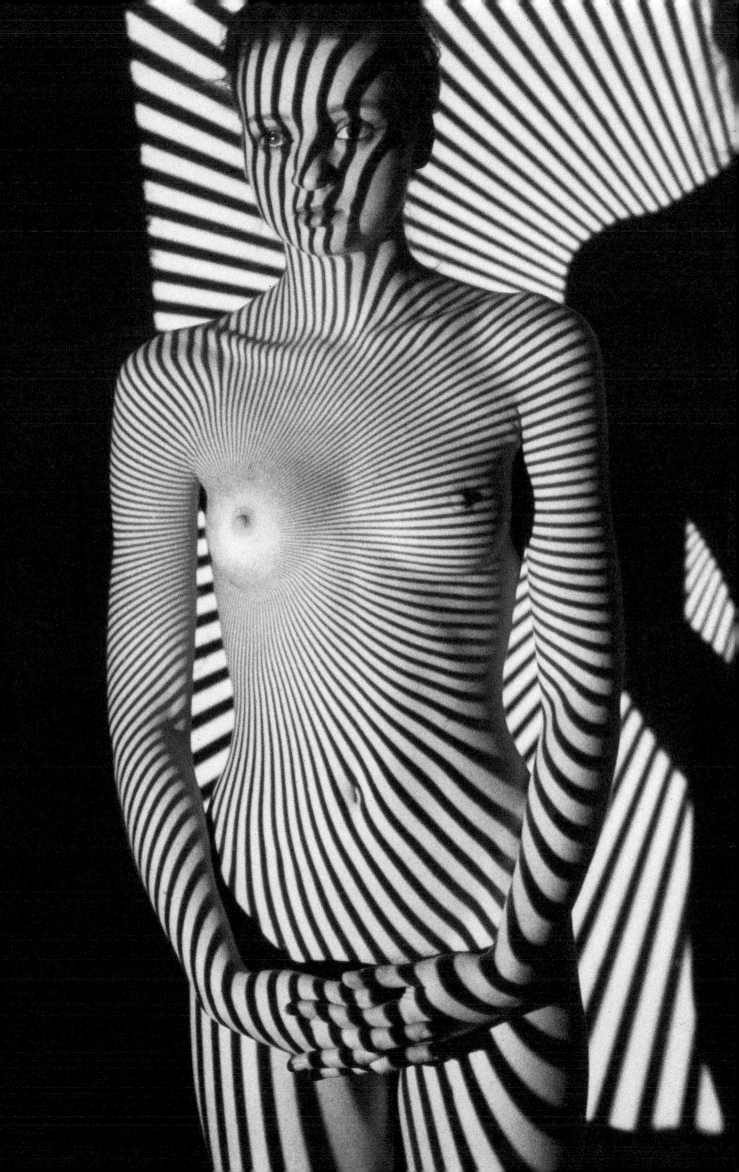

KAREN 1983 II *and* **III**
Each moment that the camera captures is lent significance, but only some moments possess that special quality which fires the senses and the imagination. I took advantage of a brief parting of the clouds when I shot the scene above. The model and the pine boards were bathed in a warm rectangle of light by the strength of the midday sun. Yet it was not until the clouds had gathered again, providing even greater diffusion than before, that I witnessed in its fullness the glorious contrast between the rich textures of skin and wood and captured it in the shot on the right.

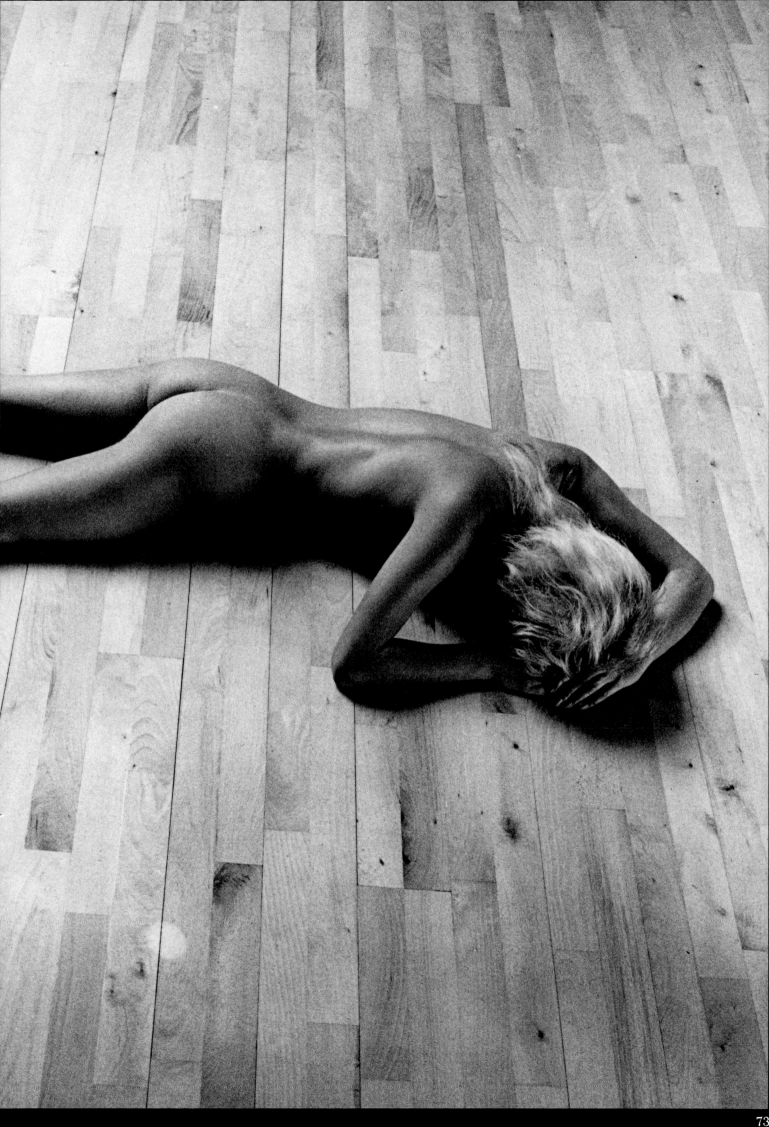

The importance of the "purity of use" of a photograph is denied by those photographers for whom all that matters is the result. In their view if a photograph works it should not be discounted by reason of the technique entailed. Sharing a common with many painters, they attempt to shock the viewer into a new awareness by exploiting technique. However, where technical virtuosity overpowers the expressive element of a picture, the result is often little more than an interesting experiment.

The camera is basically the same tool as it was when it was invented: a light-tight box with a mechanism for operating a shutter and a means of holding light-sensitive material perfectly flat. It plays no part in the selection of the images, and discrimination in this matter is entirely the responsibility of the photographer.

Nevertheless the camera can increase the powers of observation, permitting the viewer to examine closely the detail denied to the unaided eye. In this way, a photograph of a nude is not merely the reproduction of the subject, but is concerned with form, shape, harmony, tone, texture and other qualities. It is a matter of the feelings generated by these elements, and it is the photographer's ability to represent the source of these feelings that governs the picture's success. But technical ability must not be disregarded, and in this connection Cyril Connolly, in his introduction to Bill Brandt's book *Shadow of Light*, asks: "What do we look for in a photograph? Curiosity, wit, humility, detachment, some imaginative quality to offset the brutality of the machine ... and ultimately technical mastery and fastidiousness of selection. For the closing of the shutter is a death sentence, a guillotining of the moment."

CATHERINE, DUNMOW
A happy accident occurred when I experimented with out-of-date instant-picture film. The mood created was quite different from that of the scene before me, but I found the effect attractive. It seemed as though the model had been photographed through a flattering haze.

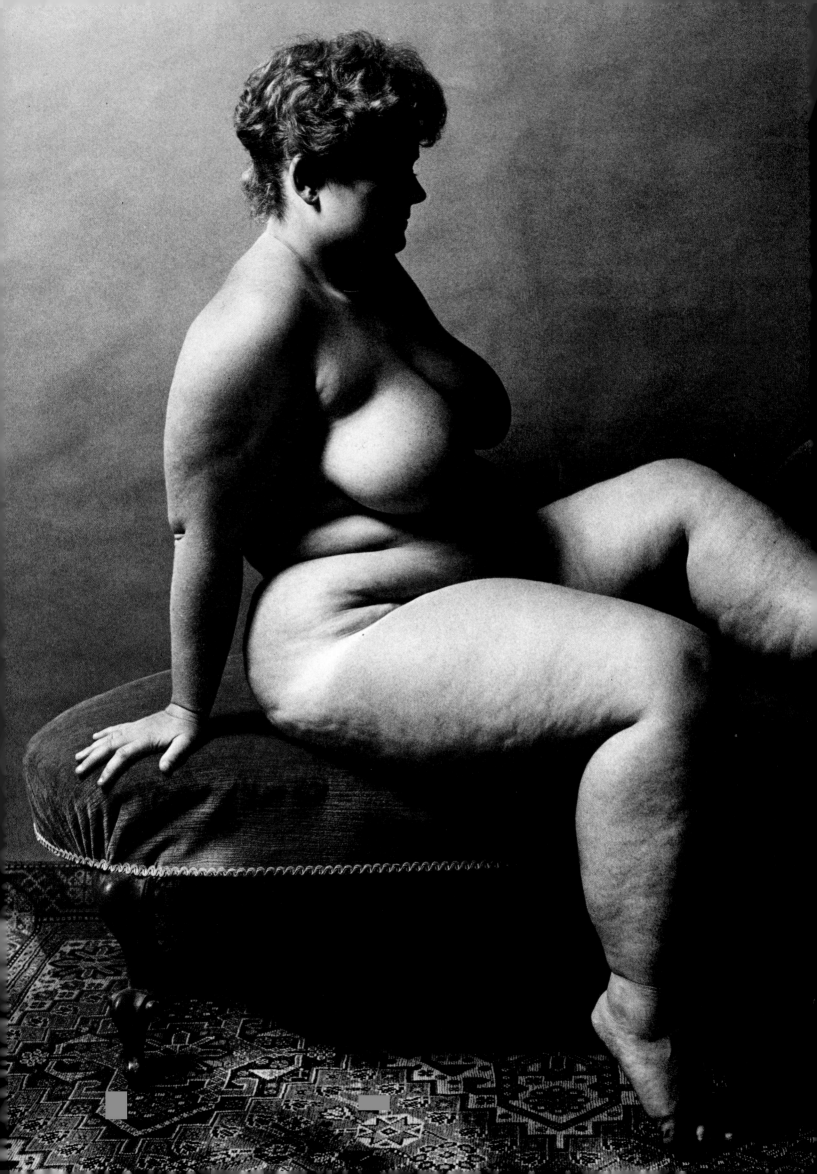

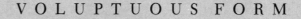

PAM, DUNMOW 1983 I
While the artist's view of what constitutes beauty in the human form is subject to frequent change, certain preferences reassert themselves at various periods. One such taste is for the voluptuous shape of the model on the left.

BRADFORD 1972 I *(overleaf, left)*
In countless thousands of rooms the evils of the sedentary life are daily combatted to the reassuring accompaniment of the TV.

PREPARATION *(overleaf, right)*
A snapshot often captures character by its very spontaneity. When elaborate posing and technical considerations are dispensed with, the subject is frequently caught in an unselfconscious mood. The model in this picture was planning to go out, but since nothing was required of her that interrupted her preparations she felt no invasion of privacy.

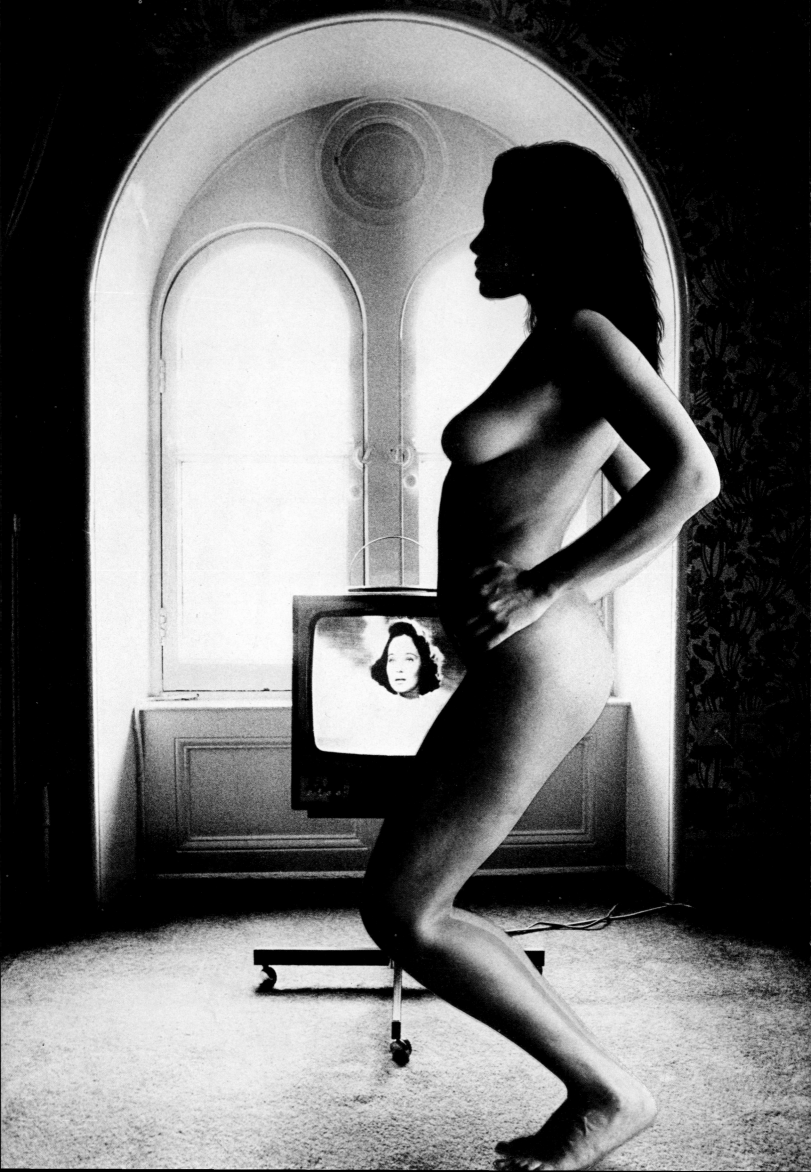

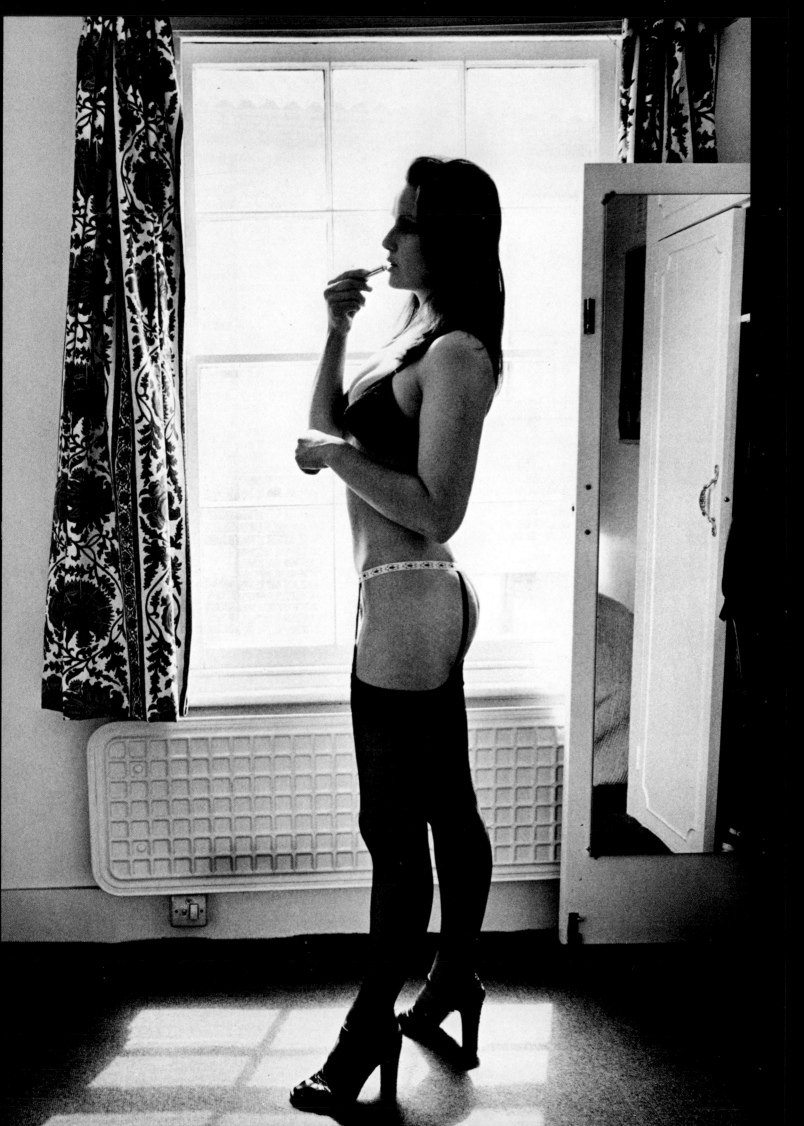

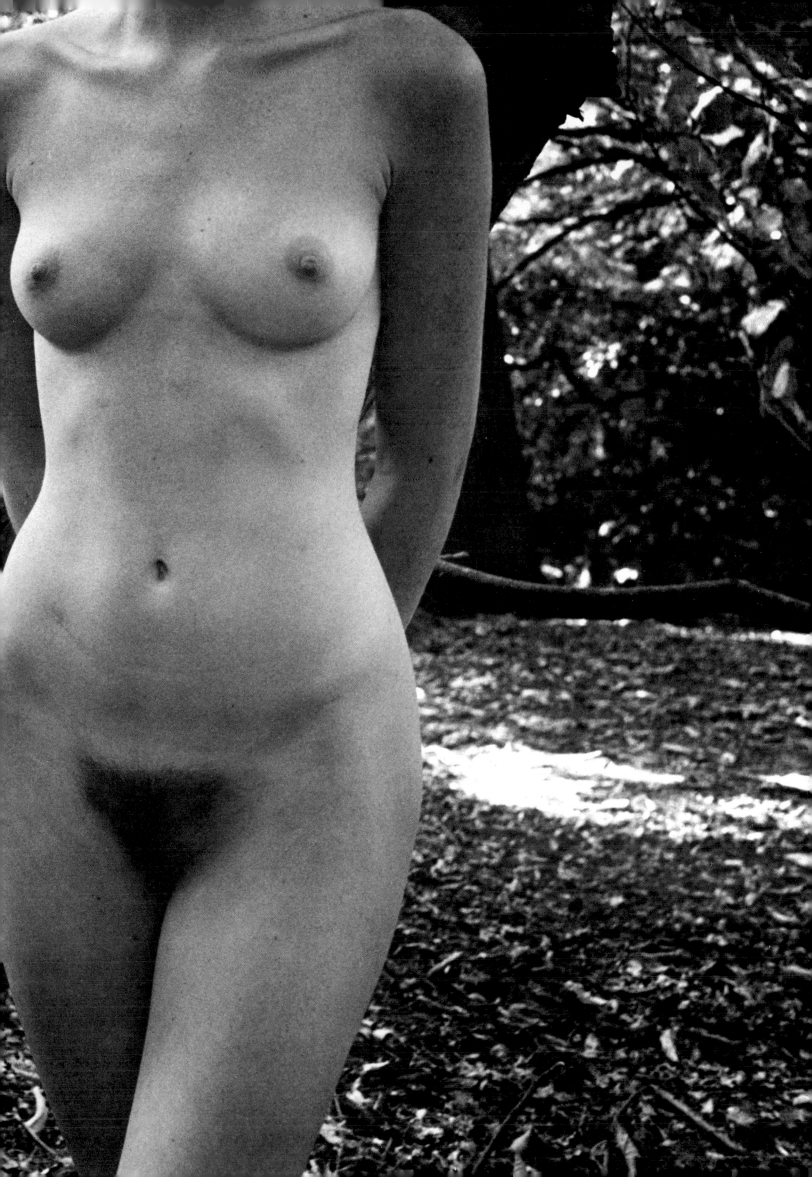

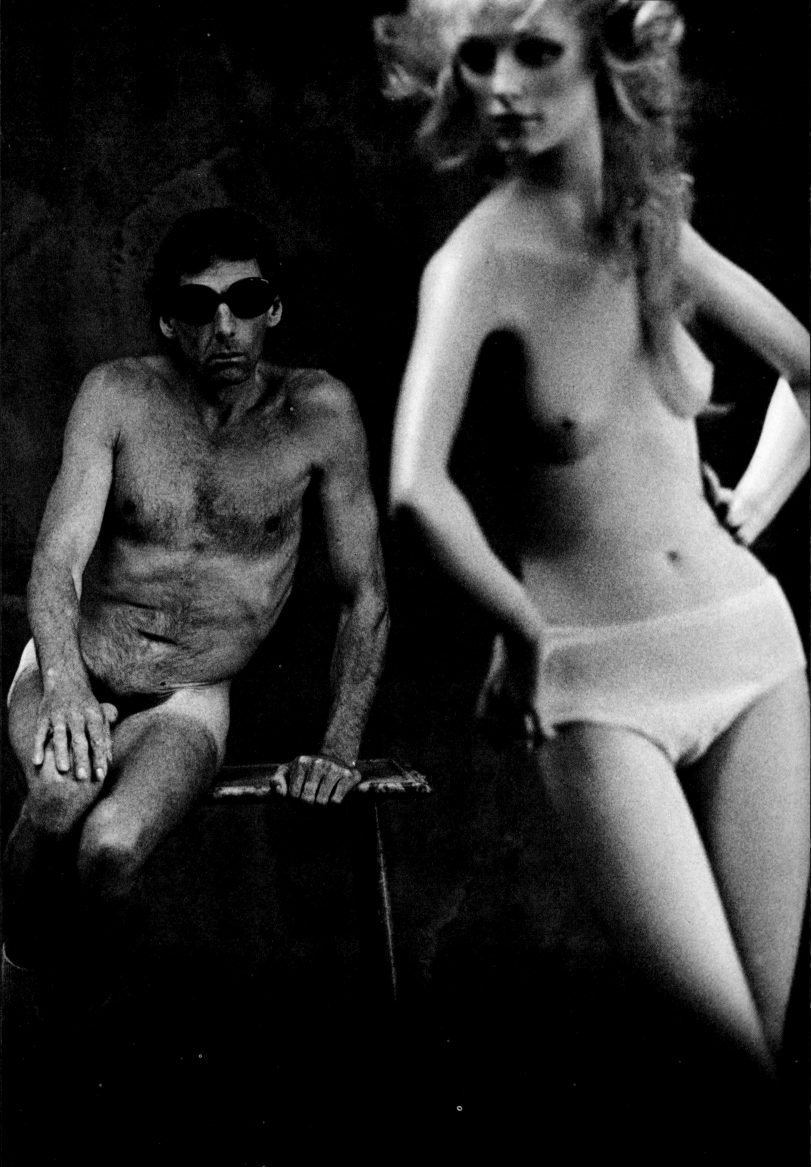

CROW WOODS I *(preceding page)*
A common type of romantic image—the attractive female form in autumn woods—takes on a macabre atmosphere as the tree seems to come alive. A gnarled hand gropes its way ominously out of its crotch in the uneasy subdued light.

THE MANNEQUINS
When nudity becomes a commodity, as in glamor photography and advertising, the model is reduced to the status of a mannequin. In the picture on the left, the roles of the mannequin and what we may take to be the commodity dealer are defined by the focus. But despite the clarity of the image, his status is not so clear-cut as that of the mannequin. Beneath the brutal anonymity of his dark glasses, he too seems vulnerable, perhaps as much a prey to manipulation.

DOLL
The passive fixity of the model's expression in the picture above recalls the images used by advertising to sell products from aftershave to automobiles. Aimed principally at men, such images hold out the alluring promise of sole possession.

POSE & MOOD

The photographer's vision of the nude is not only dependent upon his eyes but on the full range of his sensibilities. He is not concerned merely with the translation of a living form onto a flat surface but with the creation of a visual metaphor for the qualities his emotions respond to in his subject.

Above all, it is his control of the subtle qualities of light that provides the photographer with his palette. The mystery and concealment of a subdued light, the passage of a shaft of light across the naked form, the way in which each delicate curve is caressed before falling away into shadow—these all create a strong sense of physical perfection.

Light reveals and enhances, providing a sensuous warmth that is felt as well as seen. Its skilful use can render the model the embodiment of desire, voluptuous and sensuous, charged with both immediacy and fantasy. And yet its unsympathetic handling can dehumanize the form so that nothing remains but a crude, alienating symbol, a sexual commodity.

The pose also plays an important role in the creation of mood and atmosphere, for the body is perhaps the most emotive of forms. The curve of the back, a slight, exciting tension in the muscles, the interlocking shapes of the limbs, the qualities of the skin and, not least, the face—all present the photographer with expressive components. The portrayal need not be realistic, but it must excite the imagination with an element of eroticism: a successful study of the nude always suggests more than it states. Its beauty can also be disturbing, like a thunderstorm or a volcanic explosion.

LINDY, FRANCE 1975 I
The girl's eyes issue a gently erotic challenge which the apparently chaste positioning of her hair and her leg reinforce rather than deny. Her hand, in accentuating the roundness of her leg and hip, fosters the mood of mild flirtation.

ANNE, RETOURNAC, FRANCE I *(overleaf)*
The strong lines of the building, with its repetitious pattern of windows, lend a reassuring solidity to the scene. But the spiky teasels that surround the soft, backlit figure hint at a reality that is not so comfortable.

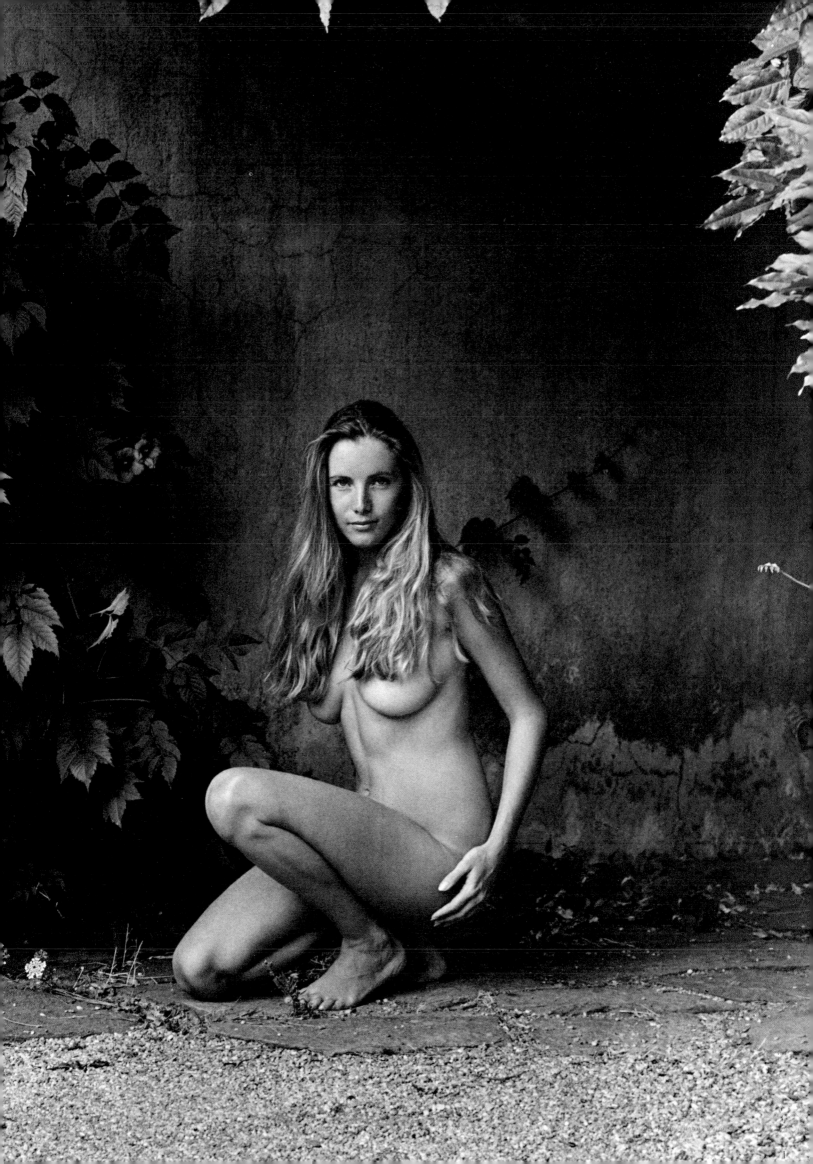

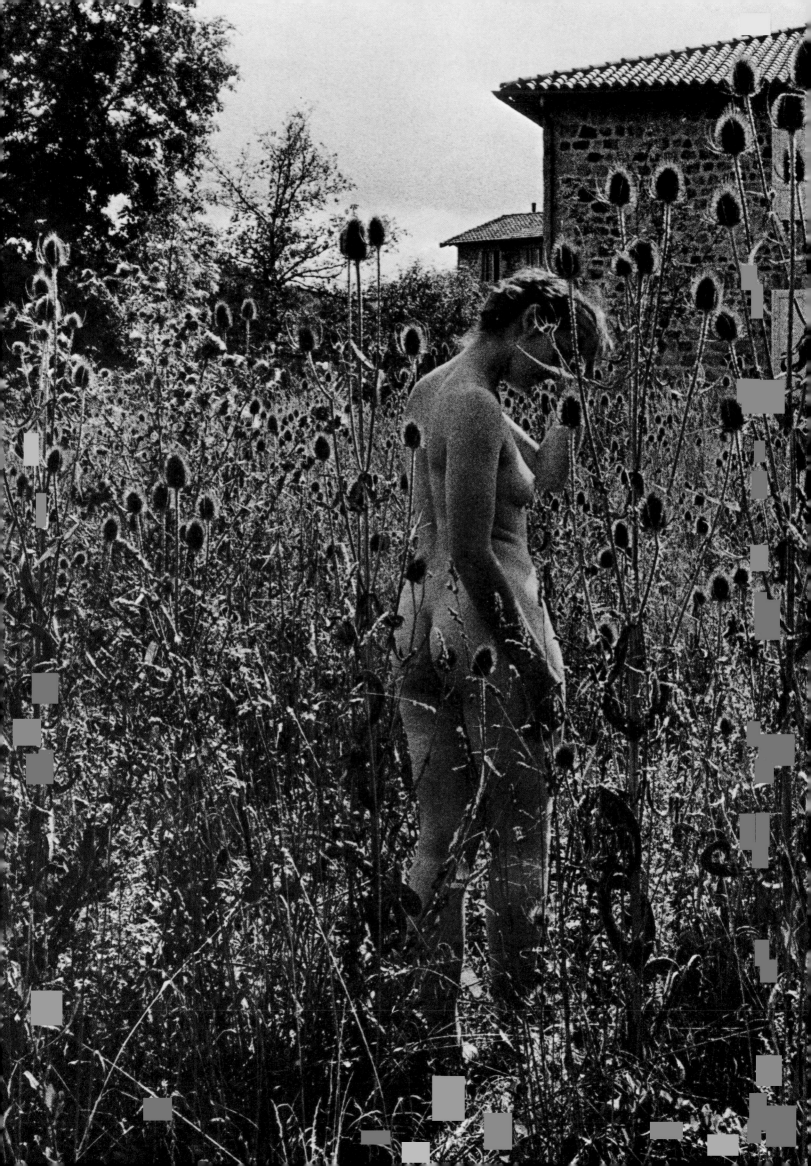

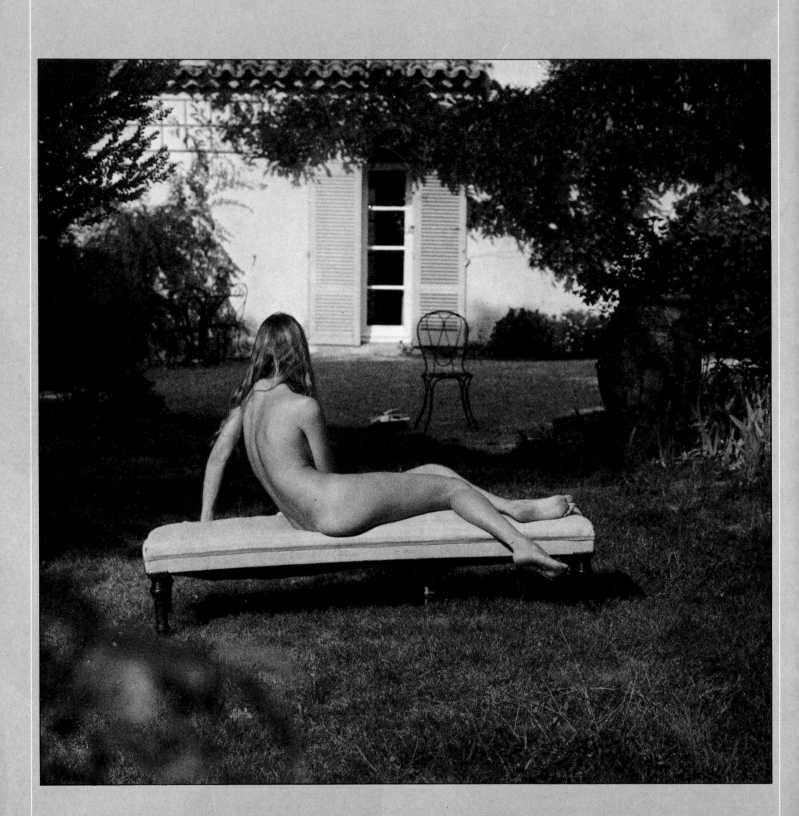

LINDY, FRANCE 1975 II
The model in the picture above reveals a clean, sculptural form in harmony with the order of the setting. Her unawareness of the camera suggests that she is totally absorbed in the pleasures of warmth and peace.

CROW WOODS II
The questioning expression of the model in the picture on the right provokes a similar reaction. Why such frailty in the midst of tranquillity?

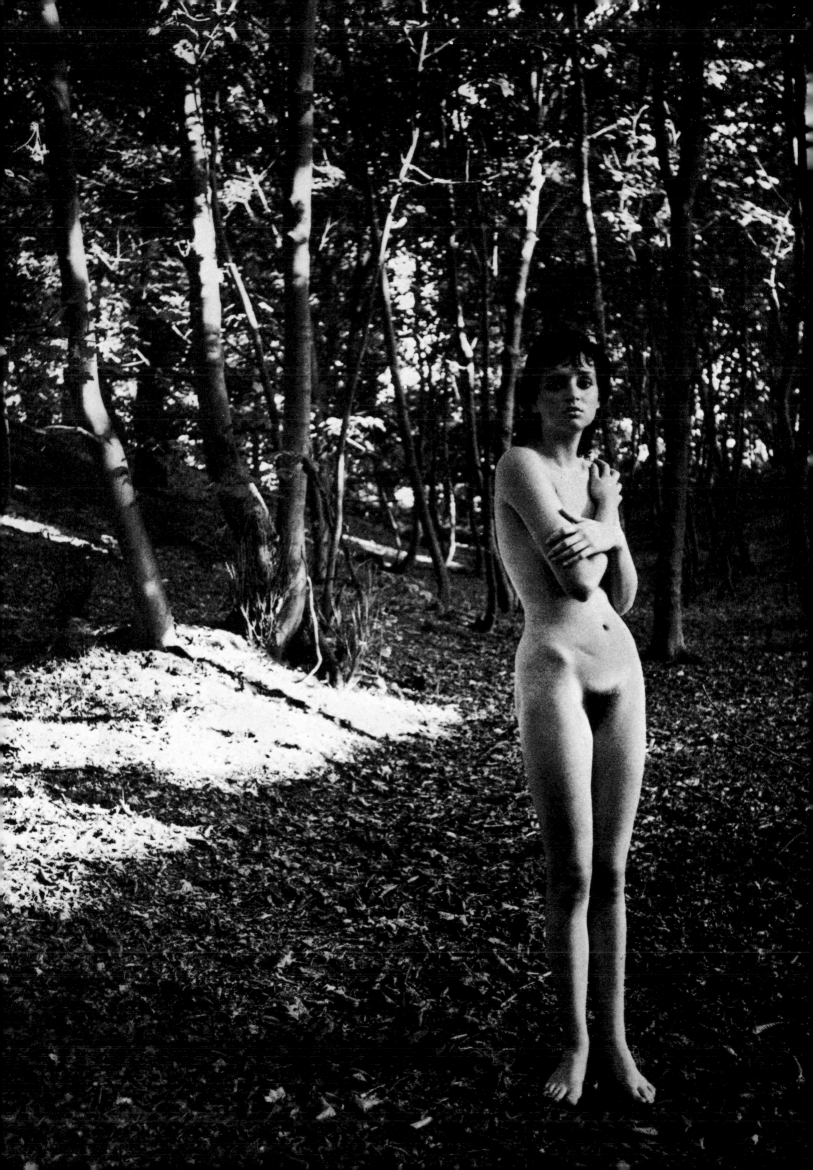

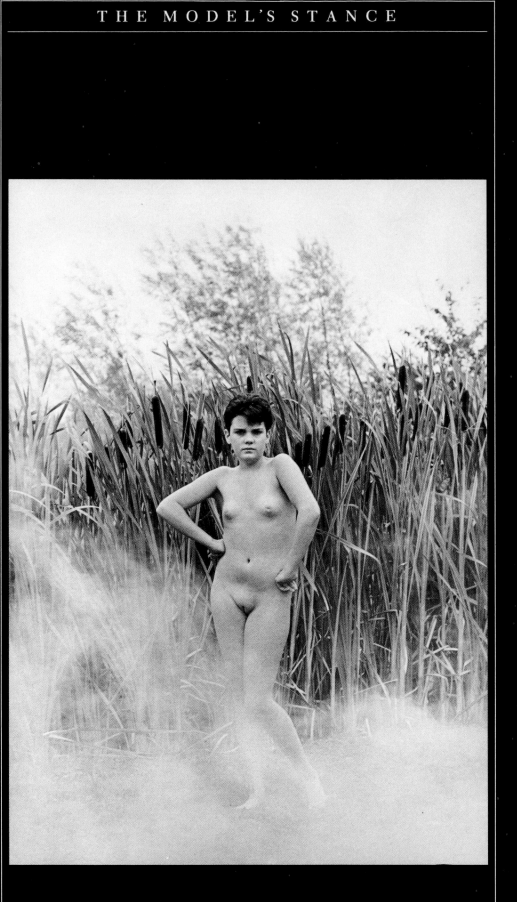

EMMA 1983
*Recalling the exaggerated postures of countless
"cheesecake" shots, the pose of the young model in
the picture above nevertheless hints at self-parody.
But perhaps she is simply trying out for the camera
what most young girls practice before the mirror.*

THE SCULPTOR'S MODEL
*The natural light that I shared with the sculptor
Timothy Easton brought out the studied tension in
the colossus-like stance in the picture on the right.*

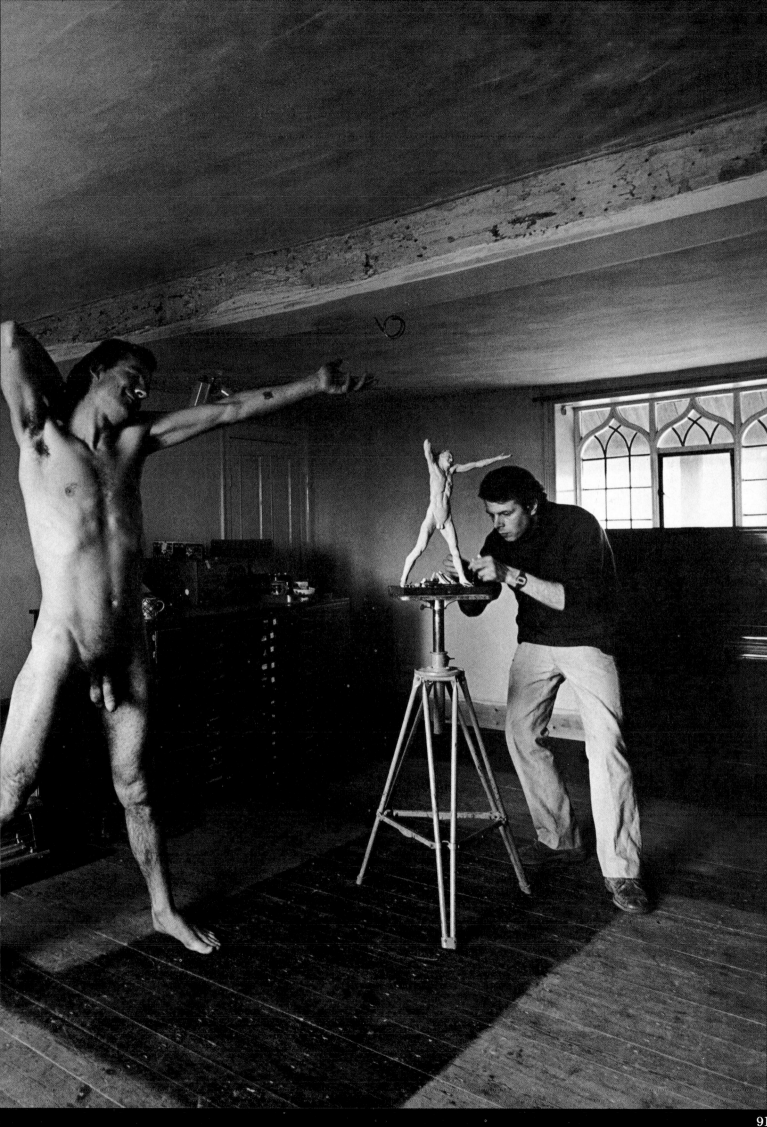

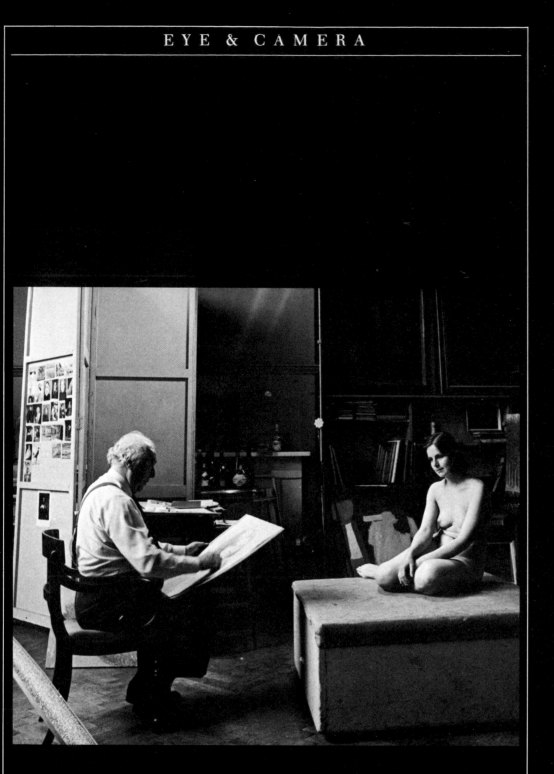

LIFE STUDIES
*The intense concentration of Robert Buhler and
Ruskin Spear in the pictures above and on the right
illustrates the need of the artist to examine detail
more closely than the photographer. The artist in
pencil or paint is often engaged over several
sessions in creating little by little a single portrait of
the sitter. The photographer also develops a
gradual understanding of his model, but can rely on
the accuracy and speed of his medium to produce a
selection of pictures in a short space of time. These
represent an amalgam of his perceptions, as a single
work might do for the artist.*

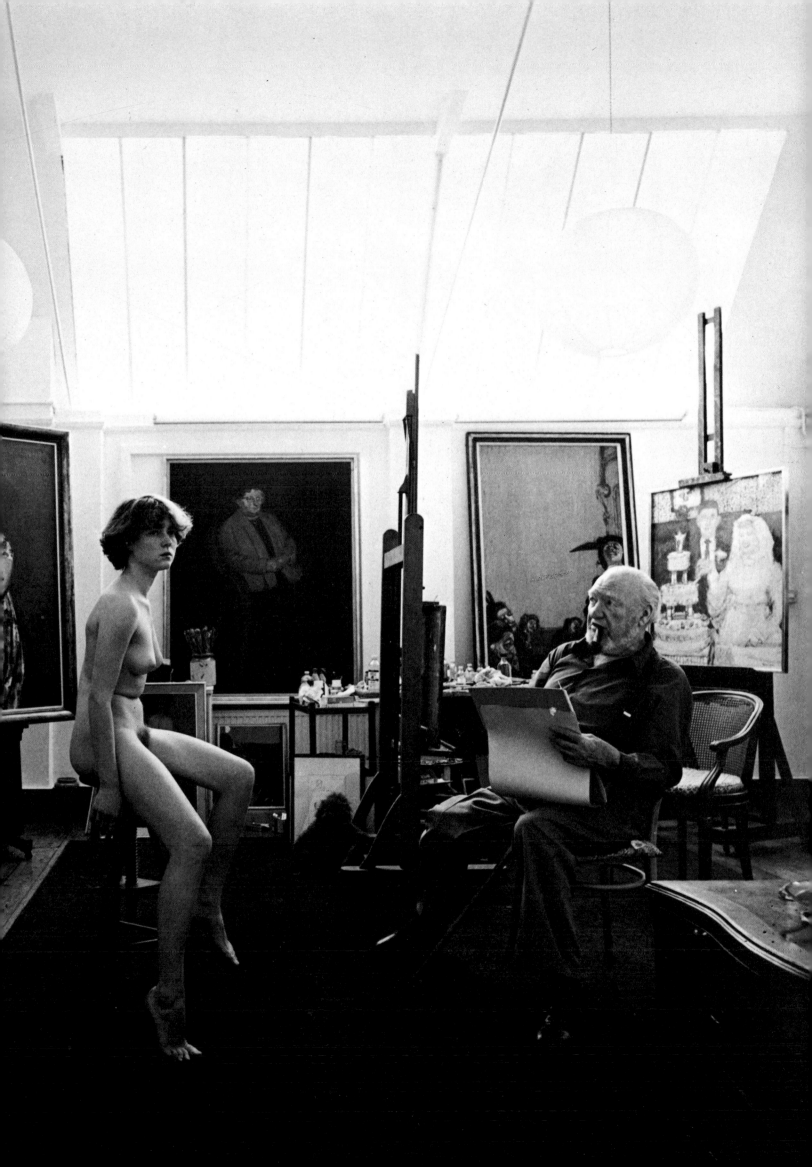

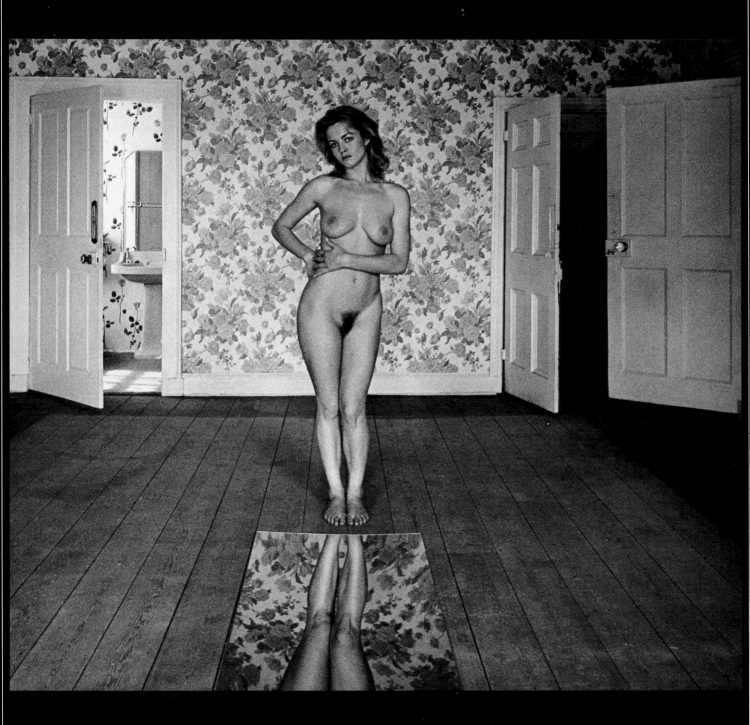

SARAH, DORSET 1983 III *and* **IV**
Some photographs encapsulate a story in a single
image. Others provide the shadowy outline for a
fiction largely of the viewer's making. The human
form always carries its own mystery, asking more
and answering fewer questions than most other
themes, as in these pictures.

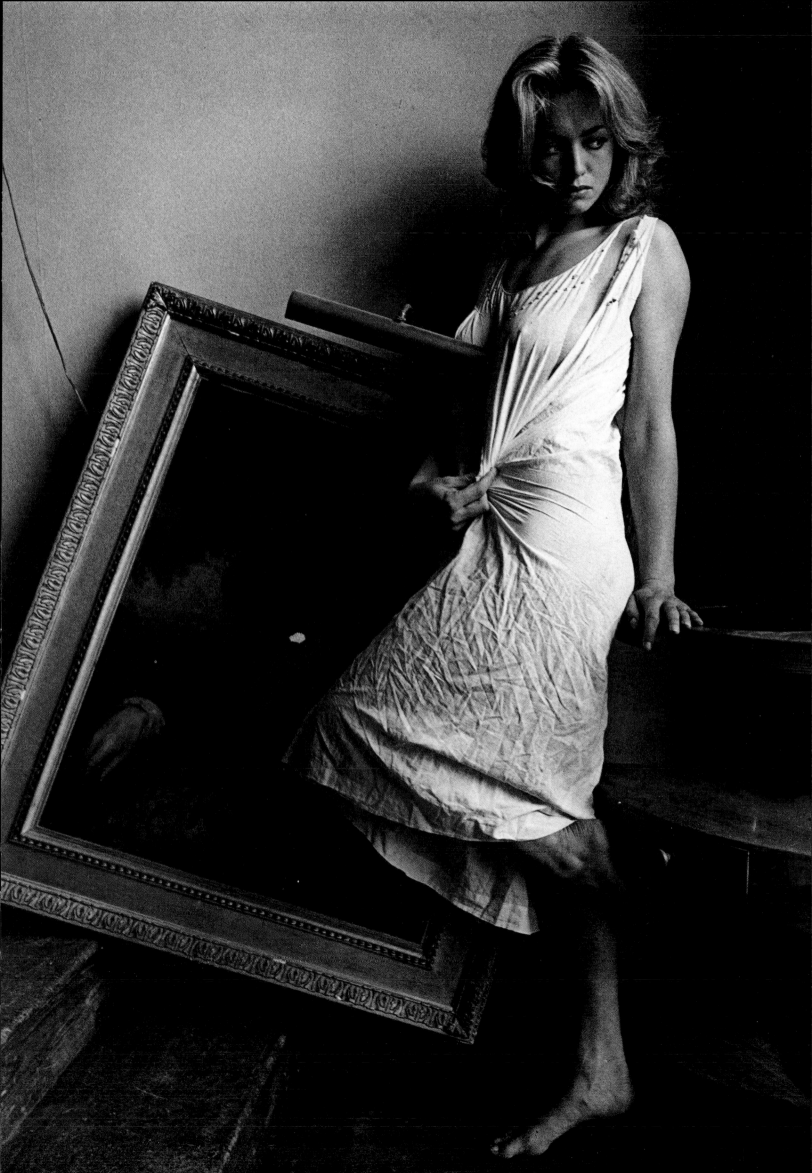

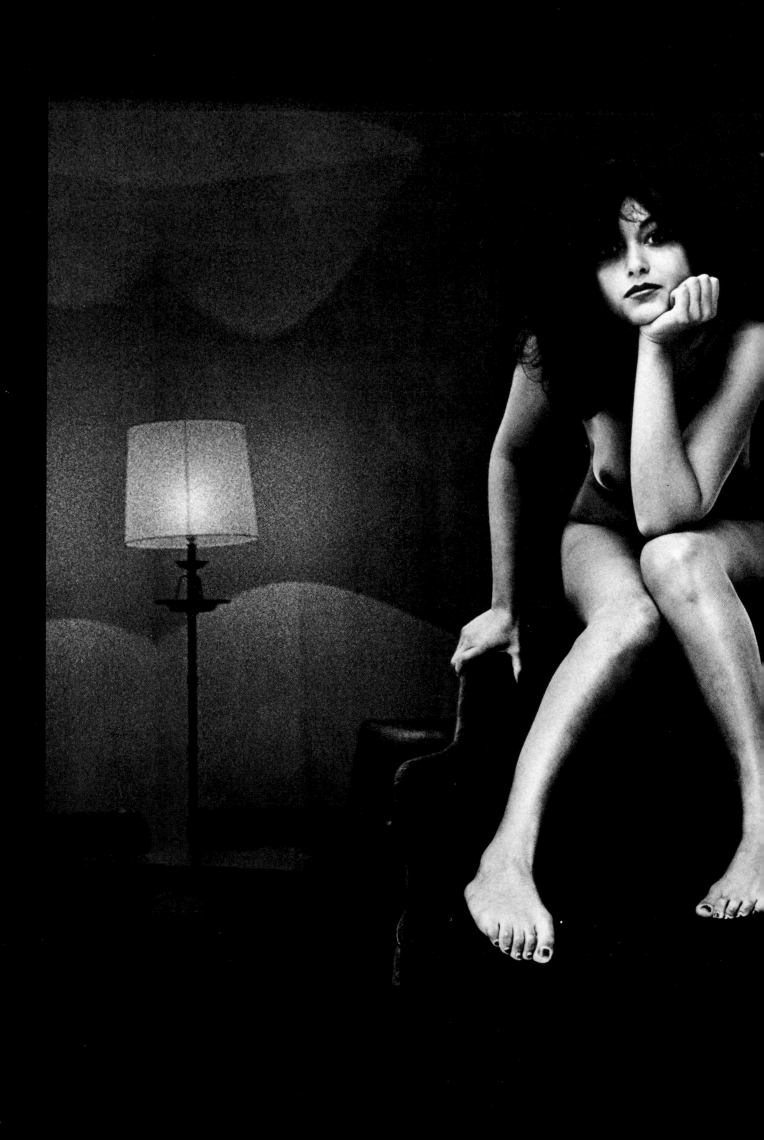

BRADFORD 1972 II
I visualized this picture in a crowded hotel lounge. I shot just the background then, and later, when the guests had left, used the TV to light the model. By montaging the images, I captured the mysterious aura of a room which, in daylight, presented a very prosaic suburban scene.

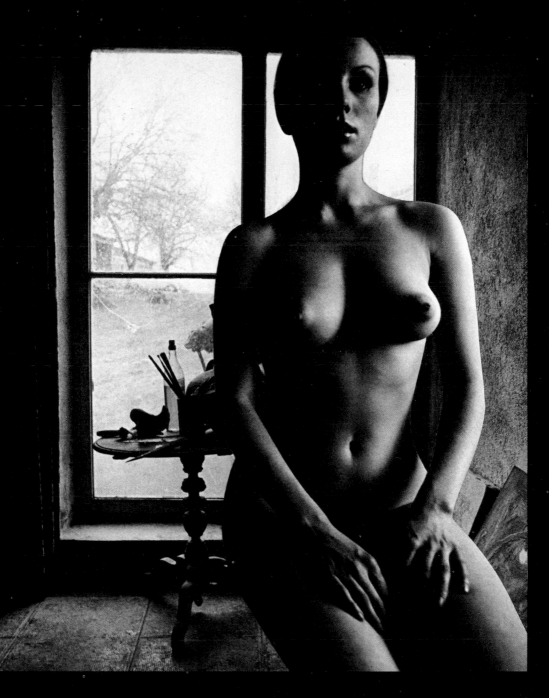

THE PAINTER'S MODEL
Strong daylight gives vitality to the portrait of the artist's model in the picture above. The image is not at all titillative: her work is honest and she is secure and proud in the knowledge that her body, with its full and rounded form, is worthy of painstaking depiction.

RENTED ROOM
In the picture on the left, nudity becomes mere nakedness, with its inescapable impression of vulnerability. The dejected pose of the model and the austerity of the room provoke questions about her feelings and situation rather than invite a study of her unclothed form.

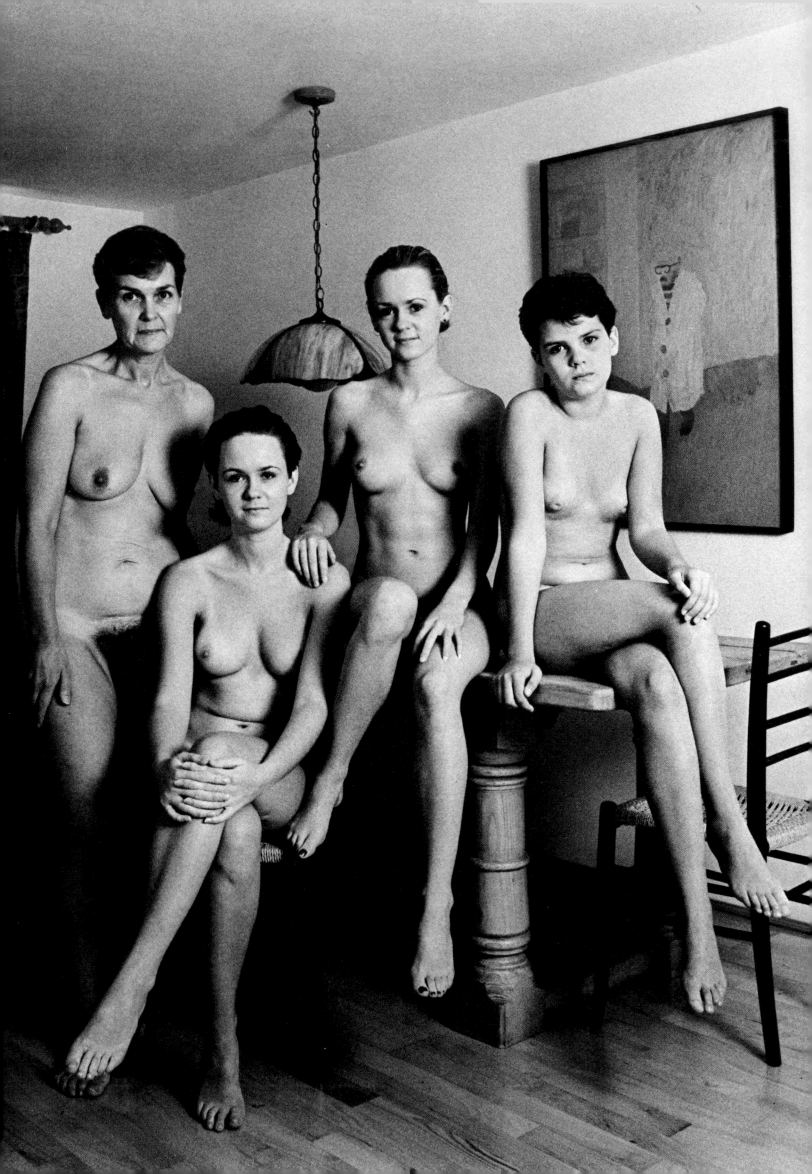

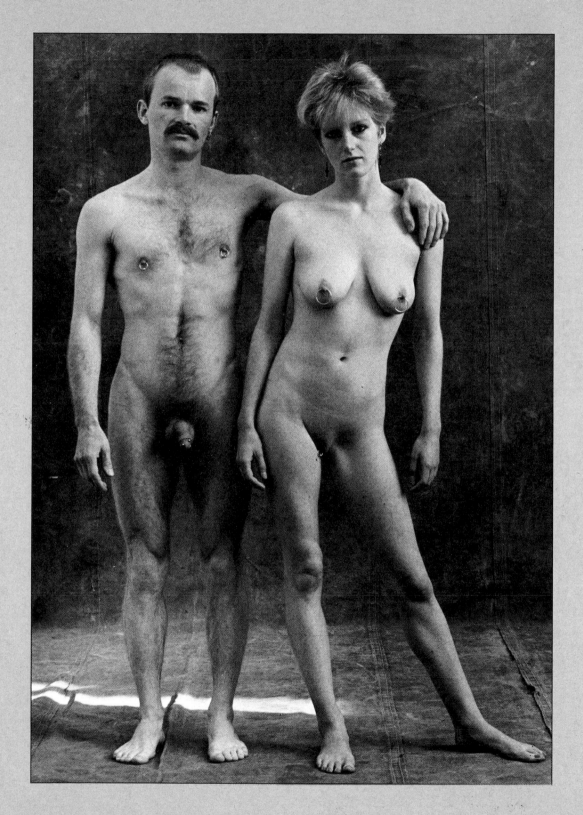

FAMILY, 1983
Conscious of each other's feelings and aware of a strong kinship that is reflected for the outsider in facial similarities, the group in the picture on the left have nothing to conceal from one another or from the camera. As a result, their nudity is relaxed and becoming.

BODY JEWELRY
The unselfconscious pose of the couple in the picture above gives a glimpse of their personalities as well as providing an attractive study in form. They seem perfectly natural, which makes the adornment of their bodies all the more expressive.

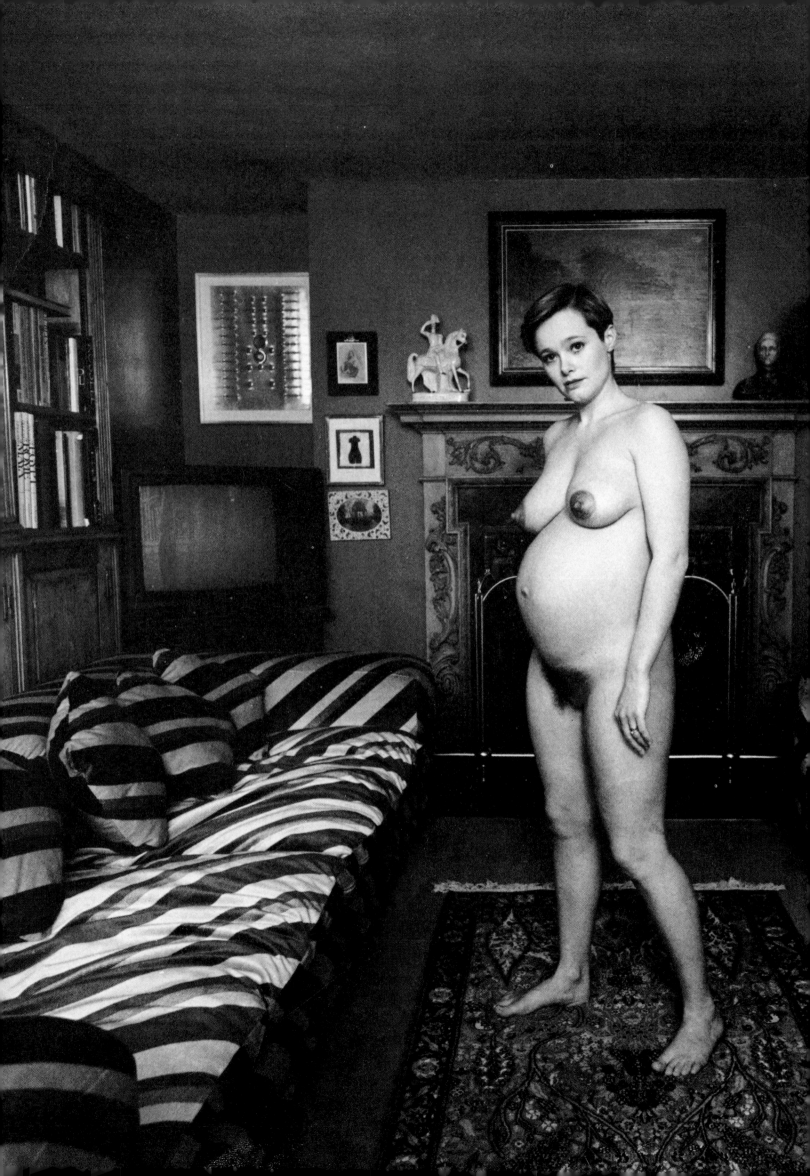

MOTHER WITH CHILD
Pictures of babies and children form an important part of most people's photo albums, but pregnancy itself attracts little desire for a memento. It is strange that most women should undergo such profound physical and emotional changes without wanting to document this most significant of experiences.

PAM, DUNMOW 1983 II *(overleaf)*
The preference of Rubens for proportions that have come to be named for the painter represented a high point in a tradition that predated him and continues to capture the imagination of artists in various disciplines. Complemented by the flowing lines of a setting reminiscent of Victorian parlour portraiture, the captivating rubenesque proportions of the model in this picture are certainly worthy of portrayal.

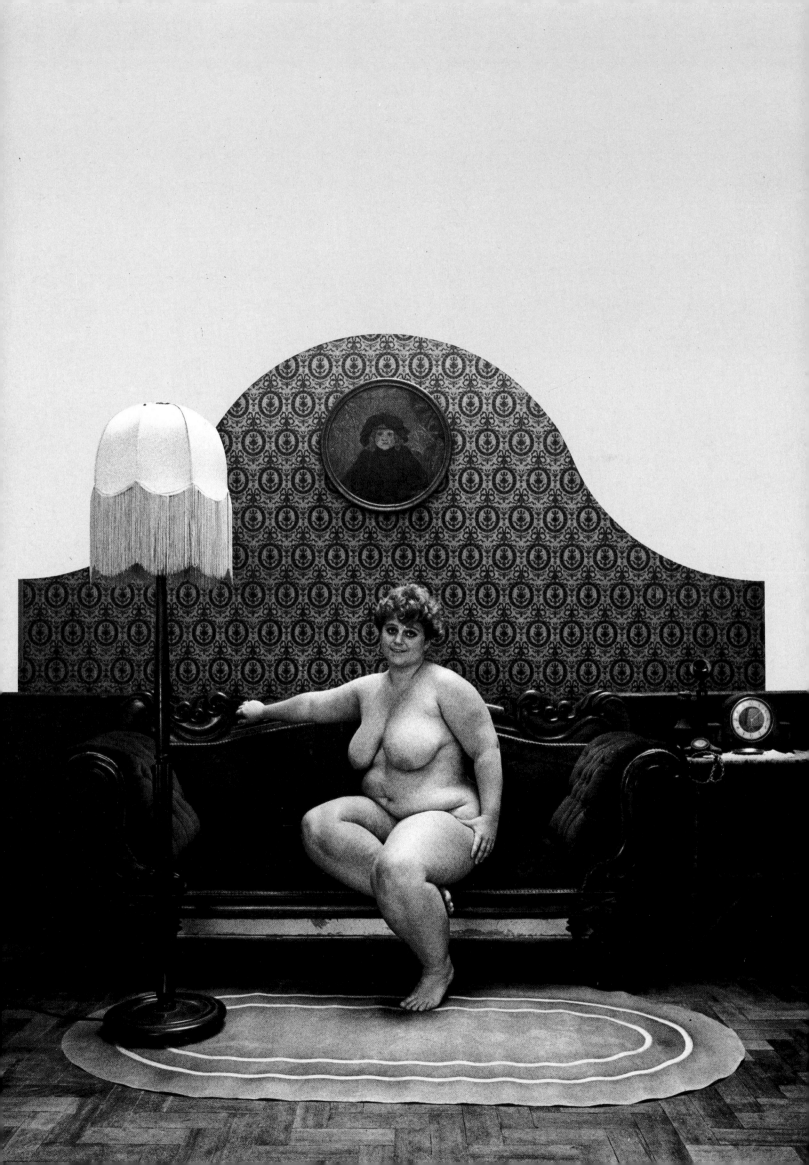

PERCEPTION AND RESPONSE

Photographs operate at every level of our society and we look at them in different ways according to our culture and our personal experience and lifestyle. At first sight photography seems to be a language that does not require interpretation. My own books have been published in some cases in twenty languages, but very few pictures are changed between the different editions, and then only for the sake of local propriety. It is only the words that are translated, in the strict sense of the term. And yet the pictures elicit different responses in each country.

Primarily a mode of expression, photography is inevitably influenced by the text which frequently accompanies it in the form of captions. Alter the text and you may well alter the meaning of the photograph. Words are signs that convey messages beyond their immediate sense, while photographs contain signs of equal ambiguity. The meaning of the written or spoken word used in conjunction with a photograph is determined to an extent by its cultural context. Accordingly, the same picture, with similar (translated) captions, can have a different meaning in different countries, despite the fact that the photographic evidence in the picture confirms the objective truth of the caption in each case.

The influence that a caption can bring to bear on the interpretation of a photograph is all the stronger in that modern reading habits reflect, as Susan Sontag remarks in *On Photography*, a "new appetite for books of few words and many photographs." For this indicates that we are reluctant to pay heed to anything longer than a handful of words, investing our *(cont.)*

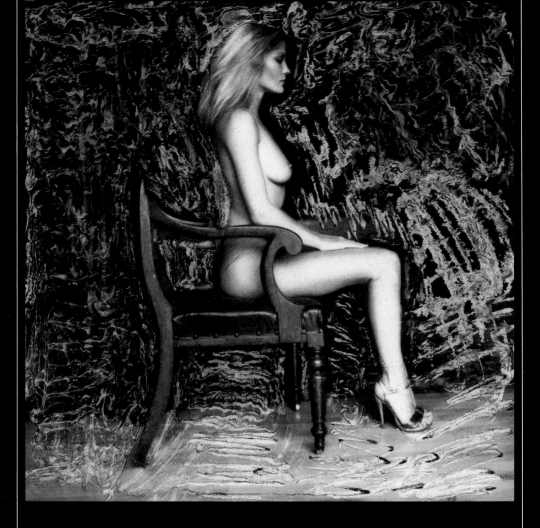

MANIPULATION II

While the emulsion of the instant print above was still soft, I used the back of a spoon to manipulate it. The turbulent quality of the background contrasts with the poise of the model and suggests the pervasive unrest that such seemingly unattainable women often provoke.

DUNMOW 1984

An area of the human body torn out of context by a dramatic image often takes on a brief strangeness. In the picture on the right, the effect of decapitation, strikingly long legs, bold localized color, and a neutral background that maximizes the subject's immediacy, is one of near-abstraction. The human form is momentarily unfamiliar, as if seen for the first time.

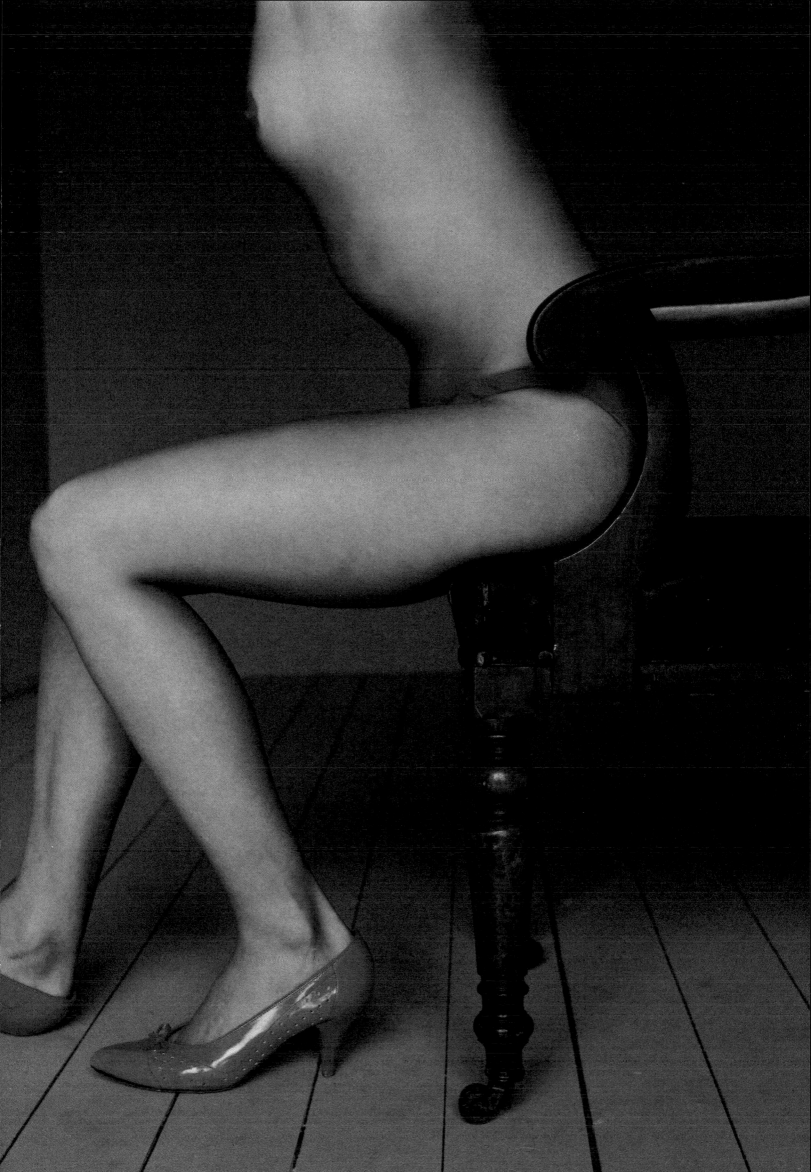

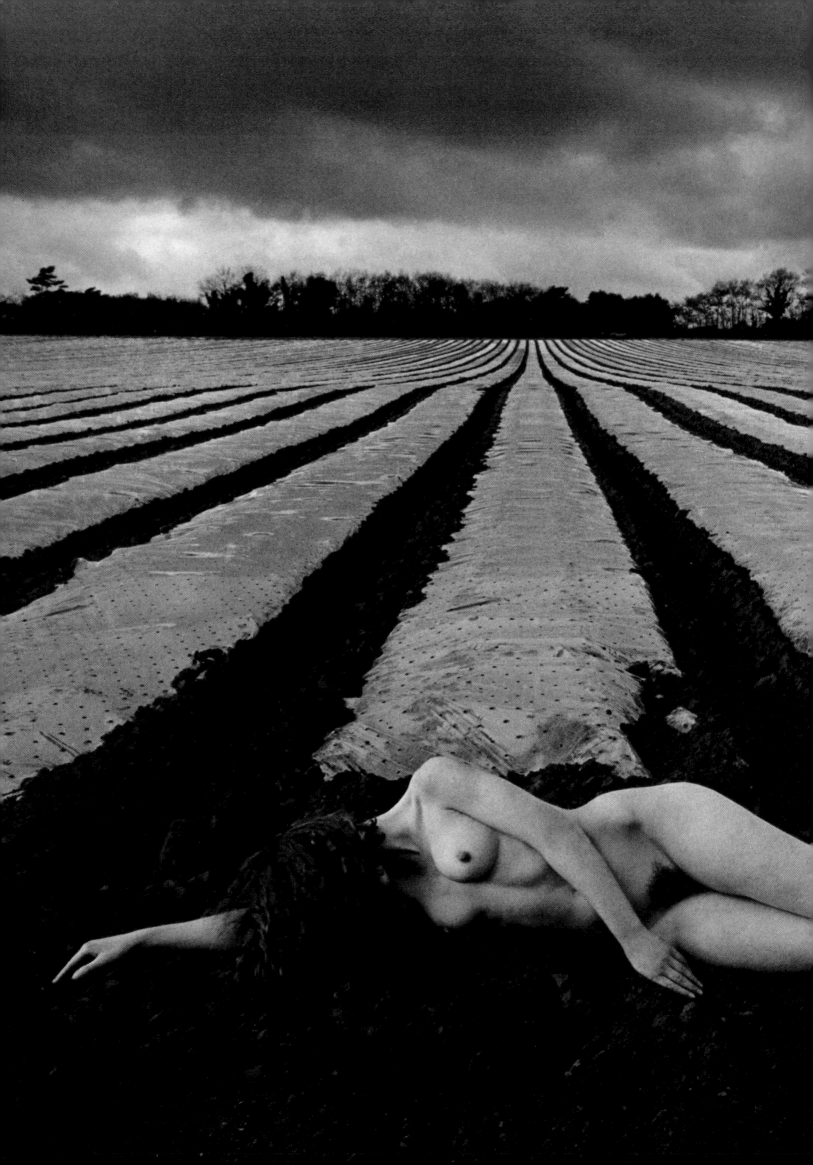

belief in terse statements of which captions are nowadays the predominant form.

Sontag comments in the same passage on the fact that photographs and quotations are taken to represent reality more authentically than "extended literary narratives." We are indeed inundated with visual images that we accept as the truth. Places become familiar through photographs, but in most cases we do not question the complexion lent them by necessarily selective images. Conversely, we feel obliged to establish the truth of places that we experience first-hand by amassing photographs of our visits. Our impressions fade and it is natural to want mementos, but many seem to feel that a place only becomes real for them if they take a picture of it.

HOLLESLEY 1983

The nude form set in a "clothed" landscape represents a powerful reversal. Is it stranger to find a naked woman in a field than it is to discover the same field draped in plastic? The air of mystery in this picture is heightened by the elongation of the body, the concealment of the face, and the lowering storm clouds.

THE MAN AT THE WINDOW
When the shock of encountering the Rabelaisian figure at the window has passed, the questions remain. What is he doing there? Who else is in the room? The ability of an image to provoke questions and to engage the viewer's imagination in an attempt to supply answers is one measure of its strength. In fact, the fire-eater (see page 7) was sunning himself after a swim when I passed by.

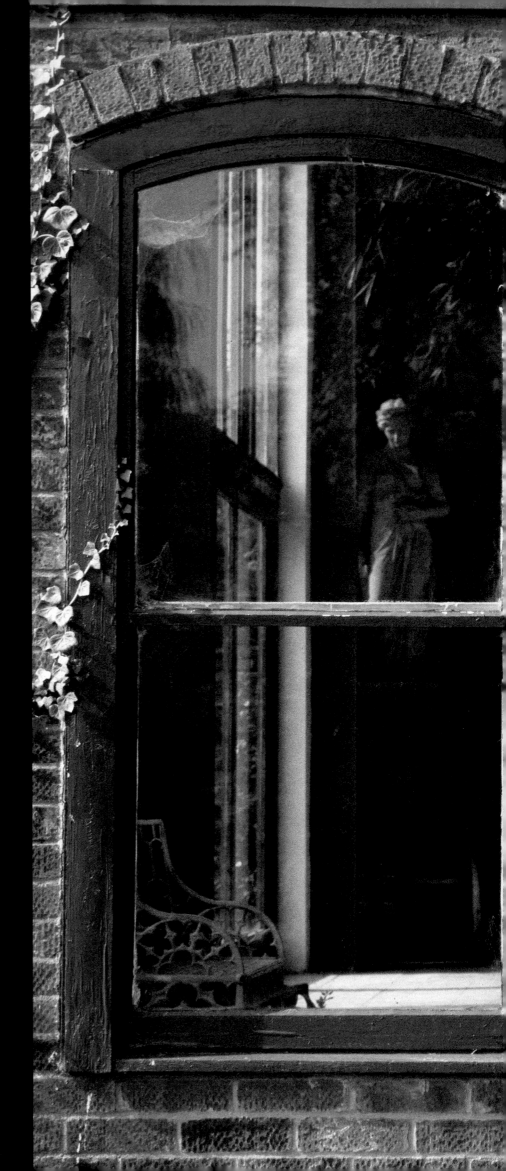

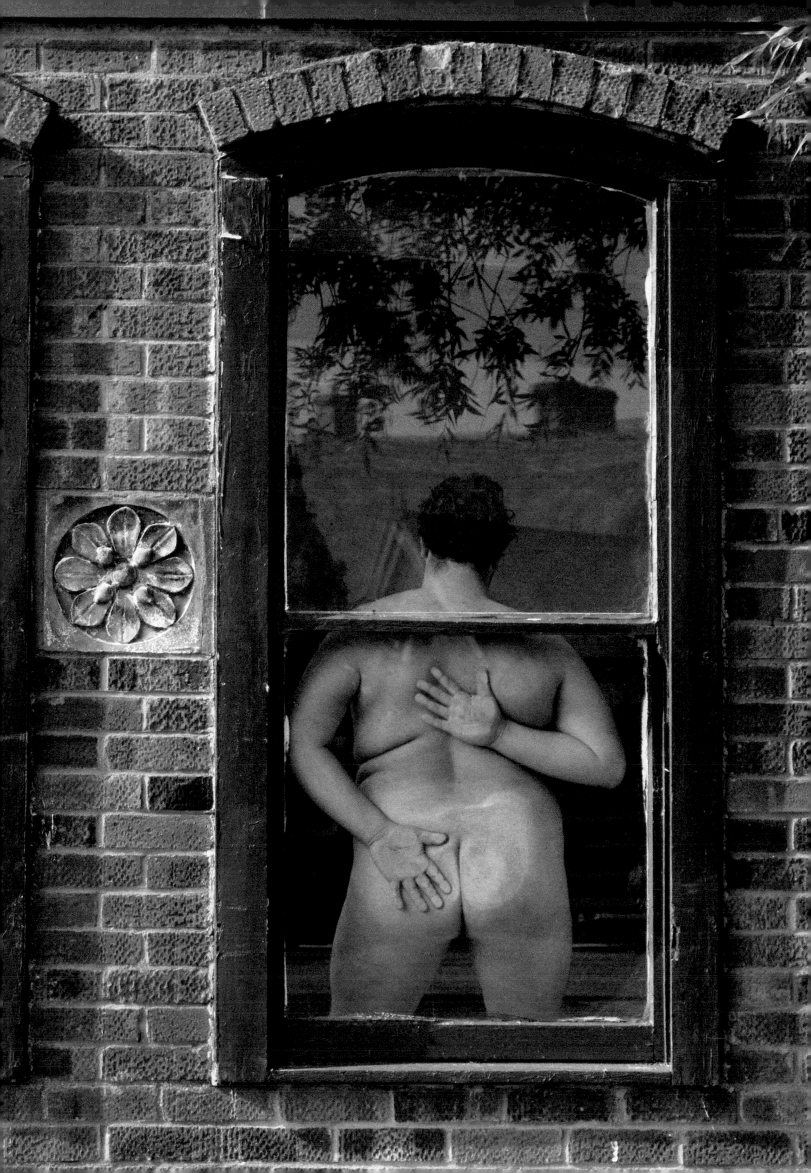

We have already seen that photographs take on different meanings in different societies. It is no less true that within a society the meaning of a picture derives in large part from its context. In a bureau, for example, a picture of the company president denotes authority above all else; autographed pictures in hotels and restaurants add to the prestige of the clientele; on calendars in bars and workplaces the female nude stimulates desire and envy, the photographer acting by proxy for the voyeur in the viewer.

Society's view of the photographic nude provides a potent example of how the same subject elicits an altered response when the social climate changes. Today, the early studies of the nude cause mild amusement when we consider the charges of indecency they attracted. By comparison with popular contemporary images, they seem powerless to cause offense. Current objections would center on the exploitation of the models as sexual objects. In this respect nothing has changed, for while there is now greater freedom to distribute candid images of nakedness, the predominant function of the nude or partly clothed body in photographs is to enhance advertisements.

CROW WOODS III
While the familiarity of the human form suggests that we should be able to take its appearance for granted, we experience a fresh sense of its scale in relation to its surroundings in a scene such as this. But even though the figure is small and inanimate, it captures the attention by the simple fact of its nudity, relegating the setting to a position of secondary importance. Even the figurative artist aims to not merely copy the natural world, but to add to it in a way that creates new perceptions. The differing characteristics of lenses make it possible for the photographer to alter the relationship between the components of his pictures to this end.

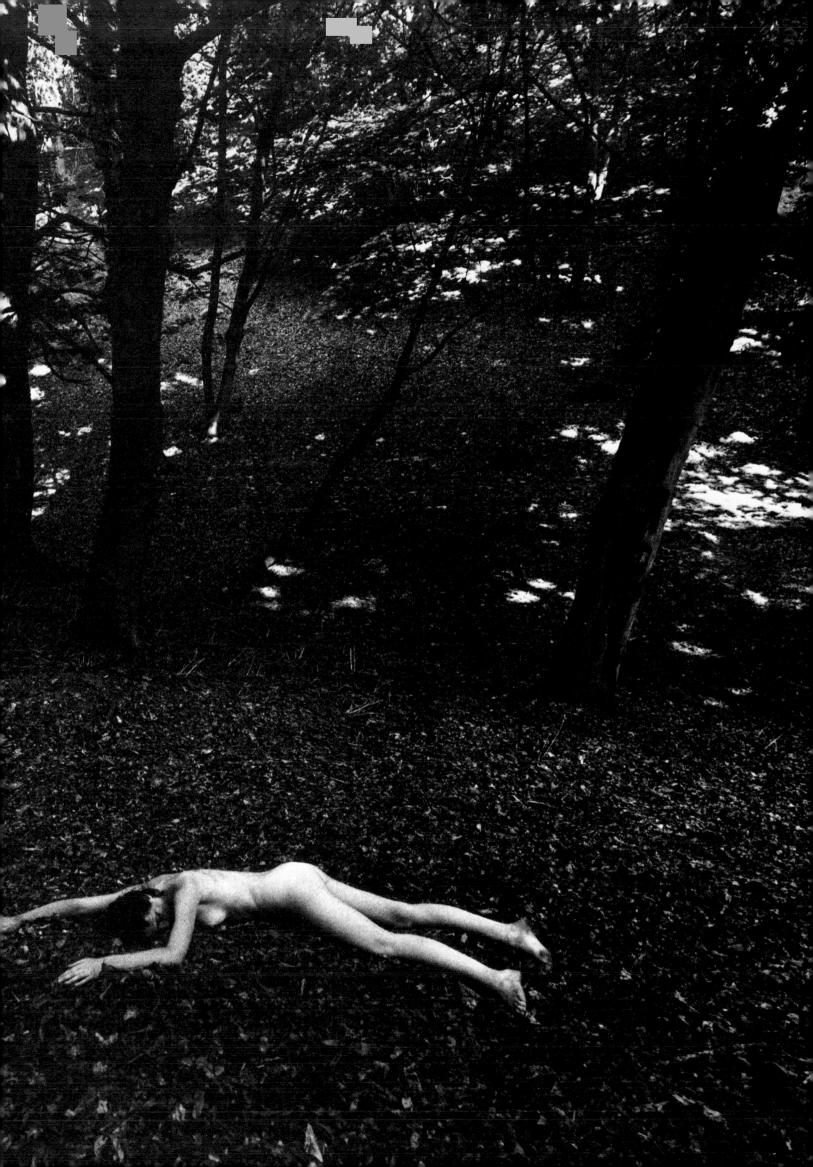

PATTERN

In the picture on the left, the long shadows of evening trace a bold pattern of leaves and branches on the model's soft skin. By partially concealing the form they force the eye to look more closely and appreciate its presence more fully.

TULA I

The picture on the right blends the romantic elements of a self-absorbed sadness and the soft, mellow light of the waning day to create a distant beauty that seems to emerge out of a dream.

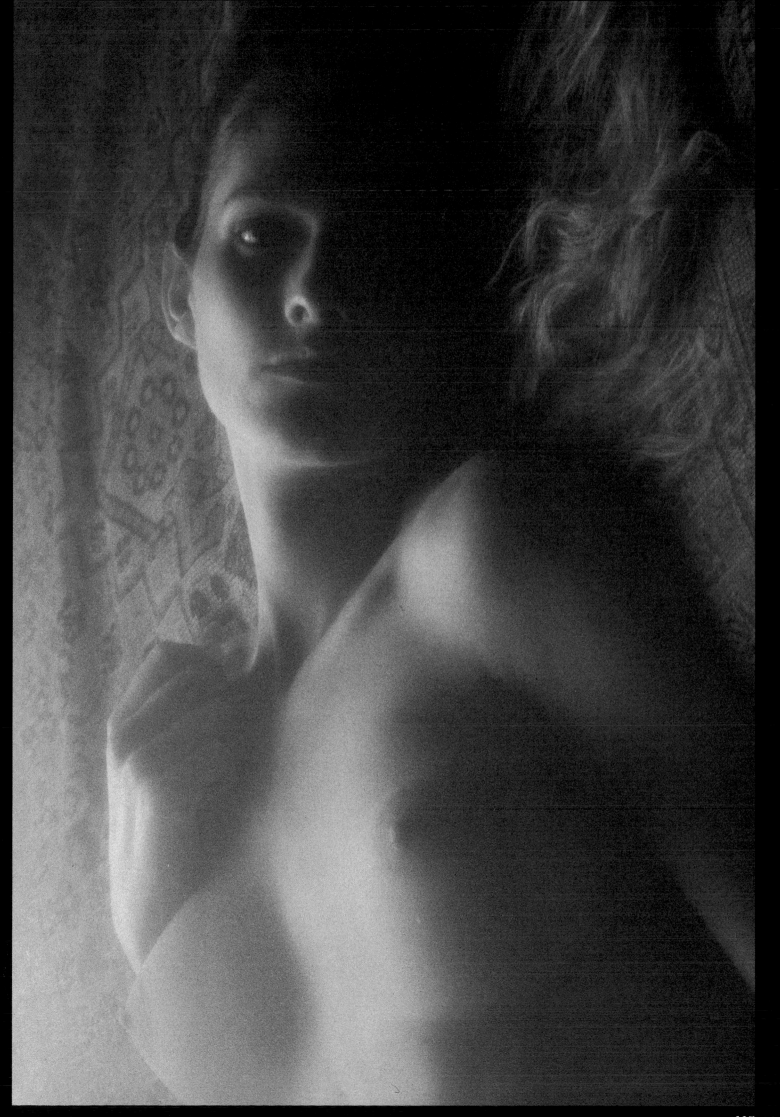

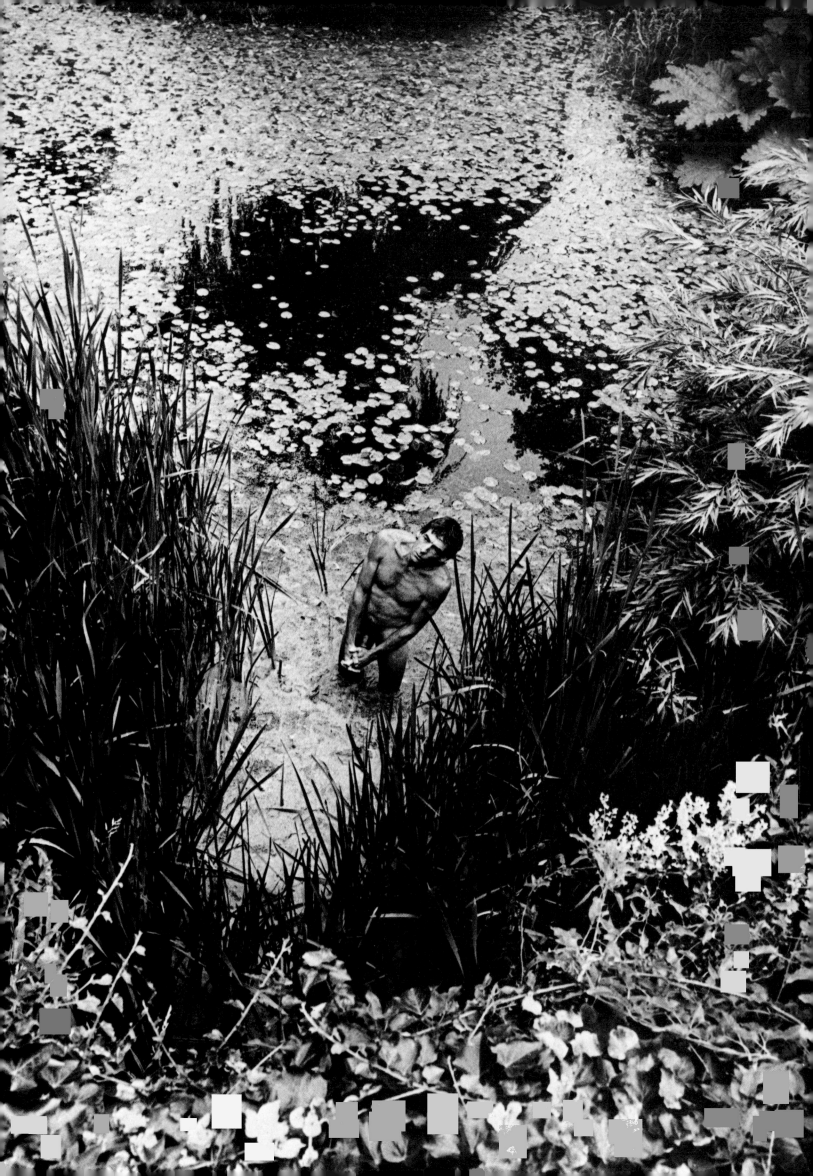

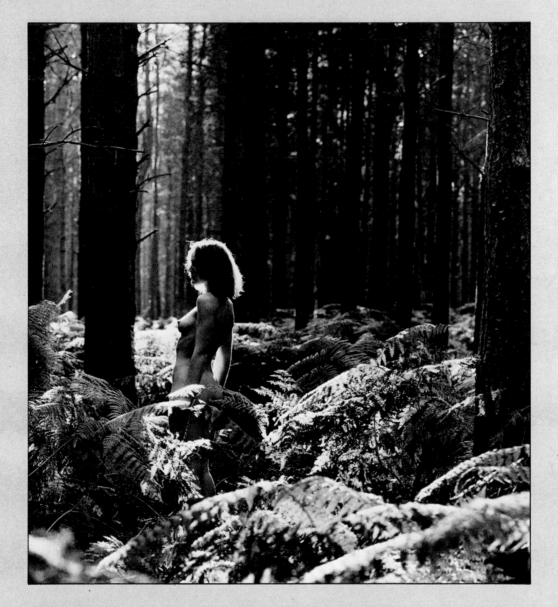

RICHARD, DUNMOW 1983
I used a high viewpoint for the picture on the left in order to make the abundant pattern of leaves dominate the image and so create an impression of human vulnerability in the face of the natural world. The slightly disorientating perspective suggests the way that primitive man, or modern man temporarily deprived of the identity afforded by his clothes, might experience the situation.

PATRICIA, THETFORD CHASE 1983
Haloed by the gentle light of an early evening sun, the model's hair in the picture above evokes the end of a summer day. The failing light softens the austerity of the trees, while a shallow focus lends a muted appearance to the foreground.

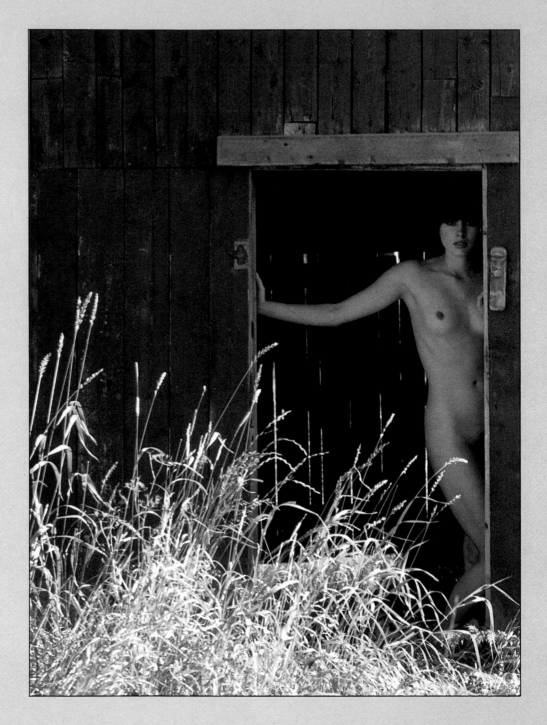

TRONDHEIM 1980 I
The straight lines of the manmade environment can be used to complement the contours of the human form. As in the picture above, there is normally a frame in the form of a door, window, or other element that will serve to define the scale of the figure. Here, the deep shadow of the barn's interior provides an effective contrasting background.

TRONDHEIM 1980 II
The naked woman happened across in a remote setting is more often the product of the male photographer's daydreams than of his experience. And yet, despite the translation of this fantasy into countless images, the juxtaposition retains the power to surprise. While much of the effect derives from the unexpectedness of pictures such as that on the right, the contrast between the tones and texture of the human body and the materials of the built environment is also of importance.

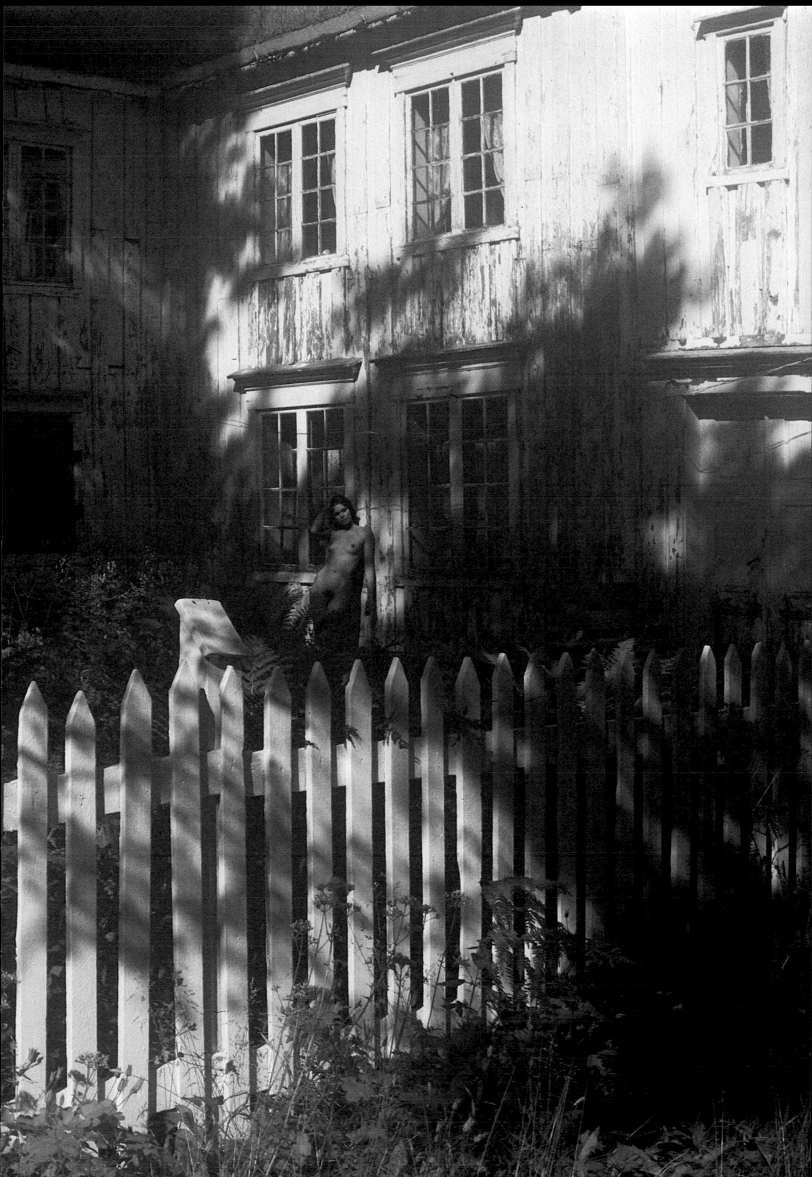

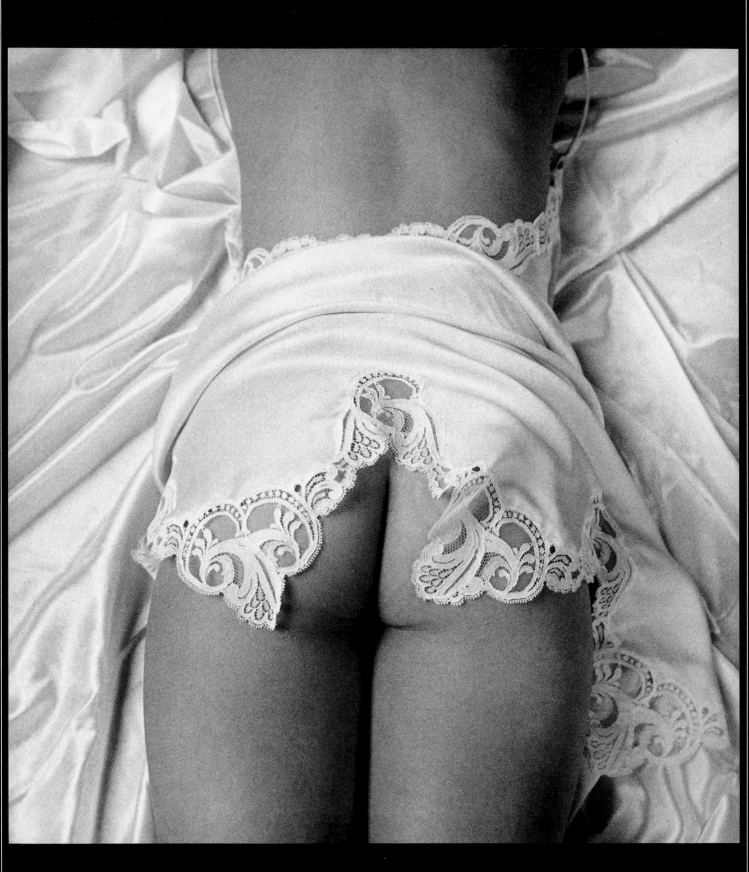

LACE, CASTLE HOWARD, YORKSHIRE *and* **CLAUDIA**
Lingerie appears widely in erotic imagery, defining the form when tight, teasing the imagination when loose. Just as stockings point up the texture and tone of the revealed portion of the thigh, so the lingerie in these pictures emphasizes the appealing naturalness of the areas it frames. Yet the images

differ sharply. The picture above is overtly provocative in its casual anonymity. By contrast, the inclusion of the face and the gently posed hand in the other allows us to glimpse the personality of a beautiful young woman who both offers a mild challenge and seeks approval of her body.

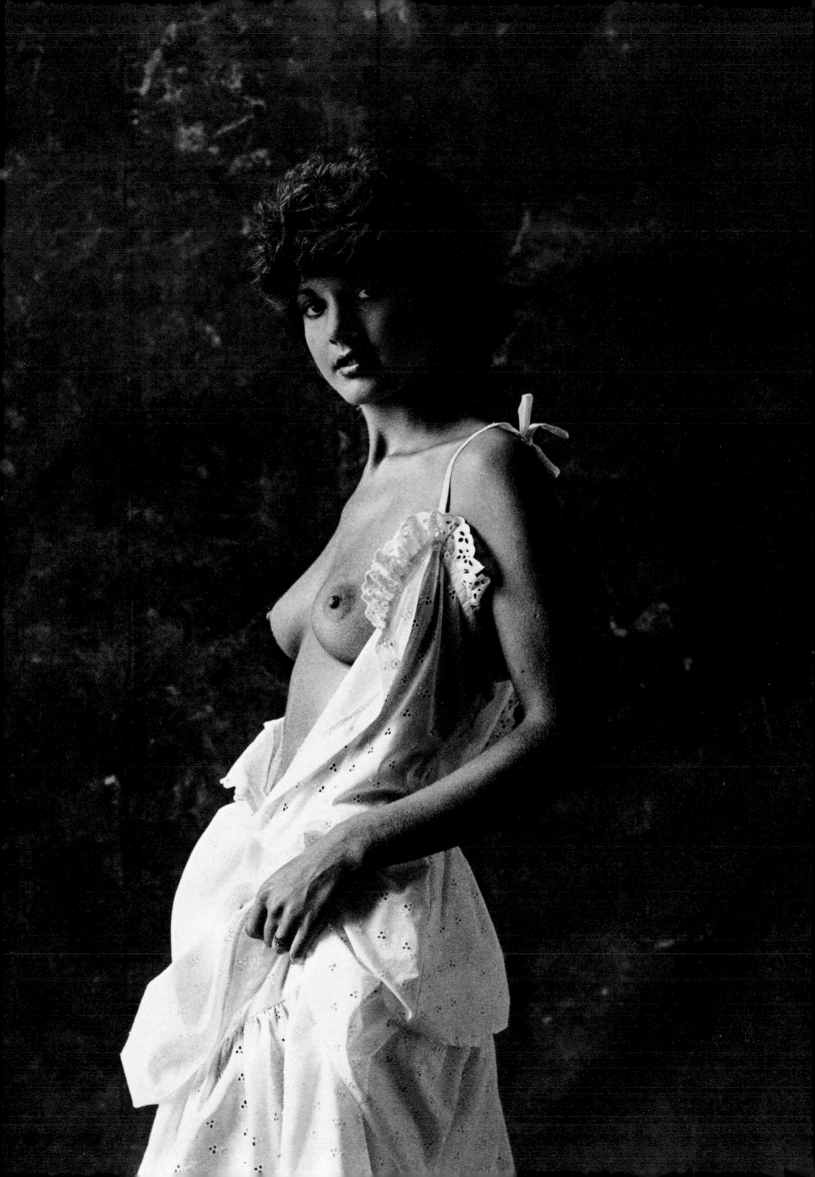

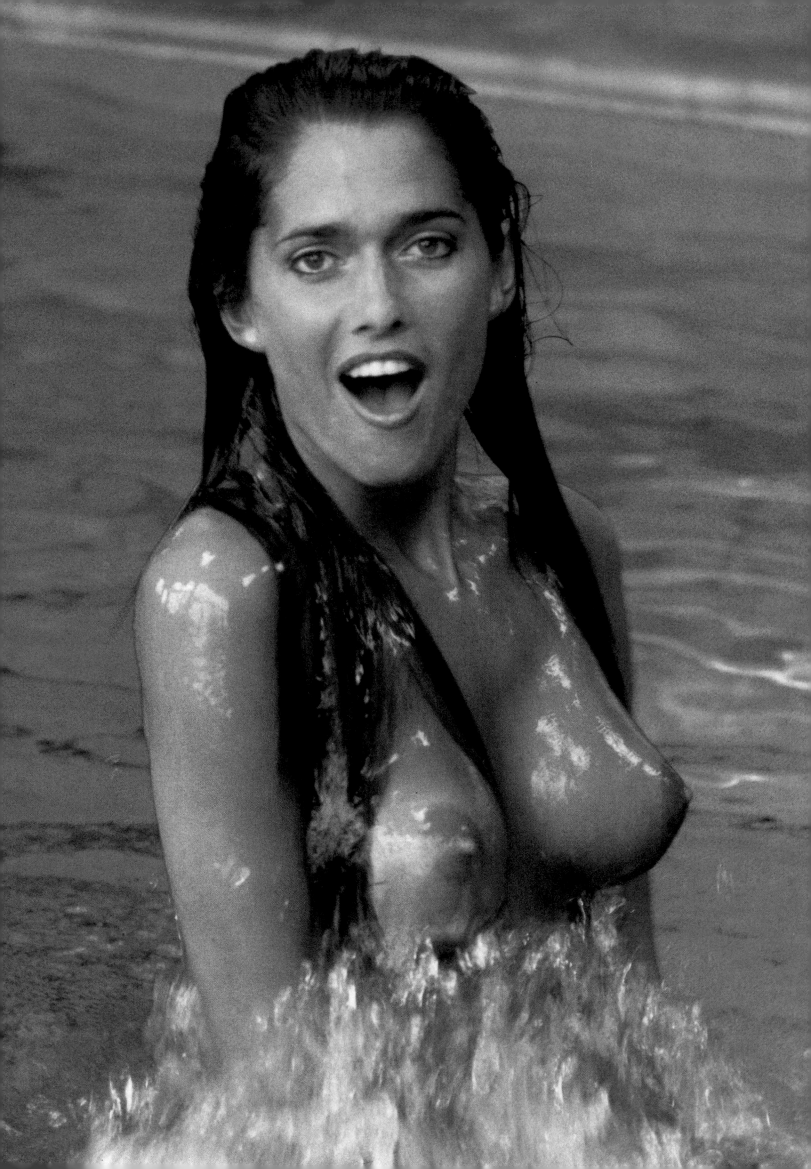

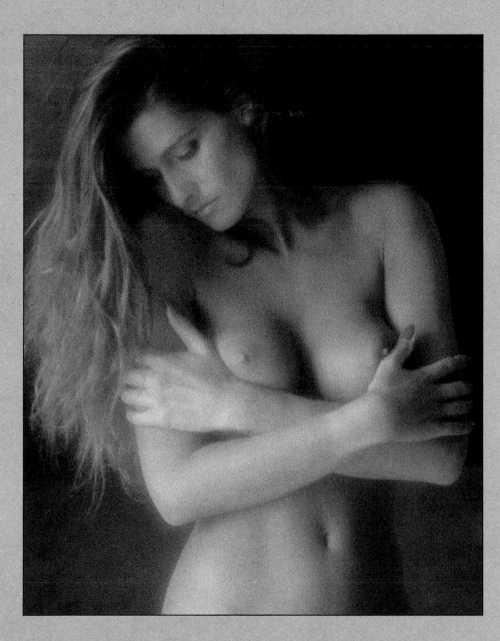

TULA II *and* **III**
These two shots illustrate how different two studies of the same model can be. A flurry of water provides an ideal means of conveying exhilaration, while water's effect on tanned skin is flattering and on hair sensuous. These factors combine with the erotic power of the form seen through wet clothing in the "wet-look" approach to glamor photography, one of the most widespread types of commercial image. The studio picture relies on a restrained but no less sensual pose, and on soft daylight reflected from pine-clad walls, to create a tender vision far removed from the mood of the bathing shot. So different are the images that two personalities seem to be portrayed.

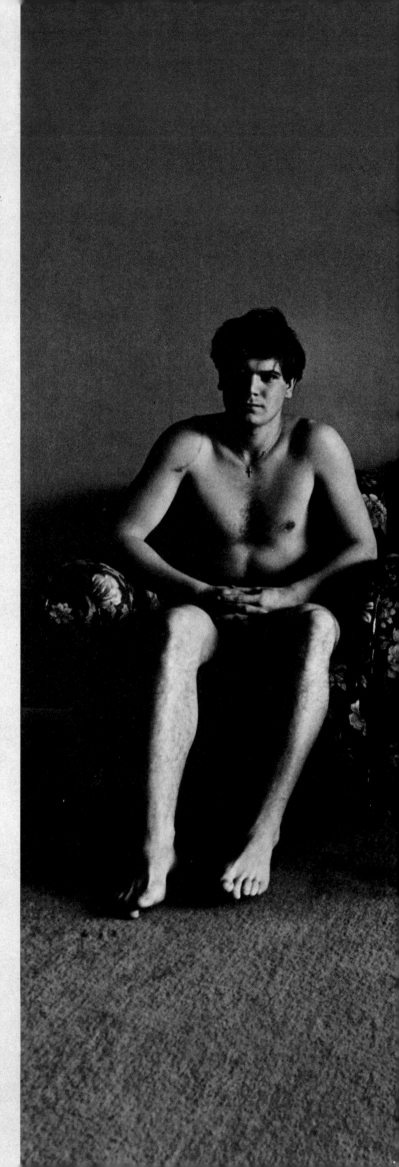

SEX AS COMMODITY

Images of glamorous women abound in publications that make no secret of their aim to titillate a predominantly male readership, but they represent a fraction of the number of such pictures used for the purpose of selling. In the early 1970s John Berger observed in his book *Ways of Seeing* that "publicity increasingly uses sexuality to sell any product or service. But this sexuality is never free in itself; it is a symbol for something presumed to be larger than it: the good life in which you can buy whatever you want. To be able to buy is the same thing as being sexually desirable."

While it is difficult in our times to shock with nudity,and while the misrepresentation of women inherent in "glamor" images is under ever greater attack, the female form continues nevertheless to lend spurious appeal to many of the products of mass consumption.

BROTHER AND SISTER 1984
Most of us have some curiosity about the lives of strangers. Here, however, the modesty of the young couple indicates a reluctance to furnish much information about themselves for the camera. They seem able to deflect attention from their nakedness itself.

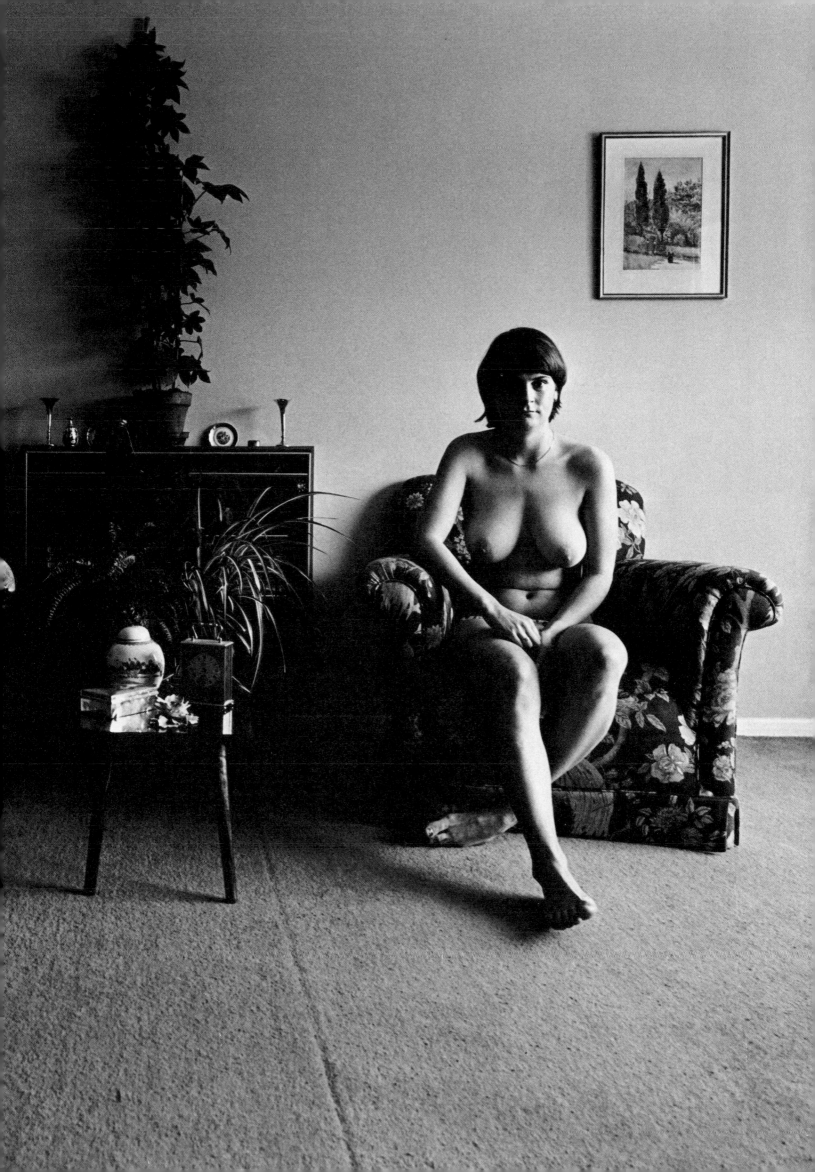

'Wish you were here'
love
Miriam

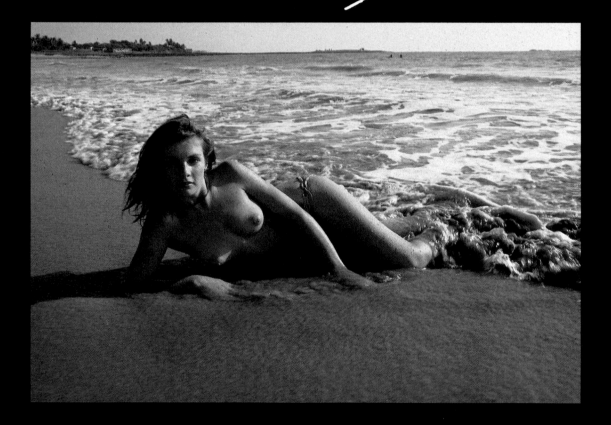

How I saw myself on a calendar
Karen

THE BED (*overleaf*)
A pause between shots often provides an unexpected picture. As the model rested from her pose, she revealed in a moment of playful exuberance a perfect image of her clean, flowing outline and beautiful skin.

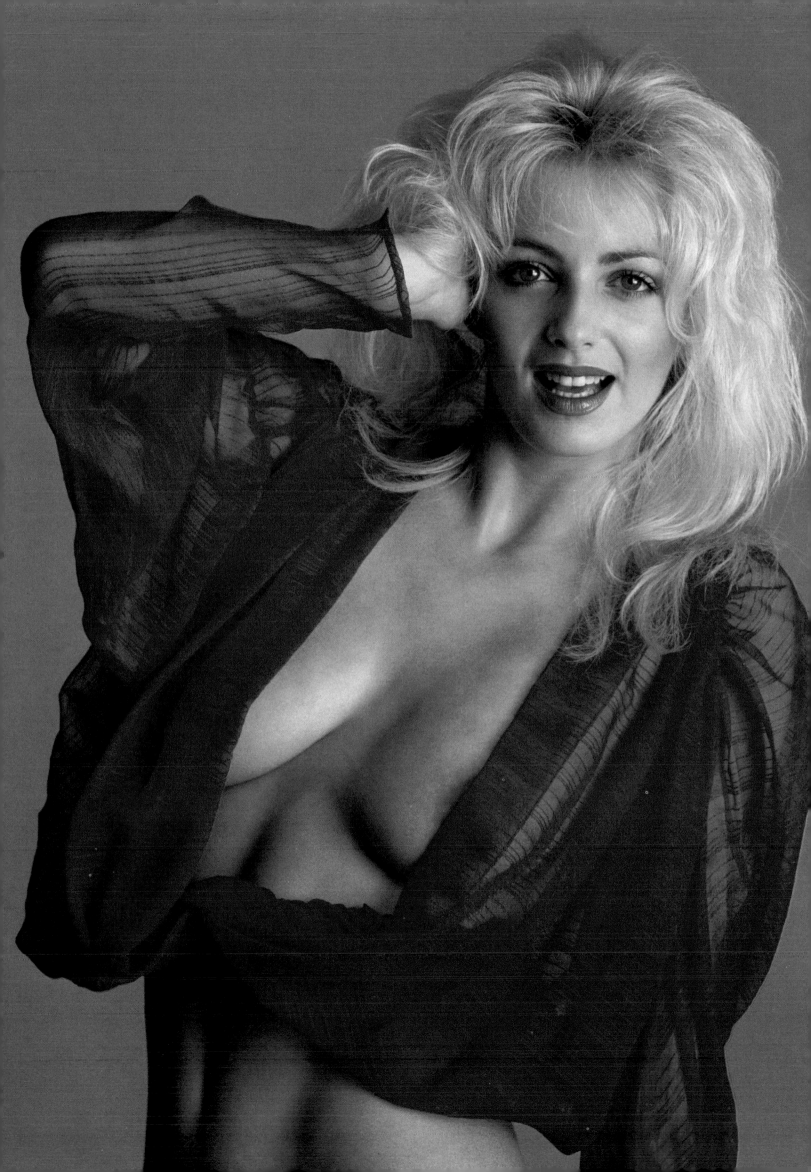

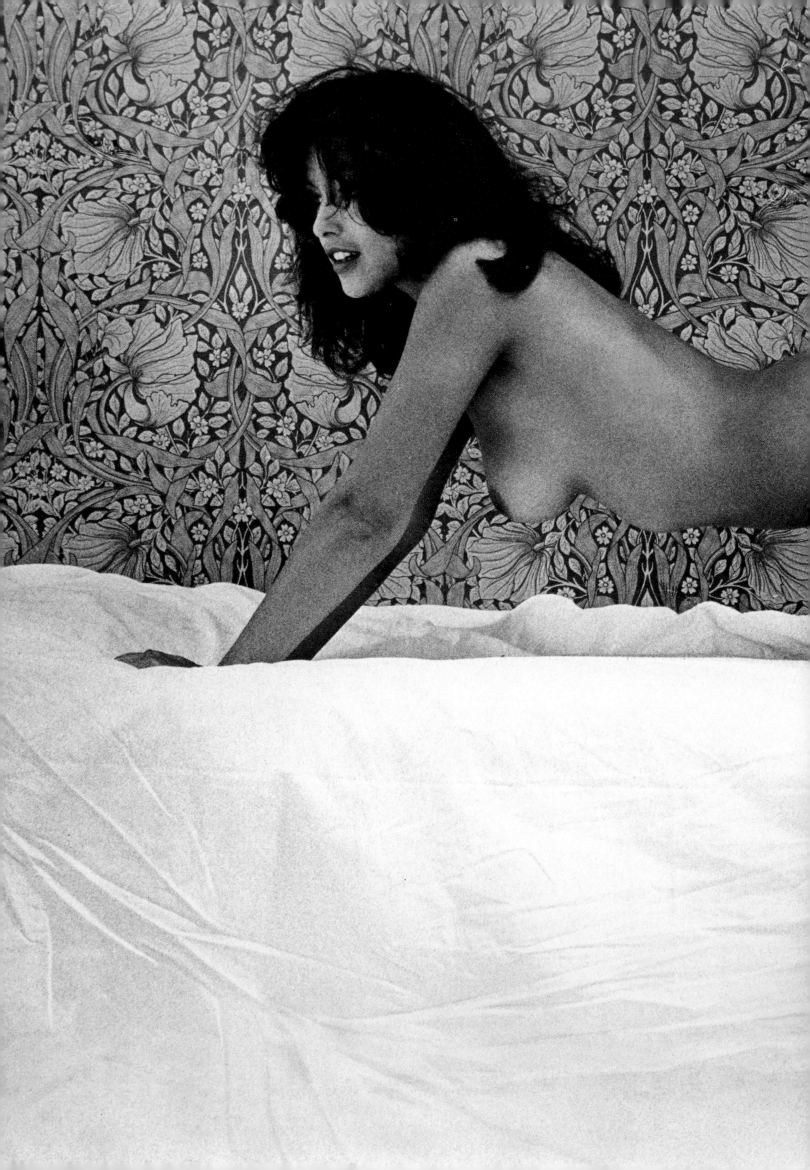

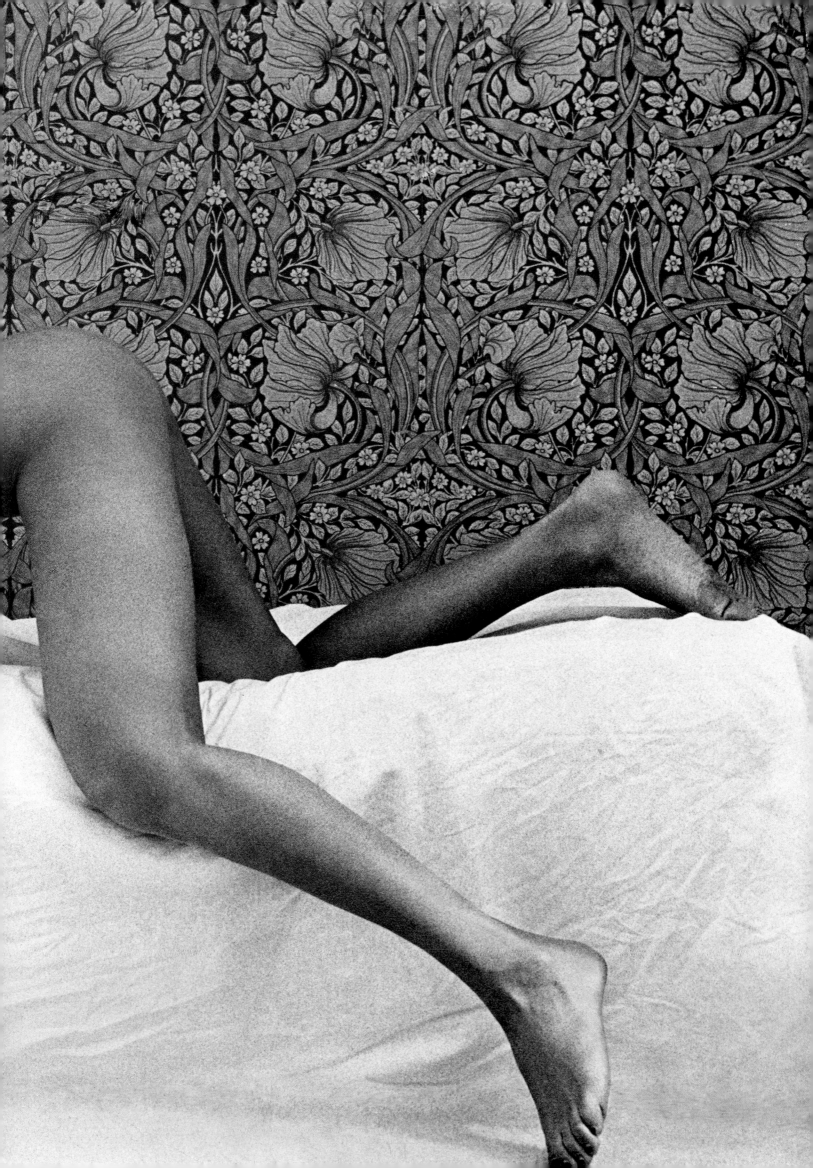

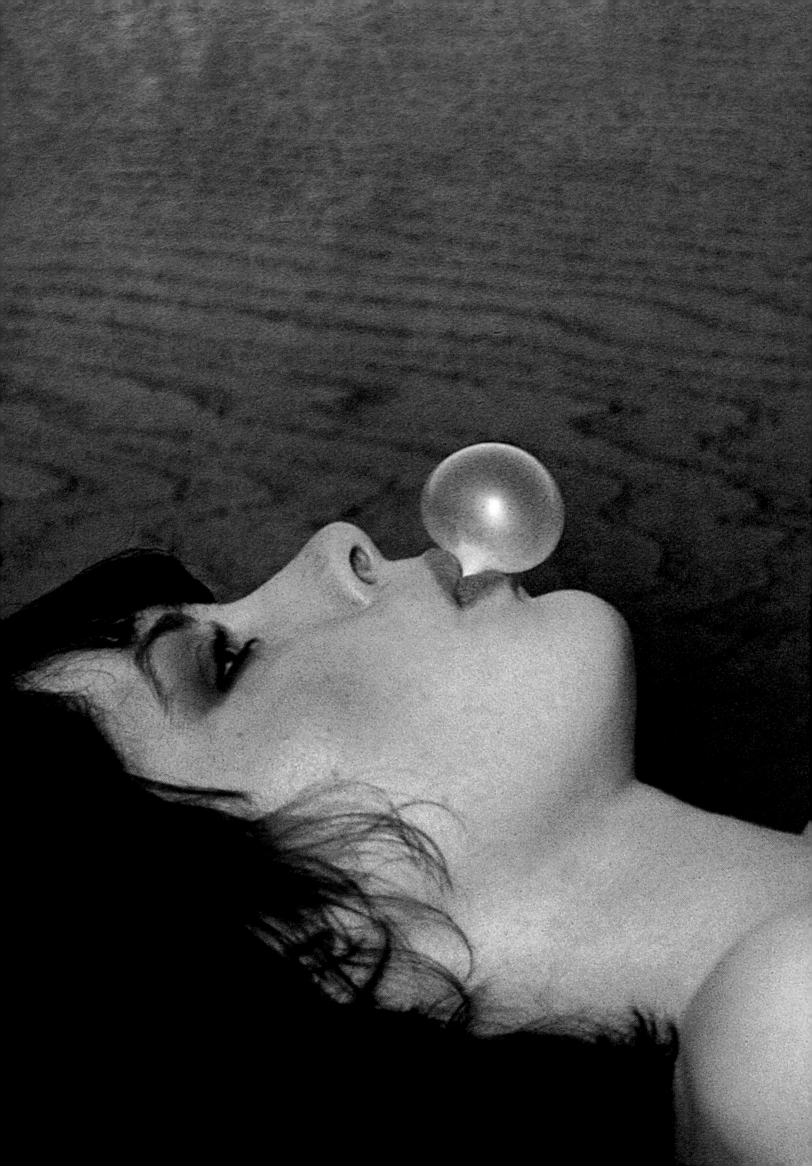

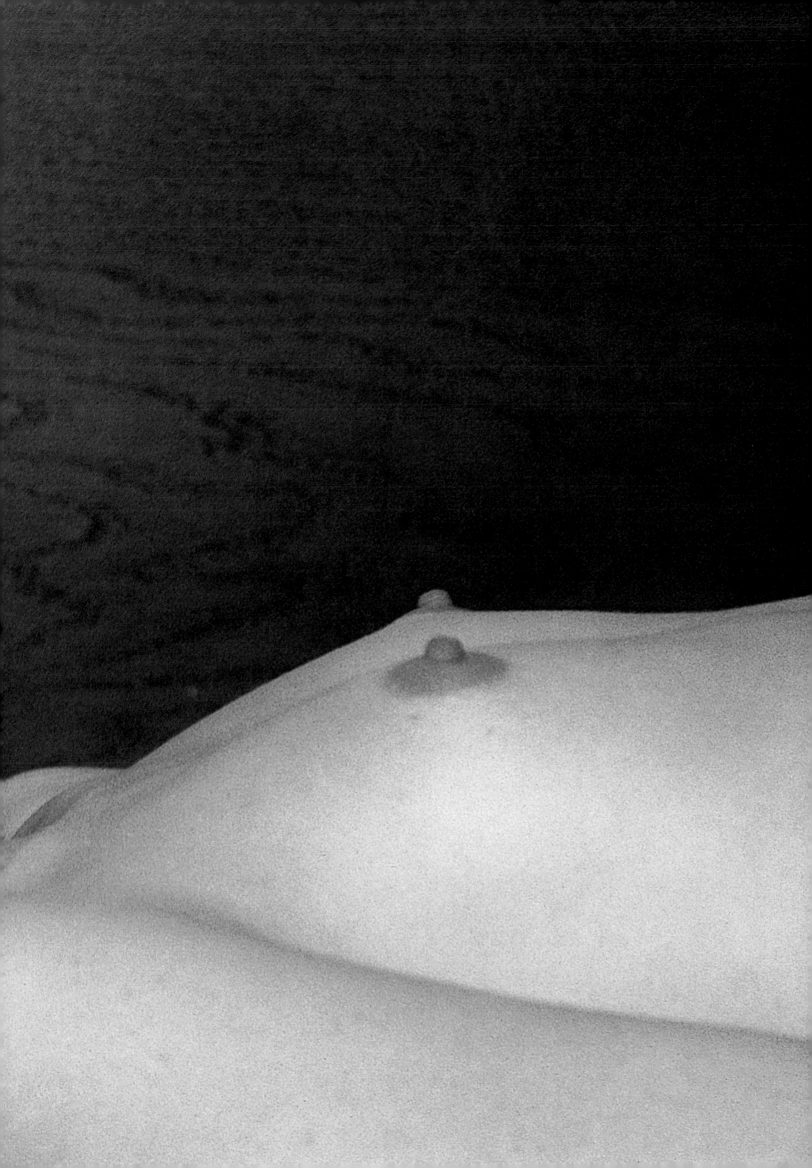

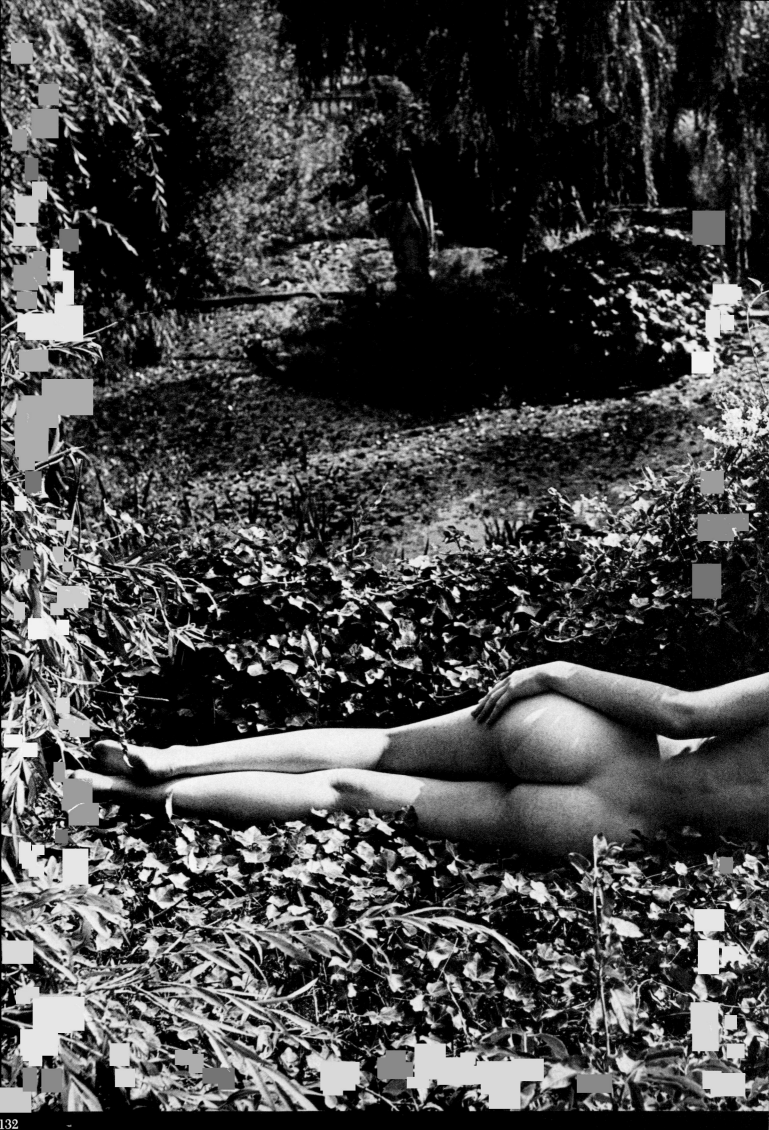

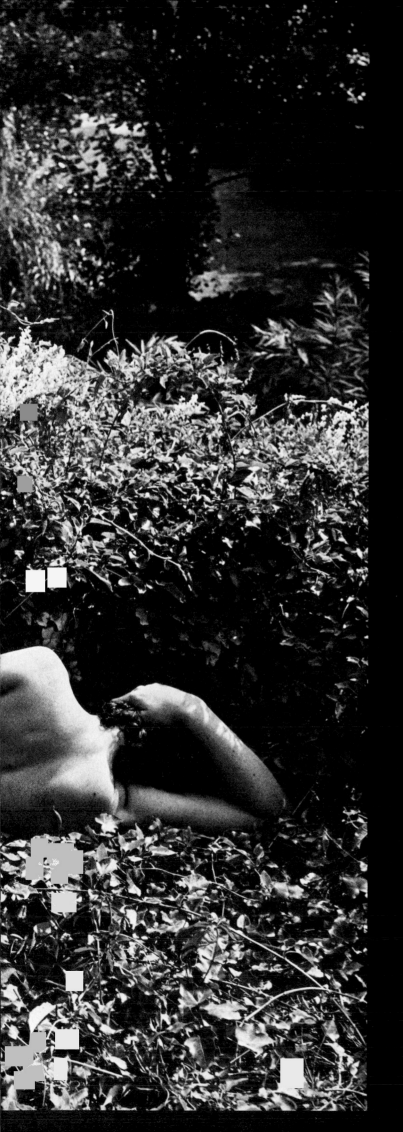

NORWAY 1978 *(preceding page)*
A photograph can contain an element of simple
fun that is also full of erotic suggestion.

DREAMING
In the picture on the left, the model's complete
unawareness of being photographed enhanced
the tranquil atmosphere. As often happens
around the middle of a hot, peaceful day, time
seemed to stand still in response to the
immobility of the setting.

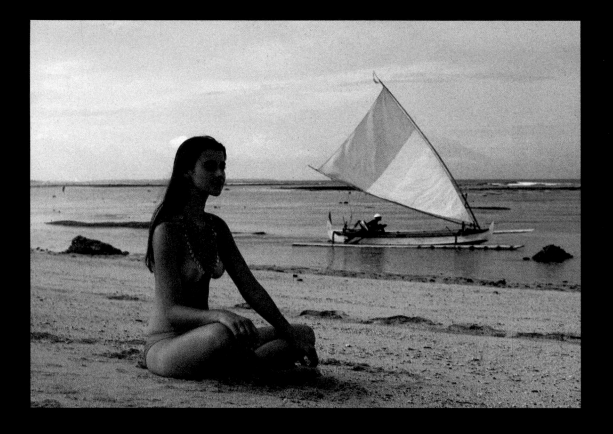

EMMA, BALI 1977 *and* **LINDY, ST TROPEZ 1975**
The art critic John Berger has characterized the glamorous world fabricated by advertising as aimed at exciting envy. Glamor photographs evoke that very response in many women. Just as sophisticated products promise to transform the buyer into the envied rather than the envious, so do images such as these challenge the female viewer to believe that she too can become the envied focus of attention rather than, by implication, the unglamorous outsider.

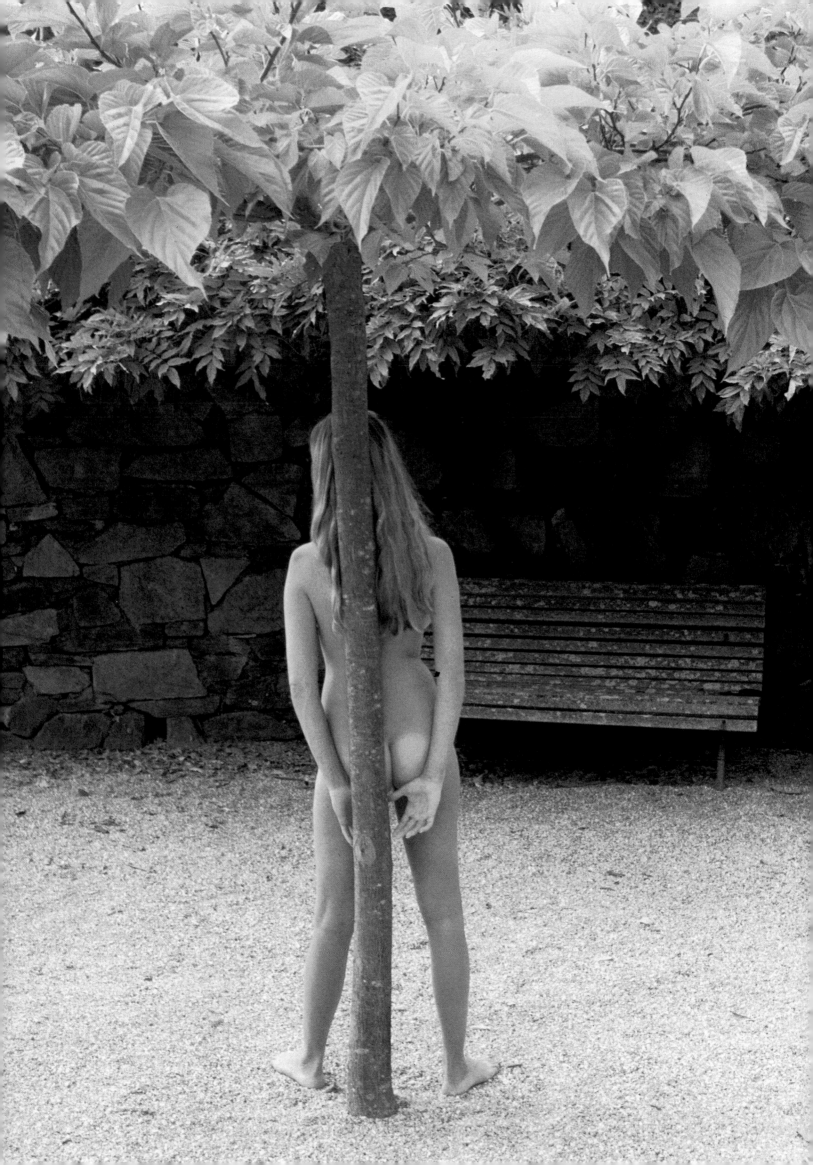

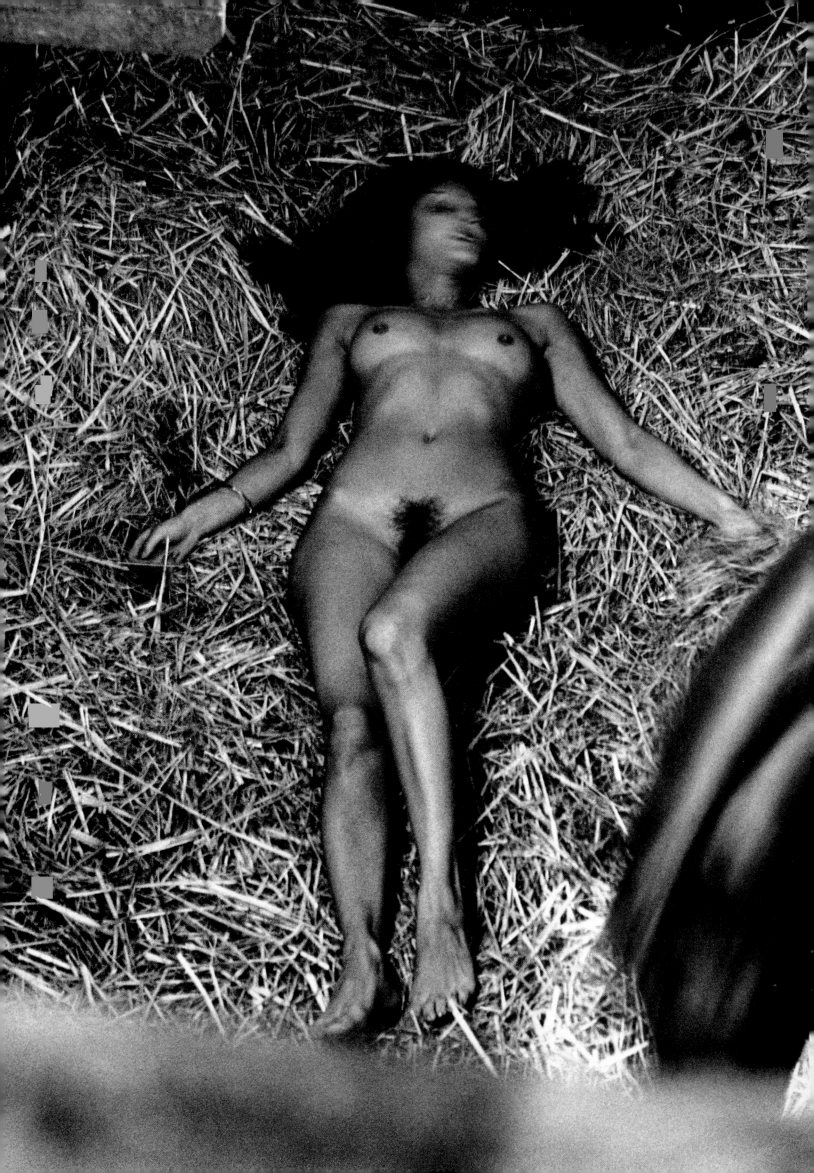

JUDY
The appeal of erotic photographs is subjective,
relying on suggestion to stimulate in the viewer a
wealth of associations. The elaboration of the
scene portrayed here represents a challenge to
the powers of the imagination.

TRACY (overleaf)
A truly erotic photograph is an inexhaustible
inducement to fantasy and speculation. Where a
mood, rather than a cold statement of sexuality
dominates, the power of suggestion is strong.

137

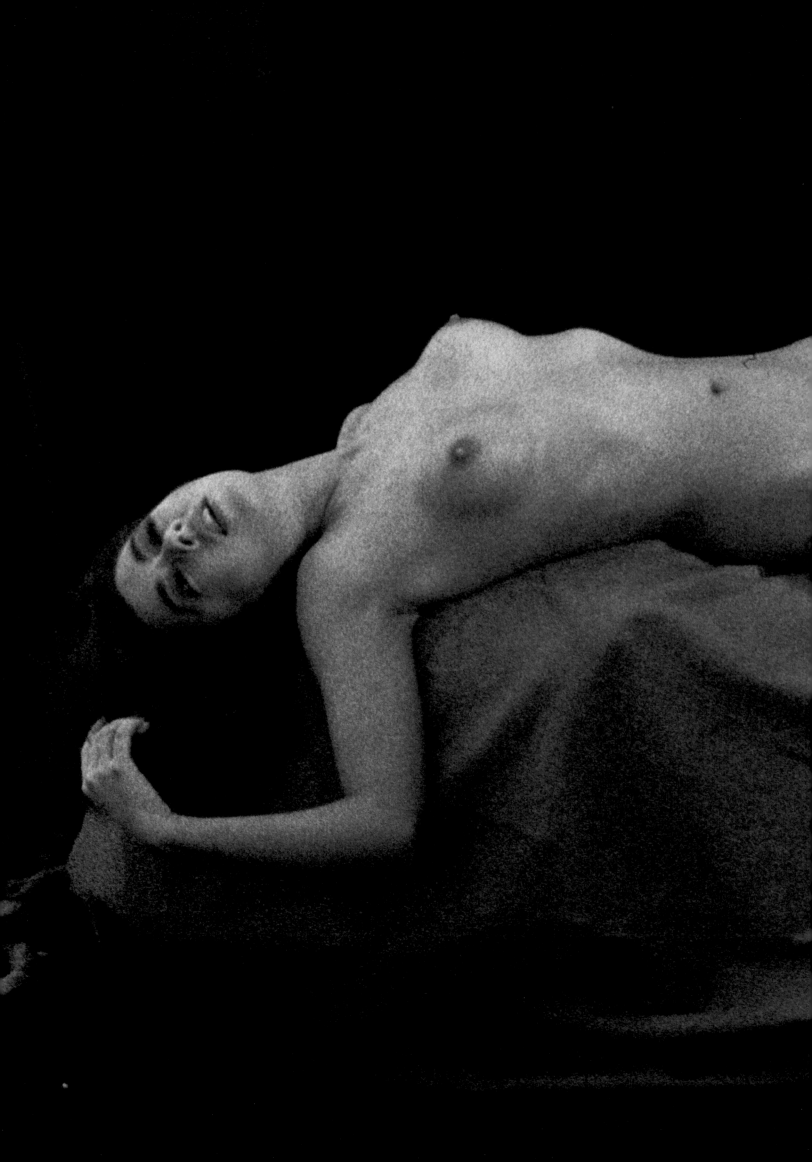

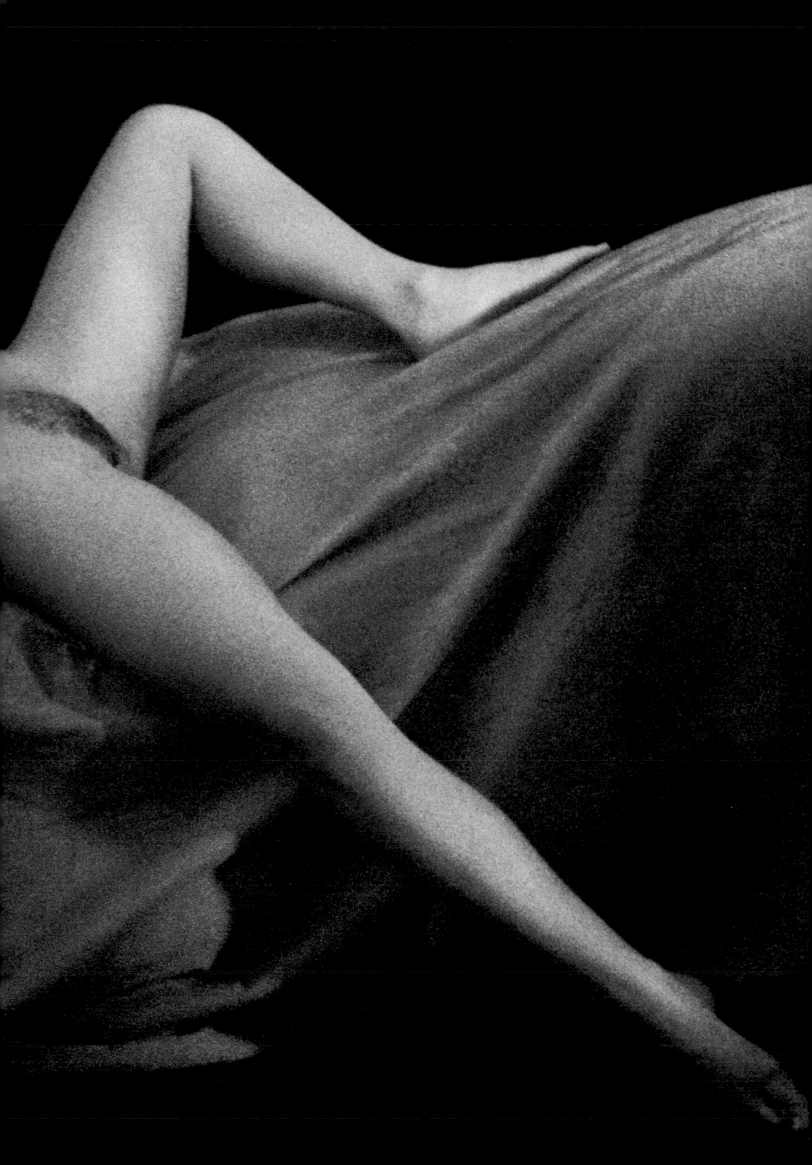

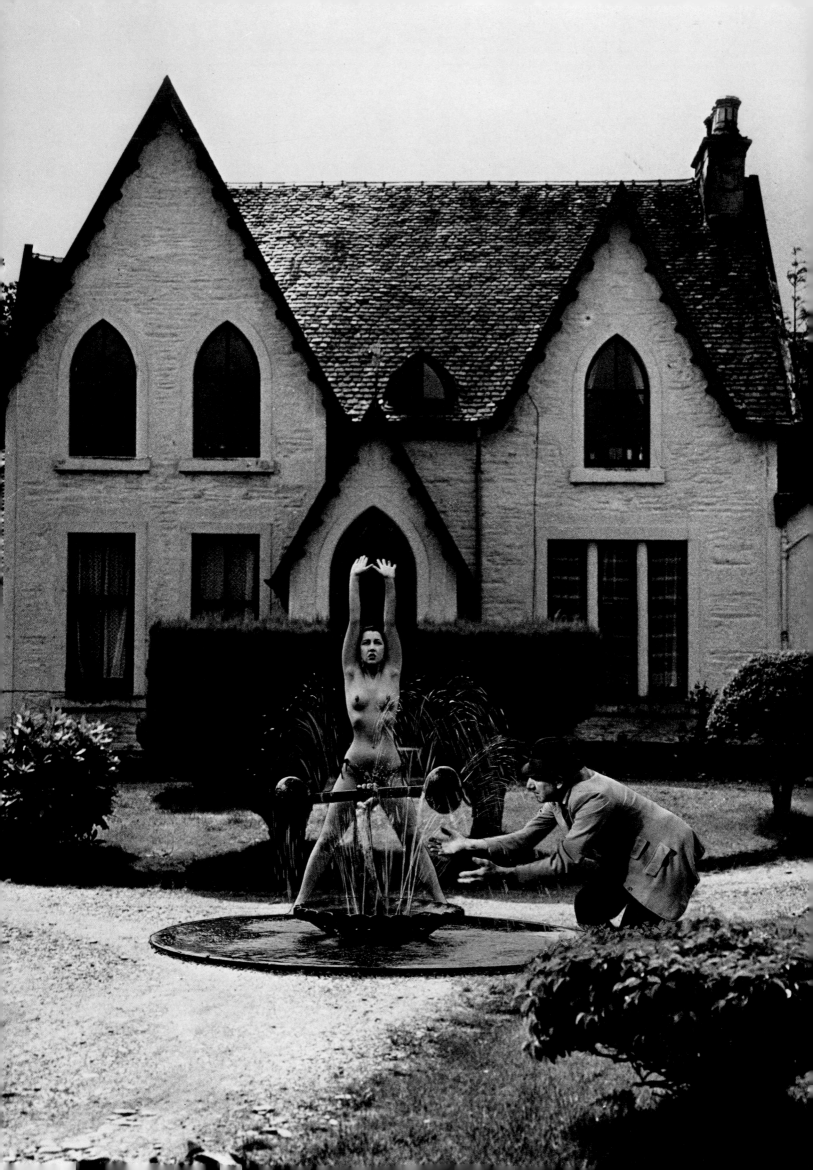

FANTASY AND ILLUSION

The fantastic, the bizarre, and the illusory have long been a source of fascination for the artist. In this century, the Dadaists were the first to possess a strong interest in these areas. Dada began, quite abruptly, in Zurich in 1916 and petered out in the early 1920s in Paris. It was a revolt by artists against the traditional values and current forms of art, and was vociferous and highly imaginative in its emphasis on the importance of chance, the absurd, and the illogical.

The greatest legacy of Dada to photography is the photomontage. Victorian photographers, notably Henry Peach Robinson, had used composite images, but the Dadaists John Heartfield and Raoul Haussmann were the first to practice the modern technique. Max Ernst gave considerable authority to the form, juxtaposing incongruous images with apparent irrationality to create unexpected meanings.

Since the 1930s a number of photographers, of whom Angus McBean is a prime example, have been inspired by photomontage to introduce disparate elements into their pictures. The visual disjuncture brought about in this way leads the viewer to reassess a picture, and in doing so to find new and unexpected meanings. In manipulating images to create a highly subjective vision, and in exploring the unconscious, dreams and nightmares, and the absurd and implausible, many modern photographers are following the path of the Surrealists, whose principal aim was to escape the straitjacket of reason and preconception and to draw instead on the unconscious mind for their images. *(cont.)*

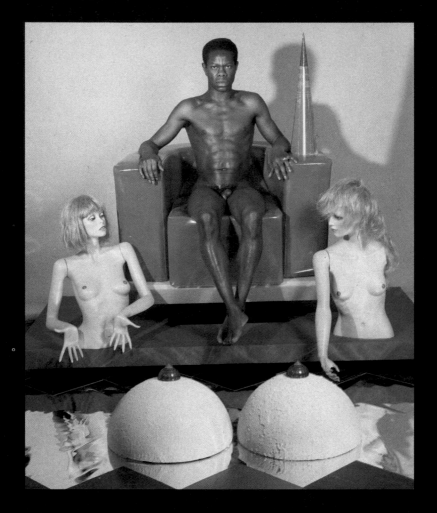

MORNING EXERCISE *(facing preceding page)*
When the girl in this picture exercises each morning, even the gables of her house seem to thrust upward in imitation of her efforts. But age seems to debar the gardener, who tries in vain to catch a few drops from the Fountain of Youth.

DILLY'S DREAM
The picture above recreates the bizarre images and conflicting emotions of a dream. The man's new-found ascendancy appears uncomfortable, perhaps because it entails the subjugation of a truncated, doll-like womankind.

SHROUD
The combination of concealment and revelation plays an important role in erotic imagery. Often, the creation of a mystery, with its inevitable appeal to the imagination, supplements a straightforward visual stimulus, as in the picture on the right. The simple device of the shroud makes an enigma of the face while intensifying the nakedness of the breasts.

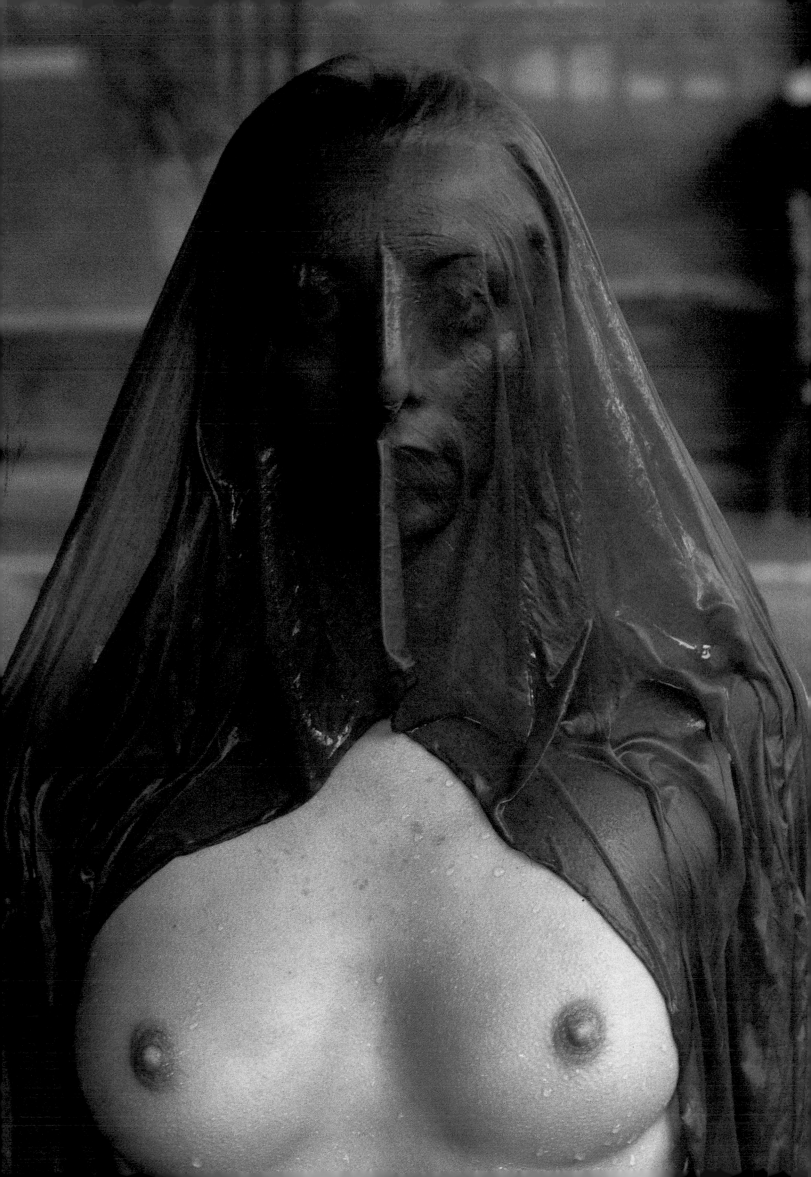

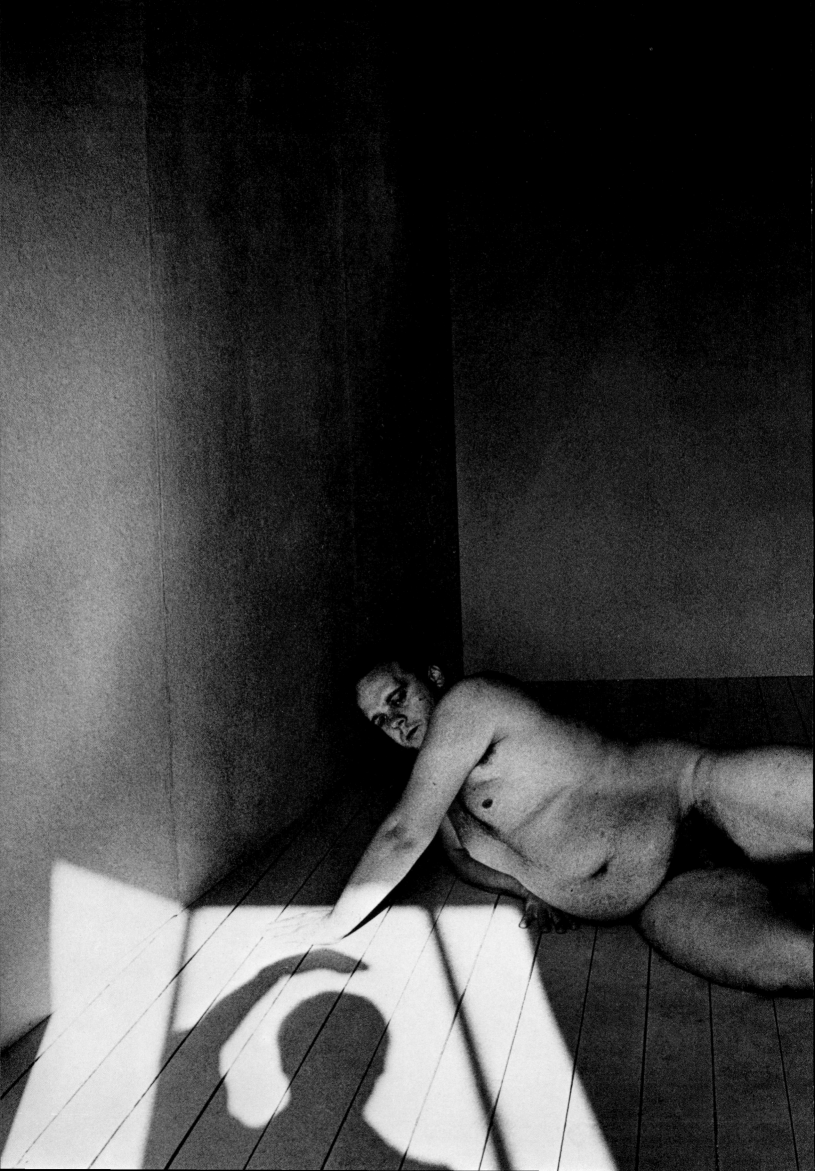

The techniques of stressing the psychological impulses behind an image and of using familiar symbols but changing their meaning by the manner of their presentation are intended to make what the viewer sees of less importance than what he experiences. Where realistic depiction and fantasy merge there is always an illusory quality that prompts the viewer to speculate but which always leaves him longing for more associations. The artist is well aware of the process he sets in train in this way and an answer to the criticism of this style in photography—that it is incomprehensible, crazy, absurd, or simply garbage—was provided by the foremost Surrealist painter of modern times, Salvador Dali: "The only difference between me and a madman is that I am not mad."

The camera may be regarded as an eavesdropping, even voyeuristic, tool. However freely given the image, it has in a sense been stolen from the past, to become a piece of evidence. But it is nevertheless evidence that is by nature subjective for, despite the apparent objectivity of a photograph reactions to it differ.

There are few responses more complex than that to the naked body, and where our reaction is further complicated by the often contradictory interpretations of the artist, the nude takes on several meanings at once. But if a picture ultimately stirs the viewer into using his own sensibilities to apprehend these meanings, he then enters into a partnership with it and its creator, and the image can be considered a success.

PHILIP
In the picture on the left, a sudden burst of sunlight threatens to dissolve away like a mirage the model, the room, and my insubstantial presence. But its glare has nevertheless provided the means of preserving a haunting after-image of the scene.

KAREN 1983 IV *(overleaf)*
A tranquil world of feeling is conjured up by the model's serene state of suspension. Floating in an indeterminate depth of water, amid shadows, reflections, and distortions, she evokes the sensations of dreaming.

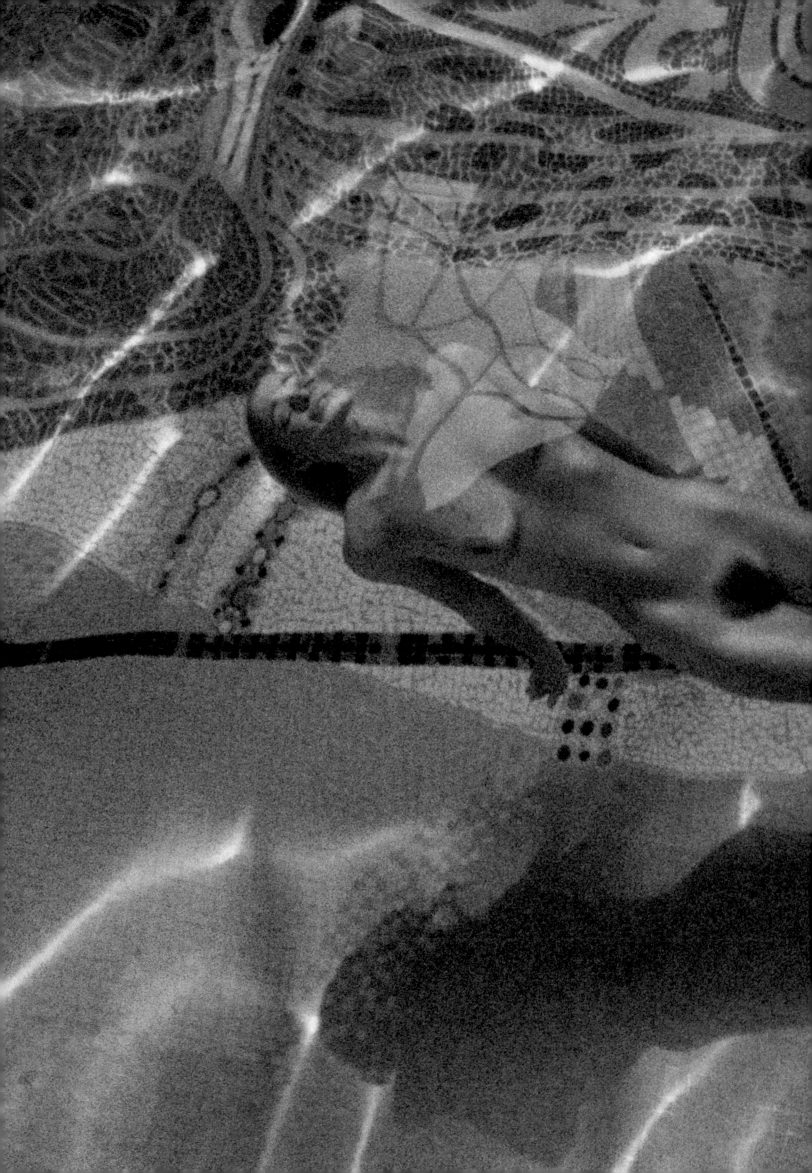

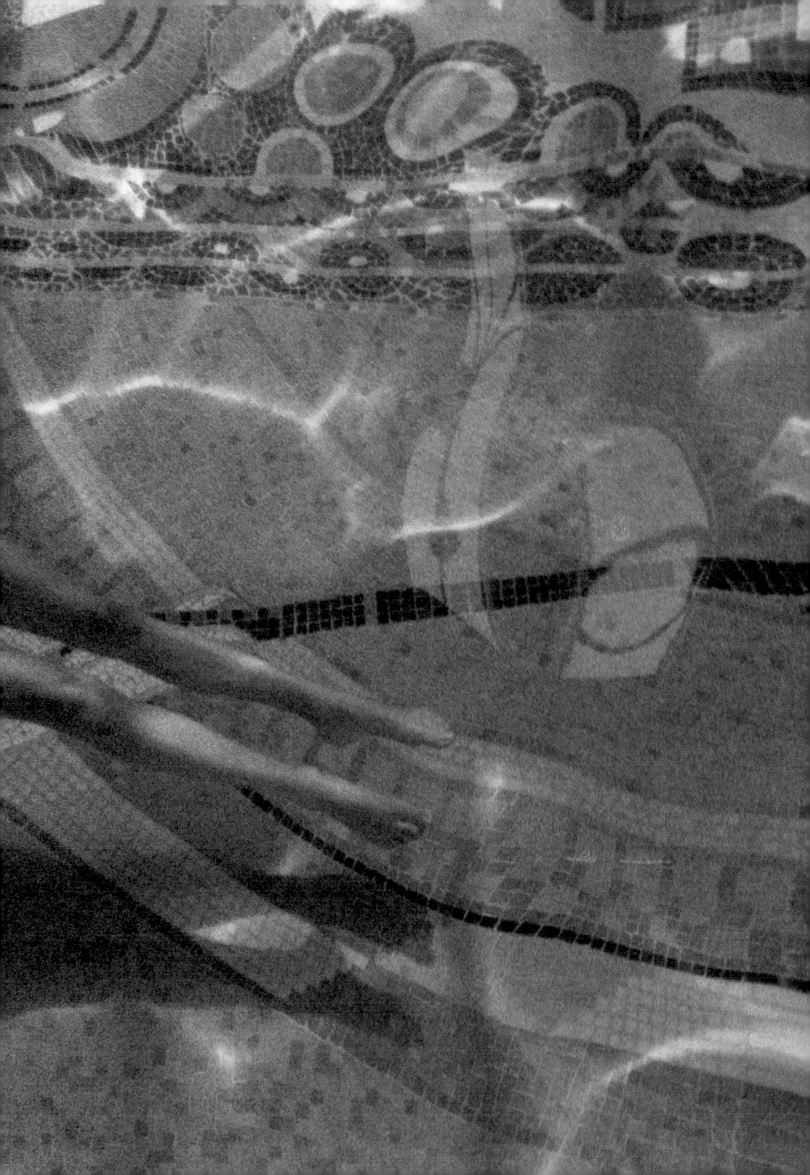

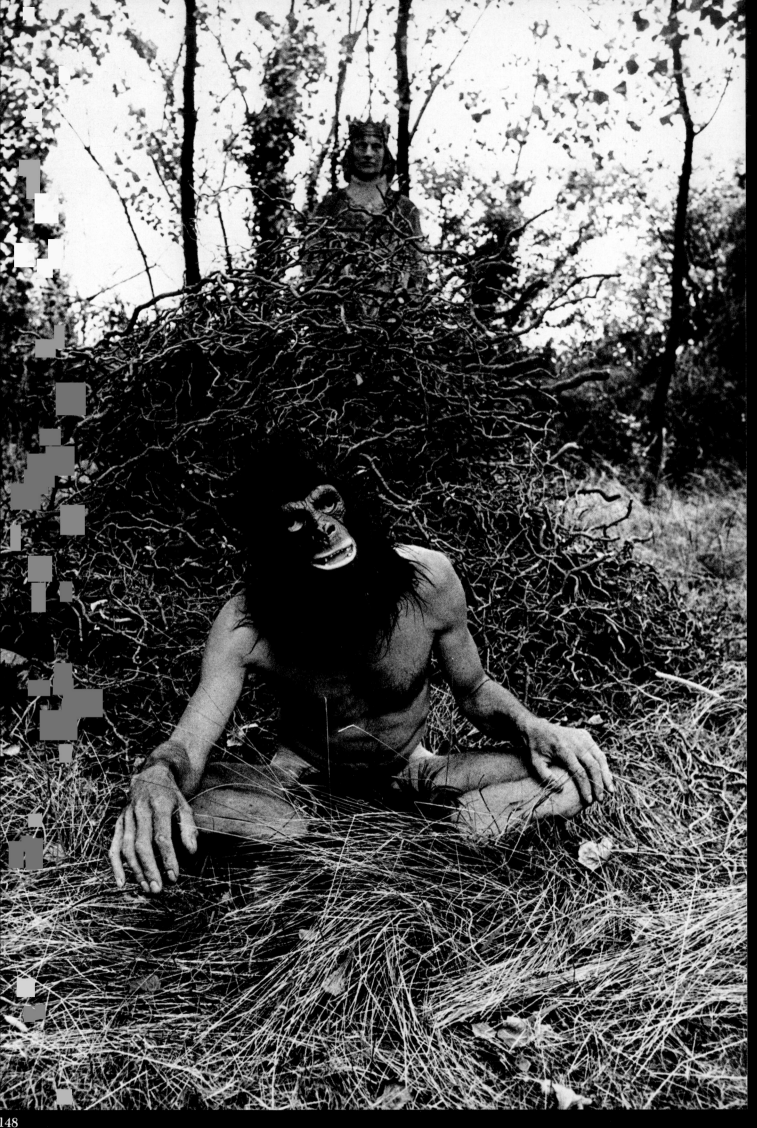

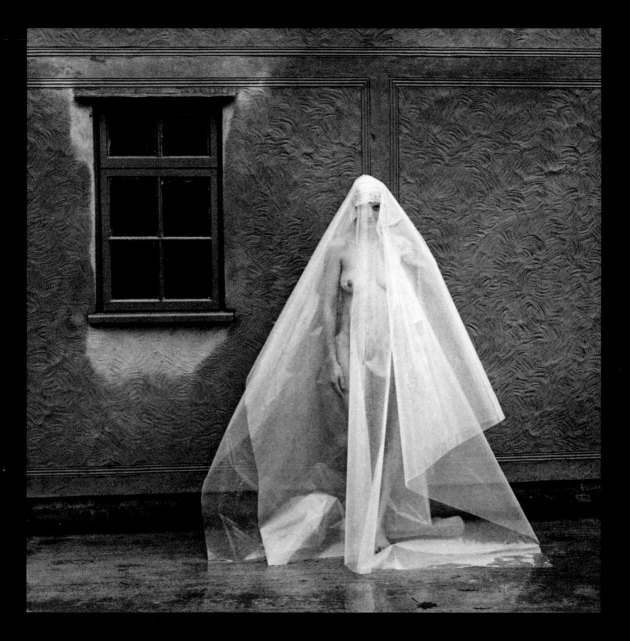

MASKED IDENTITY
*While relaxing between photographs, the model
came across an ape mask in the props room. Simply
putting it on gave him the self-assured anonymity
that makes role-playing easy and spontaneous. I
emphasized the hybrid character of the mythical
apeman by using a wide-angle lens to magnify the
nearer hand to non-human proportions.*

THE BRIDE
*Concealment of the female face is a long-
established practice among the Muslim peoples.
But while the yashmak worn by Muslim women
excites and ultimately thwarts the curiosity, the
transparent veil of other cultures invites inspection
of the face it purports to conceal. In the picture
above, the use of the veil is extended to draw
attention to the body it masks, suggesting the
notion, tenuously existent in Western society, that
the bride enters marriage as a packaged commodity
to be unwrapped, supposedly for the first time,
after the wedding ceremony.*

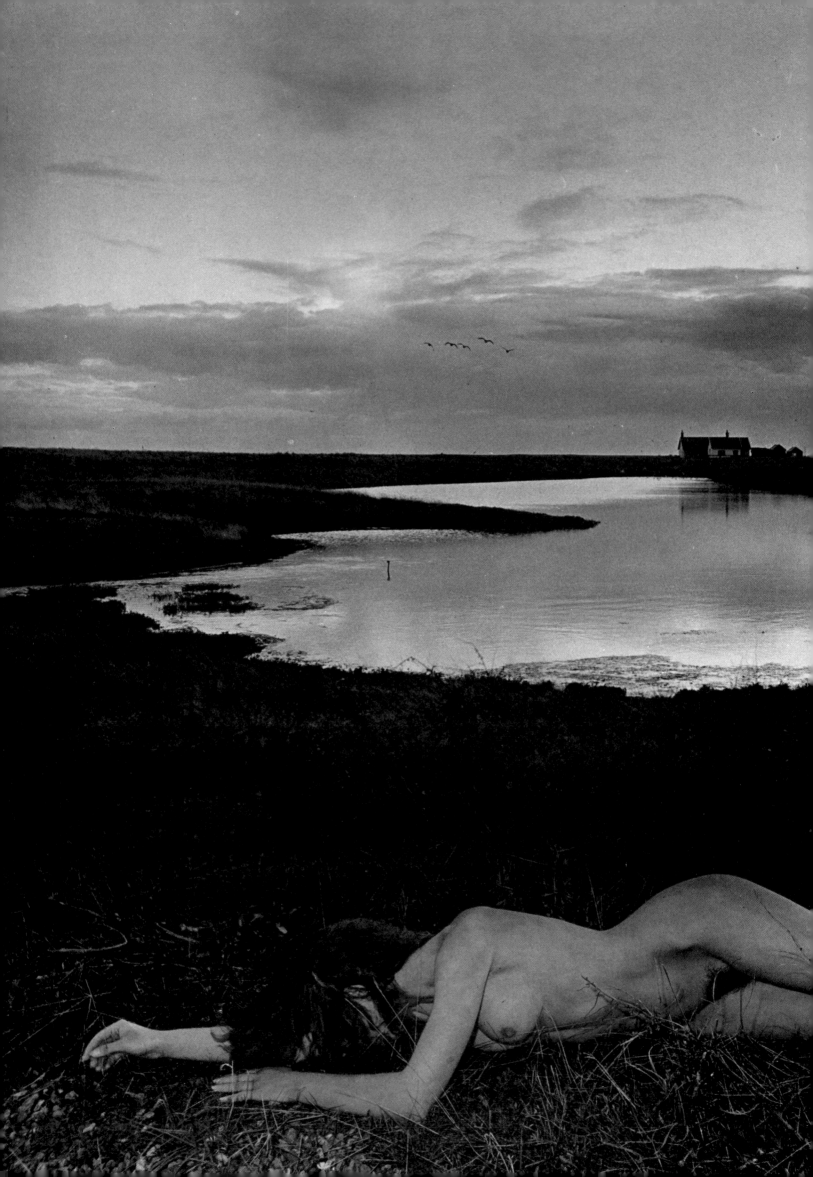

How well do we know the reality we construct for ourselves? Does the mirror image that is a photograph communicate an answer or does a metamorphosis, a transformation of reality, take place that has extensive and often new associations? When the image is that of the naked body, our awareness and our sexual susceptibility may be heightened, but our preference for a particular physical form creates a barrier beyond which it is a challenge for the artist to penetrate. In this context the painter Allen Jones has written: "Eroticism transcends cerebral barriers and demands a direct emotional response. Confronted with an abstract statement, people readily defer to an expert, but confronted with an erotic statement everyone is an expert. It seems to me a democratic idea that art should be accessible to everyone on some level and eroticism is one such level."

SHINGLE STREET, NORFOLK 1983
Photography borrowed from the Surrealist painters the technique of combining naturalistically portrayed elements in a way that creates an illusory image. The unreal atmosphere of this picture evokes the mystery that often surrounds the depiction of women and water.

PLASTIC-WRAPPED
Several types of fetishism meet here in one image. The most obvious is the covering that reveals, more commonly seen in the form of stockings and the "wet look". An allied erotic stimulus is tightness in the covering, so that the form beneath is revealed dramatically, as with corsets, tight boots, and again stockings. The picture even hints at bondage, where tightness is taken to the extreme of restraint in order to heighten the sexual excitement of the bound partner by creating a feeling of helpless passivity.

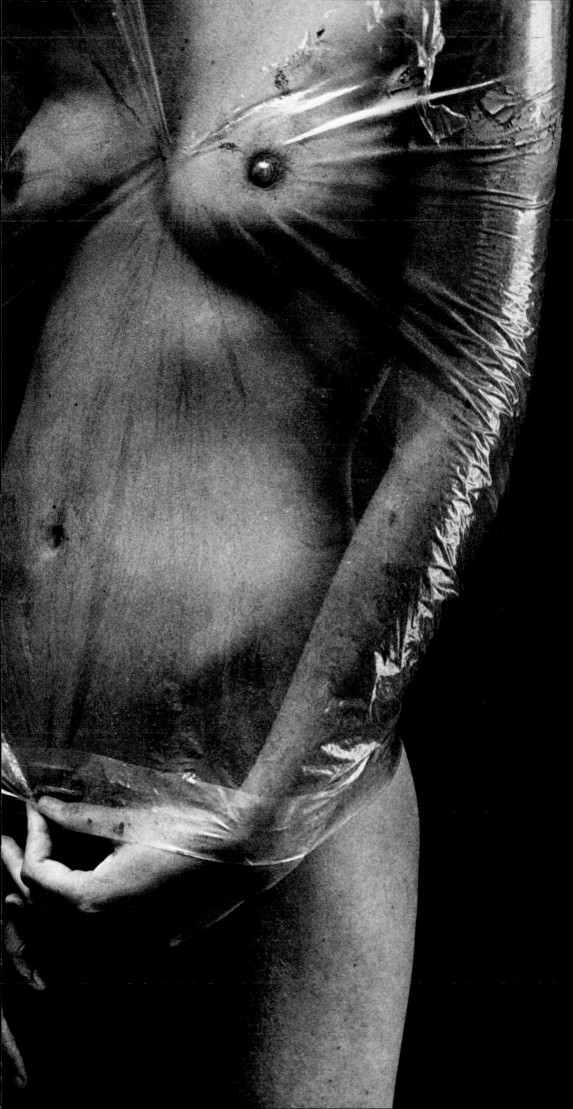

HUNTINGDON 1976 I *and* **II**
The restrained and unchanging nature of the setting for these two pictures forms a marked contrast with the narrative development. Yet it serves to unite and intensify the two images by providing a plausible context for an imaginary encounter.

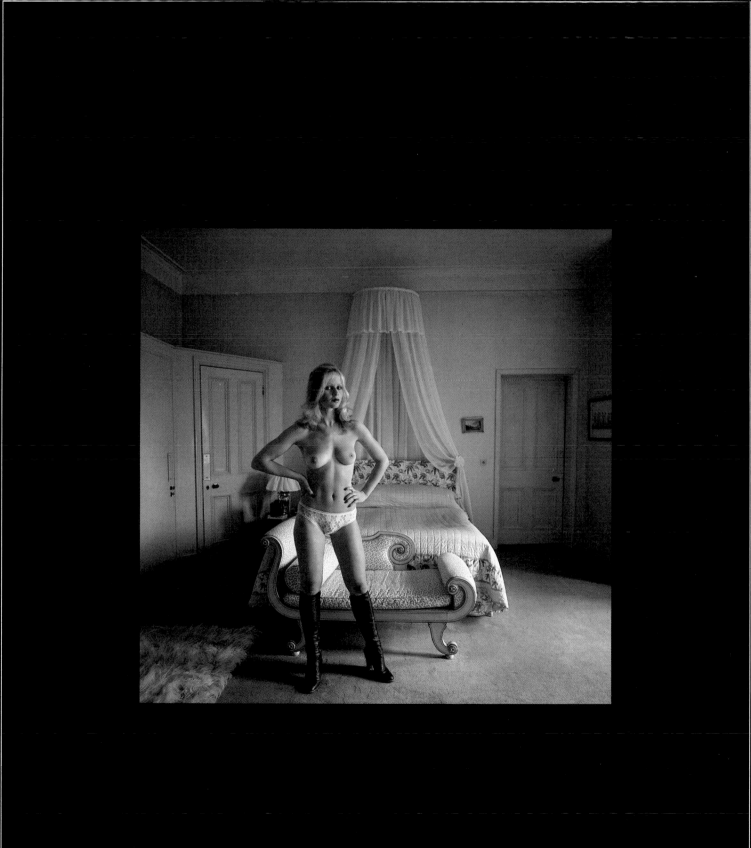

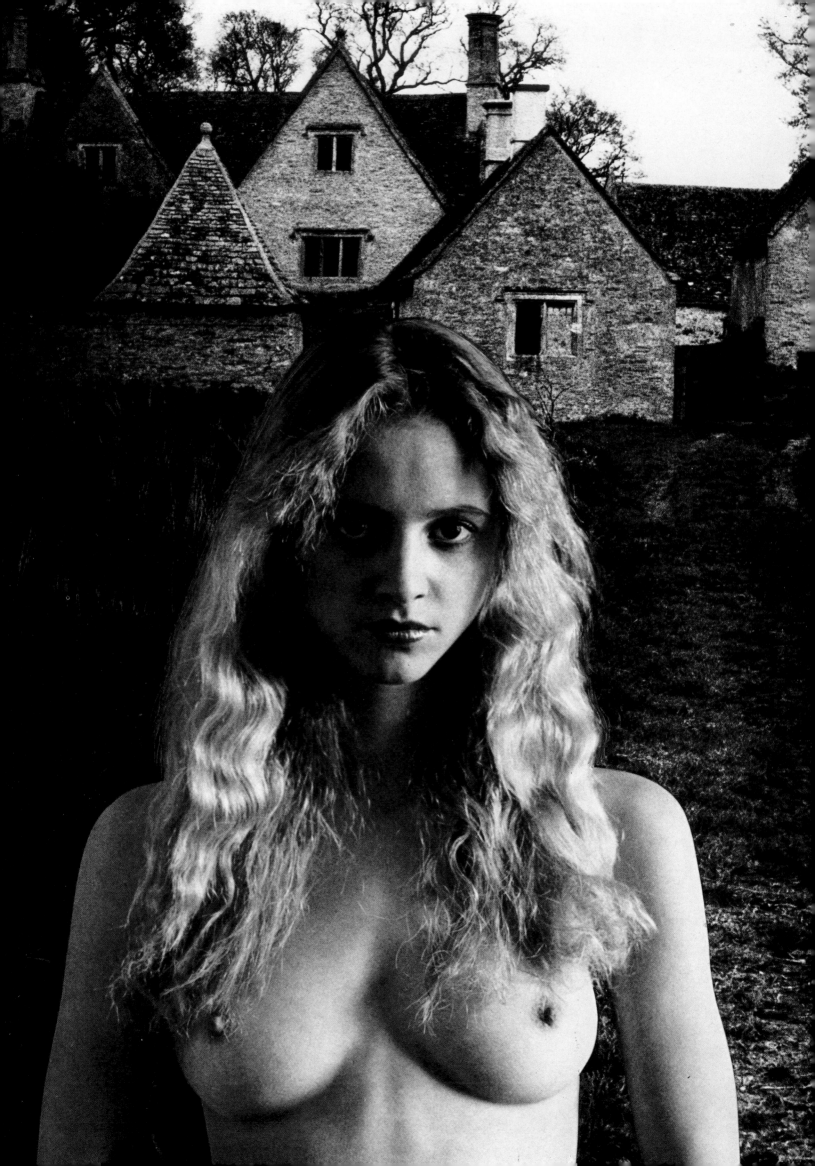

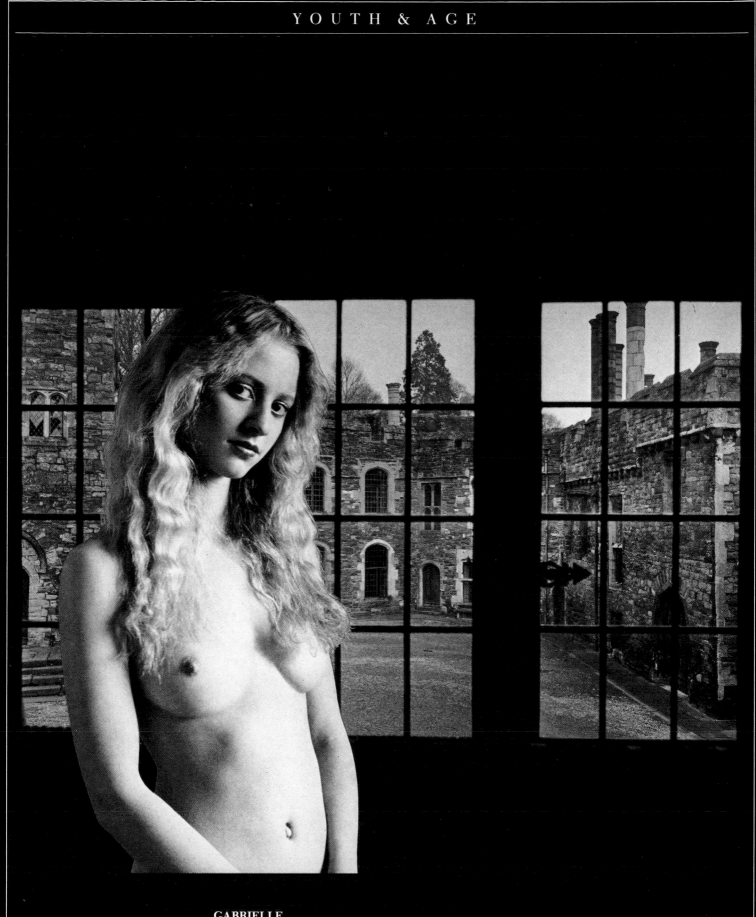

GABRIELLE
Ancient buildings often possess a magic, inviting us to savor their atmosphere as much as inspect their detail. In these pictures the model's body is young, but her expression seems to share the timeless mystery of the surroundings. At the same time it conveys a worldly curiosity at our interest, as if we were invading tourists.

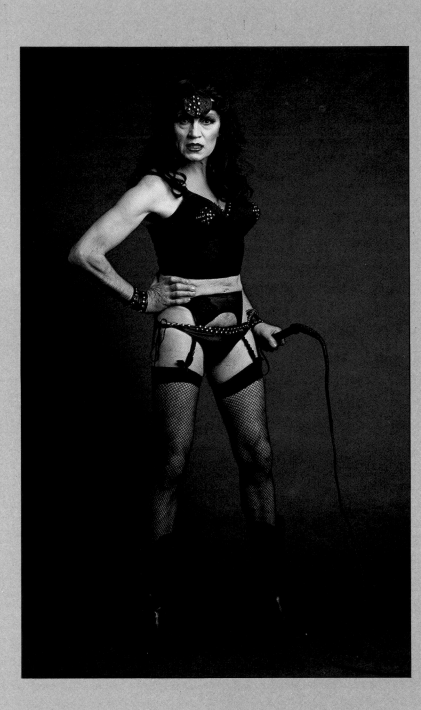

DICKIE
Female impersonation is by no means exclusive to a gay subculture. For some men it bridges the gap between the elements of both sexes that they find in themselves. The transsexual impression created by the model in the picture above is bolstered by the aggressively male, almost gladiatorial, stance.

VIRGINIA 1983
Black stockings and suspenders were originally the trappings par excellence of the demi-monde. Nowadays their appeal is widespread, but they have lost none of their erotic power in the process of becoming fashionable, and continue to represent a fetish for both men and women.

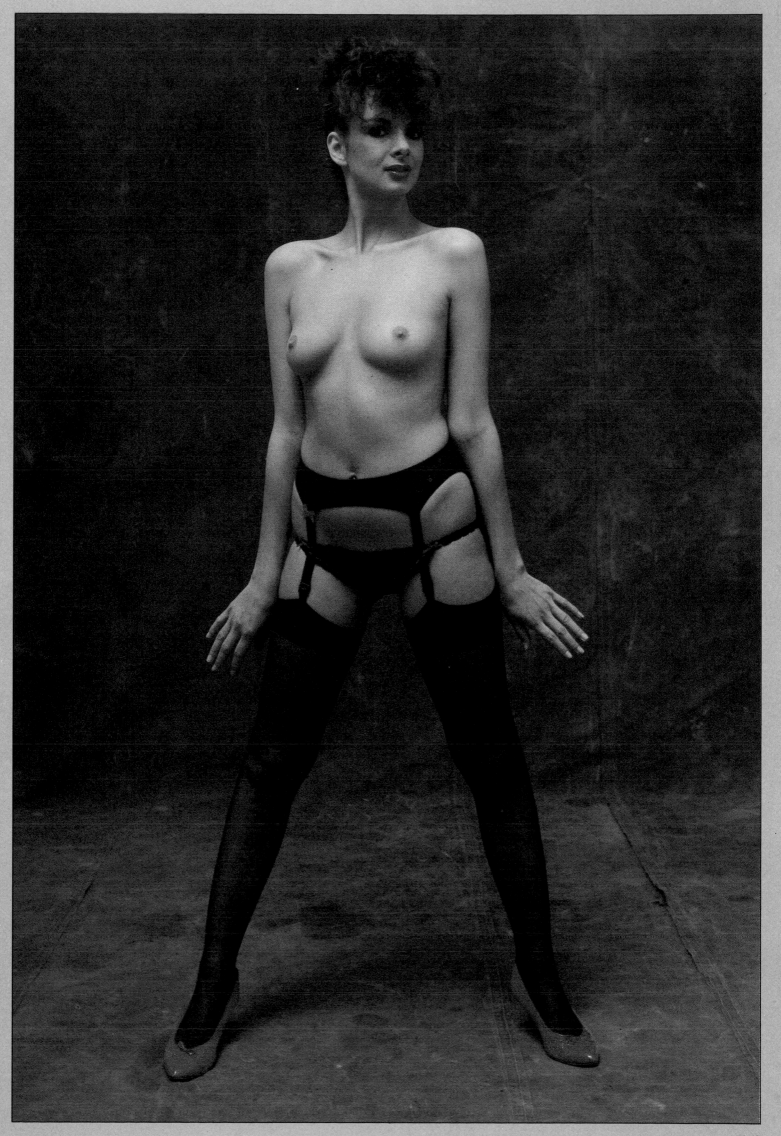

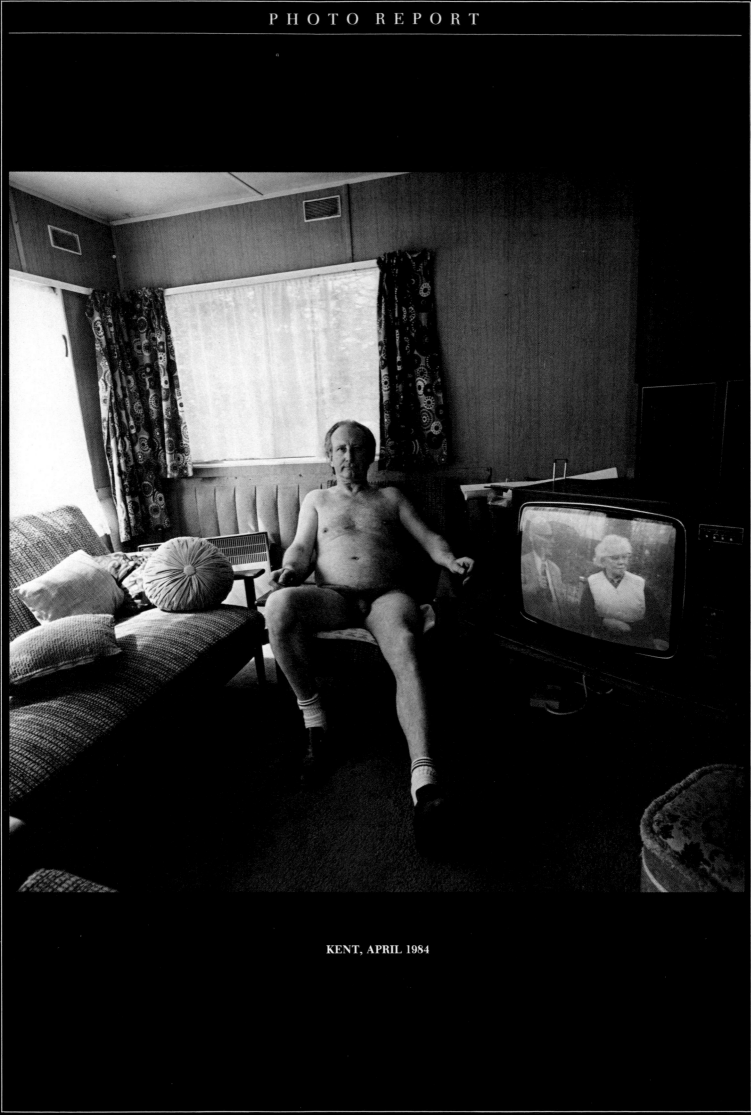

KENT, APRIL 1984

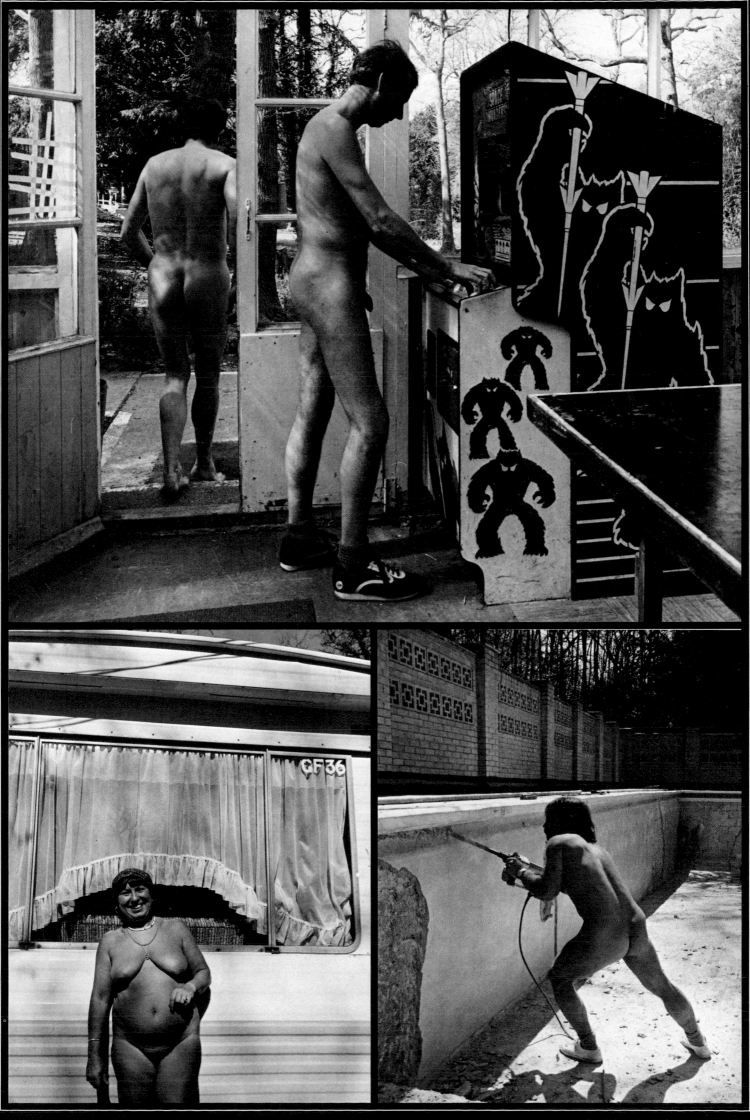

161

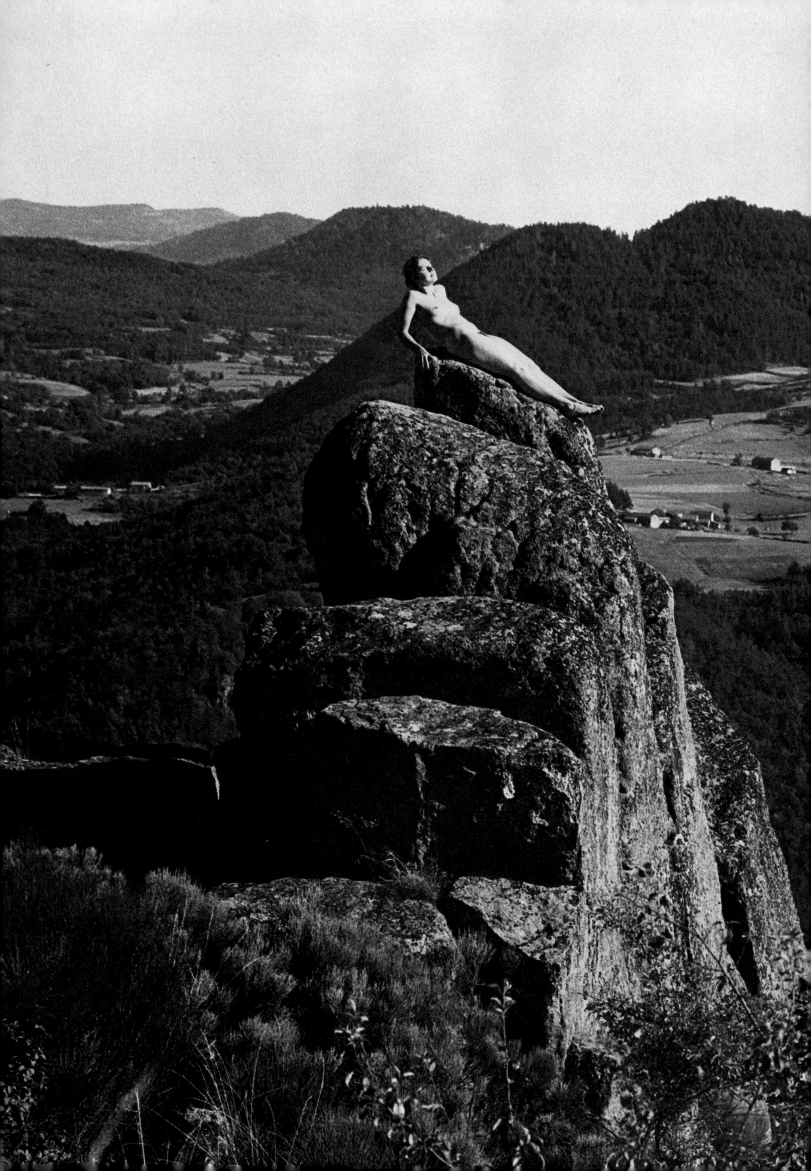

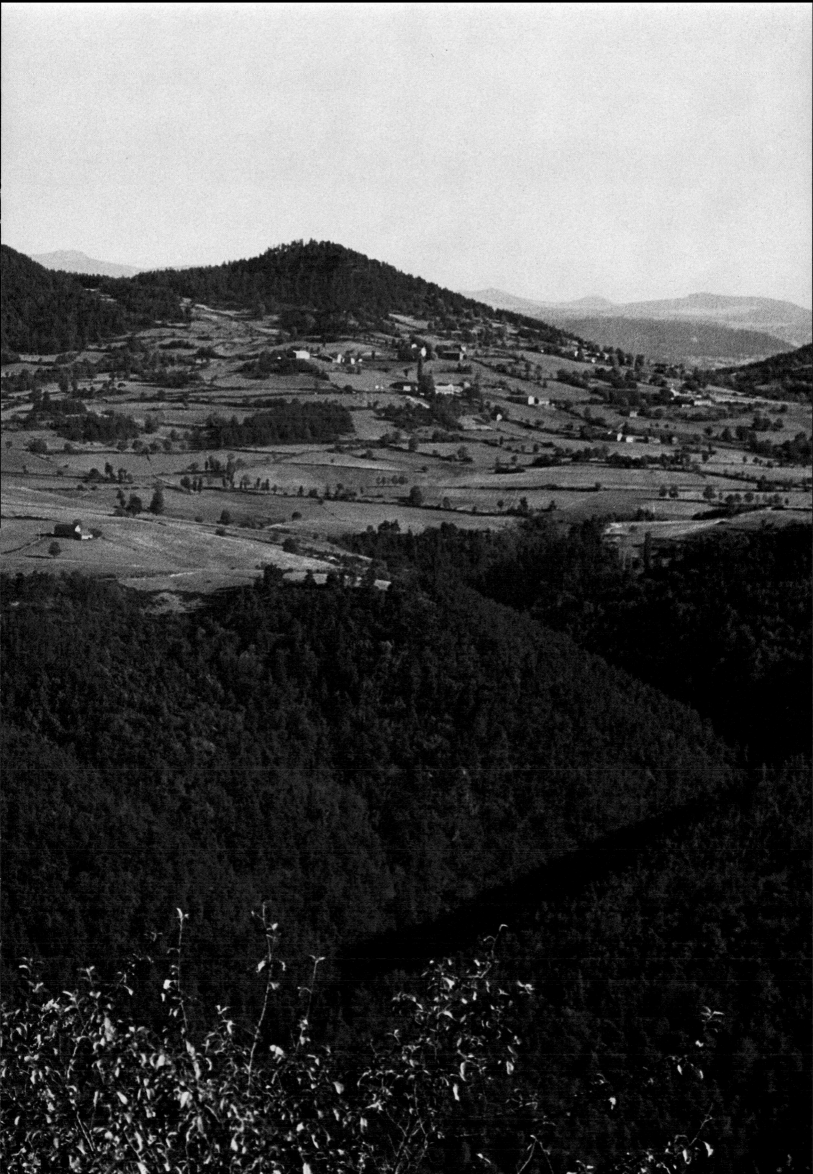

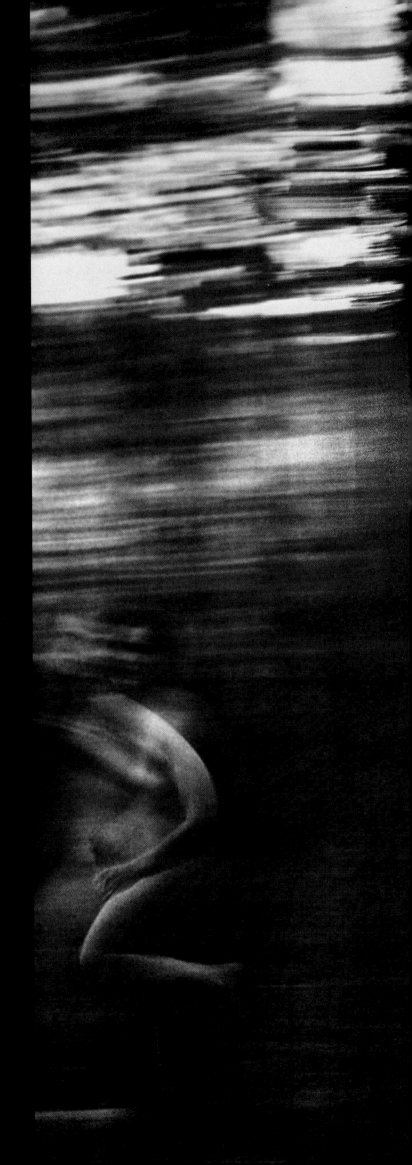

ANNE, RETOURNAC, FRANCE II *(preceding page)*
The magnetism that the nude figure possesses at close range derives largely from its sensuous qualities. It is given immediacy by the depiction of form and of skin tone and texture. In the context of a landscape, where the model is drastically reduced in scale in relation to the setting, it is the shape of the body that provides the primary interest. In this study a rock acts as a plinth, giving the model a still, statuesque quality that is as imperturbable as the tranquil valley.

ANNE, RETOURNAC, FRANCE III
Glimpsed at speed through trees, the running figure that inspired the picture on the right seemed to be in several places at once, as if in a dream or overlapping memories.

THE BALCONY *(overleaf)*
Most models experience great pleasure in being free of the restrictions of clothes and possess a pride in their looks and shape that comes from within. Many keep a photographic record of their bodies at the peak of perfection. The girl in this picture combines the soft beauty and quiet assurance that characterizes the successful nude model as she poses for the camera and, perhaps, the passer-by.

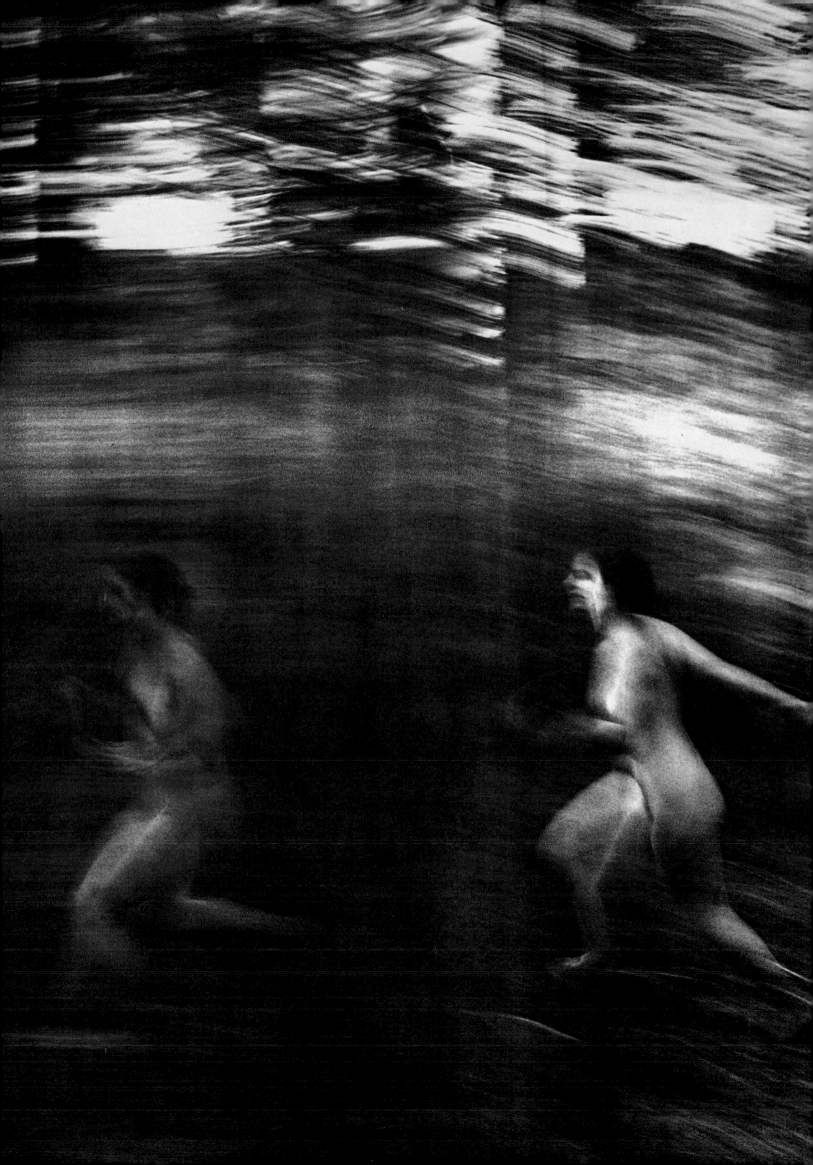

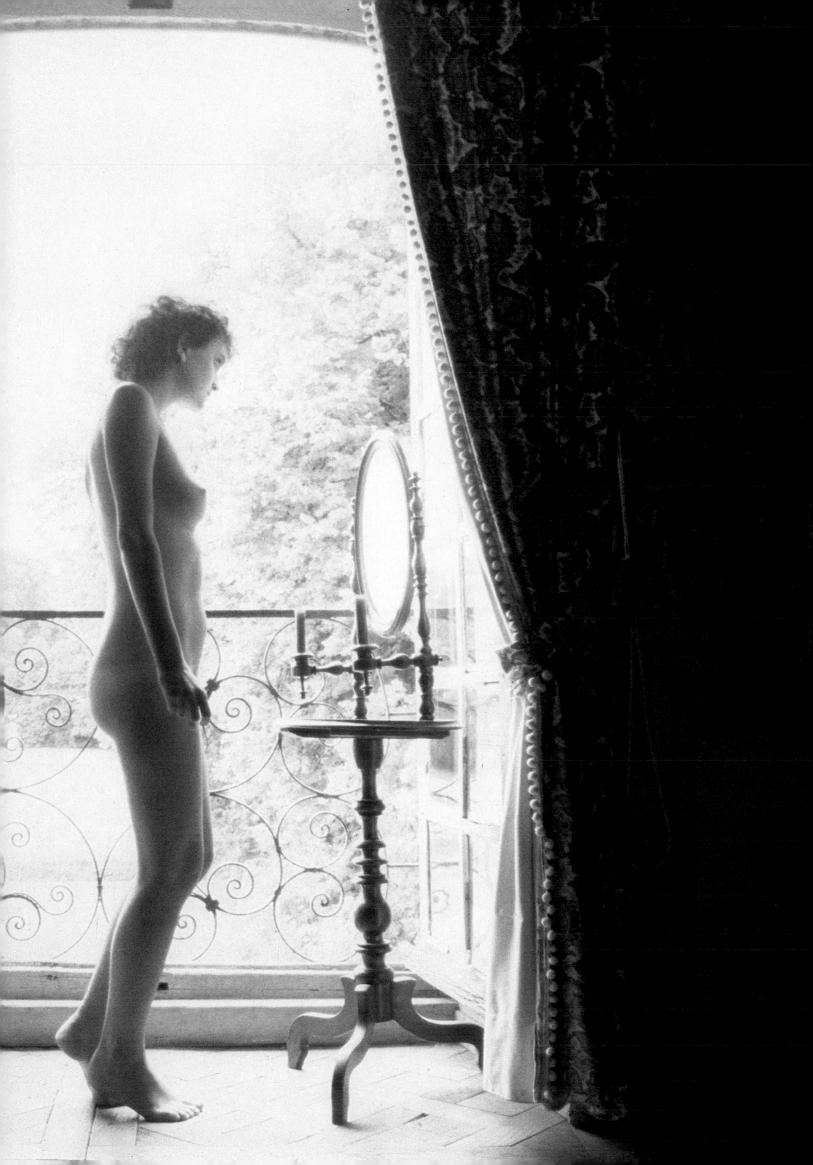

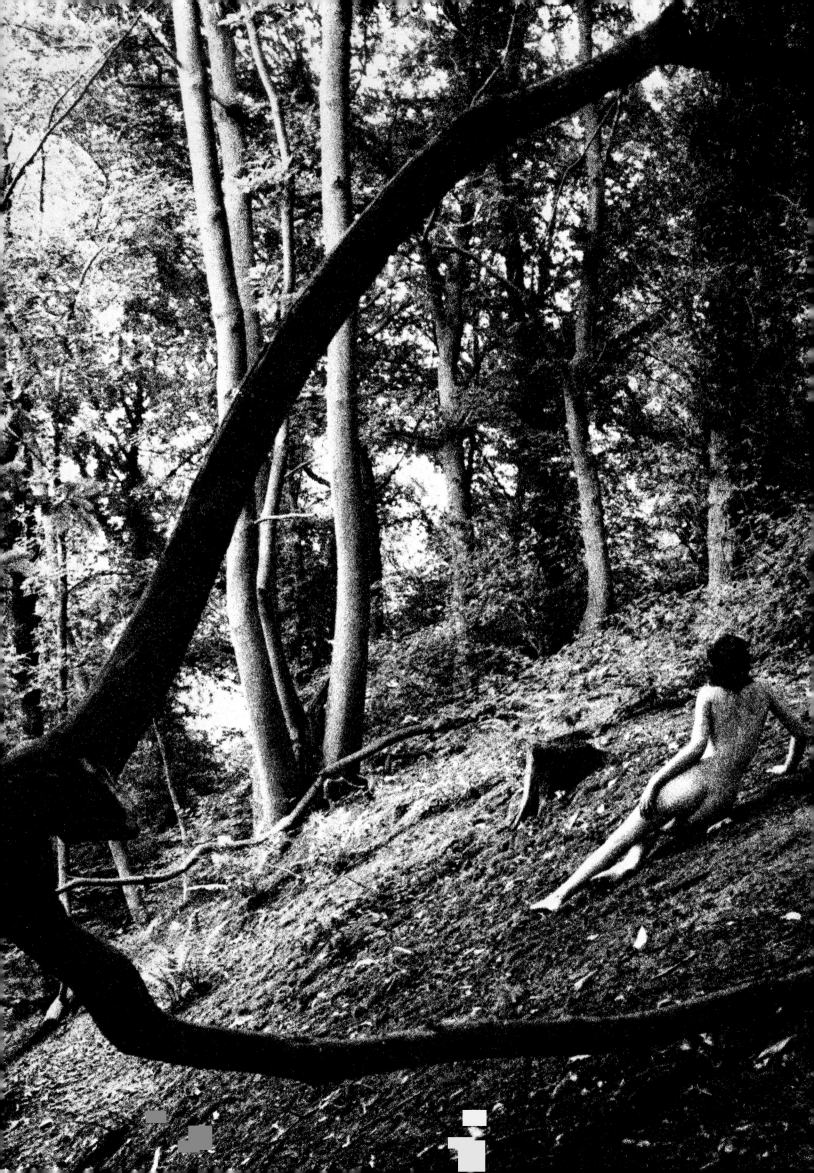

CROW WOODS IV
*In the picture on the left, the model's physical
distance is increased by the isolated mood of the
setting. Apparently immersed in thought, she
takes on a remoteness akin to that of her
surroundings and seems to belong more to the
forest than to the world of people.*

FOUND IMAGES (*overleaf*)
*Pages torn from a "girlie" magazine line the cold
frame, keeping the seeds warm and the
gardeners happy.*

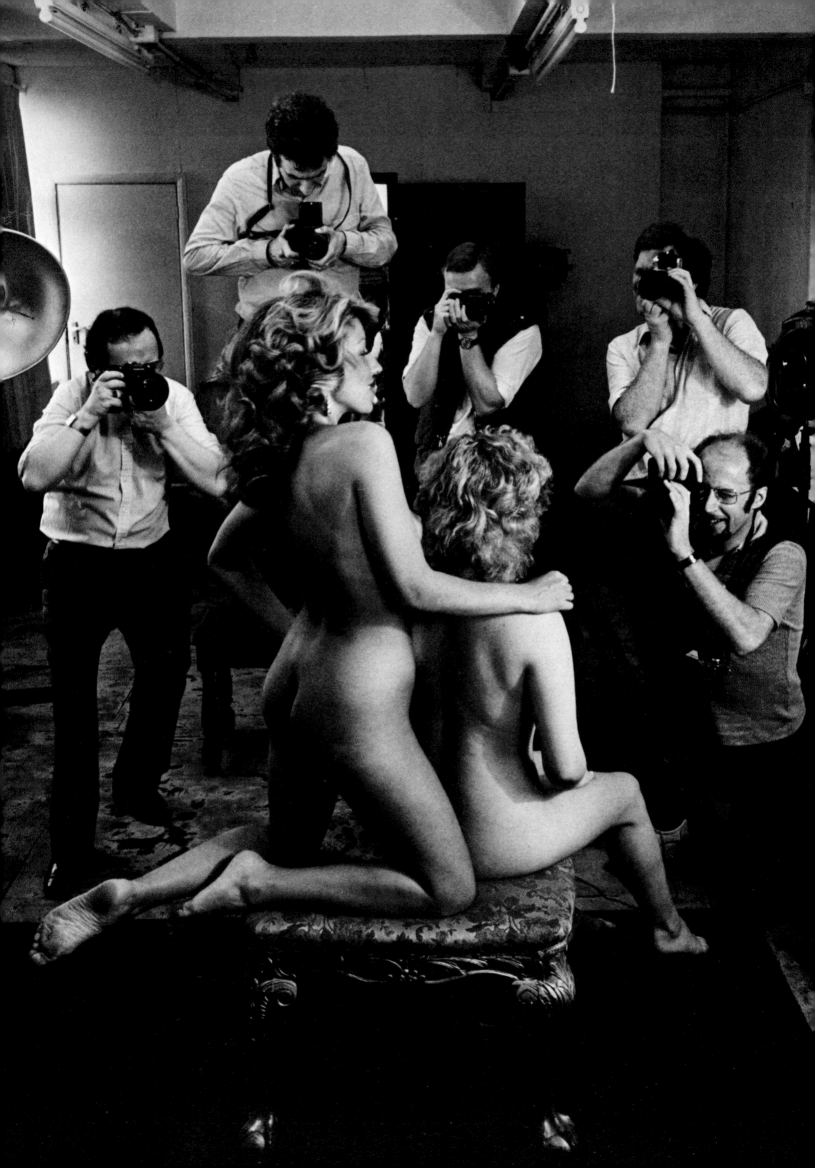

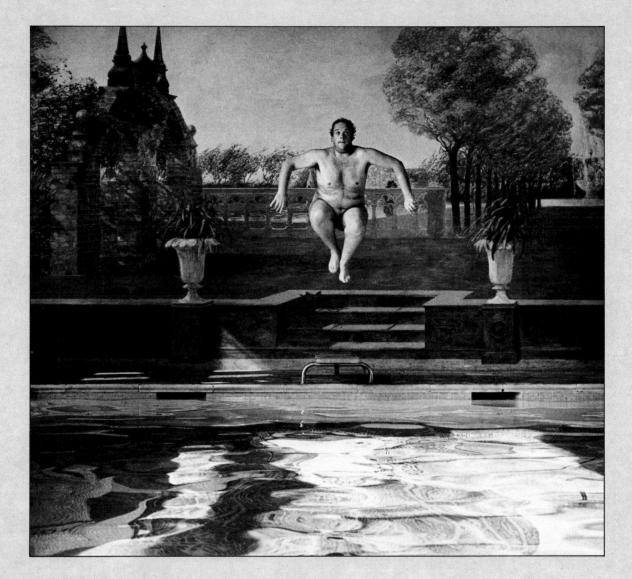

LEVITATION
In the picture above, the precise moment at which the diver was caught gave the impression that he had appeared out of the background. Despite his bulk, he seems motionless, his expression alone saying that this cannot last.

PHOTO SESSION *(left)*

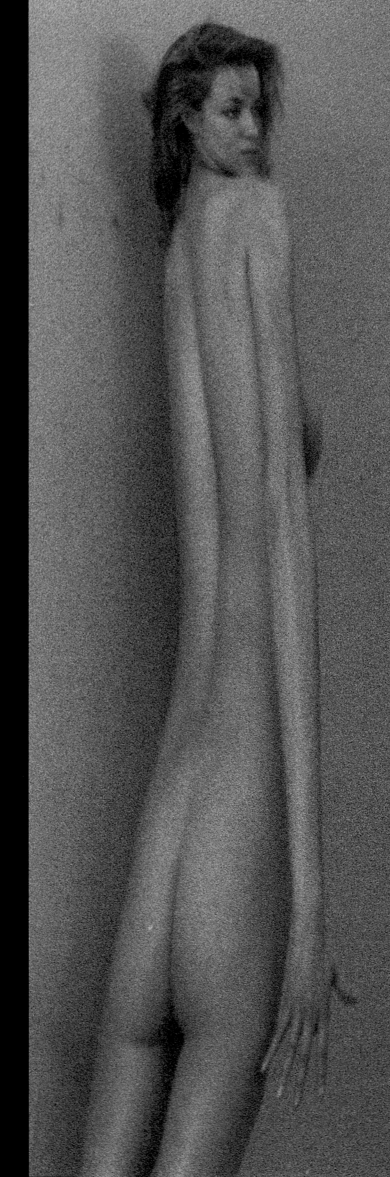

MIRRORED IMAGES

DISTORTIONS

The imaginative distortion of the human form has provided artifacts and visual images since prehistoric times. Inevitably, photography evolved its own approach, the distorted nudes of Kertész and Brandt representing some of the best examples of the theme. The distortions in the series shown here were produced with a plastic mirror used at different degrees of concavity. Such experiments are fascinating in that there are no "wrong" shots, simply an unlimited number of possibilities.

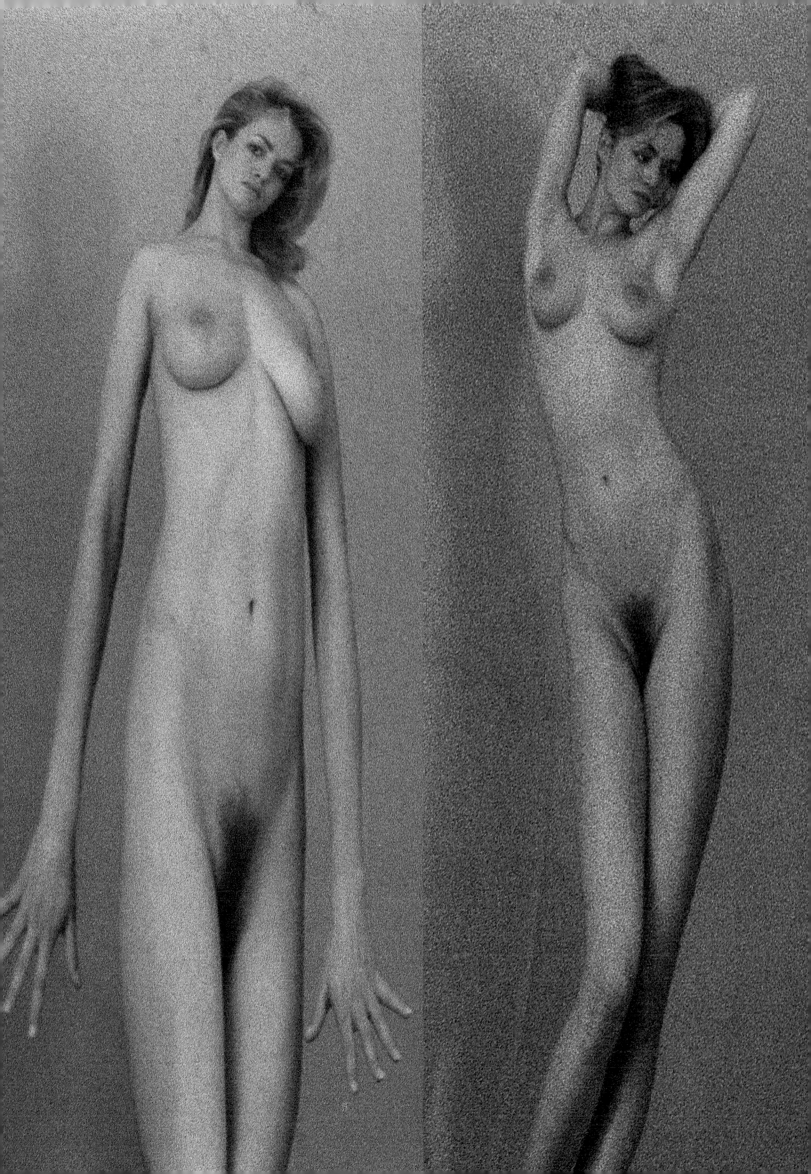

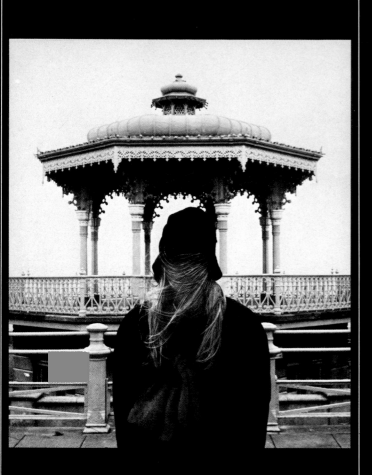

HAIR

Wild or abundant hair in a woman has long connoted a sexually passionate nature. If such powers of suggestion have been attributed to the hair of the head, how much more potent a symbol of sexuality has been pubic hair. Even in recent decades nude photographs were retouched to remove it. Since partial or complete concealment generally heightens the erotic power of nudity, retouching was entrusted with the bizarre role of concealing concealment. Like pubic hair, the hair of the head derives much of its evocative power from its use in concealment, as in the pictures here.

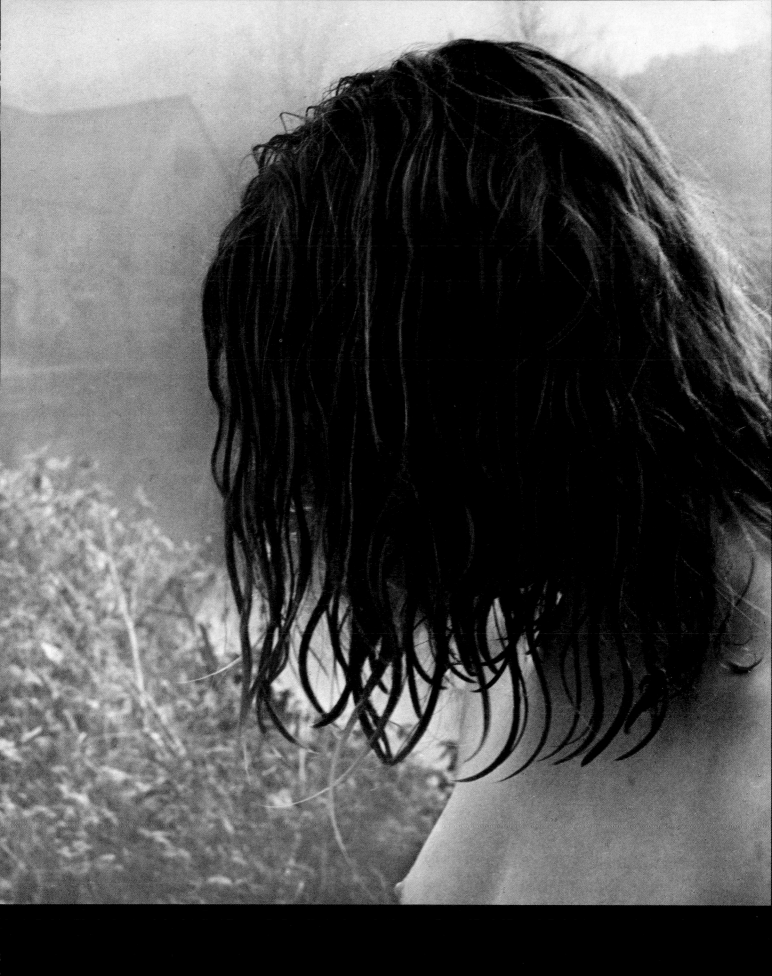

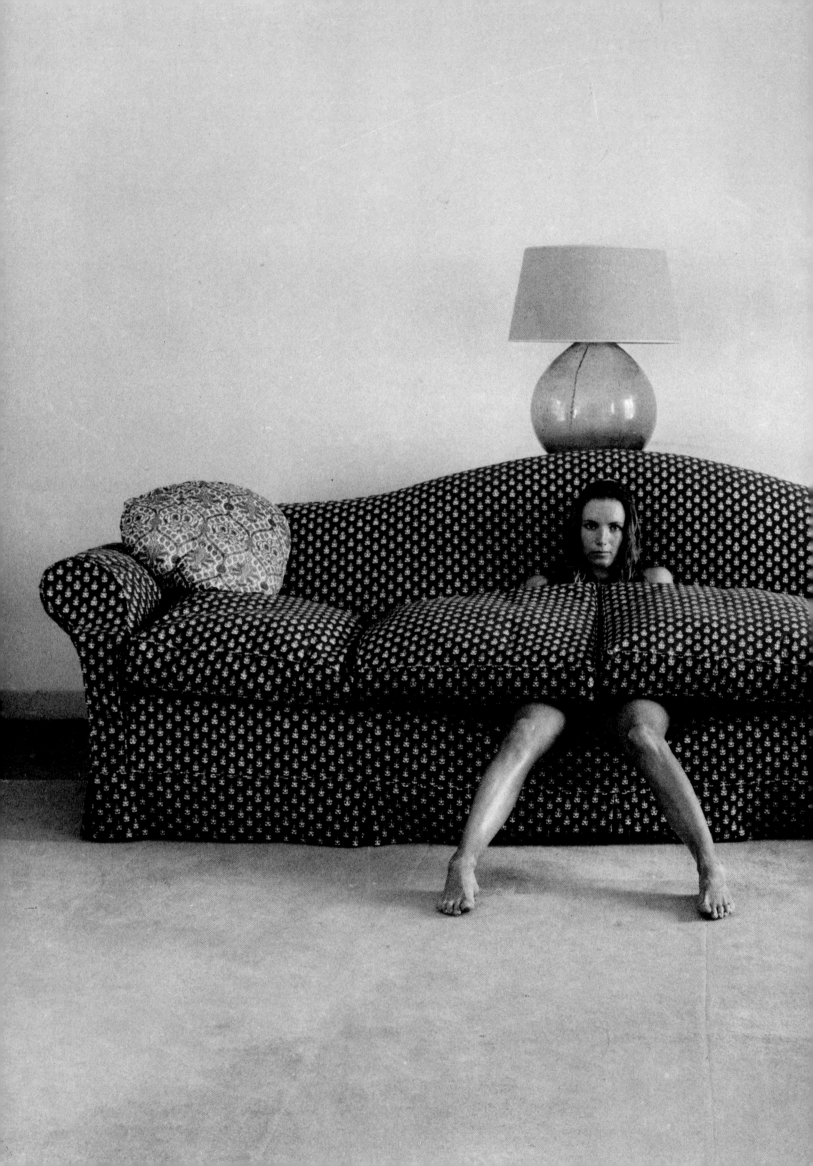

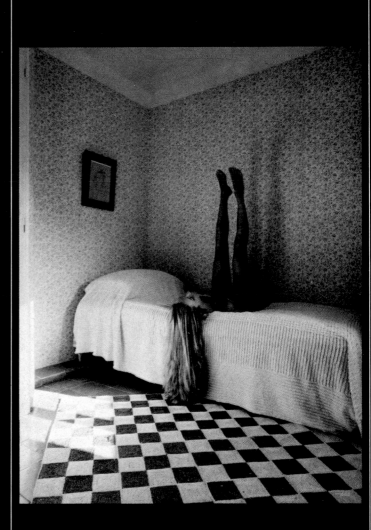

LINDY I *and* **II**
*Playful improvisation forms an inevitable part of
every session where there is a good rapport
between the model and the photographer.
Sometimes, as in these pictures, it provides a
theme without any need for elaboration.*

TRACY'S DREAM *(overleaf, left)*
*Recalling her dream, the girl realizes that she is
part of a waking world of fantasy, where her
voluptuous form provokes the desire of men and
invites emulation by her own sex.*

THE SHIRT'S REVENGE *(overleaf, right)*
*Images of fantasy reflect the contradictory
impulses of the imagination. The juxtaposition of
familiar objects in a bizarre or unfamiliar setting
often makes us reshape our accustomed view of
everyday events.*

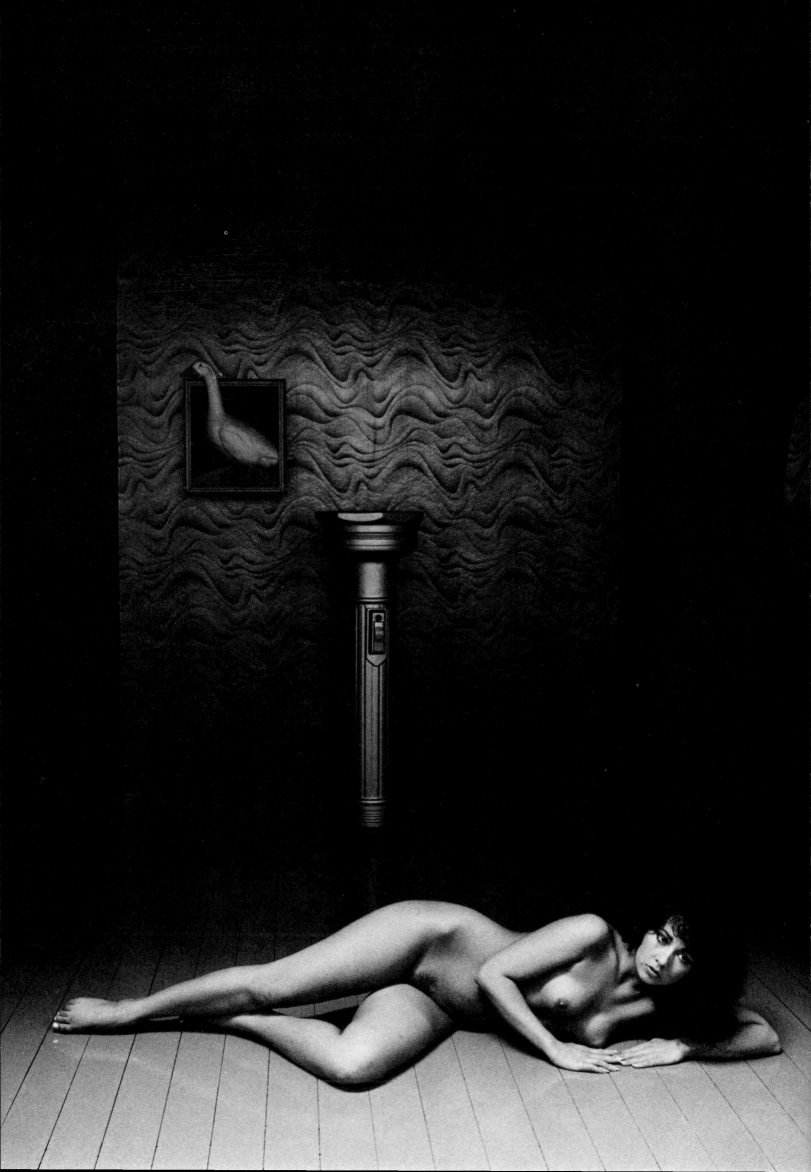

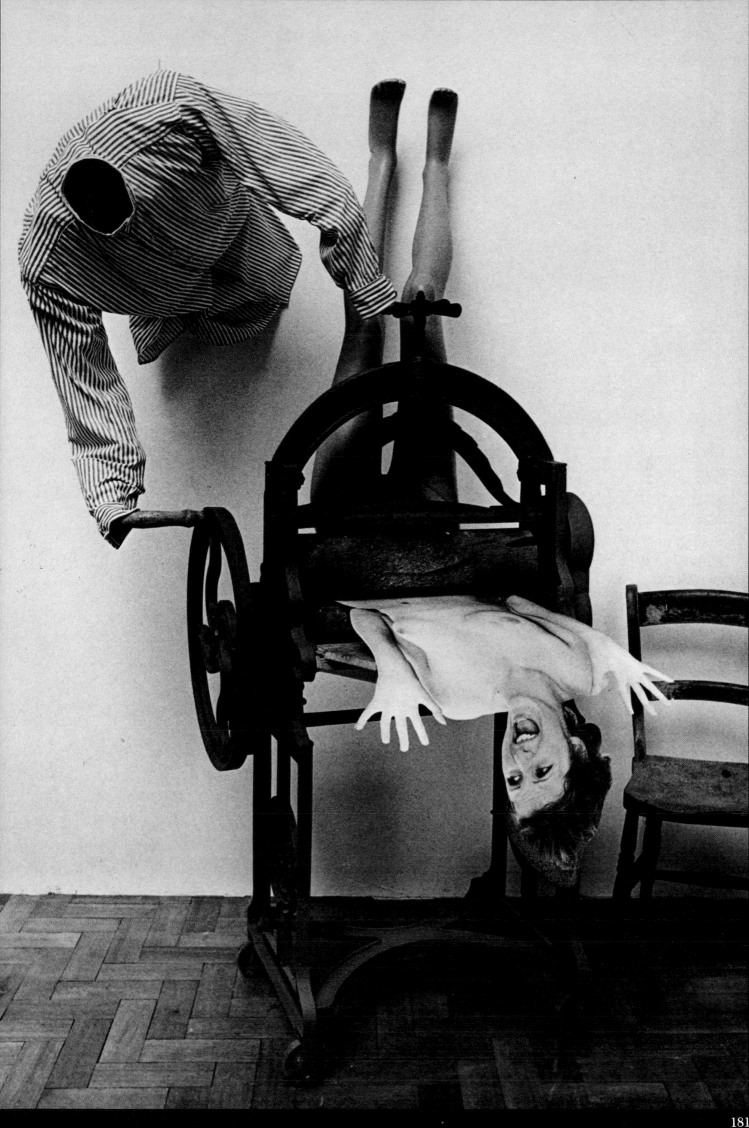

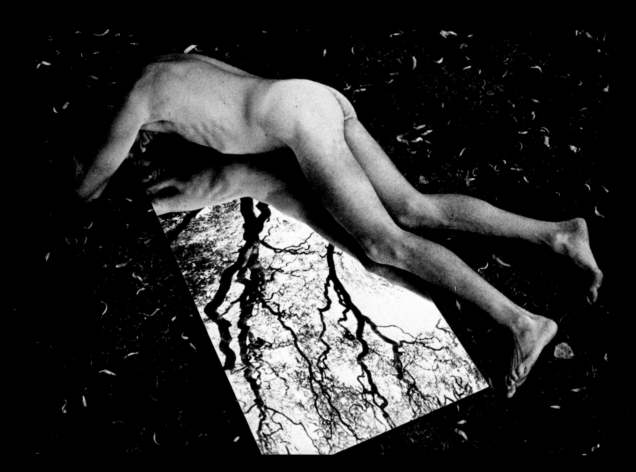

REFLECTION *and* **GRASS PYRAMID**
*We have imposed a rigid pattern of straight lines on
a natural world which is dominated by curves and
irregularity. The objects in these pictures—the
mirror, the bricks, and the pyramid—typify this
sense of order and form a contrast with the subtle
shape that man himself possesses. Here the human
form becomes an integral part of a structure,
ceasing to be the sole focus of attention that it is in
most images of the nude, but reflecting our strong
dependence on the constructed world.*

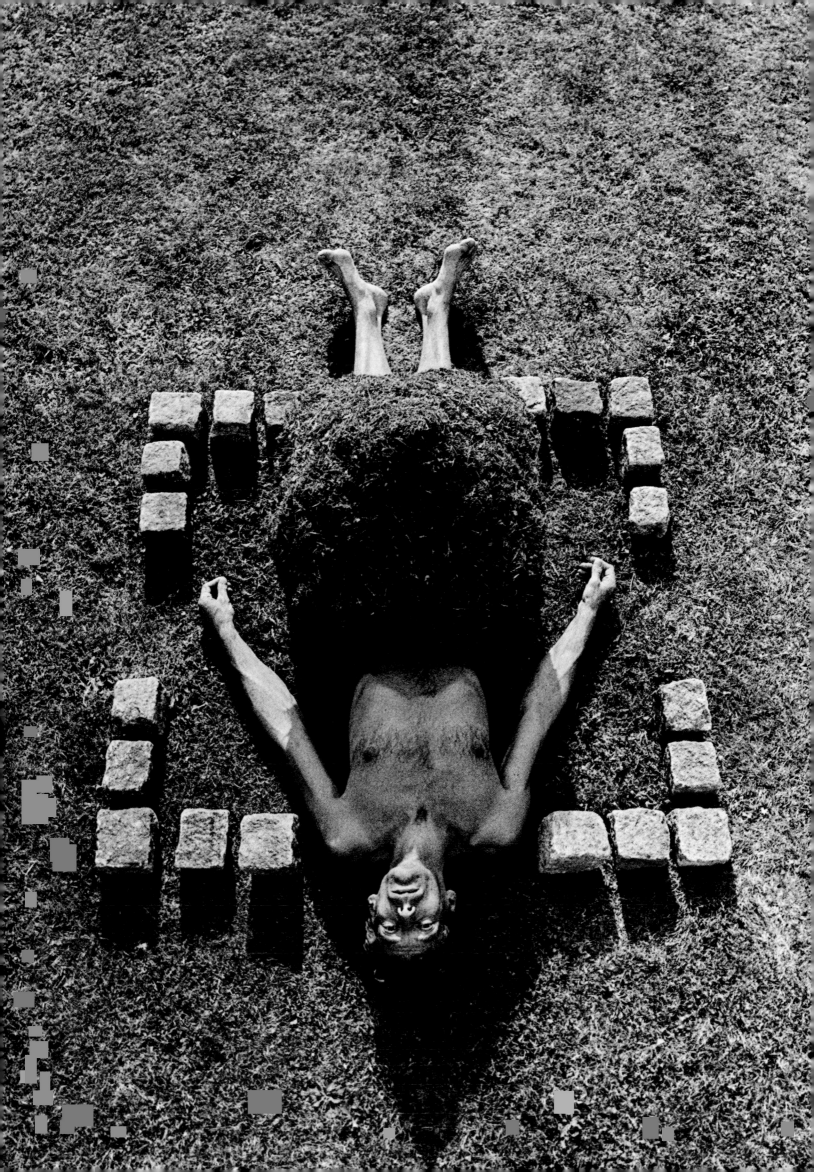

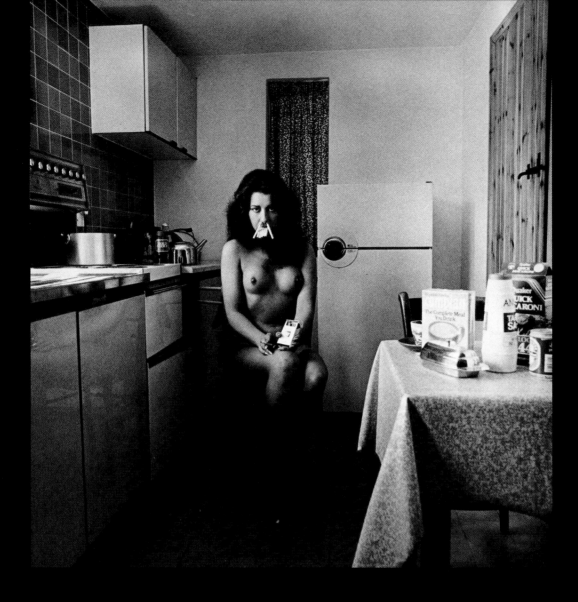

TRACY SMOKES AT LEAST EIGHTY CIGARETTES A DAY

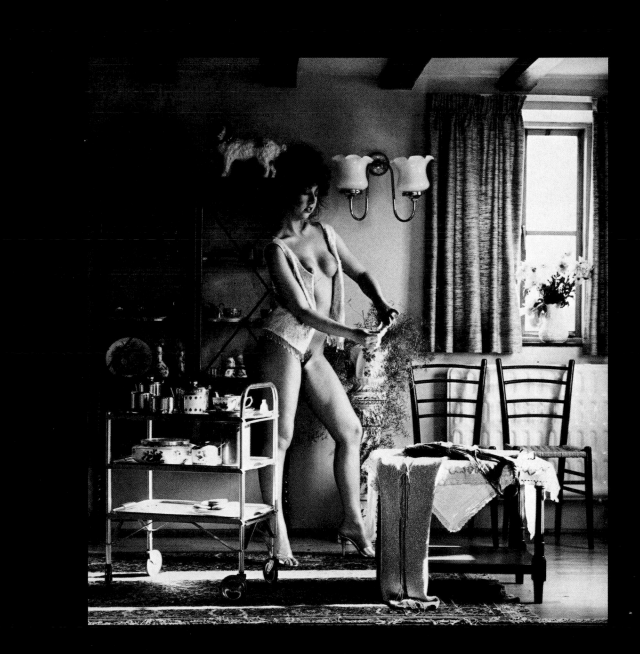

TRACY'S MOTHER-IN-LAW IS COMING TO TEA

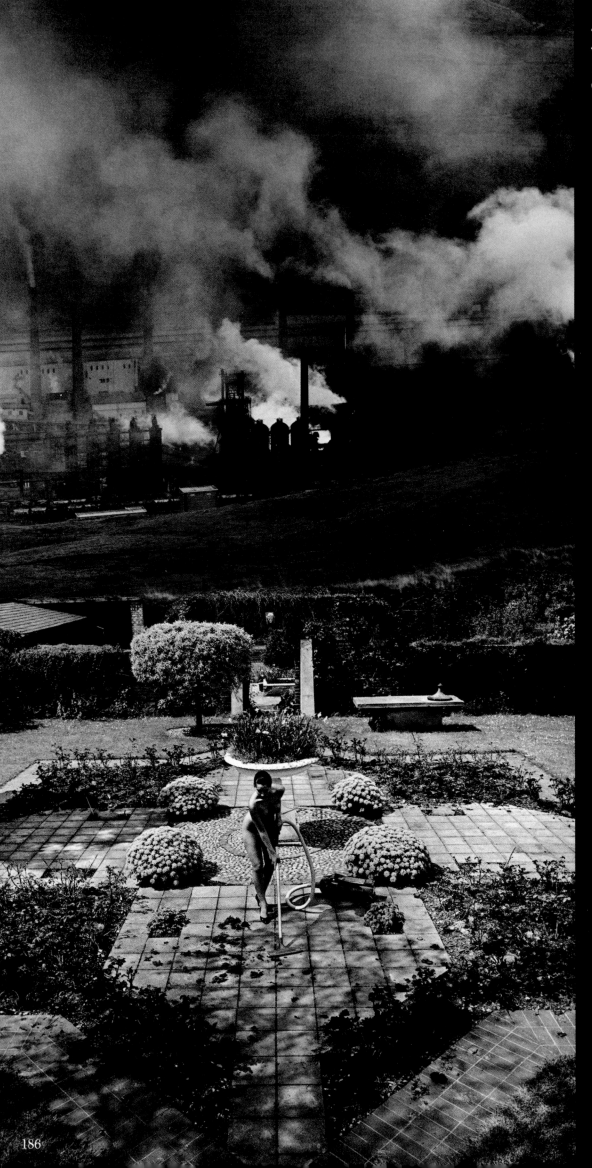

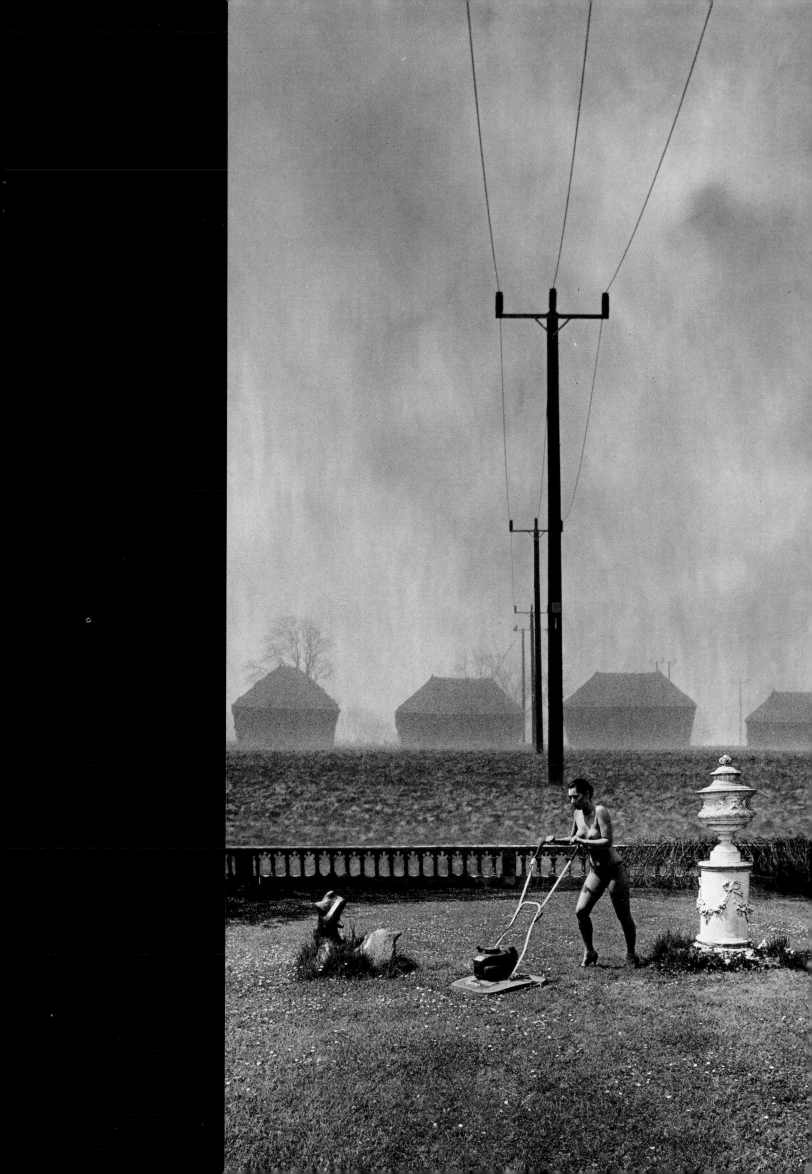

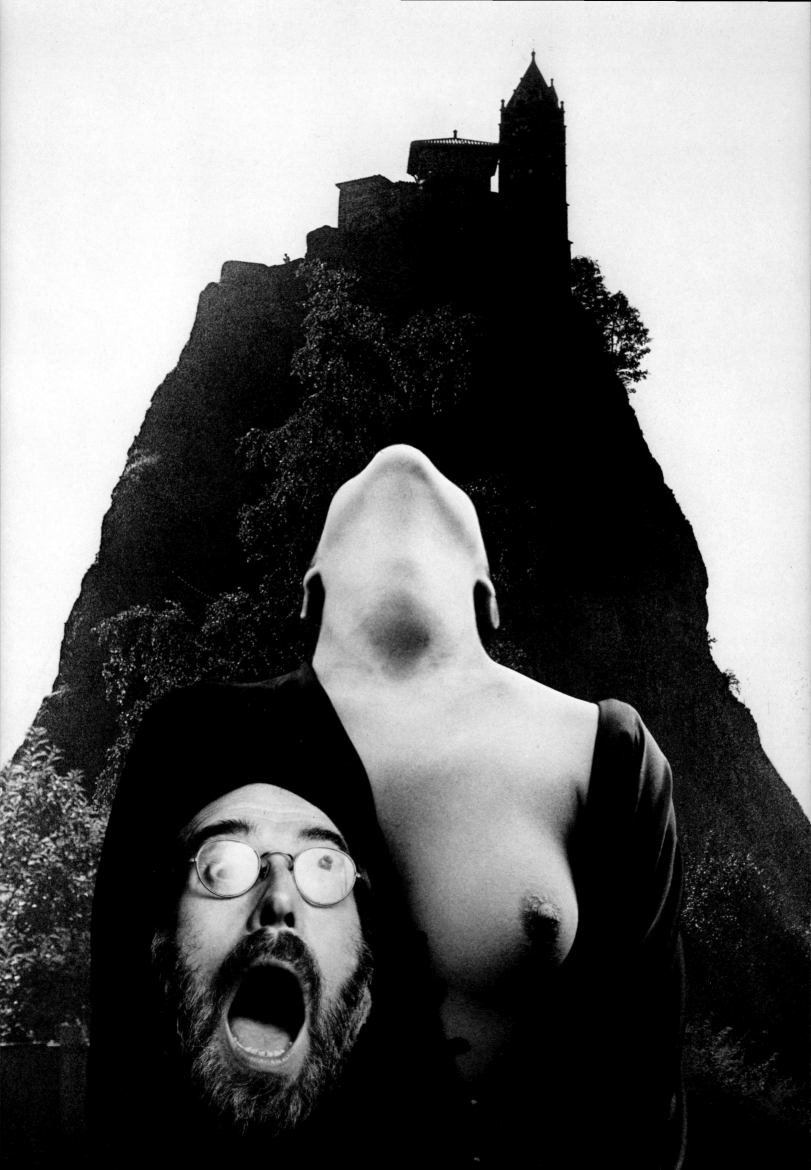

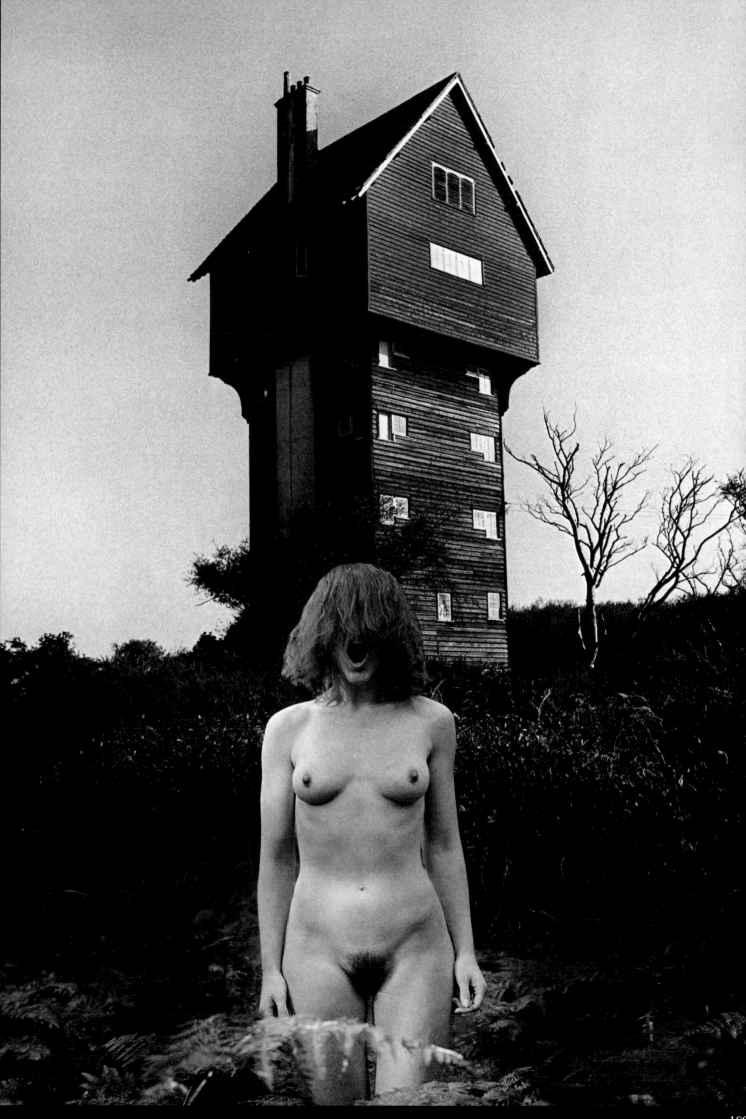

SCREAM *and* **THE HOUSE IN THE CLOUDS** *(preceding pages, left and right)*
A single photograph can encapsulate our emotions as they are reflected on our faces, crystallizing a moment of terror, for example, as effectively as a sequence of cinematic images. By its very immobility, the photograph echoes in these pictures the frozen, mute quality of insufferable horror.

THE MECHANIC
To us they're pin-ups; to Chris they're just erotic wallpaper.

KAREN *(overleaf)*
Beauty comes and goes with the fluctuations of the light.

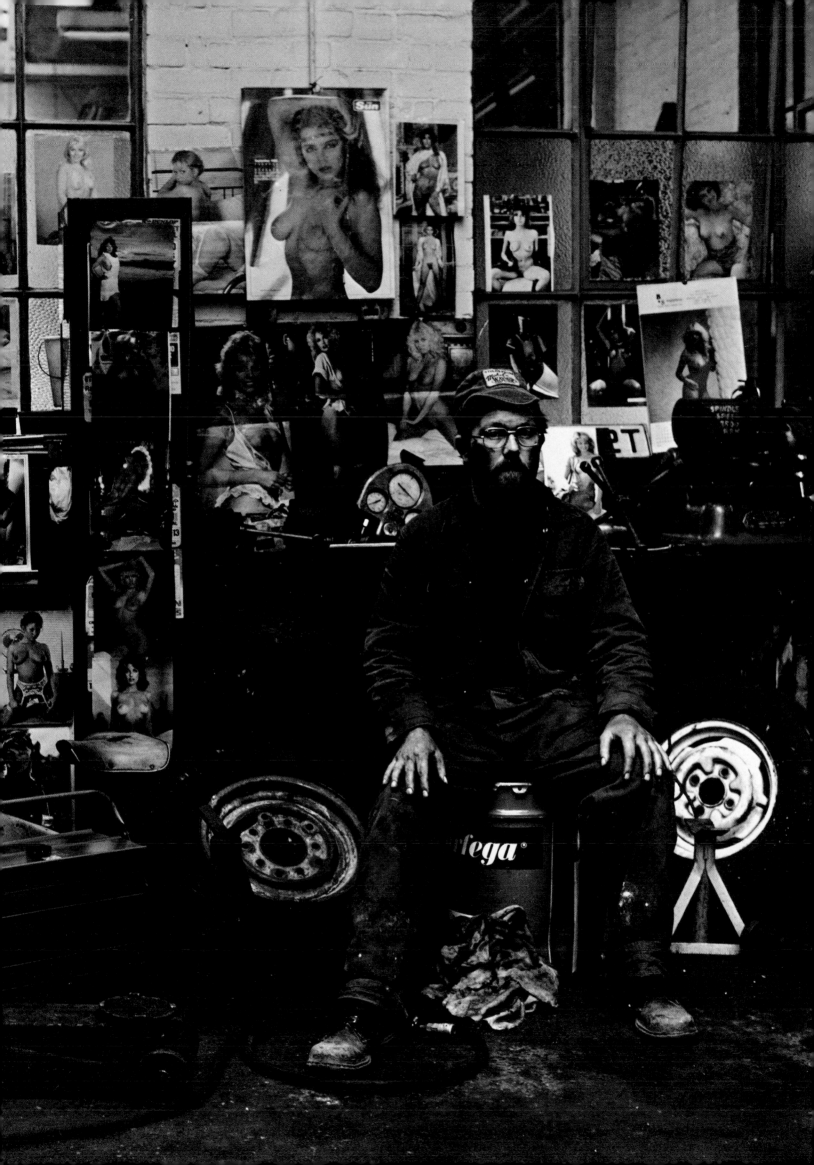

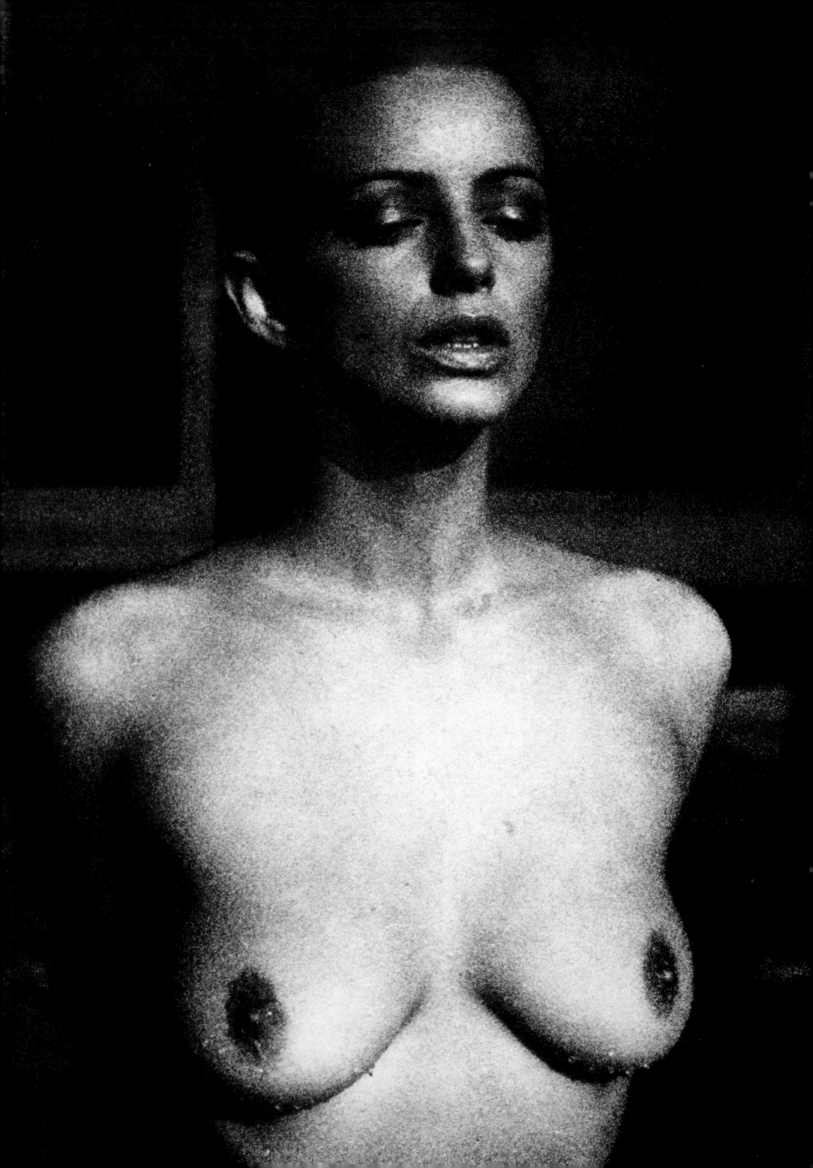

EQUIPMENT AND TECHNIQUES

The finest of cameras cannot produce an outstanding picture if the user lacks a perceptive approach to the subject. Conversely, this quality makes it possible to take successful photographs with a very simple camera.

Today's sophisticated cameras reflect considerable progress in overcoming the traditional problems of the medium, but very often the photographer allows the technical possibilities of his equipment to dominate his thinking. The real advantage of these cameras lies in the freedom they give you to concentrate on the creative rather than the technical aspects of a picture.

Lighting is a creative factor that is particularly important in nude photography, where the aim is normally the expressive representation of form. In general a directional light rather than an overall flat light is needed, but whether hard or soft depends on the mood in view. For most of my pictures I prefer a soft light: either daylight through thin cloud or from a window covered with tracing paper or a blind. This lighting reveals subtle modeling and allows the subject to adopt a wide range of poses without harsh shadow impinging on the form. It also produces well-balanced negatives with good separation and definition.

I tend to bounce on- or off-camera flash off a wall or the ceiling, or I use a flash head with an umbrella and a second reflector for fill-in light. With tungsten lamps too, I normally diffuse the light. The basic rule is: keep the lighting simple and don't let it dominate the picture. If you need artificial light, one main light and a fill-in reflector will prove adequate for most studies of the nude.

NB: The chemicals listed below were used to obtain tonal effects in the black-and-white prints. They are all poisonous and, in some combinations, highly explosive. They should therefore be used with great care and never without rubber gloves and protective glasses.

Acetone
Aluminum potassium sulfate
Ammonia
Ammonium dichromate
Carbolic acid
Citric acid
Copper nitrate
Ferric ammonium citrate
Glacial acetic acid
Gold chloride
Hydrochloric acid

Methyl alcohol
Oxalic acid
Potassium citrate
Potassium ferricyanide
Potassium permanganate
Selenium
Sodium hydroxide
Sodium sulfide
Sulfuric acid
Thiocarbomide
Vanadium chloride

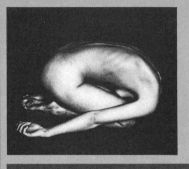

Half title
FETAL FORM
CAMERA 4 × 5 ins
LENS 150 mm
FILM Ilford 400 ASA
LIGHTING A 250W floodlight with a shallow reflector was directed at the model from a distance of 4 ft (1.25 m), creating a wide tonal range.

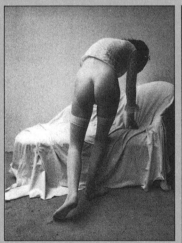

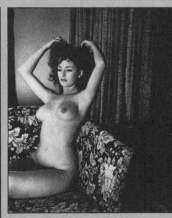

Facing title page
BRAMERTON 1984 I
CAMERA 35 mm SLR
LENS 50 mm
FILM 3M 1000 ASA
LIGHTING The model was lit by evening light from a large window 6 ft (1.75 m) to the left and a skylight. The slightly diffused, directional light defined skin texture.

Facing contents page
ANNELIESE
CAMERA Medium-format SLR
LENS 120 mm
FILM Kodak Tri-X Pan
LIGHTING A 500W floodlight was directed from the left at a distance of 6 ft (1.75 m). It was set at a height of 8 ft (2.5 m) and angled downward, to give soft light that revealed detail. The model's appearance was further softened by floodlight that spilled off the ceiling.

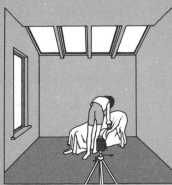

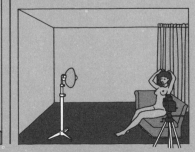

INTRODUCTION
Page 7

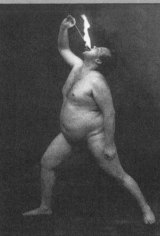

FIRE-EATER
CAMERA Medium-format SLR
LENS 120 mm
FILM 3M 1000 ASA
LIGHTING A skylight above and behind the subject diffused strong early-afternoon sunlight, showing form in detail. However, it was not bright enough to light the canvas background clearly, so that its near-uniform tone is unobtrusive. Fast film gave a grainy appearance to the shot.

FORM AND EXPRESSION

Page 8

KENSINGTON 1984 I
CAMERA Medium-format SLR
LENS 60 mm
FILM Kodak Tri-X Pan
LIGHTING Overcast light from a window 5 ft (1.5 m) to the right created a subdued atmosphere with little definition.

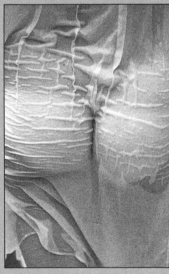

Pages 10–11

POOLSIDE I and II
CAMERA 35 mm SLR
LENS 135 mm
FILM Kodak Ektachrome 64
LIGHTING Strong sidelight gave a sensuous depiction of form, and revealed texture in skin and fabric.

Page 12

HOGLANDS 1966 (TORSO SERIES I)
CAMERA Medium-format SLR
LENS 120 mm
FILM Kodak Tri-X Pan
LIGHTING A 500W floodlight with an integral diffuser was directed at the model's back from a distance of 4 ft (1.25 m), to give dramatic definition to the vertebrae and to reveal the texture of the skin.

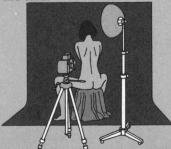

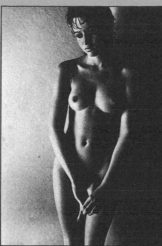

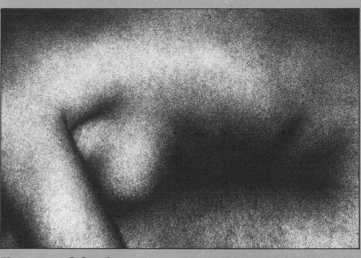

Page 13

HOGLANDS 1966 (TORSO SERIES I)
CAMERA Medium-format SLR
LENS 150 mm
FILM Kodak Tri-X Pan
LIGHTING A 500W floodlight was used from 3 ft (1 m) to produce high contrast and an abstract topographic effect.

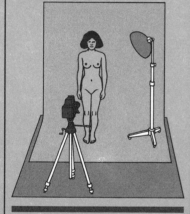

Pages 14–15

POOLSIDE III
CAMERA 35 mm SLR
LENS 35 mm
FILM Kodak Ektachrome 64
LIGHTING Daylight through a glazed wall 2 ft (0.5 m) to the left of the model stressed the skin's tactile quality.

Pages 16–17

DUNMOW 1978
CAMERA Medium-format SLR
LENS 80 mm
FILM Kodak Tri-X Pan
LIGHTING Daylight, diffused through a white blind over a window 6 ft (1.75 m) from the model's feet, revealed form and skin texture. A second window gave toplight.

Page 18

SOFT TONES I
CAMERA Medium-format SLR
LENS 80 mm
FILM Kodak Tri-X Pan
LIGHTING Weak daylight from a window to the left was diffused by the walls, creating gentle modeling to match the pose.
DARKROOM The print was made on a soft chlorobromide paper and then blue-toned, with constant rinsing, in an acetic acid bath.

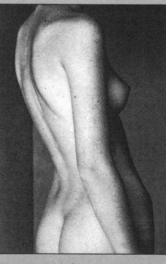

Page 19

SOFT TONES II
CAMERA Medium-format SLR
LENS 120 mm
FILM Kodak Tri-X Pan
LIGHTING The light from six 500W floodlights in a unit with an integral plastic diffusing screen was bounced from a corner 6 ft (1.75 m) from the model, who was at a similar distance from the light source. The extremely soft light provided a subtle rendering of her form and skin texture.
DARKROOM A combination of gold chloride and potassium permanganate produced warm tones in the print.
NB: This solution is very dangerous.

Pages 20–1

ELEMENT
CAMERA Medium-format SLR
LENS 150 mm
FILM Kodak Tri-X Pan
LIGHTING The model received the soft light of a 500W flood reflected from a white wall.
PRINTING Line conversion was used to produce a mezzotint.

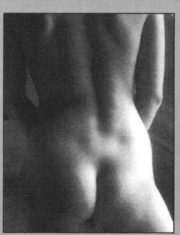

Page 23

NORFOLK 1982
CAMERA 35 mm SLR
LENS 50 mm
FILM Kodak Ektachrome 64
LIGHTING A 500W floodlight was reflected off white walls 3 ft (1 m) away onto the model, who was a further 4 ft (1.25 m) to the left. Strong contrast, with solidity, was produced and shape was accentuated.

Page 22

BETH
CAMERA 35 mm SLR
LENS 135 mm
FILM Kodak Ektachrome 64
LIGHTING Daylight from a window 6 ft (1.75 m) to the right was reflected by the pine walls, giving a pink glow. A soft-focus filter was also used.

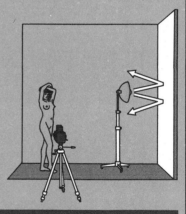

Page 24

MUSCLES
CAMERA Medium-format SLR
LENS 120 mm
FILM Kodak Tri-X Pan
LIGHTING A flash head with an umbrella was set at a height of 9 ft (2.75 m) and angled at 45° to light the model, who was 3 ft (1 m) from the stand. Its light was also reflected onto him from a large reflector on a stand 2 ft (0.5 m) to the left.
A background with muted tones was used.

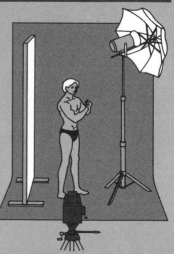

Page 25

KENSINGTON 1984 II
CAMERA Medium-format SLR
LENS 80 mm
FILM Kodak Tri-X Pan
LIGHTING A flash head with an umbrella was set at a height of 7 ft (2.25 m) and angled at 45° to light the model, who was 3 ft (1 m) from the stand. Its light was also reflected onto him by a large reflector, 5 ft (1.5 m) to the left.

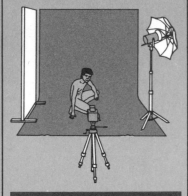

Page 26

DILLY, DUNMOW 1984 I
CAMERA Medium-format SLR
LENS 80 mm
FILM Kodak Tri-X Pan
LIGHTING Direct flash with a shallow integral reflector was aimed from a height of 9 ft (2.75 m) downward at the model, who was 4 ft (1.25 m) from the stand. Form and skin texture were portrayed dramatically.
DARKROOM The print was made on a chlorobromide paper and then sulfide toner was used in order to produce a rich brown. The figure was then masked off from the background and transparent oils and dyes were applied with a brush to the latter.

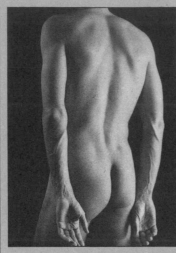

Page 27

DUNMOW 1982
CAMERA Medium-format SLR
LENS 120 mm
FILM Kodak Ektachrome 64
LIGHTING Two 500W floodlights were set up to reflect light onto the model from a 7 ft (2.25 m)-tall hinged screen angled to form three sides of a square, the open side of which was 2 ft (0.5 m) from the model. The close-range light created interesting modeling, with deep shadow areas.

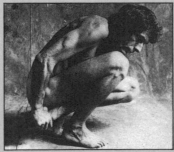

Pages 28–9

CROUCHING MAN
CAMERA Medium-format SLR
LENS 120 mm
FILM Kodak Tri-X Pan
LIGHTING Daylight diffused through a skylight above and to the left of the model emphasized the texture of his skin and hair, while creating deep areas of shadow that add a sense of mystery to the unusual pose.

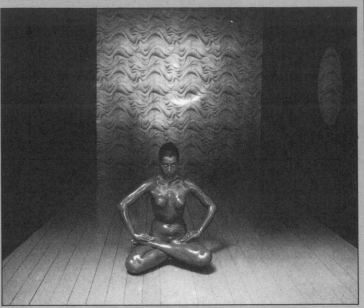

Pages 30–1

BLUE PLASTIC
CAMERA Medium-format SLR
LENS 80 mm
FILM Kodak Ektachrome 64
LIGHTING Daylight from a skylight to the left of the model was reflected onto her and the background by an 8 × 8 ft (2.5 × 2.5 m) screen 10 ft (3 m) in front of her and slightly to the right. In this way she was lit all over, the glycerine creating highlights on her body, while the texture of the background was also clearly shown.

Page 32

BENDING MAN
CAMERA Medium-format SLR
LENS 80 mm
FILM Kodak Tri-X Pan
LIGHTING Strong daylight was diffused through tracing paper over a high window 8 ft (2.5 m) from the model, to produce a dramatic high contrast effect.

Page 33

TACTILE FORM
CAMERA Medium-format SLR
LENS 150 mm
FILM Kodak Tri-X Pan
LIGHTING Three 500W floodlights were reflected from a three-sided white screen onto the model, 6 ft (1.75 m) away, conveying skin texture delicately.

Page 34

BRAMERTON 1984 II
CAMERA 35 mm SLR
LENS 50 mm
FILM 3M 1000 ASA
LIGHTING Slightly diffused evening light from a window 6 ft (1.75 m) to the left of the model and from a skylight gave gentle definition to her skin tone and texture. The high-grain film further softened the image.

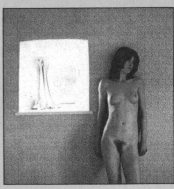

Page 35

ANNABEL I
CAMERA 35 mm SLR
LENS 35 mm
FILM Kodak Ektachrome 160
LIGHTING Two small windows—one to the left of the model and the other facing her at a distance of 8 ft (2.5 m)—provided diffused lighting that showed form and skin texture. Tungsten-balanced film was used in daylight to give a cool blue cast to the scene.

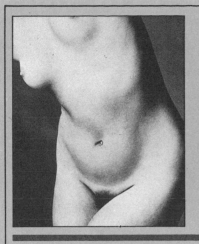

Page 36

VIRGINIA (TORSO SERIES III) I
CAMERA Medium-format SLR
LENS 120 mm
FILM Kodak Tri-X Pan
LIGHTING Daylight from a window 3 ft (1 m) from the model gave strong illumination to her right side. This light was also reflected from a white-painted screen situated to her left and in front of her, so that the lighting was balanced.

Page 37

Left

VIRGINIA (TORSO SERIES III) II
CAMERA Medium-format SLR
LENS 120 mm
FILM Kodak Tri-X Pan
LIGHTING Two angled screens were set up, one 3 ft (1 m) to the left of the model, the other the same distance to the right. The left screen presented a white surface to a 1000W floodlight, reflecting its light onto the model and creating a high-contrast effect. The other screen offered a matt black surface that absorbed light, which had the effect of darkening the front of her body.

Right

KENSINGTON (TORSO SERIES II)
CAMERA Medium-format SLR
LENS 120 mm
FILM Kodak Tri-X Pan
LIGHTING A flash head with a reflective umbrella was set up 3 ft (1 m) to the left, providing strong lighting for the model's front. A black screen the same distance to the right absorbed light from the flash, creating deep shadow on her side and back. A second flash head, to the right, lit the background.

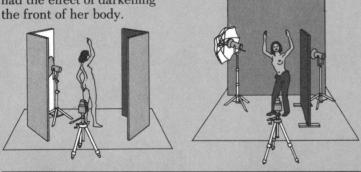

Pages 38–9

ANNABEL II
CAMERA 35 mm SLR
LENS 35 mm
FILM Kodak Ektachrome 64
LIGHTING Two 500W floodlights were positioned 5 ft (1.5 m) in front of the model, slightly to the left of the camera, and angled sharply upward to reflect soft light from the ceiling. Additional diffused light was provided by the small window behind her and another window situated diagonally opposite. The soft light flattened the appearance of the model.

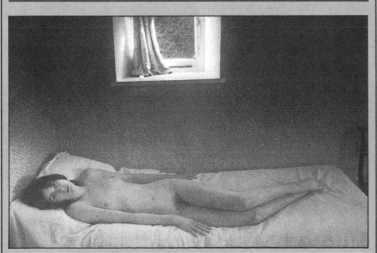

Page 40

HOGLANDS 1966 (TORSO SERIES I)
CAMERA Medium-format SLR
LENS 150 mm (with extension tube for soft focusing)
FILM Kodak Tri-X Pan
LIGHTING A 500W spotlight, directed across the subject from a position 4 ft (1.25 m) to the right produced an intense light that brought out fine detail in the skin.

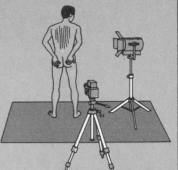

Page 41

KENSINGTON (TORSO SERIES II)
CAMERA Medium-format SLR
LENS 150 mm
FILM Kodak Tri-X Pan
LIGHTING A flash head with a diffusion screen in front was directed at the subject from a distance of 4 ft (1.25 m), to reveal the contrasting textures of skin and hair.

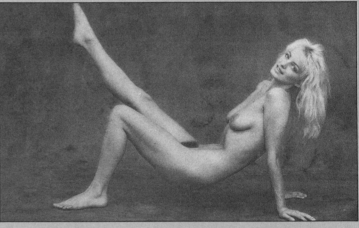

Pages 42–3

KAREN 1983 I
CAMERA Medium-format SLR
LENS 80 mm
FILM Kodak Tri-X Pan
LIGHTING Flash heads were set up either side of the camera, which was 8 ft (2.5 m) from the model, and directed at the ceiling, to reflect light down onto her. This gave high contrast, with the front of the body well lit and the back in shadow.
DARKROOM A contrasty print was made on chlorobromide paper and, after the silver image was partially bleached away, it was washed thoroughly and immersed in a weak thiourea toner to establish the basic colour. A vanadium-based toner was then applied by immersion and brush.

Page 44

HOGLANDS 1966 (TORSO SERIES I)
CAMERA Medium-format SLR
LENS 150 mm
FILM Kodak Tri-X Pan
LIGHTING A 500W spotlight, 6 ft (1.75 m) from the model and the same distance to the left of the camera, provided harsh, high-contrast lighting that accentuated the shot's abstract quality.

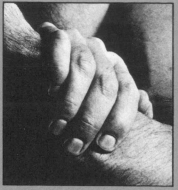

Page 45

KENSINGTON (TORSO SERIES II)
CAMERA Medium-format SLR
LENS 150 mm
FILM Kodak Tri-X Pan
LIGHTING A flash head with an umbrella was set up 2 ft (0.5 m) above the model's left shoulder and directed at a white card on the floor in front of him. This reflected a soft light, showing the texture of the skin and hair.

Page 46

SUSIE-ANN
CAMERA Medium-format SLR
LENS 150 mm
FILM Kodak Ektachrome 64
LIGHTING A 1000W quartz-iodine floodlight with an integral diffuser was directed at the model from 5 ft (1.5 m) away and to the left of the camera. It softened her form and brought out the rich color of the glass door. A blue filter was used on the flood so that daylight film would not produce a yellow cast.

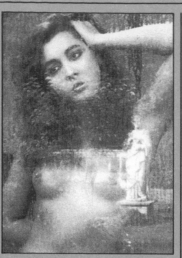

Page 47

DOUBLE IMAGE
CAMERA 35 mm SLR
LENS 50 mm
FILM 3M 1000 ASA
LIGHTING Weak daylight from an overcast sky and diffused through a window gave a soft, dreamlike quality to both the form and the reflections from the garden. A fast film gave high grain and a softness in harmony with the scene.

Page 48

STOCKINGS
CAMERA Medium-format SLR
LENS 60 mm
FILM Kodak Tri-X Pan
LIGHTING A flash head with an umbrella was used at a height of 4 ft (1.25 m) and angled to light the lower half of the model, who was 4 ft (1.25 m) from the stand. It produced attractive modeling and revealed the texture of the skin and the stockings.

Page 49

ABSTRACTION
CAMERA Medium-format SLR
LENS 80 mm
FILM Kodak Plus-X
LIGHTING A 500W spotlight was directed at the subject from a distance of 4 ft (1.25 m), limiting detail and creating an abstract effect.

Pages 50–1

EXTENDED NUDE
CAMERA Medium-format SLR
LENS 60 mm
FILM Kodak Ektachrome 400
LIGHTING Weak daylight from a stormy sky was diffused through a skylight, imparting a muted and yet restless atmosphere to this scene of desolation.

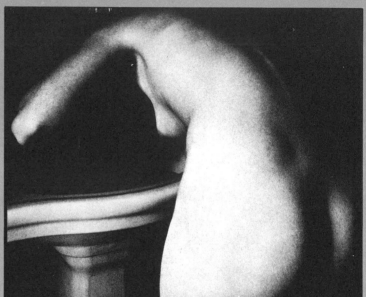

Page 53

ANNE, MONTREUIL, FRANCE II
CAMERA Medium-format SLR
LENS 60 mm

Page 52

ANNE, MONTREUIL, FRANCE I
CAMERA Medium-format SLR
LENS 80 mm
FILM Kodak Tri-X Pan
LIGHTING Daylight diffused through a north-facing skylight behind and slightly to the left of the camera gave moderate contrast with a flattering degree of modeling.

FILM Kodak Tri-X Pan
LIGHTING Daylight from a window 4 ft (1.25 m) from the model emphasized her shape and her skin's texture.

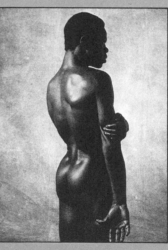

Page 54

DILLY, DUNMOW 1984 II
CAMERA Medium-format SLR
LENS 80 mm
FILM Kodak Ektachrome 64
LIGHTING Two undiffused flash heads were used—one, 4 ft (1.25 m) to the left of and slightly behind the subject, was angled downward at 45° from a height of 8 ft (2.5 m) to light his back powerfully; the other, concealed by the model, was set at a height of 1½ ft (0.5 m) to light the background from a distance of 6 ft (1.75 m).

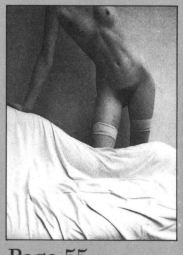

Page 55

BRAMERTON 1984 III
CAMERA 35 mm SLR
LENS 35 mm
FILM 3M 1000 ASA
LIGHTING The model received slightly diffused daylight from a window situated 6 ft (1.75 m) to the left as well as light from a skylight. This soft illumination had the double effect of defining her form and revealing the attractive texture of her skin. High-grain film was used in order to increase the soft quality of the picture.

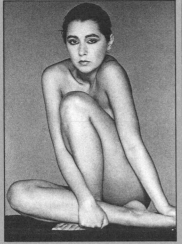

Page 56

TRACY, DUNMOW 1983
CAMERA Medium-format SLR
LENS 80 mm
FILM Kodak Tri-X Pan
LIGHTING Hard, frontal
windowlight showed the form
of the model, while black
screens 6 ft (1.75 m) to each
side absorbed light, giving
her a dark outline.

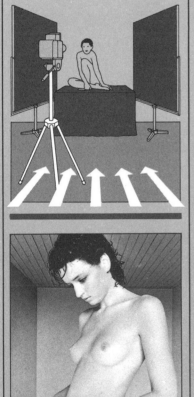

Page 57

RACHEL 1983
CAMERA Medium-format SLR
LENS 120 mm
FILM Kodak Tri-X Pan
LIGHTING Frontal daylight
diffused through tracing
paper over a window 7 ft
(2.25 m) from the model gave
a low-contrast effect that
suited her shape and the
delicate pose.

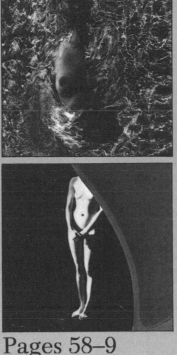

Pages 58–9

MANIPULATION I and **FRAGMENT**
The emulsion on the instant-
picture print on the left was
manipulated, while the print
on the right is the result of
faulty development.

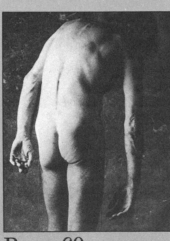

Page 60

STOOPING MAN
CAMERA Medium-format SLR
LENS 80 mm
FILM Kodak Tri-X Pan
LIGHTING Strong daylight from
a window 4 ft (1.25 m) to the
left of the model created a
highlit area on that side of his
body. It was also reflected
onto his right side, where it
had a softer effect, by a white
reflector 4 ft (1.25 m) behind
him and slightly to the right.

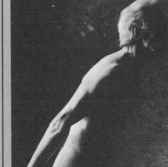

Page 64

LIFE MODEL
CAMERA Medium-format SLR
LENS 120 mm
FILM Kodak Tri-X Pan
LIGHTING A window situated
3 ft (1 m) behind the model
provided strong daylight
which created a highlit effect
on his back. Light was also
reflected onto the model's
front by a white screen 2 ft
(0.5 m) in front of him and
angled slightly downward, in
order to leave his face in
concealing shadow.

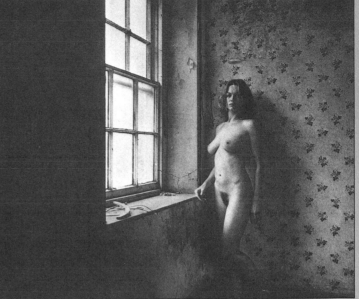

Pages 62–3

SARAH, DORSET 1983 I
CAMERA Medium-format SLR
LENS 60 mm
FILM Kodak Tri-X Pan
LIGHTING Harsh daylight
entering the room from a
window close to the model
created strong contrast.
DARKROOM The print was
made on a chlorobromide
paper. It was first given a
sepia toning, then hand
colored with transparent oils
and dyes.

Page 65

ST IVES 1983
CAMERA Medium-format SLR
LENS 60 mm
FILM Kodak Tri-X Pan
LIGHTING Weak daylight from
a cloudy sky was diffused
through a partly covered
window parallel with the
model's position, creating
gentle modeling.

Page 66

WOMAN IN WHITE
CAMERA 35 mm SLR
LENS 100 mm
FILM Kodak Ektachrome 64
LIGHTING Daylight from a
window 12 ft (3.75 m) behind
and slightly to the left of the
model revealed subtle detail.

Page 67

THE BLUE TOWEL
CAMERA 35 mm SLR
LENS 135 mm
FILM Kodak Ektachrome 64
LIGHTING Strong, frontal
daylight from a window
revealed the surface quality
of the face and breasts.

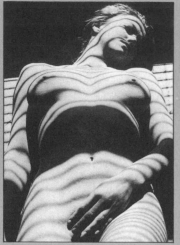

Page 68

SARAH, DORSET 1983 II
CAMERA Medium-format SLR
LENS 80 mm
FILM Kodak Tri-X Pan
LIGHTING Strong windowlight
filtered through a Venetian
blind formed a bold pattern
on the model's body.

Page 69

REPOSE
CAMERA Medium-format SLR
LENS 80 mm
FILM Kodak Tri-X Pan
LIGHTING Evening light from a
window to the left of the
model created a distinct
pattern of bars on the floor
of the room. This light
illuminated most of the
girl's face but left it partly
in gentle shadow.

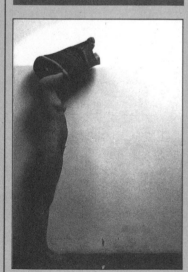

Page 70

CAROLINE
CAMERA 35 mm SLR
LENS 50 mm
FILM Kodak Ektachrome 64
LIGHTING The light of the
setting sun was diffused
through a small, circular
window 30 ft (9 m) to the left
of the model. The high
window lit her indistinctly,
but produced an elliptical
patch of light on the wall.

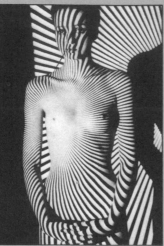

Page 71

RACHEL 1984
CAMERA 35 mm SLR
LENS 100 mm
FILM 3M 640T (tungsten)

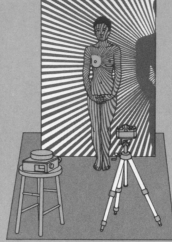

LIGHTING A projector 12 ft
(3.75 m) from the model cast
a pattern from a transparency
over her entire body, at the
same time providing strong
frontal lighting.

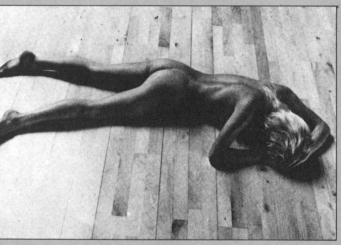

Pages 72–3

KAREN 1983 II and III
CAMERA Medium-format SLR
LENS 60 mm
FILM Kodak Tri-X Pan

LIGHTING Strong sunlight from
a skylight created a light
patch in the left-hand
picture. Diffused light from a
cloudy sky increased the
detail in the right-hand shot.

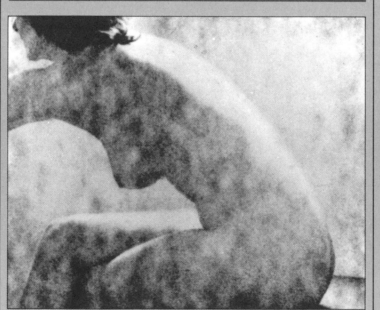

Pages 74–5

CATHERINE, DUNMOW
CAMERA Medium-format SLR
with instant-picture film back
LENS 80 mm

FILM Polaroid
LIGHTING Strong daylight
from a window just behind
the model, combined with
the use of out-of-date film,
gave an unexpected result.

PAM, DUNMOW 1983 I
CAMERA Medium-format SLR
LENS 80 mm
FILM Kodak Tri-X Pan
LIGHTING Daylight diffused
through a skylight gave subtle
definition to the form.

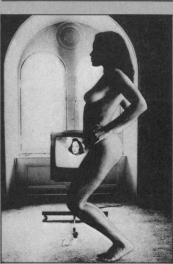

Page 78

BRADFORD 1972 I
CAMERA Medium-format SLR
LENS 60 mm
FILM Kodak Tri-X Pan
LIGHTING Daylight from a
large window 6 ft (1.75 m)
behind the model and
another the same distance to
the right silhouetted,
respectively, her face and the
front of her body.

Page 79

PREPARATION
CAMERA Medium-format SLR
LENS 80 mm
FILM Kodak Tri-X Pan
LIGHTING Daylight from a
window just behind the
model was reflected from the
walls of the room to give
definition to her form. In
order to offset the tendency
of backlighting to place the
subject in shadow, one stop
of extra exposure was used.

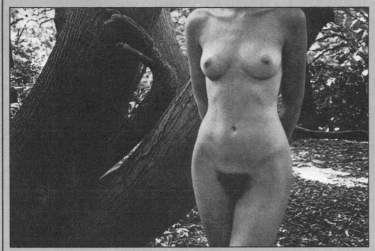

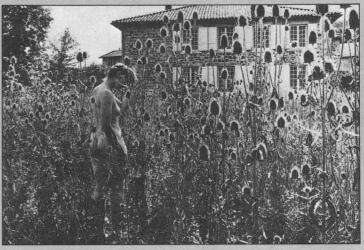

Pages 80–1

CROW WOODS I
CAMERA Medium-format SLR
LENS 60 mm

FILM Kodak Tri-X Pan
LIGHTING Weak daylight diffused through the trees produced gentle modeling in the figure.

Pages 86–7

ANNE, RETOURNAC, FRANCE I
CAMERA Medium-format SLR
LENS 80 mm

FILM Kodak Tri-X Pan
LIGHTING Backlight from an evening sun gave a soft halo to the model and to the heads of the teasels.

Page 82

THE MANNEQUINS
CAMERA Medium-format SLR
LENS 80 mm
FILM Kodak Tri-X Pan
LIGHTING Daylight from a window 9 ft (2.75 m) in front of the couple showed the form of the man. Shallow focus disguised the mannequin's texture.

Page 83

DOLL
CAMERA
Medium-format SLR
LENS 100 mm
FILM Kodak Tri-X Pan
LIGHTING Daylight diffused through tracing paper over a window 9 ft (2.75 m) to the left created flattering shadow in the face.

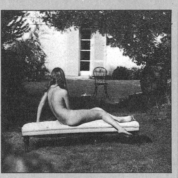

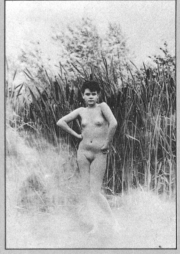

Page 88

LINDY, FRANCE 1975 II
CAMERA Medium-format SLR
LENS 80 mm
FILM Kodak Tri-X Pan
LIGHTING Diffused daylight from a slightly cloudy sky produced gentle modeling, giving the girl an attractive sculptural appearance.

Page 90

EMMA 1983
CAMERA Medium-format SLR
LENS 80 mm
FILM Kodak Tri-X Pan
LIGHTING Toplight from a cloudy sky was diffused by early-morning mist, creating a subtle definition of form.

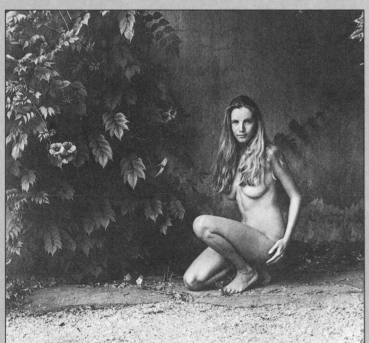

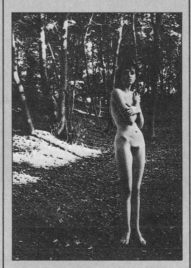

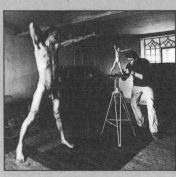

Pages 84–5

LINDY, FRANCE 1975 I
CAMERA Medium-format SLR
LENS 80 mm
FILM Kodak Tri-X Pan
LIGHTING Strong sidelight from an afternoon sun gave good definition to the model's form and its ability to reveal detail was accentuated by the use of a silver reflector that was set up 6 ft (1.75 m) in front of her and slightly to the right.

Page 89

CROW WOODS II
CAMERA Medium-format SLR
LENS 80 mm
FILM Kodak Tri-X Pan
LIGHTING The low-angle light of a sunny autumn afternoon was diffused through the trees, softening the form.

Page 91

THE SCULPTOR'S MODEL
CAMERA Medium-format SLR
LENS 60 mm
FILM Kodak Tri-X Pan
LIGHTING Daylight diffused through windows to the left of the model and behind the sculptor underlined the tautness in the nude body.

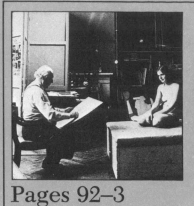

Pages 92–3

LIFE STUDIES
CAMERA Medium-format SLR
LENS 60 mm
FILM Kodak Tri-X Pan

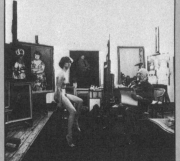

LIGHTING Afternoon light from a north-facing skylight provided clear, stable, illumination of which the artists and the photographer took advantage.

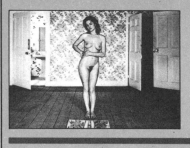

Page 94

SARAH, DORSET 1983 III
CAMERA Medium-format SLR
LENS 60 mm
FILM Kodak Tri-X Pan
LIGHTING Daylight from two large windows facing the model gave good definition.

Page 95

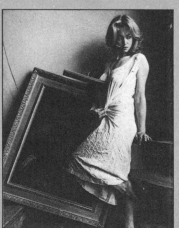

SARAH, DORSET 1983 IV
CAMERA Medium-format SLR
LENS 80 mm
FILM Kodak Tri-X Pan
LIGHTING Daylight provided by a large window at the top of the stair revealed extensive detail in the model's skin and in the dress. The tightness of the fabric accentuated her form attractively, giving immediacy to an otherwise rather distant mood.

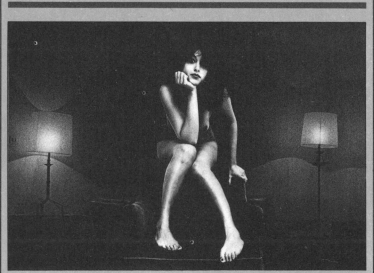

Pages 96–7

BRADFORD 1972 II
CAMERA 35 mm SLR
LENS 28 mm
FILM Kodak Tri-X Pan
LIGHTING Two domestic tungsten lamps lit the background, while the model was lit by a television 6 ft (1.75 m) away.

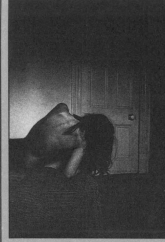

Page 98

RENTED ROOM
CAMERA Medium-format SLR
LENS 80 mm
FILM Kodak Tri-X Pan
LIGHTING Weak, evening light diffused through a window behind the model gave a low-key effect to the scene. The subdued lighting was well suited to the task of conveying the dejection of the model.

Page 99

THE PAINTER'S MODEL
CAMERA Medium-format SLR
LENS 80 mm
FILM Kodak Tri-X Pan
LIGHTING Backlight from French windows behind the model and sidelight from a large window 3 ft (1 m) to the right created a dramatic high-contrast effect.

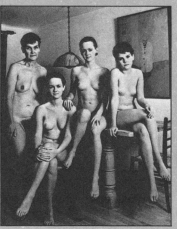

Page 100

FAMILY, 1983
CAMERA Medium-format SLR
LENS 60 mm
FILM Kodak Tri-X Pan
LIGHTING Two 500W floodlights were positioned either side of the camera, 6 ft (1.75 m) from the models. The lamps bounced soft, indirect light onto the group from the ceiling and the walls facing them.

Page 101

BODY JEWELRY
CAMERA Medium-format SLR
LENS 80 mm
FILM Kodak Tri-X Pan
LIGHTING Daylight diffused through a skylight facing the models depicted form and detail vividly.

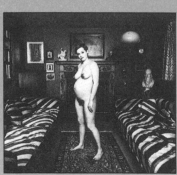

Pages 102–3

MOTHER WITH CHILD
CAMERA Medium-format SLR
LENS 60 mm
FILM Kodak Tri-X Pan
LIGHTING The model's form was revealed from a distance of 8 ft (2.5 m) by an on-camera flashgun with a swiveling head. Its light was bounced from the ceiling just in front of her.

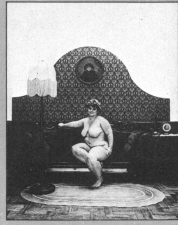

Page 104

PAM, DUNMOW 1983 II
CAMERA Medium-format SLR
LENS 60 mm
FILM Kodak Tri-X Pan
LIGHTING Daylight diffused through a high window facing the model and at a distance of 10 ft (3 m) softened her form and gently depicted her skin tones.

PERCEPTION AND RESPONSE

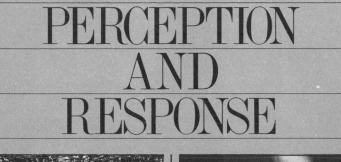

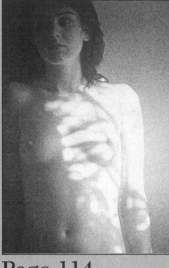

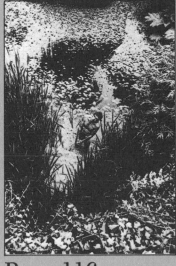

Page 106

MANIPULATION II
A standard instant-picture camera was used for this shot. The emulsion on the print was manipulated while it was still soft. The film used has since been replaced by a faster-developing material which does not permit experimentation of this kind.

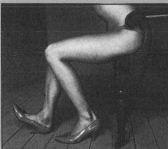

Page 107

DUNMOW 1984
CAMERA Medium-format SLR
LENS 80 mm
FILM Kodak Ektachrome 64
LIGHTING The model received direct daylight from a window just behind the camera, which was 6 ft (1.75 m) from her. This lighting revealed the texture of the skin and depicted its tones attractively.

Page 114

PATTERN
CAMERA 35 mm SLR
LENS 50 mm
FILM Kodak Ektachrome 64
LIGHTING Strong, evening light from a window 4 ft (1.25 m) to the right of the model projected a vivid pattern of foliage onto her body.

Page 116

RICHARD, DUNMOW 1983
CAMERA Medium-format SLR
LENS 60 mm
FILM Kodak Tri-X Pan
LIGHTING Weak daylight from an overcast sky lit the pattern of leaves with a gloomy light, creating an uneasy atmosphere.

Page 117

PATRICIA, THETFORD CHASE 1983
CAMERA Medium-format SLR
LENS 80 mm
FILM Kodak Tri-X Pan
LIGHTING A low evening sun backlit the model, creating a halo around her hair and giving the wood a soft appearance. Exposure was increased by 1½ stops to offset the tendency of backlight to lead to underexposure of the main subject.

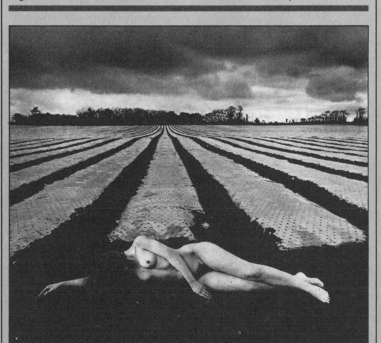

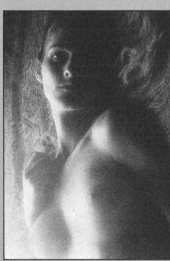

Pages 108–9

HOLLESLEY 1983
CAMERA Medium-format SLR
LENS 80 mm
FILM Kodak Tri-X Pan
LIGHTING Toplight from a stormy sky gave a restless, brooding atmosphere to the scene.

Page 115

TULA I
CAMERA 35 mm SLR
LENS 135 mm
FILM Kodak Ektachrome 64
LIGHTING A shaft of light from a window 6 ft (1.75 m) to the left (in this orientation) lit the model softly. In addition, a white reflector 3 ft (1 m) to the other side of her head and a second 4 ft (1.25 m) from the upper part of her body reflected back light that passed over her.

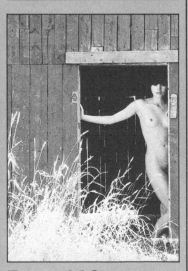

Pages 110–11

THE MAN AT THE WINDOW
CAMERA 35 mm SLR
LENS 50 mm
FILM Kodak Ektachrome 64
LIGHTING Daylight diffused through thin cloud revealed the form and the variation in the skin texture

Pages 112–13

CROW WOODS III
CAMERA Medium-format SLR
LENS 80 mm
FILM Kodak Tri-X Pan
LIGHTING Late-afternoon light diffused through the trees provided a gentle definition of form.

Page 118

TRONDHEIM 1980 I
CAMERA 35 mm SLR
LENS 55 mm
FILM Kodak Ektachrome 64
LIGHTING Bright sunlight, both direct and reflected from the area in front of the door, gave even lighting to the model's face and body.

Page 119

TRONDHEIM 1980 II
CAMERA 35 mm SLR
LENS 28 mm
FILM Kodak Ektachrome 64
LIGHTING Strong afternoon light produced extensive shadow that contrasts with the isolated tone of the model's skin.

Page 120

LACE, CASTLE HOWARD, YORKSHIRE
CAMERA Medium-format SLR
LENS 120 mm
FILM Kodak Tri-X Pan
LIGHTING Daylight from a large window behind the camera gave strong illumination, defining form and revealing the texture of both skin and lace.

Page 121

CLAUDIA
CAMERA Medium-format SLR
LENS 80 mm
FILM Kodak Tri-X Pan
LIGHTING Four 250W floodlights in a unit with an integral plastic diffusing screen cast a strong light on the front of the model, contrasting the textures of her skin and the petticoat. A white reflector positioned 4 ft (1.25 m) to the right threw back enough light to soften the appearance of the shadow side.

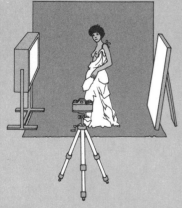

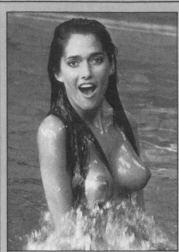

Page 122

TULA II
CAMERA 35 mm SLR
LENS 85 mm
FILM Kodak Ektachrome 64
LIGHTING Daylight diffused through a glazed wall gave distinct modeling and emphasized the texture of the wet skin.

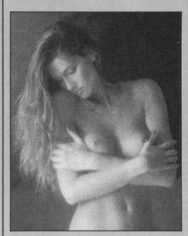

Page 123

TULA III
CAMERA 35 mm SLR
LENS 85 mm
FILM Kodak Ektachrome 64
LIGHTING Two 500W floodlights were diffused through a white bedsheet 3 ft (1 m) in front of the model and to the left of the camera. Their soft effect was echoed by light from a white reflector in a corresponding position to the right.

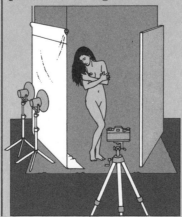

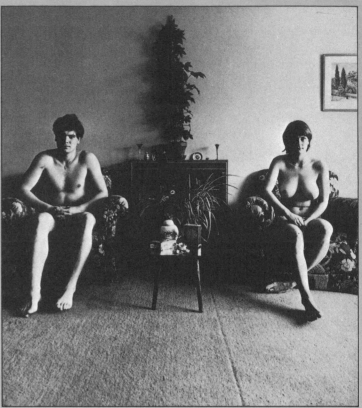

Pages 124–5

BROTHER AND SISTER 1984
CAMERA Medium-format SLR
LENS 60 mm
FILM Kodak Tri-X Pan

LIGHTING Daylight from a picture window situated 6 ft (1.75 m) to the right of the girl created pleasing modeling and tonal contrast in both models.

Page 126

**WISH YOU WERE HERE—
LOVE, MIRIAM**
CAMERA 35 mm SLR
LENS 50 mm
FILM Kodak Ektachrome 64
LIGHTING Strong daylight from a cloudless sky created attractive tonal contrast in the model's skin.

Page 127

**HOW I SAW MYSELF ON A
CALENDAR—KAREN**
CAMERA 35 mm SLR
LENS 85 mm
FILM Kodak Ektachrome 64
LIGHTING Daylight from a window behind the camera revealed the texture of skin and fabric in detail.

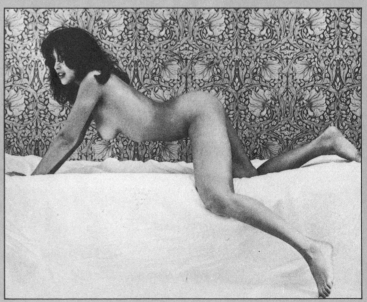

Pages 128–9

THE BED
CAMERA Medium-format SLR
LENS 80 mm
FILM Kodak Tri-X Pan
LIGHTING Strong daylight

provided by large windows facing each end of the bed gave even, overall lighting to the model, the bedsheet, and the wallpaper, emphasizing and contrasting their tones and textures.

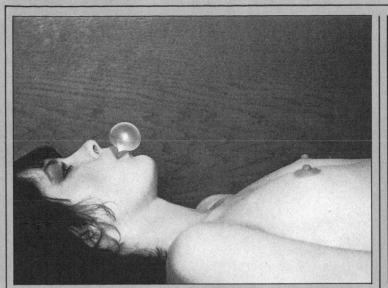

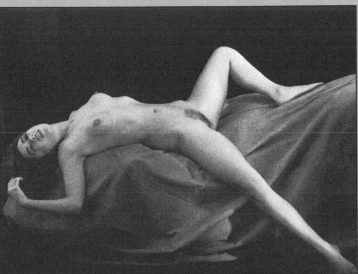

Pages 130–1

NORWAY 1978
CAMERA 35 mm SLR
LENS 85 mm
FILM Kodak Ektachrome 64
LIGHTING A flash head positioned just to the left of the camera, 6 ft (1.75 m) from the model, was aimed at the ceiling to bounce light down onto her, for a bright, evenly lit result.

Pages 138–9

TRACY
CAMERA 35 mm SLR
LENS 35 mm
FILM 1000 ASA
LIGHTING Daylight through balcony doors threw an even light onto the model. A 4 ft (1.25 m) square silver reflector was positioned 4 ft (1.25 m) behind her head to give additional light.

Pages 132–3

DREAMING
CAMERA Medium-format SLR
LENS 60 mm
Film Kodak Tri-X Pan
LIGHTING Daylight from a clear sky produced the short, strong shadows characteristic of the middle of the day.

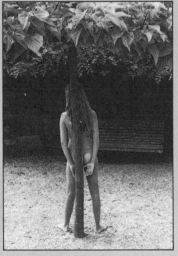

Page 135

LINDY, ST TROPEZ 1975
CAMERA 35 mm
LENS 35 mm
FILM Kodak Ektachrome 64
LIGHTING Midday sun provided bright lighting with short shadows.

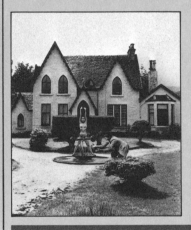

Page 140

MORNING EXERCISE
CAMERA Medium-format SLR
LENS 80 mm
FILM Kodak Tri-X Pan
LIGHTING In this montage comprising three prints, daylight through a thin covering of cloud produced weak shadows that defined the model's form. The house in the background and the gardener in the foreground were shot by a similar light.

FANTASY AND ILLUSION

Page 134

EMMA, BALI 1977
CAMERA 35 mm SLR
LENS 50 mm
FILM Kodak Ektachrome 64
LIGHTING Daylight through a thin covering of cloud created areas of moderate shadow that flattered the form.

Pages 136–7

JUDY
CAMERA Medium-format SLR
LENS 80 mm
FILM Kodak Tri-X Pan
LIGHTING Daylight through the door of the stable produced strong contrast, enhancing the scene's dramatic quality. A slow shutter speed was used in order to convey as a blur the frenzied movement of the horse's neck.

Page 142

DILLY'S DREAM
CAMERA Medium-format SLR
LENS 80 mm
FILM Kodak Ektachrome 64
LIGHTING Two flash heads, one either side of the camera and at a distance of 8 ft (2.5 m) from the model, were used. The left-hand flash provided direct lighting, creating a strong shadow, while the other was used to bounce light off the ceiling onto the group.

Page 143

SHROUD
CAMERA 35 mm SLR
LENS 100 mm
FILM Kodak Ektachrome 64
LIGHTING Daylight through a glazed wall 4 ft (1.25 m) to the right of the model provided strong lighting that revealed the texture of her skin and hints at the form of the enigmatic face. The brightness of the shroud contrasts dramatically with the skin tones.

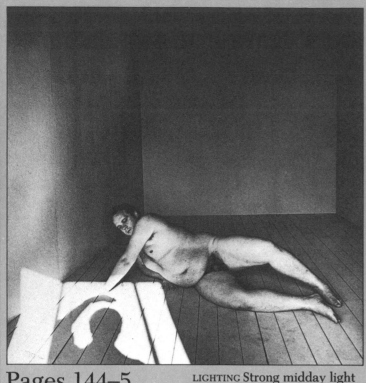

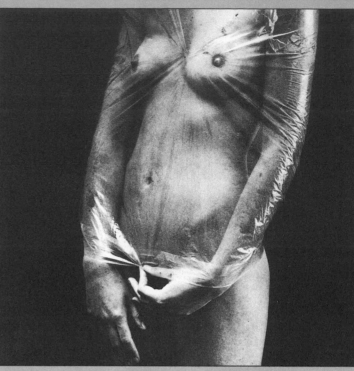

Pages 144–5

PHILIP
CAMERA Medium-format SLR
LENS 80 mm
FILM Kodak Tri-X Pan

LIGHTING Strong midday light from a high window silhouetted the photographer and minimized detail in the model's form, emphasizing his shape instead.

Pages 146–7

KAREN 1983 IV
CAMERA 35 mm SLR
LENS 28 mm
FILM 3M 1000 ASA
LIGHTING Daylight from a glazed wall along one side of the pool was diffused by the water, producing a soft effect which was enhanced by the use of a high-grain film.

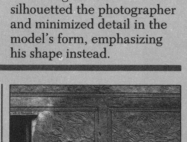

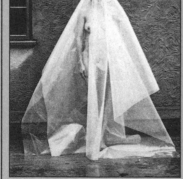

Page 149

THE BRIDE
CAMERA Medium-format SLR
LENS 80 mm
FILM Kodak Tri-X Pan
LIGHTING Strong light from an overcast sky penetrated the folds of the veil, revealing the form beneath.

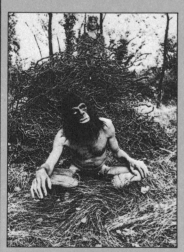

Page 148

MASKED IDENTITY
CAMERA Medium-format SLR
LENS 60 mm
FILM Kodak Tri-X Pan
LIGHTING Daylight diffused through light cloud gave moderate definition, so that attention is drawn to the fantasy element of the picture rather than to the study of form and texture.

Pages 150–1

SHINGLE STREET, NORFOLK 1983
CAMERA Medium-format SLR
LENS 80 mm
FILM Kodak Tri-X Pan
LIGHTING Daylight from a stormy sky gave a heavy, mysterious atmosphere to the background in this composite print. The model was shot by flash. The two images were then carefully merged.

Pages 152–3

PLASTIC-WRAPPED
CAMERA Medium-format SLR
LENS 150 mm
FILM Kodak Tri-X Pan
LIGHTING Two 500W floodlights were positioned 6 ft (1.75 m) to the right of the model, one slightly in front of her, the other slightly behind. She also received reflected light from a white wall 6 ft (1.75 m) to the left.

A dark background was used to intensify the presence of the model.

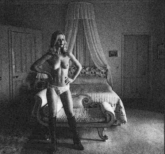

Pages 154–5

HUNTINGDON 1976 I and II
CAMERA Medium-format SLR
LENS 80 mm
FILM Kodak Ektachrome 64
LIGHTING Late-afternoon light from a window 10 ft (3 m) to the right of the subject created attractive modeling of the face in both pictures and of the nude form.

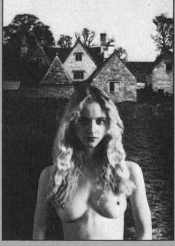

Pages 156–7

GABRIELLE
CAMERA 35 mm SLR
LENS Page 156: 28 mm; page 157: 35 mm
FILM Kodak Tri-X pan
LIGHTING Page 156: The model in this montage was lit by daylight from an overcast sky, the background by daylight through thin cloud.
Page 157: The model in the right-hand montage was lit by strong frontal daylight through a window, the room by similar light.

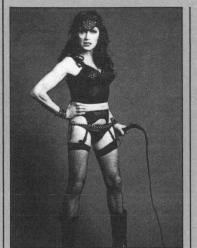

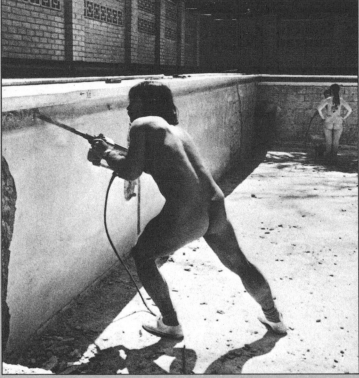

Page 158

DICKIE
CAMERA Medium-format SLR
LENS 80 mm
FILM Kodak Ektachrome 64
LIGHTING A flash head with an umbrella was pointed upward at an angle of 45° and directed diagonally at the left side of the model from a distance of 6 ft (1.75 m) and a height of 8 ft (2.5 m). It produced even, overall light.

Pages 160–1

KENT, APRIL 1984
Seated man
CAMERA Medium-format SLR
LENS 60 mm
FILM Kodak Tri-X Pan
LIGHTING Indirect daylight created gentle modeling of the man's form.

Man and machine
CAMERA Medium-format SLR
LENS 80 mm
FILM Kodak Tri-X Pan
LIGHTING Daylight through a plastic roof gave moderate definition of form.

Woman and trailer
CAMERA Medium-format SLR
LENS 80 mm
FILM Kodak Tri-X Pan
LIGHTING Strong frontal daylight provided even overall lighting.

Man with drill
CAMERA 35 mm SLR
LENS 80 mm
FILM Kodak Tri-X Pan
LIGHTING Bright daylight allowed the use of a small aperture for a good depth of field, so that detail was shown in both the man and the girl in the background.

Pages 164–5

ANNE, RETOURNAC, FRANCE III
CAMERA Medium-format SLR
LENS 80 mm
FILM Kodak Tri-X Pan
LIGHTING Daylight diffused through the trees softened the image.
DARKROOM The print was made from three negatives onto one sheet of paper. Each negative needed a different contrast paper, but gradation was controlled through bleaching, intensification, and a final sepia toning which married the three images.

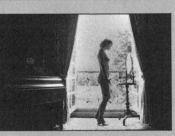

Pages 166–7

THE BALCONY
CAMERA 35 mm SLR
LENS 28 mm
FILM Kodak Ektachrome 64
LIGHTING Strong daylight provided a brilliant background and gilded the model attractively.

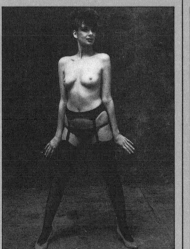

Page 159

VIRGINIA 1983
CAMERA Medium-format SLR
LENS 80 mm
FILM Kodak Ektachrome 64
LIGHTING Weak daylight through a skylight gave the picture a moody, low-key atmosphere.

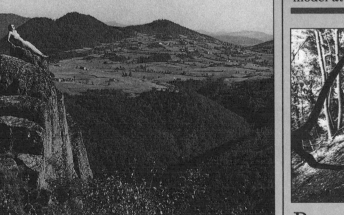

Pages 162–3

ANNE, RETOURNAC, FRANCE II
CAMERA Medium-format SLR
LENS 80 mm
FILM Kodak Tri-X Pan
LIGHTING Late-afternoon light produced high contrast, lending a dramatic quality to the scene.

DARKROOM The print was made on a chlorobromide paper. It was bleached back to half its tonal value, leaving solid blacks and bleached-out highlights. A thiourea toner added warmth and then a vanadium toner was applied by immersion and brush to achieve the final tones.

Pages 168–9

CROW WOODS IV
CAMERA Medium-format SLR
LENS 60 mm
FILM Kodak Tri-X Pan
LIGHTING Daylight diffused through the trees produced soft shadows.
PRINTING Line conversion was used to produce a mezzotint.

Pages 170–1

FOUND IMAGES
CAMERA 35 mm SLR
LENS 100 mm (macro)
FILM Kodak Ektachrome 200
LIGHTING Overcast light emphasized color and detail.

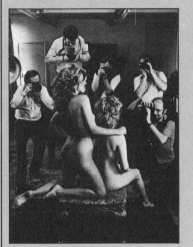

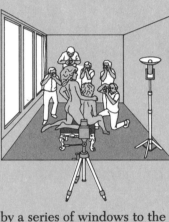

Page 172

PHOTO SESSION
CAMERA Medium-format SLR
LENS 60 mm
FILM Kodak Tri-X Pan
LIGHTING Daylight provided

by a series of windows to the left of the group and by a 500W floodlight to the right of the camera, set to bounce light off the ceiling, revealed the form and skin texture of the models. This combination of sources also lit the photographers clearly.

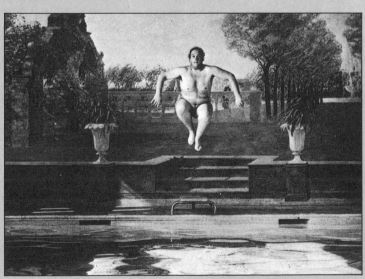

Page 173

LEVITATION
CAMERA Medium-format SLR
LENS 120 mm
FILM Kodak Tri-X Pan

LIGHTING Daylight diffused through a glazed wall along one side of the pool showed gentle modeling in the diver and revealed detail in the background.

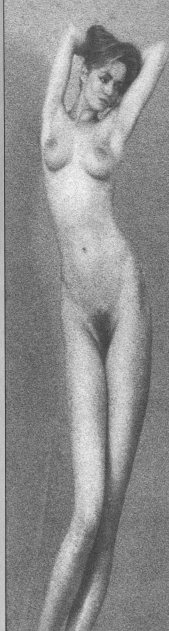

Pages 174–5

DISTORTIONS
CAMERA 35 mm SLR
LENS 85 mm
FILM 3M 640T (tungsten)
LIGHTING A 500W floodlight was used to bounce light off a white wall and onto the model, who was facing a flexible mirror supported by a chair. The camera recorded the distorted image given by the mirror from a distance of 6 ft (1.75 m).

Pages 176–7

HAIR
CAMERA Medium-format SLR
LENS Page 176: 80 mm; page 177: 120 mm
FILM Kodak Tri-X Pan
LIGHTING Page 176: Weak daylight produced subtle definition in the model and the background. Page 177: Early-morning light diffused by mist emphasized the texture of the model's hair.

Page 178

LINDY I
CAMERA Medium-format SLR
LENS 60 mm
FILM Kodak Tri-X Pan
LIGHTING Strong sunlight entered the room through French windows facing the model at a distance of 12 ft (3.75 m), producing bright, even lighting.

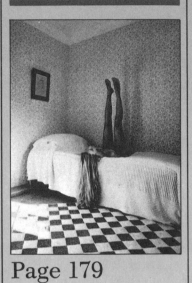

Page 179

LINDY II
CAMERA Medium-format SLR
LENS 80 mm
FILM Kodak Tri-X Pan
LIGHTING Strong sunlight from French windows to the left of the model gave soft illumination and was reflected from the white walls of the room.

Page 180

TRACY'S DREAM
CAMERA Medium-format SLR
LENS 60 mm
FILM Kodak Tri-X Pan
LIGHTING Diffused light from a skylight to the right of the model was reflected onto her by a 6 ft × 3 ft (1.75 m × 1 m) plastic mirror to the left of the camera and forming a 45° angle with it. Artificial light— 12 500W floodlamps in a large unit with an integral plastic diffusing screen—was used in a corresponding position to the right of the camera to increase the definition of the model's form and to light the background.

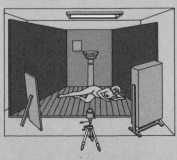

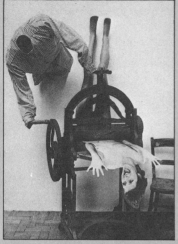

Page 181

THE SHIRT'S REVENGE
CAMERA Medium-format SLR
LENS 60 mm
FILM Kodak Tri-X Pan
LIGHTING Daylight diffused
through a skylight revealed
sufficient detail in the cut-out
nude to give the scene a
disquietingly realistic quality.

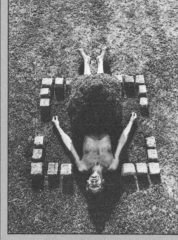

Pages 182–3

REFLECTION and **GRASS PYRAMID**
CAMERA Medium-format SLR
LENS 60 mm
FILM Kodak Tri-X Pan
LIGHTING Strong mid-
afternoon light produced a
high-contrast effect that
emphasized the austerity of
the poses.

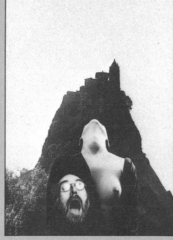

Page 188

THE SCREAM
CAMERA Medium-format SLR
LENS Head: 80 mm; model
and background: 60 mm
FILM Kodak Tri-X Pan
LIGHTING For this montage
the man's head was shot by
flash, while the model was lit
by overcast daylight.

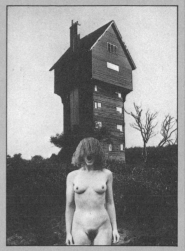

Page 189

THE HOUSE IN THE CLOUDS
CAMERA Medium-format SLR
LENS Model: 80 mm; house:
60 mm
FILM Kodak Tri-X Pan
LIGHTING For this montage the
model was lit by diffused
flash and the house was shot
by hazy daylight.

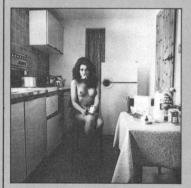

Pages 184–5

**TRACY SMOKES AT LEAST EIGHTY
CIGARETTES A DAY** and **TRACY'S
MOTHER-IN-LAW IS COMING TO TEA**

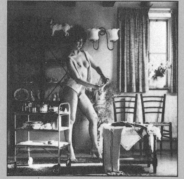

CAMERA Medium-format SLR
LENS 80 mm
FILM Kodak Tri-X Pan
LIGHTING Sidelight provided
strong modeling.

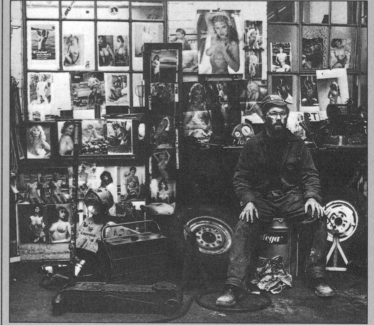

Pages 190–1

THE MECHANIC
CAMERA Medium-format SLR
LENS 60 mm

FILM Kodak Tri-X Pan
LIGHTING Daylight from a
glass roof revealed detail in
the images on the wall and
gave definition to the man.

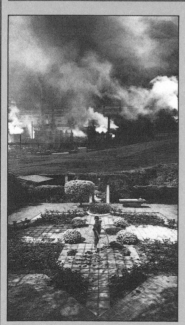

Pages 186–7

**TRACY SAYS: "GARDENING IS JUST
LIKE DOING THE HOUSEWORK,
ONLY OUTDOORS."**

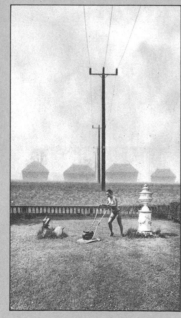

CAMERA Medium-format SLR
LENS 60 mm
FILM Kodak Tri-X Pan
LIGHTING Directional daylight
was used in both montages.

Page 192

KAREN
CAMERA 35 mm SLR
LENS 100 mm
FILM 3M 1000 ASA
LIGHTING A window 5 ft
(1.5 m) to the left of the
model gave a gentle, low
light, while a mirror on the
wall the same distance to her
right reflected light back onto
her. Fast film softened the
effect still more. This
monochrome print was made
from a color transparency
by means of an interneg.

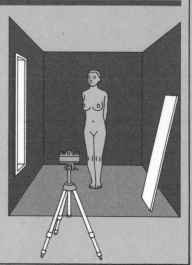

The 35 mm SLR (single lens reflex) is a versatile camera and is particularly well suited to nude photography, which, in its most rewarding form, involves experiments with subtle lighting and embraces a wide range of indoor and outdoor settings.

The SLR, unlike compact cameras and large-format models, allows you to see the subject exactly as the lens will capture it. Its TTL (through-the-lens) viewing aids accurate framing and focusing and keeps you in close contact with the subject until the shutter is released. With most SLRs you can also preview the depth of field—the amount of the scene that will be in sharp focus at a given aperture.

MEDIUM-FORMAT CAMERAS

The sensitive exposure systems characteristic of the SLR give you a choice of exposure control from completely manual, through semi- and fully automatic, to multimode, in which you select the degree of automation you require. Most photographers opt for some automation, if only to save time and effort. With a manual camera you follow the built-in meter's exposure indications, or override them in the case of problematic lighting or for special effects. In every case you set both aperture and shutter speed. A semi-automatic model does half the work for you, automatically selecting either aperture or shutter speed and leaving you to make the complementary setting. A fully automatic, or programmed, camera makes both settings, freeing you even more to concentrate on the framing and composition of your picture. The multi-mode goes further still in giving you a choice of as many as eight exposure systems to suit all lighting conditions, whether natural or artificial.

Apart from accurate viewing and sensitive light metering, the 35 mm SLR has the great advantage of a wide choice of interchangeable lenses. This allows you to picture a scene in a variety of ways, increasing or decreasing the area of vision, spreading out or telescoping the picture elements, and radically altering the depth of field, without changing your position in relation to the subject. Naturally, if you change both lens and viewpoint you have still more options.

SLR EXPOSURE SYSTEMS

Less popular than the 35 mm SLR, but still widely used, particularly for studio work, is the medium-format SLR. This gives an image of $2\frac{1}{4} \times 2\frac{1}{4}$ ins (6×6 cm) or, less commonly, of $2\frac{1}{4} \times 2\frac{3}{4}$ ins (6×7 cm) or $1\frac{1}{2} \times 2\frac{1}{4}$ ins (4.5×6 cm). A $2\frac{1}{4} \times 2\frac{1}{4}$ ins picture is over four times the size of that produced on slide or negative film with a 35 mm camera, and substantial enlargement with minimal loss of picture quality is possible. Therefore the format is ideal for images intended for publication, where enlargement of the original is most often required.

The disadvantages of medium-format cameras relative to 35 mm models lie in their high cost and in their bulk and weight. A further financial consideration is that only 12 images can be made on a standard 120 roll film, or 24 on a 220 film. However, if cost is no object, bulk film backs are a useful accessory in allowing uninterrupted shooting of up to 500 frames.

Non-SLR 35 mm and medium-format models are also used in nude photography. They have indirect viewing and little or no choice of lenses, but you can still achieve good results with them.

35 mm SLR

SMALL BUT VERSATILE The potential of today's sophisticated 35 mm SLRs is restricted more often by a lack of inventiveness in the user than by shortcomings in the camera. The viewing, focusing, and exposure systems are usually highly reliable and the choice of lenses continues to expand.

28 mm

28–85 mm 135 mm 70–210 mm

LENSES

Although 35 mm and medium-format SLR cameras are often sold equipped with what is known as a standard or normal lens—around 50 mm in focal length for the former and 80 mm for the latter—they are intended for use with a range of lenses of different focal lengths. Changing lenses is the most radical way of altering the interpretation of a subject. The standard lens provides an angle of view that is roughly the same as that of human vision, so that the arrangement of the picture elements in the viewfinder is similar to that seen by the unaided eye.

A wide-angle lens—with a focal length of 28–35 mm for the 35 mm format and 40–60 mm for the medium format—gives a very different perspective and is probably the most useful in nude photography. It increases the sense of depth in a scene, recording foreground, subject, and background in detail. This is particularly useful in confined spaces where information surrounding the subject is to be included but where there is not sufficient room to stand far enough back with a standard lens. Outdoor shots where the landscape is an important part of the scene also

benefit from the change to a wider-angle lens. A further use of this type of lens is to emphasize the effect of both low and high viewpoints, a common instance in nude photography being the low-viewpoint shot that accentuates leg length. The main problem with wide-angle lenses is that they distort the nearer parts of a subject even more than a standard lens, particularly at close range. For this reason it is best to keep the whole body of a nude roughly parallel to the lens.

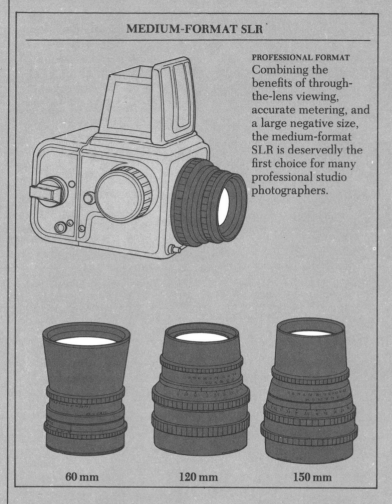

MEDIUM-FORMAT SLR

PROFESSIONAL FORMAT Combining the benefits of through-the-lens viewing, accurate metering, and a large negative size, the medium-format SLR is deservedly the first choice for many professional studio photographers.

60 mm 120 mm 150 mm

TELEPHOTO LENSES

As the name implies, a telephoto (or long-focus) lens telescopes a scene, creating a shallow perspective. At the same time it magnifies the image the eye sees so that it occupies a large portion of the frame. If you have a 35 mm camera, lenses with focal lengths from 85 mm to 200 mm will prove most useful, while the medium-format user will most often choose lenses of 100–200 mm. Where tight framing is required with no background detail, the narrow angle of view and shallow depth of field of the telephoto are ideal. In this way a short telephoto of, say, 85 or 100 mm, can be used in a studio to frame just the model's head and shoulders. Increasing the subject distance minimizes the distortion that all lenses create when used near to a subject. The main drawback of telephoto lenses is that the depth of field is shallow, so that focusing is critical. If this type of lens is used without a tripod, the denominator of the shutter speed should be at least as high as the numerical value of the lens's focal length in order to minimize the effects of camera shake. For example, a 100 mm lens should be used at 1/125 sec or faster, a 200 mm at 1/250 sec or faster.

ZOOM LENSES

A zoom lens allows you to shoot at any focal length between two fixed limits, and so does the work of several individual lenses. This facility saves time, which is often important in a fast-moving session, avoids the cost of owning a range of lenses, and saves weight for the itinerant photographer. Zooms are available at both the wide-angle end of the scale and in the telephoto range. A wide-angle zoom often incorporates the standard focal length, so that a wide range of effects can be achieved with just this lens and a telephoto zoom. Zooms are most widely available for the 35 mm format, where a lens of, say, 28–85 mm and one of 70–200 mm will meet all but the most exceptional needs. Although costly, a wide-ranging zoom is likewise a good investment for the medium-format user. The main drawbacks of zoom lenses are that the maximum aperture is usually smaller than those of individual lenses within their focal-length range, and the longer models are heavy and so require fast shutter speeds or a tripod.

FILM

The right choice of film for the lighting conditions is more crucial in nude photography than with many other subjects because the faithful reproduction of skin tones is usually vital. Light, whether it is from the sun or from an artificial source—flash, tungsten studio lights, or domestic lamps—can be measured by its color temperature. On this scale daylight has a color temperature of 5500 K (Kelvins), as does flash, while that of tungsten light is 3400 or 3200 K. Daylight film is designed to give an accurate reproduction of subjects lit by a light source with a color temperature of 5500 K, while film for use with tungsten light sources is balanced for the lower figures.

It would seem sensible to use only film which gives the right color balance. But there are often situations where the light source is changed during a film, where changing films duplicates cost and effort, or where the correct film is simply not to hand. The answer is to use filters to adjust the quality of the light to the film. For instance, if a daylight-balanced film is to be used in tungsten light the unwanted yellow-orange cast that results from this mismatch can be eliminated by using a blue filter over the lens. The question of color temperature arises only with color film; black and white film is balanced for all sources.

FILM SPEED

What both types of film do have in common, however, is varying sensitivity to light. This characteristic is known as the speed of the film and is measured on the single-number ASA scale or, increasingly, on the ISO scale, which combines American and Western European systems of measurement. The higher the ASA or ISO number of a film, the greater is its sensitivity, and the faster it is said to be.

Commonly used color and black and white films have ASA ratings between 25 and 400. Color film for use in daylight is available with a rating as high as 1000 ASA, while black and white film is supplied with ratings as fast as 1250 ASA or in a variable-speed

form, described as chromogenic, which can be used at up to 3200 ASA.

For both indoor and outdoor photography in natural light the speed of the film is critical: the lower the light the faster the film required. When artificial light is used, whether it is continous, as with studio and domestic lights, or intermittent, as with flash, the film's sensitivity is less important. What is of greater significance then—and this is also relevant to natural-light photography—is the effect of the film's speed on the appearance of the picture. The faster the film the more evident are the exposed silver particles known as grain, and the less distinct the image.

GRAIN AND MOOD

Since the mood of a picture is determined to some extent by the amount of grain, you should be aware of its tendency to produce this quality when choosing a film to suit the lighting conditions. As long as there is a strong light source, a slow film can be used, creating a grain-free image. If a grainy effect is required in this situation a fast film can be used with short exposures. Where the light is low, a slow, relatively grain-free film can be used only if extra light is introduced, whereas if a grainy effect is required then a fast film is appropriate. In order to increase the grain even more, further softening the image, a fast film can be shot at a higher ASA rating than the nominal figure and the processing time increased correspondingly.

Film speed also has an important effect on color or tone. A low ASA rating heightens color, in some cases to a degree unacceptable to the photographer who wants as natural a skin tone as possible. In black and white work a slow film heightens the tonal contrast between the well-lit and the shadow areas. Where pure tones of black and white are required, a film with a rating as low as 12 ASA can be chosen.

FILM TYPES

Practically all black and white photography is done with negative film, where the final product is a print made to a chosen size. Black and white reversal film, for transparencies, is rarely used. Color work, however, demands a choice between negative and reversal film. The great benefit of negative film is that color balance can be adjusted and incorrect exposure compensated for during processing. As the number of prints that can be made from a negative is infinite, you can achieve a very wide range of results from one original. Reversal film, on the other hand, offers higher resolution than negative film, so that the effects of enlargement are not as marked as in prints. For this reason, pictures for publication, where clarity after enlargement is invariably required, are usually in the form of transparencies. Reversal film does have its disadvantages, however, the most important of these being that it has less exposure latitude than negative film. The original must therefore be correct before processing. To guard against mistakes, important shots on reversal film are usually bracketed—exposed at the "right" exposure and again at one or a half stop either side of this so that at least one result is bound to be acceptable.

FILTERS

There are two basic groups of filters: those which correct or modify color or, in black and white work, alter tonal values, and those which change or distort the image for special effect. Color-correction filters are used when it is necessary to shoot with a film that is not balanced for the color temperature of the light source. Related filters are used to warm the tones, especially of skin, in a cold scene, to make fine adjustments to the overall color of a picture, or to introduce one or more tints to parts of a scene. Special-effect filters also have applications in nude photography. Perhaps the most commonly used type is the soft-focus filter, which blurs image detail slightly, creating the hazy effect often found in romantic or glamor pictures. Polarizing filters are designed to cut down the glare from reflected light and are frequently used in shots that include sunlit water. At the same time they intensify the color of both the sea and the sky. Also useful in brightly lit outdoor shots is the starburst filter. This creates up to 16 penetrating rays from each highlight, emphasizing the brilliance of the sun. Multiple-image and other distortion filters, however, rarely enhance a nude study, where the emphasis is best placed on the natural individuality of the subject.

Until recently filters were almost all circular and screwed directly onto the threaded front of the lens. A separate filter was required for each diameter of lens

FILTER KIT
These kits, available from a growing number of manufacturers, are based around a set of adaptor rings that fit all the lenses commonly used with 35 mm SLR cameras. The holder, which can be attached to any size of ring, takes square or round filters.

used. Now, kits with square, frameless filters are at least as commonly used. A kit consists of a filter holder that will take one or two filters and adaptor rings to fit different lens diameters. When a lens is to be used with a filter, the filter holder is screwed onto an adaptor ring with a standard front diameter and with a rear diameter the same as that of the lens. In this way a selection of inexpensive adaptor rings is all that is needed to use the same filters with a range of lenses.

TRIPODS

Most photographers cannot hold a 35 mm camera steady at shutter speeds longer than 1/30 sec. The problem of camera shake is accentuated when you are taking close-up shots, whenever sharp focus is critical, and when you are shooting from uncomfortable viewpoints. The weight of a telephoto or a zoom lens invariably compounds these difficulties. In such situations a tripod is necessary to hold the camera still.

A tripod should be able to be set at a wide range of heights without great loss of stability. Models with legs extending to 9 ft (2.75 m) are available, but legs with a maximum length of 6 ft (1.75 m) will handle most situations. For a higher viewpoint the camera can be set on a camera stand or a stable stepladder, while for low-viewpoint shots a tripod with a reversible central column is best.

A choice of tripod heads is available. These range from the simple tilt-top, through two-and three-way pan-and-tilt heads, to the smooth action and precision of gear and balance heads. Whatever the type of head, it should hold the camera securely and it should, preferably, be lockable at any angle. A cable release is used to fire the tripod-mounted camera. For long exposures the release should have a locking mechanism to keep the shutter release depressed.

TRIPOD HEADS
Almost as important as the range of operating heights in determining a tripod's versatility is the type of head. Several patterns exist, of which the tilt-top, below left, is the simplest. It offers considerable adaptability, but less than the pan-and-tilt variety, below, and lacks the versatility and precise adjustment of the balance head, below right.

TRIPOD TYPES
The lightweight tripod, top, is inexpensive, easily carried, and offers a typical maximum height of about 5 ft (1.5 m). The medium-weight model, above, adjusts to a similar height and, in some cases, has a reversible central column for low shots. It has greater stability, particularly in windy conditions.

CABLE RELEASE
When a tripod is used, the camera should be operated with a cable release, below. This is particularly important with close-focus shots. For long exposures a release with a locking plunger, right, is best.

LEG LOCKS
Tripod legs lock with quick-release levers, far left, nuts, second left, or collars, left. Some have retractable spikes, above, for use on soft ground.

LIGHT METERS

All modern 35 mm SLRs have built-in light meters that measure the light reflected from the area seen in the viewfinder. The camera uses this reading to indicate the required exposure. The most common type of meter is referred to as center-weighted—it derives most of its reading from the central area of the scene, largely ignoring the effect of shadows or highlights at the edge of the field of view. Where the central area itself has a deep shadow and a strong highlight, the meter is forced to make an even greater compromise, suggesting an exposure to lighten the shadow area and to tone down the highlit area. In this way neither component is recorded faithfully. In such situations, you can take a light reading from close to the subject, concentrating on the problematic area and then moving back to the original position to reframe and shoot. Alternatively, invest in one of the few cameras that incorporate spot metering, which accurately reads a small portion of the field of view.

While both of these remedies will improve the accuracy of exposure in difficult lighting conditions, they lack the subtlety of a hand-held light meter, which can be set to take a light reading of any portion, or the whole, of a scene. Furthermore, while a camera meter reads only light reflected from the subject, a separate light meter can base its reading on the amount of light falling on the subject—incident-light—or can combine a reflected-light reading and this incident-light reading for greater accuracy.

EQUIPMENT STORAGE

Cameras and lenses are precision instruments which should be handled carefully and protected when not in use from dust and dirt, damp, and extremes of temperature.

It is often necessary to transport equipment for location work, and then a protective case or bag is indispensable. Reinforced aluminum cases, either in the form of a business-type case or a trunk, are commonly used. The smaller case has a foam-rubber insert which is cut to take the various items of equipment, while the trunk often has an insert plus separate compartments. Shoulder bags, usually compartmented, are available in a variety of materials.

If cameras and lenses are carried separately, or are to be out of the case or bag for a long time, they need individual protection. Camera cases, in hard leather or plastic, are designed to take the camera and a short lens, although some cases have a long front section to accommodate a telephoto lens. Normally, the camera can be left in the case during use since the front portion can be let down or removed. Both hard cases and soft pouches are made for lenses. Extra protection is given by ensuring that each lens has a cap at each end. A sachet of silica gel in each camera and lens case will absorb damp, which is particularly harmful.

If you are shooting on a beach, keep the camera and lenses away from sand. Saltwater is highly corrosive and any that falls on the camera or lens should be cleaned off immediately. If you need to take pictures in the sea, protect the camera with a plastic bag, leaving an opening for the lens.

HAND-HELD LIGHT METER
When the camera is set up on a tripod it is easier to measure the brightness of a particular subject area by moving in close with a hand-held meter, above.

BAGS AND CASES
The roving photographer finds it easier to have his equipment in one place and may carry a shoulder bag in canvas or nylon, or a reinforced case in leather or aluminum, left. Both bags and cases are usually compartmented, below, for ease of use and better protection of the equipment. Separate cases, in plastic or leather, are made for 35 mm cameras and for lenses themselves, bottom.

LIGHTING EQUIPMENT

Good pictures can be taken with the aid of both daylight and artificial light. Many photographers prefer the subtle qualities of soft natural light to the often unreal effects of artificial sources, but adequate daylight is often unavailable when it is needed. While there may be various other reasons for choosing a studio or interior location—accessibility, comfort, familiarity, for example— it is the possibility of substituting a light that can be fully controlled for one that is undependable or absent that is the prime benefit of working indoors.

Studio lighting equipment is of two types—tungsten lights, which provide even, continuous illumination but are expendable, and flash units, which offer a limitless number of brief but far more intense bursts of light. Tungsten lighting is relatively cheap and is often used by the beginner, but flash is now established as the standard form of lighting for most serious studio photography.

TUNGSTEN LIGHTING

The two basic forms of light—hard and soft—can both be provided by tungsten lamps. Hard light is produced by compact "point" sources such as spotlights. With their strong beam these create harsh shadows and high contrast. The narrower the beam the greater the contrast, and most spotlights offer beam-width adjustment to take advantage of this effect. Soft light is most often provided by floodlights. These use a large lamp that spreads the light to give a well-defined image with soft shadows and low contrast. The lamp is normally set in a bowl-shaped reflector which further diffuses the light. Long tubular lamps, which face inward and bounce light from a shallow reflector, also create a soft-lit effect by causing light to fall indirectly on the subject. Spotlights can be made to yield soft light if a diffuser is placed over the lamp or the beam is bounced off a reflector board.

TYPES OF TUNGSTEN LAMP

Lamps with a simple tungsten filament lose intensity gradually and as they wear out so the color temperature of the light they emit cools progressively. Even when a tungsten-balanced film is used, careful filtration is required to restore the correct color balance. Tungsten halogen lamps, however, avoid this problem. As the tungsten is vaporized it is dispersed in the halogen and is redeposited on the filament, extending the lamp's life by as much as ten times that of its simpler counterpart. They are also up to 25 per cent brighter.

Apart from their expendability, tungsten lamps have another disadvantage when compared with flash. Since they provide a less intense light, slower shutter speeds and larger apertures are often unavoidable if the film is to be exposed properly. A further problem is that they generate intense heat and must be switched off every few minutes. These fragile lamps should be moved with great care.

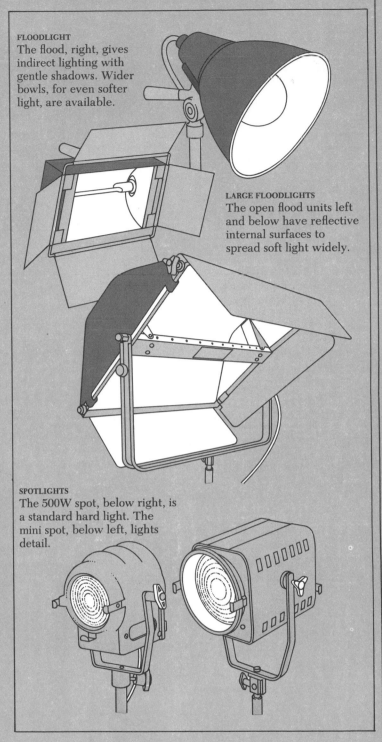

FLOODLIGHT
The flood, right, gives indirect lighting with gentle shadows. Wider bowls, for even softer light, are available.

LARGE FLOODLIGHTS
The open flood units left and below have reflective internal surfaces to spread soft light widely.

SPOTLIGHTS
The 500W spot, below right, is a standard hard light. The mini spot, below left, lights detail.

FLASH LIGHTING

The simplest flash unit for 35 mm photography is the flash gun, which is used on top of, to the side of, or very near the camera. It produces hard, direct light, creating strong shadows, and has a typical maximum range of 30 ft (9 m). Some units have a pivoting head, allowing flash to be bounced onto the subject from a wall or ceiling, for a softer effect. Others have two heads—one to illuminate the subject directly and one to provide bounced light. When non-standard lenses are used, the spread of the flash beam must be adjusted by means of adaptors to suit the lens's angle of view. Most flash guns synchronize automatically with the exposure set on the camera, adjusting range and output to suit the subject distance, which is first measured by the gun with an exploratory beam, and the chosen aperture.

Flash guns are widely used in the studio, but also provide a versatile and portable light source for outdoor work. Apart from their use at night, they can simulate the sun in dull weather, the available light filling in the shadow areas. If daylight exposure is reduced by a faster shutter speed than is required, moonlight can also be simulated by day.

Better quality guns often form part of a kit that includes diffusers and reflectors to soften the light, filters to adjust color temperature so that tungsten

main, or key, light, a light to fill in the shadows, and a third to light the model's hair or the background.

As with tungsten lamps, the type of light cast by the unit is determined by the shape of the reflector around it. A soft light is provided by a flash tube set in a shallow reflector, while a tube with a cowling gives the effect of a spotlight—hard and directional light that produces strong shadows. For a very soft effect a windowlight of up to 6 ft (1.75 m) square is used. Its arrangement of several tubes behind a sheet of diffusing material imitates the soft, stable lighting associated with the large, north-facing window traditionally favored by naturalistic painters..

Tungsten light, being a continuous light source, allows the effects of shadows to be judged before the shutter is released. Simple flash units lack this facility, so that their light is not really predictable. Better units, however, incorporate a tungsten modeling light in the center of the flash tube that previews the effect of the set-up in use.

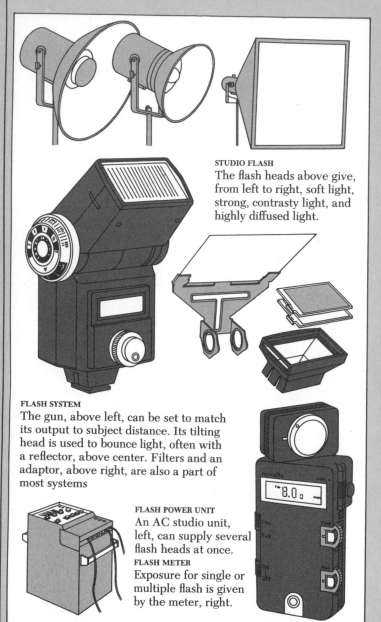

STUDIO FLASH
The flash heads above give, from left to right, soft light, strong, contrasty light, and highly diffused light.

FLASH SYSTEM
The gun, above left, can be set to match its output to subject distance. Its tilting head is used to bounce light, often with a reflector, above center. Filters and an adaptor, above right, are also a part of most systems

FLASH POWER UNIT
An AC studio unit, left, can supply several flash heads at once.
FLASH METER
Exposure for single or multiple flash is given by the meter, right.

POWER FOR FLASH LIGHTING

All studio lights require considerable mains power, and where several lights are used it is essential that the studio's wiring is equal to the task. Small units often have an integral mains-operated power source, while others use a power pack that provides a stable base for the stand and unit. Larger units are attached in groups of up to four to a free-standing capacitor that shares its power equally among the lights. A booster is often used with these more sophisticated set-ups to speed the recharging time of the units. When multiple flash is used, it is essential to synchronize firing. To achieve this, one light is commonly linked to the camera by a synchronization cord, while each of the other lights has a slave unit that reacts to the first, setting off the flash instantaneously. Alternatively, each unit has a detector which responds to an infra-red signal from the camera immediately the shutter is released. Simple lighting units offer only one strength of output, but a number of better models have a scale of up to five settings.

FLASH METERS

The effect of flash on exposure is not predictable with a camera's built-in meter or an ordinary hand-held meter, because they are designed to measure only the intensity, not the duration, of light. A flash meter, however, takes duration into account when giving a reading and can be used with a single or several light sources. With a single light the meter is pointed at the lamp from the model's position and a test flash made. The meter then gives the required aperture setting for the ASA rating in use. With multiple lighting the meter is directed towards the camera and an average reading is obtained. While a few meters are accurate to within one tenth of a stop, most are precise to within one third. The higher degree of accuracy is more than adequate for most lighting situations, but is invaluable when expensive, large-format transparency film, which offers little exposure latitude in processing, is used. Some flash meters can also be used for measuring continuous light.

film can be used—flash is balanced for use only with daylight film—and to create special effects, a manual adaptor that overrides the gun's automatic operation so that finer control of light can be obtained, and other aids. The most versatile guns can be powered by integral batteries or by a rechargeable battery pack.

STUDIO FLASH

Like flash guns, studio flash lights provide illumination that imitates natural light. This means that daylight-balanced film can be used without filtration to obtain accurate color rendition. While flash guns are used on or near the camera, flash lights can be positioned anywhere and can be used in many combinations. A common set-up for nude studies is a

LIGHTING HEAD VARIANTS
A deep reflector, right, gives hard light; a shallow bowl and a lamp cap give the opposite. Barn doors, below, left, define the spread of light. A diffuser, below, right, softens a spot, as does a scrim, bottom, left. A snoot, bottom, center, and a spot projector, bottom, right, give a narrow beam of hard light.

UMBRELLAS AND DIFFUSERS
An umbrella, top, is used to soften or color both tungsten and flash light. A screen in a translucent material, above, is used to diffuse direct light.

LIGHTING SUPPORTS
A telescopic stand with braced legs, left, center, can be used with or without a boom to provide versatile and reliable support. The low stand, left, is used for backlighting, while the medium-height stand, far left, is suitable for a wide range of lighting set-ups.

LIGHTING ACCESSORIES

Integral reflectors determine to a large extent the lighting effect of both studio flash and tungsten lamps. Their two prime functions are to concentrate or to diffuse light. There are situations, however, when it is necessary to intensify these qualities or to modify the light in other ways. For example, to create a very hard, concentrated light a conical attachment called a snoot is used. Barn doors are metal flaps on a frame that fits over the light to give precise control over the width of the beam. They create effects ranging from a broad beam to a slit of light that produces crisp shadows. When the light is to the side of or behind the subject, barn doors are used to prevent light from spilling into the camera lens rather than just illuminating the subject. To create an extremely soft-lit effect, diffusion screens can be fitted over the light, while a gauze sheet known as a scrim both softens and reduces the intensity of the light. A half scrim allows the light falling on a part of the subject to be dimmed. When color correction is necessary—most often when the film in use is not color-balanced with the light source—compensating filters are placed in a holder that fits onto the lamp.

UMBRELLAS AND REFLECTORS

In cases where the light source is too harsh for the required effect, a substantial softening can be produced with a special umbrella in silver, white, blue, or gold fabric. The lamp is pointed away from the subject and directed at the concave side of the umbrella, which is mounted around it. The device reflects onto the subject a soft light that is almost shadowless and reveals details. A silver umbrella softens light without changing its color, while a white one produces an even more pronounced softening. A blue umbrella modifies tungsten light so that it can be used with daylight film, and a gold umbrella warms the color of the light source. An alternative way of diffusing the light is to direct it through a translucent material stretched across a round, square, or rectangular frame with an area of several square feet.

Another important form of reflector is used at variable distances from the light source and the subject. It throws light onto the shadow side of the model, bringing out skin texture and even filling in small details. This device is purpose-built in the form of a sheet of white or silvered material supported by a frame, although as effective a version can be improvized from a sheet of light wood or cardboard covered with tight white fabric or crinkled aluminum foil.

LIGHTING SUPPORTS

The simplest form of support for studio lights, suitable for lightweight lamps only, is a clamp which can be attached to the poles that hold background paper, to the backs of chairs and stepladders, to the tops of doors, or to any other stable fixture. A telescopic stand offers greater versatility in that it can be moved to any position and is normally extendable from about 3 ft (1 m) to about 10 ft (3 m) in height. It has three fixed or foldings legs—the latter type is better for location work—and heavy-duty models are fitted with castors. A further benefit of the sturdier stands is that a boom can be attached and, if a counterweight is used, heavy lights can be mounted. A boom is particularly useful for top lighting and for close illumination where the stand would otherwise intrude. Low stands of up to 3 ft (1 m) are often used in backlighting.

THE STUDIO

The main advantage of a studio is the control it gives over lighting. While it may have large windows or even a skylight, weather conditions are not always suitable for natural-light photography, and you will then need to rely on an artificial source. Accordingly, black blinds are fitted over the studio windows to exclude daylight and to allow the use of tungsten lights or flash. By forgoing daylight, you become completely responsible for the lighting effects you create. A studio also allows you to manipulate backgrounds to achieve precisely the atmosphere you require, besides giving you warmth, privacy, the convenience of having all your equipment in one place, and total freedom to work in any weather.

THE BASIC STUDIO

The minimum requirement of a studio is that there should be enough space for you and your camera, the model, lighting equipment, and the background or set. You will need a room of at least 18 ft (5.5 m) in length—any shorter will prevent you from taking full-length shots with a standard (50 mm) lens since, for this sort of picture the model would be about 6 ft (1.75 m) in front of the background and you would be 10–12 ft (3–3.75 m) farther away. A minimum width of about 12 ft (3.75 m) is needed to accommodate a standard roll of background paper while allowing space at either side for lights. The ceiling should be at least 8 ft (2.5 m) high so that you can shoot from a low viewpoint without including it and so that you can bounce flash light off it onto the model to the best effect. Ideally, the room should be a spare one, so that you can leave your equipment set up permanently. If this is not possible, make sure that you have a safe storage place for it. It may be that a room in your home, or your garage, meets these requirements. If so you can take advantage of this and spend the money you would otherwise pay for the occasional hire of a studio on improving your lighting facilities and on building up a selection of background materials, including colored paper.

BACKGROUND PAPER

The walls of your studio should be mat white, neutral gray, black, or have a variety of these tones. Colored surfaces will give a color cast to your pictures. When using the wall as a background it is important not to include the distracting joins with floor and ceiling. Apart from using subtle camera angles, the easiest and most common solution to the problem is to use background paper. This comes in rolls 9 ft (2.75 m) or 12 ft (3.75 m) wide and at least 36 ft (11 m) long and is normally supported on a crossbar between two lighting stands or expanding poles. The paper is rolled down to and across the floor to provide a background of uniform tone without joins. If the floor is covered with a fitted carpet you should place a sheet of hardboard or plywood beneath the paper so that it lies flat. It is important to keep the paper clean, as marks will show on film.

The broad range of colors available allows a variety of moods and effects to be created. But white paper is the most versatile since it can be used as it is, put in deep shadow so that it is almost black, or colored by filters over the background light. Gray papers are also adaptable, while black paper is useful for low-key shots. If colored paper is used it should complement or contrast with the subject's coloring, but should not distract the eye from it. Cold colors, such as blues and greens, appear to recede, so that they give greater prominence to the model's skin tones, but reds and oranges are usually overpowering and should only be used with caution. Papers are also available in a wide variety of textures and patterns.

A more versatile form of background is provided by flats—plywood, hardboard, or styrofoam boards reinforced at the rear by battens and used plain or covered with paper or fabric. Apart from creating a movable and storable background of any desired color, pattern, or texture, flats can be used to reflect light onto the shadow side of the subject to fill in details. For this, a light-colored fabric or paper, or crumpled aluminum foil, can be used. When a more naturalistic background—an interior, for example—is required, flats can be painted or covered with wallpaper and adapted to take a door or a window. These fittings can be obtained cheaply from demolition sites. Their condition need not be perfect as a shallow depth of field can be used to render them slightly out of focus. If a corner is needed, flats can be hinged together, but not necessarily to form a right angle, since quite often the best effect is provided by a slightly wider angle.

A studio shot is often enhanced by the inclusion of props, but these should not be allowed to dominate the main subject by their size or color. Furniture, pictures, bric-a-brac, and potted plants are often called for and can double as practical or purely decorative features of the permanent studio. When more exotic props are needed, you should contact a specialist hire company. All props must be in good condition if they are to appear in sharp focus, and so cleaning materials should always be to hand.

HIRING A STUDIO

If your home cannot provide a suitable space, you will need to hire a studio. Visit it before the session to check that its size and layout permit the lighting setups you intend to use and find out exactly what equipment is available. Studios provide lights, background paper and flats, and often have a range of props. If you need extra equipment you will have to hire it elsewhere. At the same time, check that there is a comfortable and well-lit place for the model to make up and change, that there is a bathroom, that the heating is adequate, and that there are spare lamps for the lights, without which the whole session will be ruined. Studios are normally booked by the hour or day, but you should find out if there is provision for running over time and what it will cost.

STUDIO LAYOUT

The professional photographer frequently needs room to have more than one set available at the same time. He also requires storage space for the wide range of equipment that is called for and an administrative area where he can deal with and store paperwork and can entertain clients. These considerations do not normally concern the enthusiast with a home studio. Nevertheless, the improvised studio should be planned with flexibility and ease of use in mind. A generous shooting area should be kept free, so that space around the edges of the room must be used to store reflectors, screens, flats, background paper, and furniture, unless it is to be used as a prop. Lighting stands with wheels can be moved with ease and a stepladder is useful for adjustment of high lamps and for high-viewpoint shots.

KEY TO ILLUSTRATION

1 Studio flash with umbrella reflector
2 Background paper on stand
3 Windowlight (flash)
4 Floodlight with snoot
5 Spotlight with power pack
6 Trestle table
7 Projector
8 Lightbox
9 Camera on tripod
10 Blind
11 Ceiling light
12 Sliding spotlight
13 Refrigerator (for film)
14 Storage area
15 Skylight
16 Protective frame for background paper
17 Stepladder
18 Reflectors and folding screen
19 Make-up area
20 Extension cord

THE MODEL

The three most important factors in successful nude photography are the idea behind the picture, technical expertise, and the right choice of model. The importance of the latter cannot be overemphasized. No matter how fresh your inspiration or how competent your handling of a shot, if you use a model who does not respond naturally to your ideas or whose appearance is wrong, your pictures will suffer.

While this commonsense requirement to match ideas to personality and looks is obvious, it is often tempting for the less experienced photographer, having gone to the effort of acquiring a model and setting up a session, to try out shots that do not do justice to his subject. Forcing a model into the wrong mold guarantees poor results. It is important therefore to agree beforehand, as far as possible, on what you plan for the proposed session, otherwise you may find that a model who has proven ability in glamor work and usually wears some item of clothing will not be relaxed when asked to pose totally nude, or that one who is well suited to moody studies will balk at dynamic shots. Regardless of physical appeal, it is useless to go ahead if the model is not at ease with your proposed approach. If you do, reluctance and a consequent lack of spontaneity will inevitably be reflected in your work.

THE MODEL'S APPEARANCE

The ability to pose naturally is a function of personality, but the model's looks should also be considered. At any period there is a broad consensus on the sort of body best suited to nude representation, and unless a photographer feels able to achieve good results with an unusual face and body, he is likely to allow himself to be influenced by current tastes. But this does not mean that the model must conform to a narrow stereotype. In fact, the ability to convey the individuality of the subject is an essential part of all effective photography of people.

A face with a well-defined bone structure has greater potential for interesting lighting than a soft, rounded face, which will usually defeat attempts to create lighting contrast. The profile should not be overlooked as this often gives more attractive results than face-on shots. The face need not be conventionally beautiful or handsome, but it should be free of skin blemishes. If necessary, however, these can be minimized by lighting or touched out.

OVERALL SHAPE

In general, more roundness is sought in the female model than in the male. This does not mean that excessive weight is acceptable, but the overall shape should contrast with the muscular, rather angular form prized in a man. Height is not so critical as in fashion photography, where very long legs and a long body are at a premium.

In both men and women the head, body and arms should be in proportion, although the hands, being the most expressive feature after the face, are best when long and slender, particularly in a woman. In this way they delineate whatever part of the body they are resting on. The shoulders, waist and hips should also be in good proportion to each other, and the waist should be well defined in the female. A flat stomach is desirable in both men and women, and the opposite should be avoided in the man. The woman's breasts need not be large, but they should be firm, as should a man's chest muscles. The buttocks should be well rounded but not exaggeratedly so. Long legs, though not critical, are an asset, but as important as length is their shape. They should taper continously from top to bottom, without a bulge in the thighs. The feet are better if rather small and certainly should not appear long in relation to the thickness of the ankle. A good picture can be taken with only some of these characteristics present, and indeed very few models boast them all. What is indispensable, however, is good posture. The model should be able to stand upright but relaxed. While the photographer will sometimes want a gracefully curved back or neck, he should never allow the model to slouch, so that the shoulders drop and the neck appears foreshortened.

MODEL SOURCES

If you want to make a start in nude studies, ask your partner or a good friend to pose for you. The lack of experience of both photographer and model is compensated for to a degree by the familiarity which exists between you. Provided your subject has not been coerced into posing, she or he should be able to make allowances for your necessarily hesitant approach. Even so, it is your responsibility to instil the confidence in your model to stand naked and relaxed in front of the camera. If the model is a minor you should obtain the parents' permission, and under no circumstances should you try to make the pictures erotic, or you will risk prosecution.

PHOTOGRAPHING A STRANGER

It is sometimes possible to get a stranger to agree to pose nude. Here great diplomacy is needed if your motives are not to be misunderstood. If you make this sort of approach, it is best to have done some acceptable shots already to show to the prospective model to demonstrate your sincerity. You should also suggest that the model might bring a friend along to the session in order to feel more at ease. Drama students, some of whom will also have been trained in dance, may also pose for you, particularly if you promise them pictures to promote themselves. The best approach is to get permission from the college principal to advertise on the students' notice board. Camera clubs provide another opportunity for shooting nudes. The models are usually female and very often of the "glamor" type. The members pay jointly for a professional model's time, and work in a group, sharing the facilities of the studio. Independence is curtailed to an extent, but the experience of others' methods can be instructive.

POSING THE MODEL

The success of any photographic session depends on the ability to visualize pictures and to adapt to the demands of the situation. In the nude session the photographer must be able to recognize the potential of a good pose which nevertheless needs slight adjustment, and to understand the subtle benefit to lighting and composition of the smallest change in position. Always compose your picture in the viewfinder as this is how the camera will record the scene. If it helps, look at the model as a design in which the elements should be related (unless an abstract effect is sought). Many problems only become apparent when you adopt this approach. Remember that the eye is very subjective and is drawn to the attractive features when looking at the model in the normal way. Using the viewfinder encourages you to analyze the subject as a whole.

Where experience is lacking in the photographer, or the model is unaccustomed to nude work, it is best to use straightforward poses, which are often the most effective anyway. The illustrations below show a varied selection of expressive poses from the earlier part of the book. A simple but elegant shape should always be the principal aim in posing the model.

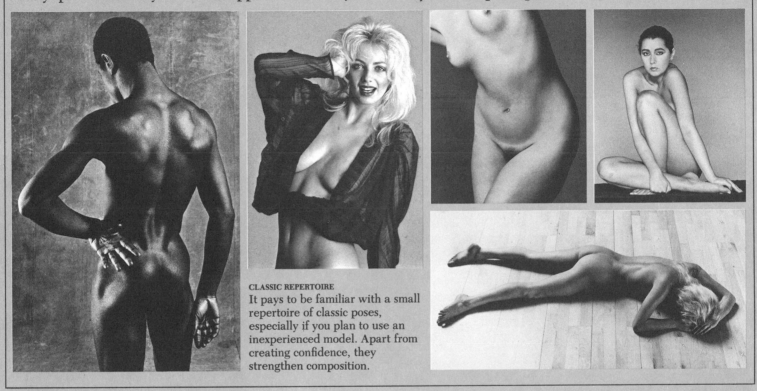

CLASSIC REPERTOIRE
It pays to be familiar with a small repertoire of classic poses, especially if you plan to use an inexperienced model. Apart from creating confidence, they strengthen composition.

MODEL AGENCIES

Model agencies are the prime source of models for the photographer who wants a wide choice of experienced subjects. The cost of agency models, however, puts them beyond the reach of most amateurs. The professional photographer, on the other hand, either works for a client who pays for the use of his pictures in a publication, or produces work on his own account in the knowledge that it is likely to be of use for reproduction in a magazine or book. The model is free to negotiate fees with the photographer, while the agent charges a commission based on the total fee received from the photographer. It is considered unethical to negotiate with the model for further work without going through the agent.

A good agency will offer you a selection of photogenic models with dedication and the stamina to work long hours or to travel for location work. If you are a new customer the agent will normally want to see samples of your work to make sure you will be able to do justice to a model, especially if your pictures are for publication. When you have outlined your requirements you will be shown model cards with shots of the models in different poses, their vital statistics, and other details. These cards save time but, because they are intended to promote only the best aspects of a model, often fail to give a complete impression. For example, facial blemishes may have been touched out in the print and clothed shots may conceal operation scars or other defects.

MODEL RELEASE

In addition to fixing payment with the model, the photographer is wise to negotiate permission to use the pictures in whatever way he chooses. For this purpose a model release is drawn up. This is a standard form available from bodies such as the Bureau of Freelance Photographers in the UK and the American Society of Magazine Photographers. The procedure is normally straightforward, the photographer indicating the use(s) to which the pictures will be put and the model signing the form after the session or, on occasion, after seeing the results. However, if the model demands that the pictures must not be used for certain purposes or in certain areas or countries, the photographer must detail these exclusions on the document. While the release grants the photographer certain legal rights, it does not exempt him from the laws concerning libel and pornography. Accordingly, he should not give permission for his pictures to be used in conjunction with text that may be libelous, nor should he agree to his work being seen in countries where it is likely to infringe laws concerning pornographic material.

When you have chosen a model, whether professional or amateur, it is best to arrange a session in which to take test shots to see how photogenic your subject is. These need not be nude studies, but must explore the face frontally and in profile, and should show posture. At this stage you can assess the model's best poses and expressions and note any weak points. If you are satisfied with the shots, arrange at least one session of an hour or more.

PLANNING THE SHOTS

Before the first session, work out the ideas you plan to use. Make sketches of the model's position in relation to the camera and the light source(s) and note the focal lengths of the lenses you will need for the different viewpoints. Plan the shots so that they run smoothly and involve the minimum number of changes of lighting and viewpoint. List any further camera equipment—filters, for example—and props that you will use.

Most professional models have a wardrobe of clothes in which they feel comfortable in the studio or on location. Ask the model to bring a selection along to the first session as you will not normally begin with nude shots and may even want to use some of them in later work. A good model should not need reminding to come to the session in loose clothing, as tight garments leave marks on the skin that remain for several hours.

If you lack definite ideas at first, look at poses in advertisements and fashion magazines or study the work of other photographers. You do not need to copy slavishly, but you will at least have a starting point from which your own ideas can develop.

THE FIRST SESSION

On the day of the session, set aside a couple of hours beforehand to go through your shooting list and to check that all your equipment is in working order. When the model arrives, warm up with some simple shots, clothed or nude, depending on the model's preference. Most inexperienced models certainly favor this approach and even a professional may at first feel vulnerable and inhibited with a new photographer. Portraits are useful here, but lively shots tend to break the ice more effectively. You will already have some idea of your model's potential from the test shots, but use this session to discover more. Establishing a rapport is probably the most important element in photographing people. With ideas and technical ability but little or no rapport you will undoubtedly fail to get the best from your subject. In a friendly atmosphere, however, you can expect your model's best efforts and toleration of your experiments with technique.

The aim of the session should be to achieve an interaction. Do not become so engrossed in your ideas or the technical considerations that you ignore the model. On the other hand, if you overdirect you will destroy the spontaneity of even the best model.

Instead, discuss your ideas freely, showing your visualizations of the shots, and welcoming suggestions. This leads to a feeling of involvement in the model and usually saves time. If you are using an assistant, a make-up artist, or a hair stylist, make sure that they are properly involved too, allowing their comments and suggestions to contribute to the session. Providing background music that is to the model's taste can also create the right atmosphere.

BOOSTING THE MODEL'S CONFIDENCE

Apart from sharing your ideas, and so creating faith in your ability, you must also boost your subject's confidence. Comment only on the successful poses, overlooking the others and waiting until the model adopts a better one. Use a mirror to show the best poses and expressions. Instant picture shots, as well as allowing you to preview composition and lighting, serve the same purpose. When an easy rapport is established, the model will work naturally, with minimal prompting. Even then do not let the encouragement slip, but continue it until the end of the shoot. Keep the session moving, changing the tempo from time to time, and do not dwell too long on one idea as most models work better with constant variation. On the other hand, take frequent breaks for refreshment and to allow the model to rest.

EDITING YOUR PICTURES

It pays to set aside a few hours for editing the results of every session. Don't simply categorize your shots as successes and file them away or as failures and discard them. Instead, analyze what made a shot work, so that you can repeat your success, and find out why mistakes occurred, so that you can avoid duplicating them.

VIEWING AND STORAGE
A lightbox and a magnifier, right, are best for comparing slides, while a projector, above, right, is useful for displaying pictures. Negatives and contacts should be indexed and are best filed in an album, above. Slides can be stored in the same way, in boxed projector magazines, or in suspension files in a cabinet.

OUTDOOR LOCATIONS

The total control over lighting offered by indoor photography makes for a broad choice of methods. By contrast, the creativity in outdoor work resides in achieving the best possible results from unpredictable and largely unalterable lighting conditions. But while daylight cannot always be relied upon, the outdoor photographer does have a wide choice of natural and manmade environments in which to work. Here, pre-session research and detailed notes are advisable.

SHOOTING IN THE CITY

Buildings can prove useful adjuncts to nude studies, not least in creating a sense of the unexpected. The roundness and luminosity of the naked human form create a powerful contrast with the angular character and often muted tones of a cityscape, so that even when there is a marked difference in scale the nude subject stands out from its setting. The geometric shapes of the urban landscape can contribute greatly to the composition of a picture—doors and windows are particularly useful in providing a frame within a frame. When put out of focus, walls can be used like background paper or flats in the studio, to give tone to a scene. A wall with an interesting texture, on the other hand, can be rendered sharp as a foil to the texture of the model's skin.

The threat to privacy and the risk of falling foul of the law restrict this sort of session to abandoned or derelict sites—industrial wastelands are particularly popular—or to shooting at either end of day, when the least number of people are about. Even so, there is the constant threat of interruption, and speed is essential. The simplest approach is for the model to wear a long coat with nothing underneath, discarding it briefly for the shoot.

THE NATURAL ENVIRONMENT

Just as brick, metal and glass can form a striking contrast with the tones and texture of skin, so do many elements in a landscape. And yet while there is little in the manmade environment to echo the human appearance, natural settings also offer flowers, grass and leaves to complement the softness of the nude form. Nature also provides ready-made aids to composition: often the structure of a bush, tree, or rock suggests a frame for a subject, while the positioning of the horizon or the sun is a significant factor in creating an effective setting for the model.

Water can be a potent element in outdoor work. Its depths can convey mystery, its stillness peace, and its turbulence excitement, all of which are common elements in nude pictures. The beach is probably the most popular setting for glamor photography and has long provided the scene for more serious work. Apart from its association with the naked or partially clothed form, which can admittedly make for predictable nude shots, the beach offers the advantage of a distinctive light. Extensive sand and water both reflect strong sunlight, softening its otherwise harsh lighting effect on the skin.

OUTDOOR LIGHT

Whatever location you choose, you will find that the unpredictability of natural light offers its own compensation in the form of variety. An understanding of the changing quality of light and its effect on a scene is essential to successful outdoor photography.

Strong sunlight from a cloudless sky emphasizes skin texture and creates bleached-out highlights and harsh shadows with sharply defined edges. Such light, particularly around the middle of the day, is ideal for dramatic shots where the intention is to show straightforward sensuality. Its harshness defeats a more delicate interpretation of the subject, but there are several remedies for this situation. First, since shadows are at their shortest at midday you can sometimes change the harsh effect by slightly altering the position of the model and the camera in relation to the sun. Secondly, you can use a reflector or a flash gun at any time of day to fill in detail on the shadow side of the subject. Where shade is available you can benefit from natural diffusion, or you can soften the light artificially by placing a diffusing screen of nylon or tracing paper between the model and the sun. A compromise solution is also possible: you can choose between a mainly highlit effect or a shadowy picture and expose accordingly.

EARLY AND LATE LIGHT

In the early morning and late afternoon, strong, direct sunlight has a different effect from that of the middle of the day. The sun is lower in the sky and casts long, oblique shadows that are less dense. This light is usually pleasing, providing subtle modeling of the subject, but the yellow or orange cast associated with morning light and the bluish cast often apparent in the late afternoon may need to be corrected with, respectively, blue and orange filters.

DIFFUSED LIGHT

The type of light favored for many subjects, and particularly the nude, is strong sunlight filtered through thin but evenly distributed cloud or haze. This light is directional enough to provide good modeling but sufficiently diffused to reduce contrast. The result is soft shadows and a gentle treatment of skin texture. Even when the cloud cover makes the day dull, diffused light has an advantage over strong, direct sunlight. The latter creates such a brightness range that colors are degraded, whereas dull light, which does not produce strong highlights or dense shadows, gives a more faithful color rendition.

Overcast conditions do present problems, however. For example, a bluish cast is common, most noticeably near the sea or at high altitude. Orange filtration is indispensable in such situations. Again, an overcast sky produces "top light," which often leads to shadows under a model's eyes, nose, and chin. In this case the open shade provided by a tree or building can be used, or a reflector can be placed below the head to cast light up into the shadow areas.

ACKNOWLEDGMENTS

I would like to thank first and foremost the editorial team for their sustained effort and encouragement. I also owe warm thanks to my assistant Anne Giles, who printed many of the pictures and appears in a number of them, and who was always at hand to help with practical problems. My gratitude is also extended to Bill Rowlinson, who printed most of the other pictures and applied special treatments to seven of them. I would also like to thank Robert Buhler, Timothy Easton, Dominic de Grune, and Ruskin Spear for their kind assistance. Thanks are also due to Studio Accessories of Blackpool for supplying Multiblitz reflectors, to Pentax UK Ltd, and to 3M UK plc. Finally, I must express my gratitude to my wife Julia for her patient and accurate typing and her support and encouragement.

John Hedgecoe

Dorling Kindersley Limited would like to give special thanks to Anne Giles for printing the pictures on pages 8, 24, 25, 32, 36, 37 (left), 41, 45, 48, 52, 56, 60, 64, 68, 73, 82, 83, 88, 89, 90, 92, 93, 94, 95, 100, 101, 102–3, 104, 116, 117, 120, 121, 128–9, 148, 149, 160–1, 172, 173, 178, 180, 181, 182, 183, 184, and 185; and to Bill Rowlinson for the special treatment of the pictures on pages 18, 19, 26, 42–3, 62–3, 162–3, and 164–5, and for printing the monochrome pictures on pages 4, 16–17, 28–9, 53, 57, 65, 69, 72, 76–7, 80–1, 84–5, 86–7, 91, 108–9, 112–13, 124–5, 132–3, 144–5, 150–1, 174–5, 179, 190–1, and 192. He used the Beers two-solution developer for all the pictures and made the prints on doubleweight bromide or chlorobromide paper with a cathode and condenser-head enlarger.

Dorling Kindersley would also like to thank Mike Tribe for design assistance, David Ashby and John Woodcock for their illustrations, Ken Hone for retouching and montaging, Fred Ford and Mike Pilley of Radius Graphics for paste-up and artwork services, and MS Filmsetting Ltd, of Frome, Somerset, for the typesetting.

SUGGESTIONS FOR FURTHER READING

John Berger *Ways of Seeing* (New York, 1977)
 Art and Revolution (New York, 1969)
Bill Brandt *Shadow of Light* (New York, 1977)
Kenneth Clark *The Nude: A Study of Ideal Art* (New York, 1959)
William Gaunt *The Aesthetic Adventure* (New York, 1975)
Edward Lucie-Smith *Eroticism in Western Art* (New York, 1972)
Herbert Read *The Meaning of Art* (New York, 1931)
Hans Richter *Dada: Art and Anti-Art* (New York, 1978)
Aaron Scharf *Art and Photography* (New York, 1974)
Susan Sontag *On Photography* (New York, 1977)